Relax—there will be no test.

Europe 101 boils down European history and art. The tangle of people and events—from the pyramids to Picasso, from Homer to Hitler—is sorted out into a fascinating and orderly parade of history. The tourist sights you'll see today come right out of the past—and the better you understand that past, the more fun those sights will be.

The first half of this book connects yesterday's Europe with today's sights—art, museums, people and buildings—giving you practical background for your travels. In addition, related articles of interest ("Tangents") appear in the last half, offering a closer look at things like "Music in Vienna," "Life in a castle," "How to tackle a museum," "The five most exciting Greek ruins" and "Victorian London," etc.

This unique approach to art and history with maps, timelines and illustrations, makes this "professor in your pocket" an essential tool in any thinking tourist's preparation for Europe.

Beyond their formal university education in European history, art and culture, the authors have spent a total of 70 months roaming Europe. They understand what the average traveler needs to know to appreciate the sights and culture. And, just as important, they know what isn't important.

Now, for the first time, travelers can enjoy a fun to read practical book that prepares them for Europe's history, art and culture.

II

EUROPE 101
HISTORY AND ART
FOR THE TRAVELER

by Rick Steves,

author of "Europe Through the Back Door", "Europe in 22 Days", "Great Britain in 22 Days" and "Spain & Portugal in 22 Days"

and Gene Openshaw

graphics and maps by
 David C. Hoerlein

production by
 Terry Duffy

A fun story of Europe's people, art and history designed to make castles, palaces, and museums come alive. The first and only easy-to-digest history and art book for travelers.

Including 33 articles in the last half of special importance to travelers.

Published by John Muir Publications, Inc.
P.O. Box 613
Santa Fe, NM 87504

Library of Congress Catalog Card No. 87-042858
Library of Congress Cataloging in Publication Data
Steves, Rick, 1955
Europe 101

ISBN 0-912528-78-8

First Edition April 1985
Second Printing April 1986
Revised July 1987

Distributed to the trade by W. W. Norton & Co.
New York, NY

Table of Contents

Part 1—THE BODY: Europe's History and Art

Part 2 — TANGENTS: Articles developing areas of special interest to travelers

**To those
that could care less
about history and art ...
that they might care more.**

Why we wrote this—
And how it will help you...

Most history is about as exciting as somebody else's high school yearbook—a pile of meaningless faces and names. This history is different. *Europe 101* has a specific purpose—to prepare you for your trip. We have thrown out the dreary dates and meaningless names. What is left is simple, fast-moving and essential to your understanding of Europe.

Europe 101 strips history naked and then dresses it up with just the personalities and stories that will be a part of your travels. Take Frederick the Great, for instance. "Great" as he was, he's just Frederick the So-So to the average tourist so he doesn't appear in this book. Louis XIV, on the other hand, gets special attention because nearly every traveler visits his palace at Versailles or its many copies throughout Europe. When you understand Louis he becomes a real person who puts his leotards on one leg at a time just like you and me—and his palace comes alive. Unprepared tourists will wonder why you are having so much fun in "just another dead palace."

Art, like history, can be confusing and frustrating. *Europe 101* carefully ties each style of art to its historical era and relates it to your trip. You can't really appreciate Baroque art through "Better Homes and Gardens" eyes—you need a Baroque perspective.

Those who know and love art but can't get to Europe gnash their teeth while unappreciative tourists race through the Louvre just to see Mona's eyes follow them across the room. Museums can be a drag or they can be unforgettable highlights—depending on what you know. *Europe 101* will prepare you. Europe here you come!

Owner's Manual

This handbook is carefully organized to make Europe's history, art and culture more meaningful and fun. When used properly, it's your professor in a pocket.

Take a minute to understand the layout. There are two halves— 1) the CORPUS (Latin for "body") and 2) the TANGENTS (English for "things you go off on when you're excited").

The Corpus is the essential story of Europe's history and art through the Ancient, Medieval, Renaissance, Early Modern and Modern worlds. The Corpus is the basics packed into 200 pages. Read it from start to finish.

The last half of the book, the Tangents, builds upon the Corpus, painting a more detailed landscape of areas of special interest to tourists. Which Tangents you read depends on your interests and travel plans.

Each Corpus chapter ends with a timeline and a map. These handy reference pages let you visualize how the history and art interrelate.

To get the most out of our art chapters, borrow an art history picture book with good color prints from the library. Refer to it as we introduce you to our culture's finest art.

Since much of the book will have important applications to your travel plans, take notes. Read with pen in hand and fill those margins— you can be your own tour guide.

Now, spend a few minutes dreaming about your upcoming trip, go over the itinerary in your head, then turn the page and dive in.

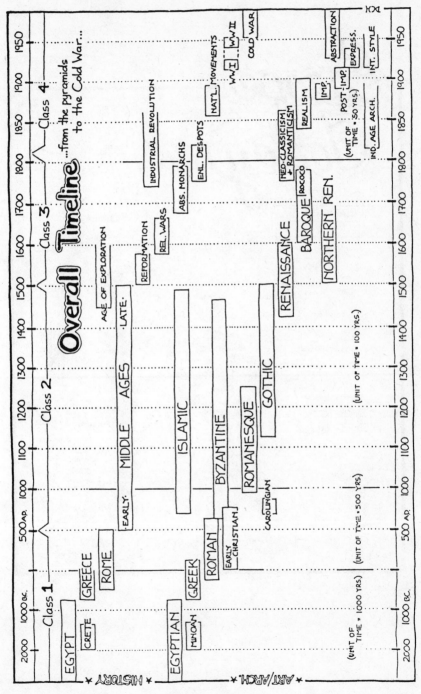

XI

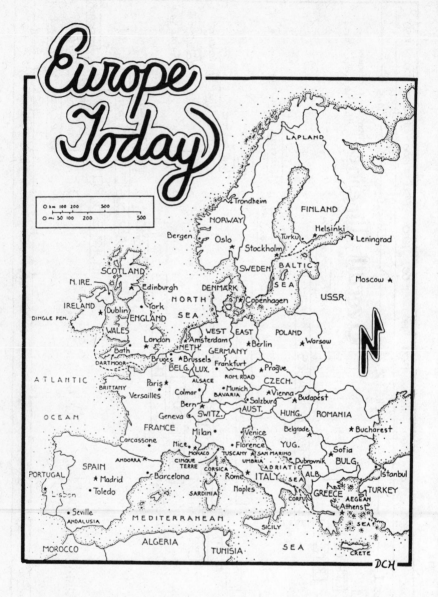

The Ancient World
3,000 B.C.—500 A.D.

Civilization was born when nomads settled. Before this, there was no tourism. Uncivilized man, armed with crude stone tools and fire, survived by hunting wild animals and gathering plants and fruit. Life was nomadic, a constant search for new plants and game. Gradually, this searching became patterned, and people would return to the most fertile places in the best season. Their interaction sparked the birth of civilization.

People saw the advantages of farming their own plants and raising their own animals on a choice spot. Gradually there were more farmers and fewer hunters. By 7,000 BC groups were settling in the most fruitful areas—near rivers.

This transition from hunter-gatherer to farmer-herdsman led to cooperation and leisure time—two key elements in the rise of civilization. As we know, people living together and dealing with mutual problems need to cooperate. This cooperation, or social organization, enabled early societies to accomplish giant projects—like building irrigation and drainage systems—that no one could do alone. This new

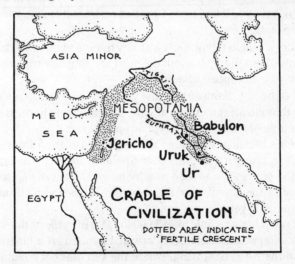

cooperation snowballed into governments, greater exchange of knowledge and ideas, development of common languages, the rudiments of writing to preserve this new knowledge, and paid vacations.

1

Domestic people were more productive than nomads. In the off-season, they had time on their hands—time to sing songs, tell stories, make decorative pottery, organize religion, and build permanent buildings.

By 6,000 BC small independent cities appeared. Present-day Iraq, Iran and the Middle East, ideally located and with a good climate, was the birthplace of Western civilization. Standing at the "Crossroads of the World," where Asia, Europe and Africa meet, this area (known as Mesopotamia) was perfect for receiving and spreading through trade all the world's knowledge. This was the age of Jericho, followed by Ur, Uruk, Lagash and Babylon, each in its time, the hub of the known world— Greece and Rome rolled into one.

3,000 BC marks the beginning of recorded history when writing appeared (which reaches its culmination in this book). Also at this time, Egypt was united, establishing a great civilization which was to thrive for 2,000 years.

Egypt

Even if you don't visit Egypt, it's worth knowing about because of its influence on Greek culture and because of the large number of Egyptian artifacts in Europe today. In London's British Museum and the Louvre in Paris, you'll find more Egyptian art treasures than you'll ever see in the States.

Consider a visit to Egypt. Only a ninety minute flight or all day boat ride from Athens, Egypt is about the most exciting side trip you could plug into your European adventure.

Egypt is the Nile. From an airplane you see only a lush green ribbon snaking through an endless sea of sand. By learning to harness the annual flooding of the Nile, the Egyptians prospered.

The Nile's blessing, combined with relative isolation from enemy civilizations, brought contentment and political stability. The Egyptian leader, the pharaoh, was seen as a living god. The religion stressed preparing for the afterlife, and the status quo reigned virtually unquestioned for 2,000 years.

Egypt's art, changing little from 3,000 to 1,000 BC, reflects this stability and obsession with an afterlife. Nearly all Egyptian art is funerary. It's found on the Nile's west bank, where the sun dies each night—and people were buried.

The pyramids, built over decades by hordes of slaves, were giant stone tombs designed to preserve a king's body and possessions so they

would arrive safely in the afterlife. Many pharaohs even took their servants with them alive—for awhile. The walls were painted with images of earthly things in case his real goodies didn't make it (a primitive forerunner of "baggage insurance").

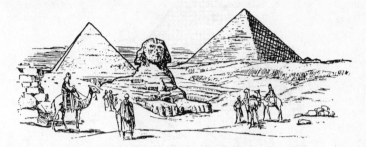

THE GREAT PYRAMIDS AND THE SPHINX - 2500 BC

Just outside of Cairo. These, like nearly all Egyptian art, were funerary—intended for the dead.

Saqqara (2,700 BC) is the original pyramid. It is a "step pyramid," designed as a series of funerary buildings stacked on top of each other. The three great pyramids at Giza (2,500 BC) are the most touristed of the pharaoh's stairways to heaven—and well worth visiting. These are far from the only pyramids, however. You'll find dozens of them as you explore the Nile.

Eventually, grave robbers broke into most of the pyramids. The pharaohs decided to stop marking their tombs with pyramids, and instead, hid them in the "Valley of the Kings" near Luxor. Mounted patrols guarded these hidden waiting rooms for the Eternity Express. Only recently have many been opened, revealing incredible riches and art looking brand new—but over 3,000 years old. King Tutankhamen ("Tut" to his friends) was just a mediocre pharaoh, an ancient Gerry Ford, whose tomb was discovered intact. Many more unmarked and hidden pharaohs' tombs wait in darkness.

The distinguishing characteristics of Egyptian art—two dimensional, strong outlines, rigid frontality—are explained by Egyptian religion and politics. Their art was symbolic—to preserve likenesses of things and people for the afterlife and to explain the divinity of the pharaoh and the relationships of the gods. It was more important to be accurate than life-like.

It's dangerous to equate "good" art with "life-like" art. Often an artist with great technical skill will purposely distort a subject to make an

3

emotional, social, intellectual or artistic point. Understand the artist's purpose before judging his work.

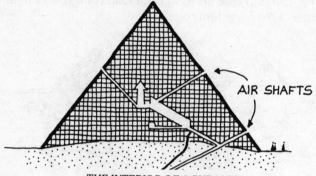

THE INTERIOR OF A PYRAMID

The pyramids were huge tombs designed to hold the dead pharaoh and his eternal luggage until he entered eternity. Notice the air shafts which let the soul fly out of the tomb. While pyramids were booby-trapped and carefully designed to foil grave robbers, most were robbed.

The Egyptian artist was a master at portraying details realistically. But he would paint or sculpt only the details most essential to recognize the subject. Their art is picture symbols—like our "deer crossing" road signs.

When an Egyptian died he waited in a kind of twilight zone until his soul found his image. When the soul found a good permanent likeness of the dead man's body, it jumped in, giving the man the Egyptian equivalent of eternal life.

Now, if you were rich, it's worth having your statue on display everywhere you can, to improve your chances of being found by your soul. You didn't get fancy with your art when you're dealing with eternal life.

These statues were stone "mug shots"—bold, stiff, frontal, and designed according to a rigid scale. For instance, the head might be half the height of the body, a forearm is as long as a shin and so on. If any pharaoh made it to heaven it was Ramses. Not only did he have more statues than anyone, he had his name chiseled over the names of many earlier pharaohs' statues—just in case the soul could read.

This symbolic portrayal was carried to great extremes. Even fish and birds were shown as if a biologist had "stretched them out," trying to capture every identifying trait. This was so effective that scientists today can identify the species of most of the animals found in Egyptian drawings.

The symbolic style lends itself to story-telling. The Egyptians used pictures to tell the myths of the gods and to explain the relationship of the god-king pharaohs to their inferiors, For example, portraying a pharaoh as twice as tall as his subjects, while not "life-like," accurately represents his social and political status. Each god and pharaoh had an identifying symbol. A beard was the sign of royalty. Even Queen Hatshepsut, history's first woman ruler, was portrayed with a beard taped on.

EGYPTIAN ART - 1350 BC

Nefertiti, Akhnaton's wife. Much of Egypt's greatest art is in Europe, including this masterpiece in Berlin. Early European archeological teams were allowed to take home their favorite find.

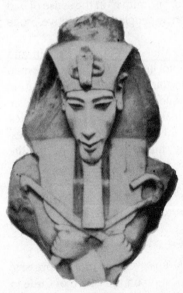

EGYPTIAN ART - 1350 BC

Akhnaton, Egypt's great non conformist and Tut's father-in-law, promoted individuality. During his reign we see the first real change in 2,000 years of Egyptian art. Note the exaggerated personal features and the sensual curves in this pharaoh's likeness.

The one striking exception to Egypt's 2,000 years of political, religious and artistic rigidity was the reign of the Pharaoh Akhnaton (1,350 BC). We owe our knowledge of this period to the recent discovery of the tomb of Akhnaton's son-in-law and successor, Tutankhamen.

5

Akhnaton startled the conservative nobility and priesthood of his time by lumping the countless gods of the Egyptian pantheon into one all-powerful being—Aton. He was the first monotheist.

In paintings of the royal family, we see a new artistic freedom, with more natural, life-like, personal settings—a "family portrait" with Akhnaton, his wife Nefertiti, and their children. Tut's wife is shown straightening his collar. There is a naturalism and gaiety in these pictures that is radically different from the stiff symbolism of earlier years.

Yet, after this brief period of freedom, the old rigidity returned. And, when Egypt finally declined as an economic power in the following centuries—a victim of conquest by enemies with more efficient weapons—its artistic legacy to the rising Greek world was the technical mastery of a formal religious style.

Pre-Greek World

Let's backtrack a bit. Back to caveman days, around 12,000 BC . . .

In the primitive art of prehistoric Europe we see a forerunner of the symbolic style of Egyptian art. (It's not "primitive" in the sense of bad or crude, but in the sense of art created by people with primitive, Stone Age technologies.)

Cave paintings and statuettes, like those at Altamira, Spain and Lascaux, France, are magic symbols—not just decorations. A cave man thought he could gain control over the animals he hunted by capturing their likeness. The paintings were like voodoo dolls—they would create a likeness with just enough details to make it recognizable—then stick pins in it (or whatever) to influence the animal from afar. (It's questionable how much game was actually caught by this method, but the same theory is used today, when Americans strike their TV sets to influence the outcome of the Super Bowl.)

Egyptian art can be seen as a bridge between the magic symbolism of primitive art and the free, naturalistic, decorative art of the Greeks.

The Minoans

The Minoans of Crete (pron. min-NO-uns) were the most impressive pre-Greek civilization. An isolated location on the island of Crete (a 12-hour boat ride south of Athens) and their great skill as traders enabled Minoans to thrive from 2,000 to 1,400 BC. Their great palaces (Knossus and Phaestus) were built without fear of attack, open and unfortified. They were gracefully and elegantly decorated, featuring tapered columns that created an atmosphere of intimacy and coziness.

It was a delicate, sensual, happy-go-lucky world worshipping an easy going Mother Earth goddess. They were more concerned with good food and dance than with the afterlife. Life here was an ancient Pepsi commercial.

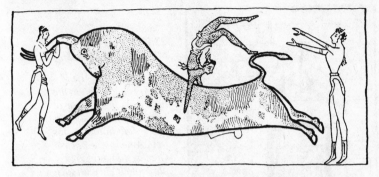

BULL DANCE - FRESCO OF THE "EASY GOIN' MINOAN" - 1500 BC

Painted on wet plaster 3500 years ago on the Isle of Crete, this shows the grace of that happy-go-lucky civilization that so mysteriously vanished. Located in the fine little Minoan museum in Heraklion, Crete.

Their art was so free and easy, it's fun to speculate that the laid back Minoan may have influenced Egypt in the free era of Akhnaton. (Learn to seek out cultural connections like these when you study history—it begins to make sense and is more fun to study.)

In 1,400 the Minoan civilization vanished. The great palaces became ghost towns overnight and no one knows why. Some people think that the eruption of Santorini (home of Atlantis?) caused a tidal wave which swept the Minoan civilization into oblivion. Today the island of Santorini is just the lip of a crater (lined with tourists) and the ruins of the Minoan civilization on Crete attract crowds from all over the world.

The Myceneans

The Minoans definitely influenced the pre-Greek tribes of the mainland. You can even see the inverted Minoan column in the famous "Lion Gate" of the ruined Mycenean capital, Mycenae (2 hours by bus from Athens). Greek legend has it that the Minoans ruled the early Greeks, demanding a yearly sacrifice of young Greeks to the dreadful Minotaur (half bull, half man) at the palace of Knossus. The Minoans' domination, however, was probably more cultural than political.

The death of the Minoan civilization left the many isolated, semi-bar-

baric tribes of Greece to just fight it out. The period from 1200-800 BC is often called the Greek "Dark Age." What we know about this Greek period comes largely from the poems and songs passed down and collected into the Iliad and the Odyssey by Homer (ninth century BC).

THE LION GATE, MYCENAE - 1250 BC

This gateway to the Mycenean citadel shows the heavy, fortified style of this militaristic society. Just a few hours by bus from Athens. The ancient Greeks, thinking no people could build with such huge stones, called the architecture from this period "Cyclopean". (Artist's reconstruction)

The Iliad tells of the Myceneans' attack on Troy (in present-day Turkey) and how they finally won by sneaking into the city in the belly of a huge wooden horse. The Odyssey describes the Greek warrior Ulysses' long journey home after the war. However mythical these stories may be, they show the Greeks' desire to establish some order in their warring world. The Iliad's Trojan War is a good symbol of all the small wars of this period, while Ulysses' return home to a world filled with anarchy and lawlessness represents the long and difficult unification and rise of classical Greece.

Classical Greece

The incredible output of art, architecture and philosophy during the "Golden Age" of Greece was the flowering of many centuries of slow economic and cultural growth among her quarrelsome tribes.

By 800 BC, the bickering Greek tribes had settled down, bringing a new era of peace, prosperity and unification. As great traders, the Greeks shipped their booming new civilization with its ideas and riches to every corner of the Mediterranean. As their population grew they expanded, establishing colonies as far away as France, Spain and Italy, where we can tour many great Greek ruins today. Southern Italy and Sicily have some wonderful Greek ruins.

There was a growing sense of unity (Pan-Hellenism) among the Greek-speaking peoples. A common alphabet was developed. The first Olympic Games, during which wars were halted and athletes from all over Greece competed, were held in 776. There was increasing political unity through both conquest and alliance. The basis of all this, however, was still the small self-contained city-state.

The individual city-state, or polis (as in "metropolis"), was a natural product of Greece's mountainous landscape and its many islands, where people were isolated from their neighbors. The city-state's landowners ruled in a generally "democratic" style. A city-state's typical layout would include a combination fortress/worship site atop a hill called the acropolis ("high city"). The agora, or marketplace, sat at the base of the hill, with the people's homes and farms gathered around. An important feature of the agora was the stoa, a covered colonnade or portico used as a shady meeting place—ideal for discussing politics.

The polis was usually small enough to walk across in a day but large enough to provide all the cultural and economic needs of its people. It was an independent mini-nation.

Athens in the Golden Age
450-400 BC

Athens was one such polis (with the basic acropolis-agora layout) that rose, through alliance, industry, trade and military might, to a dominant position in the Greek world.

Cursed with poor, rocky soil, Athens turned to craftsmanship for its livelihood. Able administration stimulated this industry by recruiting artisans from throughout the Greek world. By 500 BC, Athens was the economic and cultural center of a loosely unified Greece.

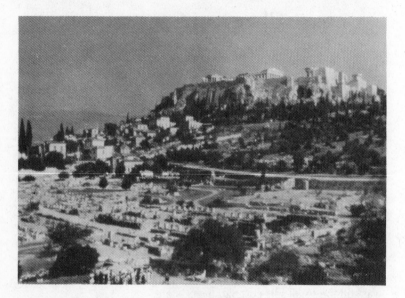

OLD ATHENS

This is the historic core of Athens: the acropolis (city on the hilltop), the agora (old market), and Plaka (the extent of the 19th-century town and now the tourist, shopping and nightlife center).

The Persians (present-day Iran) posed a threat from the East. They ruled Ionia (today's Turkish west coast), which was a center of the high Greek culture where the elegance and riches of Persia mixed with the creative imagination of the Greeks. This Persian threat united the Greeks under Athenian leadership. With their superior navy, the Greeks defeated the Persians, leaving Athens the protector and policeman of the Greek peninsula.

Athens demanded payment, or tribute, from the other city-states for her defense of the peninsula. In less than 100 years, Athens rose from a stable, small-crafts city-state to the cultural, political and economic center of an empire.

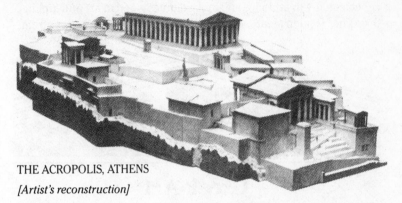

THE ACROPOLIS, ATHENS
[Artist's reconstruction]

The new wealth in Athens set off a cultural volcano whose dust is still settling. The creativity of the "Golden Age" in art, architecture, government, philosophy and even science set the tone for every western civilization up to the present. And all this was achieved within the space of a century by a city of 80,000 people!

After the Persian War, the Athenians immediately set about rebuilding their city, which had been burned by the invaders. Grand public buildings and temples were commissioned, to be decorated with the greatest painting and sculpture ever. Giant amphitheaters were built to hold dramatic, musical and poetic festivals. During all this cultural growth and public building, the average citizen remained hard-working and simple, living modestly but comfortably.

In schools and in the agora, under the shade of the stoa, the Greeks formulated many of the questions that have occupied man's mind ever since. Both Plato (who wrote down many of Socrates' ideas) and his student, Aristotle, organized schools of philosophy. Plato (c.380 BC) taught that the physical world is only a pale reflection of true reality (like a shadow on the wall is a pale version of the 3-D, full-color world we see), and that rational thinking is the path to understanding the true reality. Aristotle (c.340 BC), on the other hand, being an avid biologist, emphasized study of the physical world, not some "unseen" one. We'll see these two divergent ideas resurface again and again, especially in Christian theology centuries later. St. Augustine was a Neo-Platonist, and Thomas Aquinas a student of Aristotle.

11

The Greeks studied the world and man's place in it. They weren't content with traditional answers and old values. The "Golden Mean" was a new ideal stressing the importance of balance, order and harmony. This was a virtue both in individuals—for example, someone who excelled equally in athletics and in academics—and in art and architecture. The "Golden Mean" was the "Golden Rule"—nothing to extreme.

Greek Art

Greek art is known by its symmetry, harmony, and "classic" simplicity. It strikes a happy medium (a "golden mean") between the rigidly formal Egyptian art and the unrestrained flamboyance of later (Hellenistic) art.

In architecture, this ideal of "nothing to excess" was expressed in two different styles or "orders"—Doric and Ionic. While these names are most commonly used for a type of column, the columns themselves are representative of different overall styles.

Doric is strong and simple, following the earliest styles of temple building. A Greek temple was a house for a god's statue. Its exterior was the important part while the interior was small and simple. The people worshipped outside. The earliest temples were built of mud brick and wood. When stone began to be used the Greeks kept the old style. The columns were shaped like the old timber supports (even grooved as if the bark had been gouged off) and the wooden beam ends, now in stone, continued to divide the square panels on the eaves.

The Parthenon, in Athens, is the greatest Doric temple. The columns are thick but much more graceful than those on the massive Egyptian temples. Its Doric columns swell slightly in the middle to give the impression that the roof is compressing them just a little. The designers of the Parthenon used other eye-pleasing optical illusions. The base of the temple, while appearing flat is actually bowed up in the middle to overcome the illusion of sagging that a straight horizontal line would give it. (If you and your partner stand on the same step at opposite ends, you'll see each other only from the waist up.) The columns bend inward

just a hair (if you extended them up over a mile they would come together). This gives a more harmonious, cohesive feel to the architectural masterpiece of Greece's Golden Age.

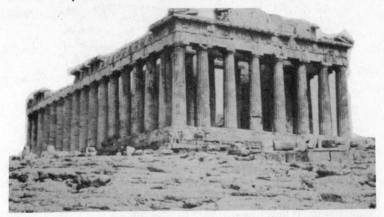

THE PARTHENON, ATHENS, 450 BC

This is an example of Doric simplicity. It stood nearly intact until the 17th century when it was destroyed by an explosion during a Venetian-Turkish war. Today its greatest threat is 20th-century pollution.

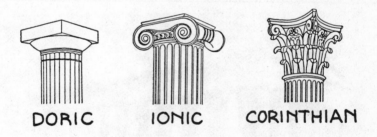

DORIC IONIC CORINTHIAN

CLASSICAL ARCHITECTURE

The easiest way to identify the classical "orders" is by the columns—Doric: earliest, simple, stocky. Ionic: fancier, thinner, with more pronounced grooves and a rolled capital. Corinthian (Roman style): most ornate, with a leafy capital. As temples evolved, columns grew more slender and widely spaced. [A memory aid: the more syllables, the fancier the order.]

While Doric beauty was somewhat austere (we could even say "spartan" since the city-state of Sparta was in Doria), the later Ionic style reflected grace, ease and freedom, while still remaining balanced and

GREEK TEMPLE

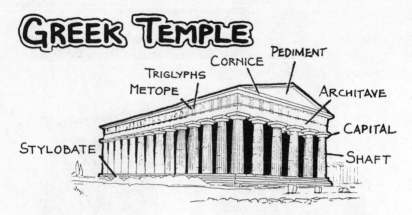

PEDIMENT
CORNICE
TRIGLYPHS
METOPE
ARCHITAVE
STYLOBATE
CAPITAL
SHAFT

simple. An Ionic column is more slender, with a more decorative "capital," or top. The capital's curls give the impression of spleening (from author's private word reserve) under the weight of the roof. While this style is a conscious effort to decorate or beautify the temple, the ornamentation is never extravagant or superfluous.

A third order, the Corinthian, was developed later, during the Hellenistic period, and was passed on to Roman architecture where it is often seen side by side with Doric and Ionic. The Corinthian is the next step in the path from simplicity to decoration. A Corinthian column's flowery capital doesn't even pretend to serve an architectural purpose. It is blatantly ornamental.

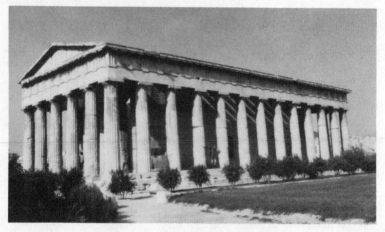

THE THESEUM, ATHENS, 450 BC

In Athens' agora, where Socrates, Plato and Aristotle hob-nobbed, you'll find the best-preserved Greek temple anywhere.

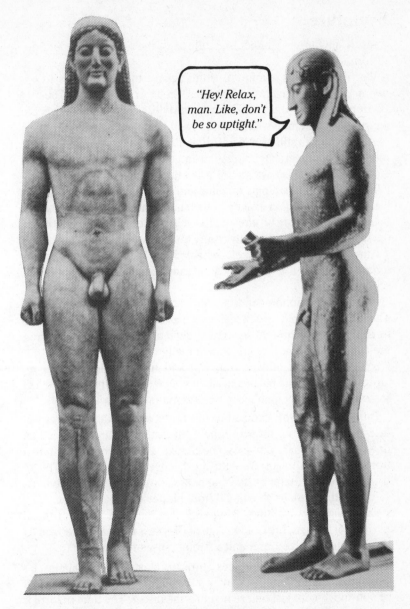

GREEK "KOUROS," OR BOY

Moving from the stiff, Egyptian-type frontality of the Archaic period, towards the balance and naturalism of the "Golden Age," the Greek kouros ("boy") at right has lost his rigidity.

15

Sculpture

Much modern architecture still uses the classical orders for decoration.

We see the same evolution from rigidity to gracefulness to exuberance in Greek sculpture. The early Greek Archaic period (750-500 BC) reminds me of the formal Egyptian style, where statues of people were almost schematic diagrams, preserving only the essential details of the subject in a stiff frontal pose. It is as if the sculptor couldn't let his model move for fear of missing some important detail. This posed frontality is seen in the Greek "kouros" or youth statues of the sixth century (500's) BC. They are strongly outlined and remarkably realistic—but not life-like. A kouros looks exactly like a human, but like no human in particular, since there are no individual details. It seems to have been made on an assembly line with universally interchangeable parts.

Athens' National Museum of Archeology, by far the greatest museum for ancient Greek art, has many good examples of each stage of Greek sculpture.

Greek society honored individuality and admired the human body. This attitude, combined with technical mastery of the skills of sculpture, freed the subject from those archaic, rigid poses. Artists now relaxed their subjects and portrayed life as it really was.

Sculptors showed subjects from side and three-quarter angles, capturing movement and balancing all these new slants. Attention to detail soars as not just any man's arm but *this* man's arm is sculpted.

Painting was revolutionized in the same way by the discovery of foreshortening. (You "foreshortened" the last time you drew receding lines to turn a square into a 3-D box.) Now a subject could be shown from any angle—not just from the most convenient front pose. The artist could record things as they happened, even putting his individual stamp on the work by showing it from his personal perspective.

Even with this exciting new-found freedom and their technical mastery of the arts, the Golden Age of Greece is best characterized by the golden mean, restraint and a strong sense of harmony.

The famous statue, the "Discus Thrower," illustrates this balance. It's a remarkable study in movement, yet the body is captured at a moment of non-movement just before he hurls the discus. The human form is posed but natural, perfectly balanced with nothing in the extreme— the golden mean. Previously the body had been the sum of its parts. Now it was an organic whole.

The brief "Golden Age" of Greece (450 BC) was the balance point be-

tween Archaic and Hellenistic Greece. Both society and its art evolved from aristocratic, traditional, stiff and archaic (600 BC) to democratic, original, realistic and wildly individual (300 BC). As the balance is lost to radical individuality we enter the Hellenistic age.

THE DISCUS THROWER,
BY MYRON - 450 BC

Notice the evolution from the stiff kouros (p. 15) to the movement of this Golden Age statue.
Like most great Greek statues, the original is long gone and we enjoy it today thanks to fine Roman copies. This is a Roman copy of a Greek statue with a Catholic fig leaf.

Hellenism

The ideas of the small Greek peninsula were spread single-handedly throughout the Mediterranean and Near East by one man—Alexander the Great. Alexander ushered in the Hellenistic Period ("Hellene" is Greek for "Greek").

As Athens declined in power through costly wars with Sparta and other neighboring city-states, the Macedonians to the north (present-

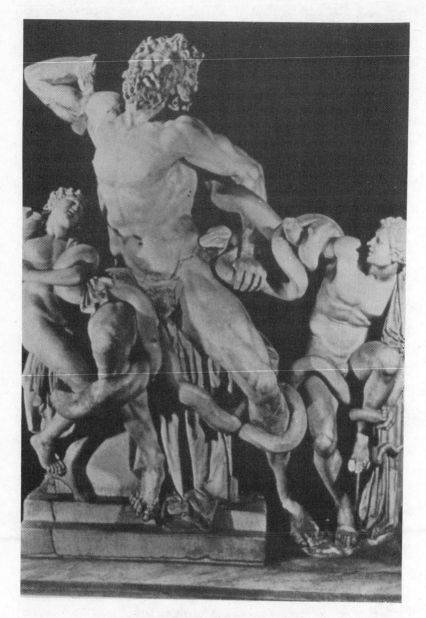

LAOCOON, VATICAN MUSEUM, ROME -
1st CENTURY AD

This is the "classic" example of the Hellenistic style. It is so exuberant it seems ready to jump right off its pedestal. The classical composure is lost. Unearthed near Rome in 1506, it astounded Michelangelo and the Renaissance sculptors.

day Yugoslavia) swept in. Their leader was 20-year-old Alexander, who had been tutored by Aristotle. By the time Alexander died, at the age of 32, he had created the largest empire ever seen, stretching as far east as India. (What have you accomplished lately?) He was a military genius, a great administrator and a lover of Greek culture. Alexander went to bed each night with two things under his pillow: a dagger and a copy of the Iliad. He may have conquered Greece politically, but Greece ruled Alexander's empire culturally.

During the Hellenistic era, Greek was the common language of most of the civilized world. Cities everywhere had Greek-style governments and schools, observed Greek holidays and studied Greek literature. Public squares throughout the Mediterranean looked Greek. Alexandria (Egypt) was the intellectual center of the world, with over a million people, a flourishing arts and literature scene and the greatest library

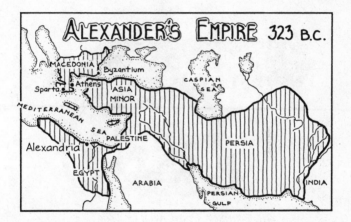

anywhere. No ship was allowed to enter the port without giving up its books to be copied.

When Alexander died in 323 BC his political empire crumbled. But the Greek civilization he fostered lived on for centuries. This Hellenistic culture was obsessed with an anchorless creativity. The "cynics" were history's first hippies, and the mood was "back to basics," focusing on the individual. As the Romans began to conquer these lands and people, they found them easy to administer, with a ready-made centralized government and economy. They were more "civilized" than their Roman conquerors. The Romans quickly absorbed what was profitable into their own culture, and civilization took one more step westward.

Rome

Rome is history's supreme success story. By conquest, assimilation and great administration, Rome rose from being a small Etruscan town to ruler of the Western world.

Rome lasted about a thousand years, from 500 BC to 500 AD. The first 500 years were the Republic and the last half was the Empire. Today armies of tourists endure the hot Roman sun and battle its crazy traffic to see what's left of that greatest of civilizations.

Legend says that Rome was founded in 753 BC by twin brothers, Romulus (hence, "Rome") and Remus (hence, "Uncle Remus"?). They had been orphaned as babies and raised by a she-wolf before starting the greatest empire ever. This story must have seemed an appropriate metaphor for the Romans, explaining how such a "civilized" people (as they considered themselves) could have grown out of such "barbarian" surroundings.

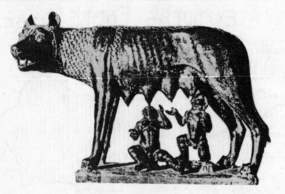

THE ETRUSCAN "SHE-WOLF"—500 BC

Long after the Etruscans sculpted this statue, Romulus and Remus were scooted under, and it became the symbol of Rome. You'll see copies of this everywhere, but the original "she-wolf" is in the museum on the Capitol Hill in Rome.

Rome was situated perfectly at the first bridge on the Tiber River, and as far upstream as boats could navigate. It also bridged the advanced Etruscan civilization to the north with the agriculturally rich Greek colonies to the south.

In 509 the local Romans threw out their Etruscan king, establishing a plutocratic (rule by the rich) "Republic."

War was the business of state and their conquests were cemented by

a well-organized, generally enlightened or benevolent rule. People knew that when they were conquered by Rome they were now on the winning team. Political stability would replace barbarian invasions, and they would enjoy building projects—roads, baths, aqueducts and theaters. With contented subjects the empire continued to expand. By 260 Italy was theirs and by 100 BC Rome controlled the entire Mediterranean world.

This giant empire strained a government which was originally designed to rule just a small city-state. During the last century BC, Rome, while still growing and prospering, had to deal with civil strife, class struggles, corrupt politicians, and the corrosive individuality of Hellenism.

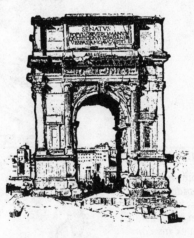

ROMAN TRIUMPHAL ARCH

Emperors always milked their military victories for propaganda purposes. Grand triumphal arches glorified their exploits. Today you'll find these arches scattered from Germany to Morocco.

Julius Caesar, an ambitious general, cunning politician and charismatic leader, out-maneuvered his rivals and grabbed the reins of Rome (about 50 BC). Caesar, supported by his armies, suspended the constitution and replaced the "Republic" with the "Empire." His dictatorial rule restored order and reformed the government.

He further consolidated his power by naming a month, July, after himself. He ran through many reforms, but underestimated the conser-

vatives in the senate and those who loved the old Republic. He was assassinated (E tu, Brute?), and a struggle followed between would-be dictators and republicans. A decade later the political vacuum was filled by Julius' adopted son, Caesar Augustus. (This family name became a title—Caesar, Tsar, Kaiser.)

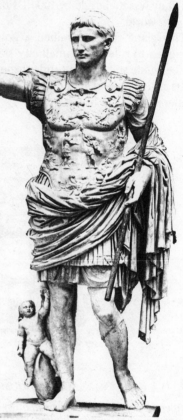

CAESAR AUGUSTUS—1 BC

The sculpture of Rome was often political propaganda. Here, Emperor Augustus [looking as classically powerful as Charlton Heston] demonstrates his complete control and mastery of the empire.

Pax Romana—The Roman Peace

Augustus, called the architect of the Roman Empire, established a full-blown monarchy and ushered in the "Pax Romana." This "Roman peace" was two hundred years of relative peace and prosperity with an enlightened and generally benevolent rule throughout the vast empire. Augustus, like Julius, named a month in his own honor. He was more sensitive to the senate and its traditions, but still reformed the government, restored temples, undertook huge public building projects and

At its height, Rome thought of the Mediterranean as "our sea" (Mare Nostrum). The Empire stretched as far as the Danube, Rhine and the southern border of Scotland. At this time the word "Rome" meant the civilized world.

even legislated morality. He declared himself the "pontifex maximus" (high priest).

The Pax Romana, the first two centuries after Christ, was a period of unprecedented political stability made possible by a smooth succession of leaders. Historically, the throne was hereditary and, also historically, emperors' sons made lousy rulers. The great rulers of the second century (Nerva, Trajan, Hadrian and Antoninus) had no blood sons but adopted as his son the man most capable of ruling. Then, when he died his "son" inherited the throne—and ruled well. This worked fine until Marcus Aurelius had a blood son, Commodus. As emperor, this palace brat ran around in animal skins carrying a club as if he were Hercules—and marked the end of a string of strong, stable and responsible Roman emperors.

The Pax Romana saw a well-governed Rome reach its zenith, stretching from the Nile to the Danube, the Rhine and the south border of present-day Scotland (where the Romans decided to "call it an empire" and built Hadrian's Wall from coast to coast across north England). Everywhere the Roman army went it built roads, aqueducts, and cities on a grid plan. They called the Mediterranean "Mare Nostrum" (our sea), and trade thrived. The word "Rome" became universal, referring not to the city but to the whole civilized world.

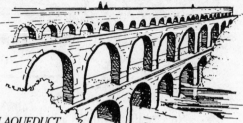

PONT DU GARD, ROMAN AQUEDUCT

A giant, 2,000-year-old water system near Nimes in Southern France.

Roman Art

The Romans were not great artists. While the Greeks loved beauty and intellectual stimulation, the Romans were engineers and administrators. Their accomplishments were big and functional, designed for accommodating the masses with roads, colosseums and baths rather than portraying beautiful gods. If offered a ticket to a forum discussing the nature of Truth or to a gladiatorial battle to the death, a Roman would choose the latter.

Rome's greatest contributions to history are in law and engineering. Her legal and administrative traditions were the basis for all Western governments that followed. In engineering, the Romans developed the use of the arch and concrete, enabling them to build the largest and most complex structures of their time.

Maybe it's lucky that the Romans weren't great innovators in art. As a result, they admired, preserved and copied the precious Greek art which otherwise might have been lost or destroyed. In fact, most of the examples of Greek "Golden Age" sculpture you'll see during your trip are excellent Roman copies. The originals are long gone, but every high class Roman wanted quality copies of Greek originals in his villa. These fill the museums today.

Roman art and architecture are characterized by utility and grandeur. (An ancient Roman in modern America would consider a Los Angeles freeway interchange a great work of art.) The Romans focused on functionality and purpose. Decoration was secondary.

The Colosseum is a perfect example. Built in 80 AD with 50,000 numbered seats, they could fill and empty this stadium as fast and orderly as we do ours. It could be flooded to give sports fans mock naval battles. Animal skins could be drawn across the top to turn it into a giant shaded domed stadium.

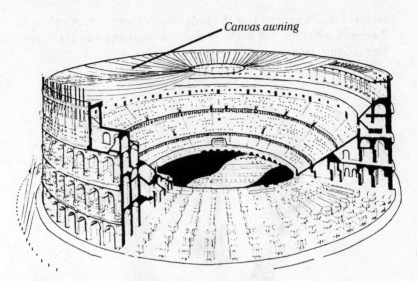

Canvas awning

THE ROMAN COLOSSEUM - AD 80, ROME

A good example of Roman engineering to accommodate the needs of the masses. To double the seating capacity they put two theaters together to make an amphitheater. Built with barrel vaults and concrete, it could fill, hold, and empty 50,000 fans as orderly as our football stadiums do today. Opening day was celebrated with the slaughter of 5,000 animals.

The Colosseum's essential structure was Roman, built with arches, barrel vaults and concrete. The three orders of Greek columns on the exterior have nothing to do with support. They are just niceties pasted on for looks—and because Greek things were in vogue. It's a fitting symbol of Roman art—Roman practicality with a Greek facade.

On opening day at the Colosseum the Romans enjoyed the slaughter of 5,000 animals. 1200 years later the Colosseum was appreciated only as a quarry offering free pre-cut stones to anyone who could carry them away. Today tourists respect it as a monumental symbol of a great civilization.

Roman Portraiture

One art form where the Romans actually surpassed the Greeks was in the making of portraits. The Greeks were more concerned with sculpting or painting an idealized human without distinguishing individual characteristics; the Romans, however, had a religious need to recreate a personality. Roman ancestor worship and family solidarity

required realistic portraits of the father and his ancestors. Also, when it became a law that the emperor must be worshipped as a god, portraits of him were necessary.

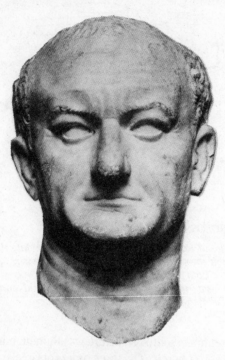

EMPEROR VESPASIAN - AD 75
or is it LBJ?

Roman portraiture (especially the common "bust") reached a new level of naturalism. Of course, many portraits were idealized and prettied-up in their stern dignity, but many are startling in their accurate portrayal of downright ugly people. We have a living history in the busts of the famous emperors—they come alive as people, not just faceless names from the past. Go to a museum in Rome (the National Museum across from the train station or the city museum on Capitol Hill or the Roman History museum in the E.U.R.) and look into the eyes of dozens of emperors.

Roman art was the preserver of Greek and Hellenistic art. It also made advances in architecture and in realistic portraiture. When Rome faded as a political empire, much of her art lay "dormant," ignored until the Renaissance, or rebirth, of classical ideals a thousand years later.

Fall of Rome

The third century is known as the "Age of Iron and Rust," a period of socio-economic breakdown and the beginning of Rome's end. Taxes were oppressive, cities were shrinking and disorderly, prices increased 1000% over 20 years and the barbarians were restless. Like most ancient civilizations, Rome had a false economy based on slavery and booty. When Rome stopped expanding, the flow of booty and slaves that had fueled the empire for so long dried up. The army was no longer a provider. It was an expensive problem. Politically, the government was more like a banana republic than a great empire. Over one 50-year period, Rome had 19 different emperors—18 were killed.

Rome's tumble was a gradual process delayed by two enlightened rulers, Diocletian and Constantine, AD 285-340. In an attempt to maintain control, the empire split in two, with Constantinople (present-day Istanbul) ruling the eastern half and Rome continuing to hang onto the crumbling West.

But her downfall was inevitable. In 476 the last emperor checked out and the Roman Empire's long terminal illness was over.

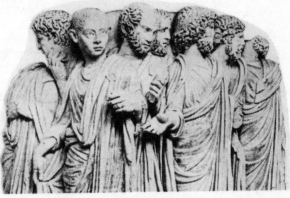

A ROMAN EMPEROR DURING THE FALL - AD 250

As Rome began to fall, so did its art. This relatively crude work shows a boy emperor nervously awaiting assassination.

Rome's ghost, however, lived on. Her urban nobility fled the cities, establishing themselves as the landed lords of medieval Europe's feudal countryside. Latin, the Roman language, was the language of the educated and ruling classes throughout the Middle Ages. The Roman Catholic Church inherited the empire's administrative finesse and has been ruled by a "pontifex maximus" ever since.

Relax...

You've just absorbed 3,500 years of history and art. That wasn't so bad, was it? Now, before you shake off the dust of the Ancient World and plunge into the Dark Ages,

take a break.

While you're digesting Egypt, Greece and Rome take a leisurely peek at everyday life in the Ancient World. Here's a list of some related articles in the last half of the book:

If the art has you buffaloed, check out the art appreciation tangents in the general tangent section. The contents on page V list a few articles that may be worth reading now so you will get more out of the art chapters that follow.

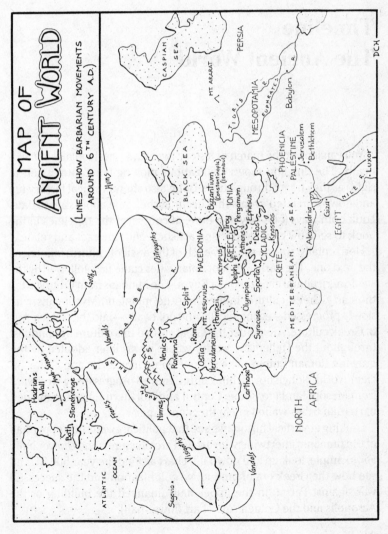

MAP OF ANCIENT WORLD

(LINES SHOW BARBARIAN MOVEMENTS AROUND 6TH CENTURY A.D.)

DCX

Timeline
The Ancient World

You can look at the march of history two ways—horizontally and vertically. The timeline shows civilizations moving horizontally (left to right) as they travel through time. But it also shows vertical history (up and down)—related events that occur at the same approximate date. Look both ways (one way at a time, of course) at the timelines in the book to see how civilizations and artistic trends interact and relate.

Horizontally, we can see how each of the ancient cultures influenced the next one. The early Mesopotamian cities came first, followed by the stable agricultural civilization of Egypt. The Minoans from Crete started the early Greek culture, influencing the mainland Myceneans who slowly progressed—economically and politically—into the Golden Age of Greek culture. Alexander the Great spread this culture by conquest throughout the Hellenistic world, where it was later adopted by the growing Roman Empire. The sack of Rome marks the end of the ancient world. Notice how, while culture moved progressively westward from Mesopotamia to Rome, Central and Northern Europe remained barbarian tribes wallowing in the Stone Age.

Looking at vertical history we see that political events (the upper half of the timeline) intertwine with art and architecture trends (lower half). For example, look up and down the chart around the year 500 BC and see how the Greek era of productive colonization and the successful war against Persia (in the upper half) financed the building of the Acropolis and the Golden Age of art (lower half).

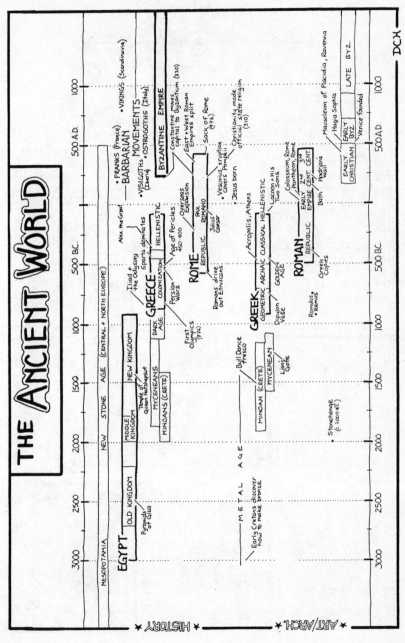

THE ANCIENT WORLD

31

The Middle Ages

A thousand years separate the ancient and the modern worlds. Simplistically, I would call the first half of the Middle Ages the "Dark Ages" (from AD 500 to 1000) and the last half the "High Middle Ages" (from 1000 to 1500).

The castles and cathedrals that fill the average tourist's scrapbook are the great accomplishments of medieval Europe. To most travelers, these are very big and very old—period. When understood, these buildings come alive. Some study will spark the spirit of the old churches and fill the castles' armor with real people.

The Dark Ages, 500-1000

By 500 AD, Rome was gone and three realms filled the void, each originally posing a threat to Roman culture but ultimately instrumental in preserving that great classical culture: the Christian church, the Byzantine Empire, and the "barbarian" peoples of Northern Europe.

Two of these realms, the church and the Byzantine Empire, are actually extensions of the old empire, traceable back to the reign of the great Emperor Constantine. In trying to revive his fading empire, Constantine recognized the rights of the Christian church, a body which had grown, despite persecution, into one of the stabilizing institutions of the empire. Later it became Rome's official state religion.

The church bridged the ancient and modern worlds by carrying much of Rome's classical learning and administration through the Middle Ages, passing it on to the rising secular world during the Renaissance. The church organized itself according to Roman law. The pope—the bishop of Rome and recognized head of Christendom since the first Roman bishop, the apostle Peter—was similar to the emperor in power. Even the hierarchy between the pope and his bishops and cardinals was patterned after the reorganization of the Roman hierarchy by Emperor Diocletian. This Roman administration lived on long after the final collapse of Imperial Rome.

Monasteries preserved classical literature and the Latin language. When Benedict set up what was to become the most powerful monastic order of the Middle Ages he scheduled a daily program of monk-duties, combining manual labor with intellectual tasks like translating and copying ancient texts, including works that were purely secular and even heretical.

THE DARK AGES, 500-1000

The church also preserved some of Rome's sheer grandness. Its great wealth, amassed from tithes and vast land holdings, was put into huge church buildings, decorated as ornately as anything Rome had ever seen. The pomp and pageantry of the church rituals you may see in your travels is reminiscent of the glorious days of the Roman Empire.

Byzantine Empire

The Eastern Roman Empire, often called the Byzantine Empire, was the other great preserver of Roman culture. In a second desperate attempt to invigorate his failing empire, Constantine (in about 330 AD) moved his capital from Rome to the new city of Constantinople (modern-day Istanbul). In a sense, this was the real end of Rome—the center of the civilized West packed up and moved east, where it would remain for a thousand years while Europe struggled to establish itself. The emperor, his court, the scholars and artists all moved to the East, leaving the self-proclaimed emperors in Rome no real power outside Italy. "East Rome" was civilized while West was "dark."

We think of the Eastern Empire as Byzantine rather than Roman because it quickly took on an Eastern outlook. Greek was its official language, its art and literature were Hellenistically flavored and the church followed "Eastern Orthodox" ways, eventually splitting with the pope's Latin church.

Nevertheless, the Byzantine Empire had a great influence on the West. Throughout the Middle Ages the emperor in Constantinople was seen by Christians and barbarians all over Europe as the civilized

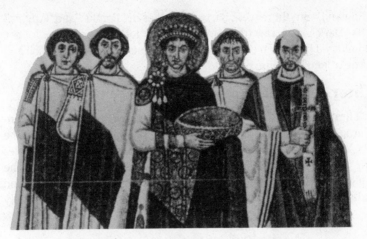

BYZANTINE EMPEROR, MOSAIC, RAVENNA, AD 550

Emperor Justinian, shown with his attendants, was Europe's grand ruler. The art of his era was generally mosaic—made from patterns of small stones and glass. Ravenna and Venice have many mosaics and architectural treasures from the Byzantine glory days.

world's supreme ruler. Constantinople was the world's number one city for 800 years. It provided a model of the unified and glorious Europe that so many kings and popes dreamed of. When the Crusades put the East and West in contact, the long forgotten classical Roman and Greek knowledge was reinfused into Europe. After Constantinople was finally overrun by the Turks, scholars and artists fled to the West, where their knowledge added to the growing spirit of the Renaissance.

Today's Istanbul is an exciting brew of ancient past and cosmopolitan present, Moslem East and Christian West. I've spent as much time in Istanbul as in any European city—and I can hardly wait to get back.

Barbarian Europe

The third realm of the Dark Ages was a scattered, barbaric and chaotic compost pile from which modern Europe would sprout. There was no "France," no "Germany," no "Europe." There was no effective government, no sense of state, just small autonomous tribes and peasant communities. Local life was isolated, fragmented, dreary, illiterate, superstitious and self-sufficient at best. Thoughts of an afterlife concerned people more than secular growth. Money, trade and progress had little to do with the Dark Ages.

Quietly, the seeds were planted. There was no nation of "France" or

"England." But there were barbarian tribes of "Franks" and "Angles." The Dark Ages saw the emergence of local nations no longer dominated by Roman culture, when the Franks became the French and "Angle-land" became England.

Charlemagne

Throughout this period, popes and kings were trying to restore Europe to the glorious days of a unified Roman Empire. One light in the Dark Ages was the reign of Charlemagne (SHAR-luh-mayn)—"Charles the Great," King of the Franks. The top dog of early medieval rulers, he united most of the western Christian world, from Germany to Sicily, and established what we call the Carolingian Empire. He worked closely

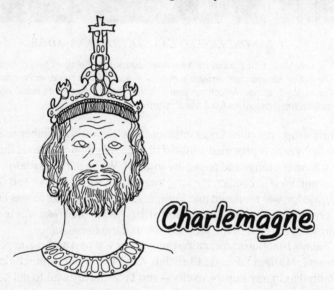

Charlemagne

with the pope, and both leaders realized that cooperation was essential to wielding power effectively. To underline this alliance, establish himself as the protector of Christendom and remind Europe that the greatness of classical Rome could once again be hers, Charlemagne was crowned Emperor by the pope in Rome on Christmas Day, AD 800. Sleepy Europe quivered with excitement at this "Roman revival." Charles returned to his capital city of Aix-la-Chapelle (present-day Aachen in Germany near Belgium and well worth a visit) to carry this "Carolingian Renaissance" as far as he could.

Aix-la-Chapelle was the first capital of "Europe." Trade and communication increased, the court became a cultural center where artists

and scholars worked to revive Roman ideals. Academia flourished and classical works were studied and copied. It's said that Charlemagne could read a little (a rarity at the time), and went to bed each night with a slate to practice his writing.

Charlemagne was top dog ruler, but the next Franks were wieners. When he died, the empire was divided among his three sons. His successors returned to their quarreling ways, and as they bickered the light flickered—out. Later kings claimed to rule a revived "Holy Roman Empire," but these kingdoms, as Voltaire pointed out, were neither holy, nor Roman, nor an Empire. It would be a long time before Europe would enjoy another leader of Charlemagne's stature.

Europe's confusion was worsened by a series of foreign invasions (700-900). The Vikings from the north, the Magyars from Hungary and the Moslems from Spain ravaged cities, forcing whole peoples to migrate to safer lands. It was nearly 200 years before the invaders were defeated or absorbed into Europe.

Feudalism

The people of medieval Europe developed a strict social and economic system called "feudalism" in an attempt to give their chaotic world some order and security. Feudalism carefully defined the duties

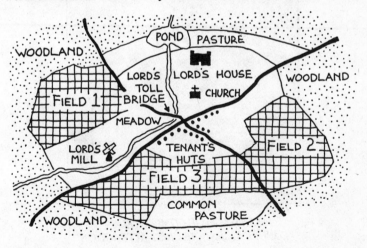

MANORIALISM

The manorial system, which supported the lowest man on the feudal ladder, was the foundation of Europe's Dark Age socio-economic system. Here is a typical peasant community around the landowning lord's manor house.

37

of each class (like chessmen, who can only move a certain way), with each class dependent on the other for its livelihood. The peasants pledged part of their crop to a local noble, who in turn gave them land to work and the promise of protection and a system of justice. This noble was in the service of a more powerful noble, and so on up to the king. A strict code of honor connected this two-way deal, stressing loyalty and servility.

The feudal nobility played war for kicks. ("Feud"-alism was an appropriate name.) On a sunny afternoon the knights would suit up, trample their peasants' crops and raid the neighboring noble's domain in an attempt to kidnap the lord. Most of medieval Europe toiled to survive, while a few lucky ones spent their leisure hours playing chivalrous games. The pawns of this war game were, of course, the peasants.

Romanesque Art, 1000-1200 AD

Churches, churches, churches! Most tourists get "churched-out" after a few weeks on the road. Any small town's biggest, most central building is its church. You'll be drawn right in. After awhile they all start

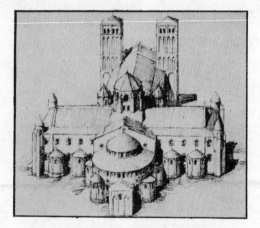

SANTIAGO DE COMPOSTELA —
EUROPE'S FIRST "TOURIST ATTRACTION"

This Romanesque church in Northwest Spain housing the body of St. James was a very popular pilgrimage site. Europe's first "tourist guidebook" was written to direct pilgrims over the long journey to Compostela. Today, it's just as majestic as ever but visited by very few tourists.

to look the same. But they aren't! If you can recognize the distinguishing features of Europe's different churches they become more than just handy places to escape the rain.

The greatest Romanesque buildings were churches. The Romanesque style is the first real "European" art form. The art and architecture of this period reflect Europe's desire for stability and security in a chaotic and warring world. It is "Roman"-esque because it uses Roman features—columns and rounded arches—to create an overall effect of massiveness and strength.

Romanesque buildings, mostly churches, are like dark fortresses with thick walls, towers, big blocks of stone, few windows, dark interiors and a minimum of decoration. The grand pattern of the Romanesque churches has its roots in ancient Rome. The pagan temples of Rome were designed only to house the image of the god—not crowds of worshippers. So when Christianity became Rome's adopted religion, new churches were modeled not after her temples, but after the largest Roman secular structures, the Roman law courts or basilicas. The same basilica floor plan that you'll see in the Roman Forum (Basilica Emilia) was used in nearly every medieval church—a long central hall with narrower halls on either side, and at the far end, a semi-circular area (apse) for the altar.

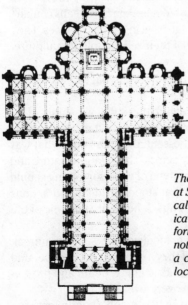

The floorplan of the pilgrimage Cathedral at Santiago de Compostela (Spain) is typical of many European churches—a basilica-style main hall with a crossing transept forming a Latin cross. Note: a "cathedral" is not a type of church architecture. It's simply a church that's a governing center for a local bishop.

This plan was ideal for handling large congregations—especially the massive processions of pilgrims who would come to worship Christian relics (like a piece of Jesus' cross or the body of a saint). The pilgrims would walk down one side aisle, around the apse, and out the other aisle, worshipping at each chapel along the way. Columns separated the walkways (ambulatories) from the long central nave where the congregation stood—sitting in church hadn't been invented yet.

An aisle forming a cross with the main hall, called a "transept," was often added but the basic basilica plan remained.

Religious Art

While the floor plan was essentially Roman, the Romanesque decorations were strictly Christian. Through most of the Middle Ages sculpture and painting were used only to embellish architecture, and art was the church's servant. It's not until the Renaissance that we see painting and sculpture for its own sake.

Theologians wondered, "What is art's place in the church?" The Bible is explicit that no "graven images" should be made for worshipping. Did this include paintings? Craftings of nature? Bible stories? The debate lasted centuries. By 600, it was generally agreed that art had great value in worship as a way of educating and inspiring the masses of illiterate Christians. Remember, most Middle Age Europeans couldn't read, write or speak Latin, the language used in church services. They went to church to "read" the stories of their religon told in sculpture, stained glass and tapestry.

Modern tourists, also "illiterate" of Europe's languages, can still see the religious stories told in church art.

This religious purpose of art created the style we think of as "medieval". Artists concentrated on inspiring and uplifting the peasants by boiling their subjects down to the essential details—just what was necessary to get the point of the story across. They ignored nature and painted the commonly accepted stereotype of what something should look like. Pictures became symbols that stood for ideas and actions rather than representations of real things. A lion was symbolic of the resurrection—not a lesson in zoology.

Classical techniques were forgotten. Medieval art was stiff, unreal, two-dimensional. Figures looked as if they'd been cut out of paper and pasted into random groups. Background, shading, depth and proportion didn't matter. Scenes were often overcrowded.

Sculpture told stories in "low-relief" (cut out only slightly from the

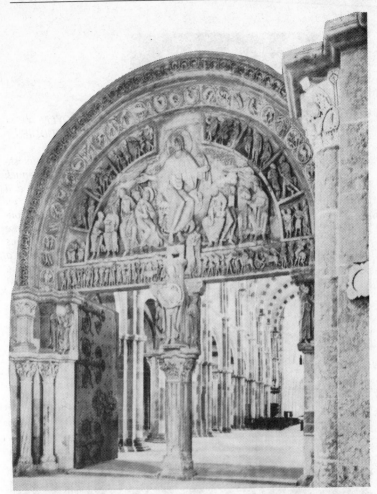

ROMANESQUE CHURCH—VEZELAY, FRANCE

Vezelay, half-way between Paris and Switzerland, is the textbook example of Romanesque architecture—so we're using it. Notice the round arches in the nave (central hallway) and the rather cluttered narrative relief sculpture on the semi-circular area above the door (the tympanum). The tympanum is a good place to look for a building's most interesting sculpture.

wall or surrounding material, as opposed to "freestanding"). A church's most interesting and creative sculpture is found in the tympanum (area under the arch above the door) or hiding in the capitals of the columns along the nave. Sculptors were allowed a little craziness here, and it's fun to see their grotesque fantasies peeking through the capital's leaves,

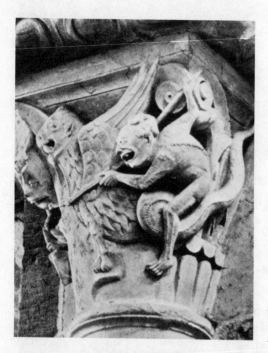

GARGOYLES AND THEIR BUDDIES

The medieval superstitions of Europe snuck into Romanesque and Gothic churches on rooftops and in inconspicuous corners. These gave the anonymous medieval sculptors a chance to have some fun.

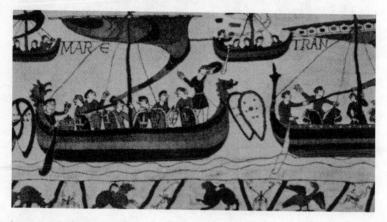

THE BAYEAUX TAPESTRY

Actually embroidery, this 900-year-old narration of the important Battle of Hastings (where the Normans of France invaded and began their conquest of England) is about the best example you'll see of Romanesque "painting." Here, realism takes a back seat to narration. Bayeaux is just two hours by train from Paris.

or the weird gargoyles and their buddies filling nooks and sticking out of crannies.

Remember, art doesn't have to be realistic to be good. It would be easy to write medieval art off as lousy art but we must always consider art in the context of its period and its function. (Maybe they're called the "Dark" Ages because *we're* in the dark about *them*.) This art, like Egyptian art, had narrative and religiously symbolic purposes. The artist wanted to inspire the viewer and did not need to be realistic to do it. In fact, being "freed" from the constraints of realism enabled the medieval artist to experiment with new (and often bizarre) color schemes, compositions and proportions, sometimes exaggerating them to enhance the spiritual effect. The final product is far from "classical" but it can be impressive technically if you accept it on its own terms.

High Middle Ages, 1000-1500

At the turn of the first millennium (AD 1000),Europe began waking up. It made some basic economic, political and ideological changes that would culminate a few centuries later in the Renaissance. For the previous five hundred years, progress could have been graphed as a straight, horizontal line. That line now arched upward, carrying Europe into the modern age.

Barbarian invasions were no longer a great threat and the people settled down. This new security encouraged them to build and plan for the future. Agricultural advances like improved plows and harnesses and crop rotation increased productivity. A new European style of inventiveness appeared when, for the first time, natural power sources were harnessed by the windmill and waterwheel. Fewer farmers were needed to feed the society. Towns grew up offering the newly mobile peasant an exciting alternative to life under his feudal master. Urbanization increased trade and improved communication. Europeans were no longer hopelessly isolated in a dark feudal struggle for subsistence. Europe perked up, experiencing the same enthusiasm that marked the USA's westward movement. Land was cleared, roads and bridges were built as Europe flexed its muscles.

Crusades, 1100-1250

This new progressive spirit showed itself in the aggressive "holiness" called the Crusades, a subject you will see and hear plenty about in your sightseeing.

The Crusades were a series of expeditions promoted by various popes and kings to protect the holy city of Jerusalem from Moslem invaders. Although they started as religious missions, nearly anyone could find a self-serving reason to join these holy wars of prophets and profits.

The East was a luxury dreamed about by many Europeans. The Crusades opened new and lucrative trade routes to the Orient. The supply routes set up for the wars remained as purely economic and cultural links between North Europe and Italy and between Italy and Byzantium. The nobles enjoyed this opportunity to conquer new land for fiefs, while their knights sought adventure, glory and spoils in the Crusades. The pope's prestige and authority seemed to soar with each Moslem killed, and Christians chased salvation by converting "heathens" and protecting Jerusalem.

Richard the Lionhearted and Saladin, two of the greatest medieval knights, are shown jousting in this medieval illustration. Richard was a renowned Crusader.

While the Crusades finally failed with the Moslem capture of Jerusalem (and later, Constantinople), they did have a great effect on Europe, giving it a broader, more cosmopolitan outlook. The Crusaders opened a floodgate of new ideas from the East and brought back many classical ideas that the West had lost during the Dark Ages. The Crusaders also learned important stone-working skills that helped Europeans build the great castles and churches of the Middle Ages.

Venice emerged from the Crusades the big winner. Europe's appetite was whetted by the East's luxury goods, and Venice established itself as the dominant middleman. The Venetians prospered, expanding to control the entire Adriatic area politically and to become Europe's economic powerhouse until new trade routes to the East were developed several hundred years later. Today Venice's past glory decays elegantly and her lavish architecture reflects her former position as the middleman between Byzantium and medieval Europe.

Birth of Nation-States

During the High Middle Ages, Europe dumped feudalism in favor of larger political units. Cities didn't fit into the rural feudal mold. Merchants preferred political stability, uniform laws, coinage and measurements and independence from the whims of feudal lords. In earlier times a trading ship might cross 35 "national" boundaries and pay 35 customs duties just to take a load down the Rhine River. The urbanites welcomed a king who could keep the peace between the feuding feudal nobles, creating a larger political unit more conducive to efficient business and trade. And, finally, warfare had progressed to the point where the mounted feudal knight was obsolete.

Europe had a new chessboard with shoemakers and banks replacing knights and castles. The time was ripe for the emergence of national monarchies heading large states. England and France appeared in something like their modern form. When William of Normandy crossed the English Channel in 1066 and became William the Conqueror, he set up a strong central government and forced a greater unification of England's feudal lords. England became part of the Angevin Empire which, by the time of Henry II and Queen Eleanor of Aquitaine, stretched from Scotland south through western France to the Pyrenees.

For a brief period, the court of Henry and Eleanor was the cultural heartbeat of Europe where troubadors sang; poets, scholars and artists hob-nobbed; and chivalrous knights laid capes in puddles for ladies to walk on.

This empire, however, was short-lived. When Henry's son, Richard the Lionhearted, died, England returned to fragmented rule by local nobles. These nobles cemented their newly recovered autonomy by forcing the new King John to sign the Magna Carta (1215) which constitutionally guaranteed their rights. This set the stage for hundreds of years of power struggles between strong kings and strong nobles (who later formed a Parliament).

The French bits of the shattered Angevin Empire were conquered and united, and France emerged as Europe's superpower.

Church vs. State

The popes joined the kings in the European power sweepstakes. Throughout the Middle Ages the kings and popes played "tug of war" with temporal power. After AD 1000, on the crest of a spiritual revival,

a series of energetic popes reformed the church, the monasteries and the communications networks, establishing the papacy as a political power to rival the kings.

In many ways, the medieval church operated like a "nation" without borders. It owned lots of land, taxed through tithes, influenced political decisions on all levels, and attracted Europe's most talented men to work in her service. Local kings and princes were threatened by and jealous of this rich and powerful so-called "spiritual organization" that meddled so deeply in their affairs.

This pope-king thing came to a head in the debate over who had the right to appoint bishops. The pivotal battle of wills was between Pope Gregory VII and "Holy Roman Emperor" Henry IV of Germany. The powerful German king appointed a bishop against the pope's will and was excommunicated. Despite his military might, Henry learned that his people supported him only if he was in good with the pope. Fighting for his political life, he "went to Canossa" (Italy, 1077) to beg forgiveness of the pope. The famous image of him kneeling for hours in the snow outside Gregory's window reminded later leaders that the pope was supreme.

The strongest popes knew they could make or break kings at will, not by threat of military force, but by playing the power and jealousies of the local nobles against their king.

Note how earlier the church and the nobles shaped European history. Now the popes and kings have joined in. Later we'll see how the city class (French Revolution) and the working class (Socialist Revolution) were dealt onto the card table of European history.

Gothic Art, 1150-1400

The combination of church wealth, political stability and a reawakened spiritual fervor brought Europe a new artistic style—Gothic. Centered in rich, stable Northern France this style replaced the gloomy, heavy Romanesque with an exciting lightness and grace.

From the first page of the Bible it's evident that light is divine. Abbot Suger, who "invented" Gothic in 1144 at St. Denis, outside Paris (it's been rebuilt and is not worth visiting today), wanted to create a cathedral of light. The rest of Europe followed suit, building churches with roofs held

up by skeletons of support, freeing the walls to become window holders. Now, when Christians went to church they were not merely surrounded by the stone of the earth, they were bathed in the light of heaven.

Gothic architecture (other art forms were still generally subservient to architecture) began with certain technical improvements over Romanesque. In a Romanesque church, the heavy stone roof was simply arched over the supporting pillars like a bridge. These pillars had to be fortified into massive walls to support the weight, leaving only tiny windows and a dark place of worship. Gothic architects discovered better ways to distribute the weight of the roof. First, they made criss-cross arches to span the columns diagonally. Second, they made pointed arches which could reach higher while minimizing the increased weight on the supports. The weight of the roof pressed outward rather than down. "Flying" buttresses were used to counterbalance the outward pressure the roof put on the supporting pilars. The Gothic builders were masters at playing one form against another to make a balanced harmonious structure.

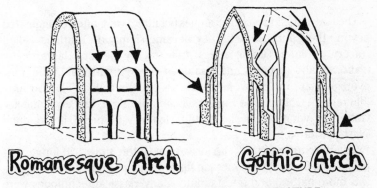

THE BASIC ARCHES OF MEDIEVAL ARCHITECTURE.

Romanesque buildings were barrel-vaulted. They required massive wall support, so windows had to be kept small. The Gothic style featured rib vaults supported by flying buttresses. This structure concentrated support on the columns and buttresses, allowing the walls to become giant window holders.

In the end, the church was supported by a skeleton of columns, ribs, pointed arches and buttresses. The roof could be taller than ever, the walls became window holders, and brightness filled the church.

Stained glass became a booming new medium for artists and an excellent opportunity for more narrative art to be "read" by the devout but illiterate peasants.

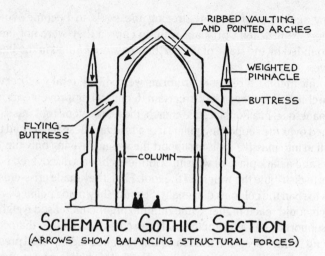

SCHEMATIC GOTHIC SECTION
(ARROWS SHOW BALANCING STRUCTURAL FORCES)

Gothic churches were bigger, brighter and taller than the earlier Romanesque churches. Pointed arches distributed the roof weight outward, while buttresses pushed in.

The ribs of the kitty-corner arches (vaulting) were often exaggerated beyond their purpose until they became simply decorations, called tracery. In later Gothic styles, this tracery became fantastically elaborate and complex and was often covered with gold. The most overripe state in the evolution of this style is called "Flamboyant" (flame-like) Gothic. The English version of this style, Perpendicular Gothic, is what you'll see in the Henry VII Chapel in London's Westminster Abbey.

Sculpture took a giant leap forward in Gothic times. No longer just pillars with faces, as Romanesque statues tended to be, Gothic sculpture was more natural and freestanding. Many classical techniques were used, especially in making clothing drape naturally over the body. Faces had personality and emotions. But the art was still a religious tool and, like the glass, every piece of sculpture had a symbolic message to those who came to worship.

The Gothic style was very competitive. Architects, sculptors and painters traveled all over Europe to compare and study new churches, causing Gothic churches to be remarkably consistent.

Italy tempered the tense verticality inherent in Gothic to make it more compatible with the horizontal stability that came with her classic roots. This is particularly evident in the great Italian Gothic cathedrals of Florence (capped by a Renaissance dome), Siena and

KING'S COLLEGE CHAPEL, CAMBRIDGE, ENGLAND

The Gothic style evolved into a very ornate "Flamboyant," or flame-like stage—known as "Perpendicular" in England. Here we see nearly all the wall space devoted to brilliant stained glass. The essential ribbing on the ceiling is decorated with extra "tracery," or purely ornamental rib-lets. You can see why this is often called "fan vaulting."

Orvieto—no flying buttresses, not so tall, and more likely to please a Caesar.

Throughout Europe, these largest economic enterprises of the Middle Ages represented an unprecedented technical accomplishment and tremendous spiritual dedication. The building of a Gothic church dominated the rich and poor alike of an entire area for generations. Paris' Notre Dame took 200 years to complete.

Understand that a Gothic church was carefully designed to be and usually still is a place of worship, not a museum. If you think of it as just a dead building to wander through and take pictures, you'll see the nave but miss the boat. A church is designed in the tastes of its century to

49

GOTHIC SCULPTURE

While Romanesque sculpture is embedded deep in church walls and niches and often is a tangle of emotion, Gothic steps further out from the wall and shows a sense of calm, orderly composure. Still, these figures from Notre Dame Cathedral in Paris are supportive of the architecture and far from the bold free standing works of the Renaissance.

facilitate worship. Through experiencing its purpose the real beauty of a church is easy to appreciate.

Gothic cathedrals are especially exciting when filled with music. Attend a concert or enjoy an "evensong" service. Meditate, cup your hands behind your ears and catch every echo as the music rinses the medieval magic into your head. Let your eyes follow the praying hands of the pointed arches upward to the heavens. Enjoy bathing in the warm light of the sun shining through the glistening treasure chest that was melted down and painted onto the timeless windows. Wind up your emotions and let them go. A Gothic church can be as alive as you are.

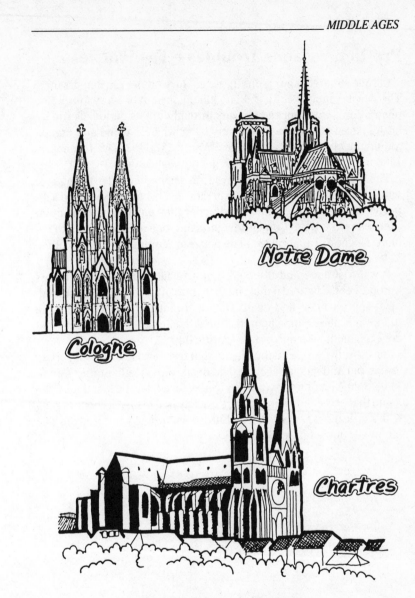

EUROPE'S MEDIEVAL MASTERPIECE -
THE GOTHIC CHURCH

Many great Gothic cathedrals adorn Europe. Here we see Chartres, considered by many to be the greatest Gothic building; the Cologne Cathedral [Germany], one of Europe's tallest [just across the street from the station]; and Paris' famed Notre Dame. At Chartres, just an hour south of Paris, take one of Malcolm Miller's Gothic appreciation tours. Twice a day Europe's most famous lover of Gothic gives tourists a great lesson in how to enjoy this style of art.

51

Pre-Renaissance Troubles—The Plague

Europe suffered labor pains in the century before the Renaissance. The worst plague ever hit in 1348, killing one out of every four Europeans. Europe was rocked by wars throughout this period. Germany bashed itself about in a lengthy civil war while England and France fought the bloody "Hundred Years' War" (1337-1453). (Wait a minute. 1453 minus 1337, that's. . . Let me get my calculator. . .)

The super-success of the papacy led to corruption and extravagance within the church. Its giant bureaucracy had become flabby and self-perpetuating, and the popes lived richer than any king. At one point there were two popes, one in Avignon and one in Rome. (Plan to explore Avignon's Papal Palace.) The popes excommunicated each other. Reform was badly needed.

It was a strange and troubled time—social neurosis swept across Europe. People figured it must be the wrath of God. Witchcraft soared, devil appeasement and death cults had much of Europe doing the "dance macabre." Some figured, "What the heck, the end is near" and dove headlong into one last hedonistic fling.

Actually, the wars and the plague that tore Europe to shreds served to thin out and vitalize society. The dead were mostly Europe's poor. Those in the labor force who survived enjoyed, for the first time, a demand that exceeded their numbers. Society had to treat its bottom rung with a little more respect. A lean Europe was primed and ready to ride the waves of the future. Serfs up.

THE DANCE MACABRE

The troubled 14th century gave Europeans many reasons to think they were victims of God's wrath.

Meanwhile... Events Outside Europe

Dark Ages: 500—1000

—Emperor Justinian the Great briefly reunites Roman and Byzantine empires (ca. 550).
—Mohammed leads "Hejira" (exodus) from Mecca to Medina (622).
—Mayas build great cities in Central America.
—Chinese build 500-mile Grand Canal to connect the country's main rivers (610).
—"Arabian Nights" courtly life in Baghdad (modern Iraq,)—arts and sciences flourish (800).
—Arabs learn papermaking from Chinese prisoners, craft spreads to West.
—Tea first becomes popular in China.
—St. Cyril brings Christianity and an alphabet (still used) to Eastern Europe and Russia (863).
—Vikings sail west to the New World (1000).

High Middle Ages: 1000—1500

—Japanese courtesan, Murasaki Shikibu, writes the *Tale of Genji,* possibly the world's oldest novel (1000).
—Averroes, a Moslem scholar, translates Aristotle for the West (1170).
—Omar Khayyam, Moslem poet, writes, "A loaf of bread, a jug of wine and thou." (1100).
—China introduces first paper currency (1024).
—Toltecs build city of Chichen Itza with Mayan help (1000).
—Kiev (Russia) is cultural center of a Slavic empire (1050).
—Angkor Wat temple complex of Khmer empire (Cambodia) (1150).
—Hang-chou, China, is largest city in the world with 1.5 million (ca. 1200).
—Enormous Mongol empire forged by Ghengis Khan includes China, India, Persia, the Middle East and Russia, reaching as far west as Hungary (1200-1300).
—Marco Polo travels to Kublai Khan's magnificent court in China (1275).
—St. Thomas Aquinas applies Aristotle to Christian theology; first banned, it later became doctrine (1270).
—Constantinople falls to the Ottoman Turks (Moslems). End of the "Roman" Empire (1453).
—Columbus discovers America. By treaty, Spain and Portugal divide the New World between them (1492, 94).
—Vasco da Gama of Portugal arrives in India via the Horn of Africa (1498).

Relax...

You've just covered 1,000 medieval years. Before you leave the Dark Ages and enter the bright glow of the Renaissance, let your eyes adjust and

take a break.

The Middle Ages—the bridge between the Ancient and Modern world—is often misunderstood. Here's a list of some related articles in the last half of the book:

Timeline
The Medieval World

Three realms carried civilization through the Dark Ages after the Fall of Rome—Christian and barbarian Europe of the Early Middle Ages, Byzantium (the Eastern Roman Empire) and the Islamic nations. At first, Europe had little contact with the two non-European realms—and little cultural activity, as shown by the blank lower half of the chart.

Then, in the pivotal year 1000, great changes began. The Crusades sparked cultural exchange between East and West and a new spiritual awakening. Increased agricultural production, industry and trade brought new prosperity.

Looking at vertical history we see the fruits of these High Middle Ages in the rise in building and art (lower half of the timeline). The spiritual awakening and prosperity produced many churches in Romanesque and, later, Gothic style, starting in France and moving to Italy, England and Germany—each with its own type of Gothic, becoming increasingly more decorative. The Crusaders brought back Eastern knowledge of castle building, and soon, every feudal lord had his own stone home.

As the European economy became more productive, centering in towns, relying more on trade and industry than subsistence farming, feudalism was replaced by larger political and economic units. The Black Plague and costly wars further destroyed the old order. Europe prepared to enter the Renaissance.

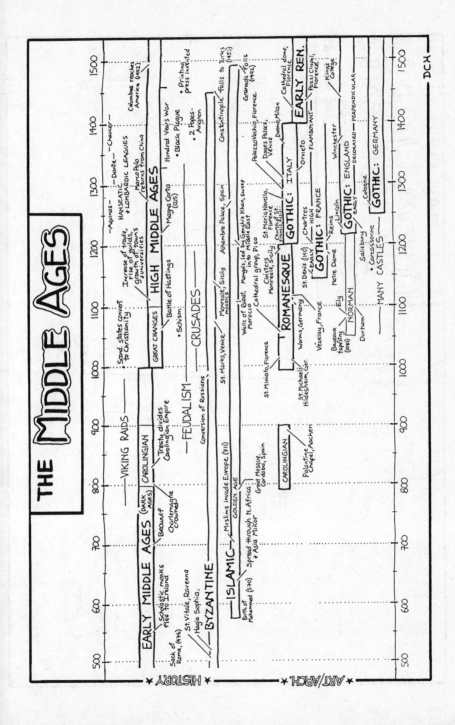

THE MIDDLE AGES

HISTORY

500 — 600 — 700 — 800 — 900 — 1000 — 1100 — 1200 — 1300 — 1400 — 1500

EARLY MIDDLE AGES (DARK AGES) CAROLINGIAN GREAT CHANGES HIGH MIDDLE AGES

- Scholastic monks flee to Ireland
- Sack of Rome, (476)
- St. Vitale, Ravenna
- Hagia Sophia,

BYZANTINE

ISLAMIC — GOLDEN AGE

Birth of Mohamed (570) Spread through N. Africa & Asia Minor Muslims invade Europe (711)

Beowulf Charlemagne Crowned

VIKING RAIDS

Treaty divides Carolingian Empire

FEUDALISM

Conversion of Russians

- Scand. states convert to Christianity
- Increase of trade, Rise of guilds, growth of towns, universities

- Battle of Hastings
- Schism

CRUSADES

Walls of Rabat, Morocco Mongols, led by Genghis Khan, sweep into Middle East

- Magna Carta (1215)

Alhambra Palace, Spain

Monreale, Sicily St. Marks, Venice Monreale, Sicily mosaics

- Aquinas — Dante — Chaucer
- HANSEATIC & LOMBARDIC LEAGUES
- Marco Polo returns from China
- Hundred Years War
- Black Plague
- 2 Popes: Avignon
- Constantinople falls to Turks

Granada falls (1492)

- Columbus reaches America (1492)
- Printing press invented (1455)

EARLY REN.

ART/ARCH

500 — 600 — 700 — 800 — 900 — 1000 — 1100 — 1200 — 1300 — 1400 — 1500

Great Mosque, Cordoba, Spain

CAROLINGIAN

Palatine Chapel, Aachen

St. Miniato, Florence St. Michael's Hildesheim, Ger.

ROMANESQUE

Worms, Germany Vézelay, France Cleister, Monreale, Sicily Cathedral group, Pisa St. Maria Novella, Florence Church of St. Francis, Assisi

GOTHIC: ITALY

St. Maria Novella, Florence Palazzo Vecchio, Florence Doges Palace, Venice Duomo, Milan Cathedral dome, Florence Pazzi Chapel, Florence King's College

GOTHIC: FRANCE

St. Denis (1140) EARLY Chartres HIGH Reims Notre Dame Orvieto FLAMBOYANT

GOTHIC: ENGLAND

Bayeux tapestry (1088) NORMAN Durham Ely Lincoln Salisbury Winchester EARLY Carcassonne DECORATED Cologne PERPENDICULAR

GOTHIC: GERMANY

MANY CASTLES

DCX

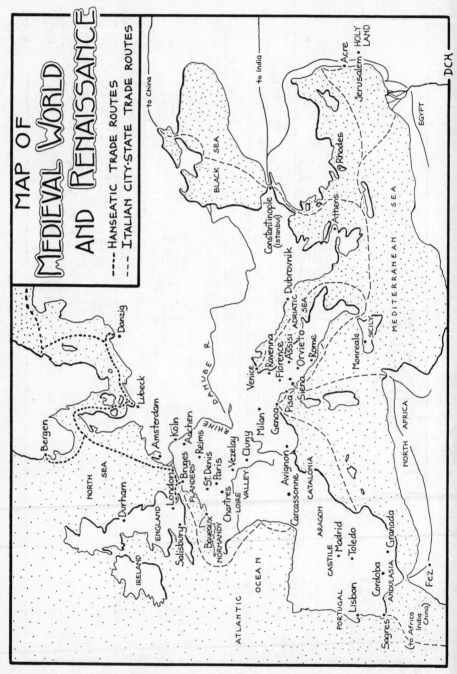

MAP OF MEDIEVAL WORLD AND RENAISSANCE

---- HANSEATIC TRADE ROUTES
--- ITALIAN CITY-STATE TRADE ROUTES

MICHELANGELO'S "DAVID," FLOREN
The face of the Renaissance. Man ι
the shaper of his destiny—no lon
just a plaything of the supernatu

Renaissance
1400-1600

The Renaissance was the "rebirth" of the classical values of ancient Rome. (In fact, the word renaissance means "rebirth.") Northern Italians, taking a fresh new secular approach to life, considered themselves citizens of a New Rome. The new Renaissance man was the shaper of his destiny and no longer just a plaything of the supernatural. Individualism and humanism skyrocketed and life became much more than a preparation for the hereafter. There was an optimistic confidence in the basic goodness of man and his power to solve problems.

This freed an avalanche of original thinking and creativity that gave our civilization its most exciting and fertile period of art since the great Greek streak 2,000 years earlier.

The Renaissance also did more for tourism than any other period in history. All over Europe, but especially in Italy, visitors are setting their touristic sights on the accomplishments of the creative geniuses of this age.

The Renaissance was more than simply a return to the ancient days and ways. This was a period of new birth as well as rebirth which laid the foundation of the modern world. Politically, the modern nation-state was born. Economically, as capitalism replaced feudalism, the middle class was hatched. Intellectually, this period spawned the Protestant Reformation, humanism, modern science and secular thought.

Italy was the perfect launch pad for this cultural explosion. As the natural trading center and middleman between the East with its luxury goods and the merchants of the West, its cities were rich. Venice was a thriving trading center of 100,000 people and 3,000 ships in 1400. The East-West trade shuttled many classical ideals, which had flown eastward with the fall of Rome a thousand years earlier, back to Italy. Italy never completely forgot her classical heritage, and she welcomed its return.

North Italy was the most urban corner of Europe. In 1400, 26% of the people there were city-dwellers, while only 10% of England was urban. The Italian cities were generally independent, not having to cope with a pope or worry about a king. They did their own thing—and that required participation in government, more literacy and better communication. This urban metabolism stimulated commerce and industry.

The cities actively recruited skilled craftsmen, and the social structure became more flexible, offering the working class hope for improvement.

Florence led the Renaissance parade. A leader in banking and wool manufacturing, it prospered after the Crusades. It had a large middle class and strong guilds (labor unions for skilled craftsmen).Their success was a matter of civic pride. They considered themselves citizens of Florence and cousins of the highly cultured people of the Roman Empire. Their pride was expressed in mountains of money spent to rebuild and beautify the city. Other Italian cities followed suit.

New ways of thinking brought prosperity (or, for the Marxists, "Prosperity brought new ways of thinking"). The talented and ambitious men of the Middle Ages had served in the church. Now an active life of business and politics was considered just as meaningful and respectable as the passive, contemplative life of the monastery. Chasing money was no longer considered shameful, as long as the wealth was used properly.

Such values were found in the writings, letters and speeches of the ancient Romans, and, even with their "pagan" flavor, they were accepted by devout Christians. Scientific and religious beliefs were synthesized. The Renaissance was not a repudiation of God but the assertion of man. In 1450 a Florentine summed it up nicely:

"The world was created not for God who had no need of it, but for man. Man is the most perfect work of God, the true marvel of his genius. Man has his end, not in God, but in a knowledge of himself and his own creativity."

Out of this secular orientation came the non-Christian school, training young people for the new world of business and politics. Schools and private tutors based on Roman models popped up all over. Throughout Europe, educated upper class people had a common cultural base—they all spoke Latin, appreciated classical literature and shared a common secular morality. There was a new international network besides the church to cut across borders and spread new ideas.

Renaissance Art

The accomplishments of the Renaissance most obvious to the tourist are those in art and architecture. The art from 1400 to 1600 is a triumph of order and harmony and the technical remastery of the secrets of the classical artists, lost during the Middle Ages. This period also saw the discovery and exploration of many new artistic techniques.

In Renaissance art we see both rebirth and new birth. The rigid, symbolic, religious formalism of Medieval art is conquered by a more

natural, realistic style. This trend is like the movement from formalism to realism in ancient Greece, as artists broke away from symbolic portrayal and started painting subjects with individual character and personality. Like Greece's "Golden Age," the Renaissance is a time of balance between extreme formality and wild naturalism. Later, in the

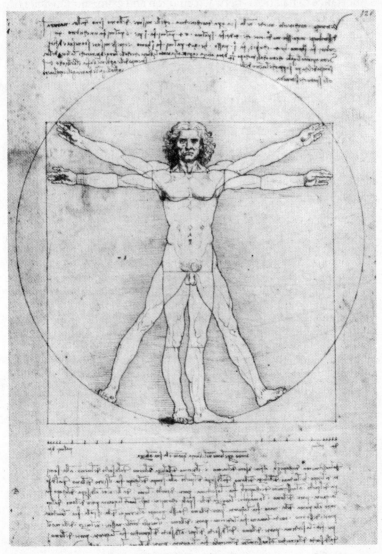

Page from Leonardo da Vinci's Notebook.
Leonardo invents jumping jacks.

Baroque period (as in Greece's Hellenistic era), the artists go overboard in their naturalism—losing that sense of order.

Renaissance art has many classical characteristics—realism, glorification of the human body and the individual, non-religious themes, and an appreciation of beauty for its own sake. Overriding all these is the importance of balance—between emotion and calm, motion and rest, as well as between the various figures of the composition.

Beautiful art was a rich man's hobby. The new secular patronage stimulated art—giving it more pizzazz. The artist was hired to please his viewer sensually—to satisfy his patron. Wealthy merchants of the

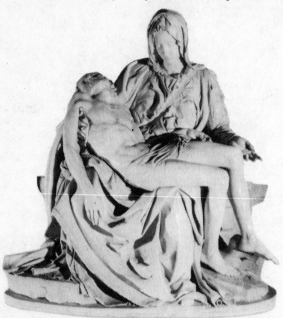

MICHELANGELO'S "PIETA," St. Peter's Cathedral, Rome

Sculpted at the age of 22, showing the dead Christ held by the eternally youthful Virgin Mary.

Italian city-states commissioned art for their personal collections and for public display as a show of civic pride. They wanted art to reflect the power of man, his dignity and his participation in life.

The medieval church's monopoly on art was broken. Secular patronage opened up new realms for artists previously confined to religious subjects. "Pagan" themes were very popular.

Many Renaissance artists were very devout, however, and created

more emotional and moving works than anything in the Middle Ages. They glorified God by glorifying man, His greatest creation. Religious themes were portrayed more realistically, emphasizing the human aspect. In Michelangelo's Pieta, for example, the suffering of Jesus and his grieving mother is not shown symbolically, it's shown in detail. Michelangelo intentionally elongated Jesus' dead body to exaggerate its weight and the burden of sadness borne by Mary.

The artist was no longer an anonymous laborer, ranking socially with a bricklayer. He was well paid and accepted as a part of society's elite. Raphael and Leonardo were wealthy and famous. Their presence at a party made the evening.

Artists of the Renaissance deserved the respect they got. They merged art and science besides mixing paints and building scaffolds; their apprenticeship required mastery of the laws of perspective. They studied nature like a biologist. They studied human anatomy as avidly as a doctor, learning not just how the body looks, but how it works, so that they could catch it in motion. The well-rounded "Renaissance Man" was born.

Technical expertise, combined with secular patronage and the classical love of sheer beauty, raised Europe to a level of artistic excellence not seen since Greece's Golden Age two thousand years before.

Renaissance Architecture

The proud people of the Renaissance gave "Gothic" its name as an insult. "Gothic" means barbarian, crude, "of the Goths." Gothic cathedrals were seen as tense, strained and unstable. The Renaissance architect turned to his ancient Roman forefathers and developed, or rediscovered, a round, geometrical, stout, symmetrical, balanced and domed style.

The father of Renaissance architecture was Filippo Brunelleschi who built the symbol of the Florentine Renaissance, the dome of the cathedral of Florence. Brunelleschi traveled to Rome to carefully measure and study the classical buildings and monuments. Back in his hometown he consciously copied Roman styles—columns, arches, pediments and domes—creating buildings that were as "Renaissance" as could be. This classical order and the harmony of his design caused a great sensation, inspiring other artists to mix Roman forms with original designs.

Italian architects and artists, in demand throughout Europe, had no shortage of commissions to build secular palaces, homes and public

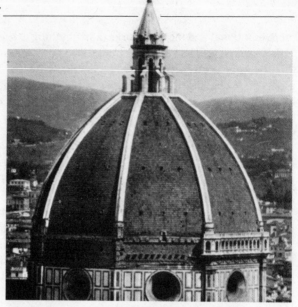

BRUNELLESCHI, CATHEDRAL DOME, FLORENCE, 1420-36

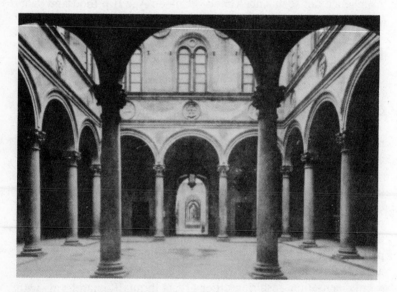

COURTYARD OF A MEDICI PALACE BY MICHELOZZO, FLORENCE, 1450

The typical Renaissance architecture—balance, symmetry, arches, Corinthian columns, circles and squares.

*PAZZI CHAPEL
BY BRUNELLESCHI,
FLORENCE,1450*

*The ideal Renaissance church—built
symmetrically, perfectly proportional
around a central point. Located right
next to the St. Croce church.*

buildings in the Renaissance style. The pope hired Michelangelo to
come to Rome and design the dome of St. Peter's—Christendom's
greatest cathedral. French kings built Renaissance chateaus on the
Loire, and even the Russian tsar imported Italian expertise to remodel
Moscow's Kremlin in the new style.

Renaissance church design echoed the upbeat optimism and confi-
dence of the time by trading the medieval Latin cross floor plan (sym-
bolic of the crucifixion) for the Greek cross floor plan (four equal arms
symbolizing the perfection of God).

Sculpture and Painting

The great Florentine painters were sculptors with brushes. They
painted like the ancient Greeks had sculpted, making solid figures with
great weight, solemnity and "presence." In fact, many of them, like
Michelangelo and Leonardo, were equally famous for sculpture and
painting. Sculpture and painting evolved simultaneously from flat, sym-
bolic medieval art to the full realism of the Renaissance.

Donatello (pron. "dona-TELL-o, 1386-1466) was the first true
Renaissance sculptor, possessing both the skills of classical sculpture
and the personality of the Renaissance artist.

The statues he did for the church of Or San Michele in Florence as a
young man show his classical attitude towards the human body. St.
Mark, although fully clothed, has the posture of a classical nude. The
clothing drapes naturally, formed not by the artist but by the body
beneath. You almost feel that if you lifted Mark's robe, you'd get
punched.

To see how far Donatello had come from Gothic sculpture, compare
it with Nanni di Banco's "Four Saints," done at the same time for the
same church. While Donatello's Mark stands boldly on the edge of his
niche, Nanni's "Four Saints" hide within a deep Gothic niche, attached
to half-columns (pilasters), afraid to step from the safe support of the

church into the light of day. Donatello freed sculpture from its 1000-year subservience to architecture.

While you're at Or San Michele, check out Donatello's famous "St. George." It stands like a symbol of the Renaissance Man—alert yet re-

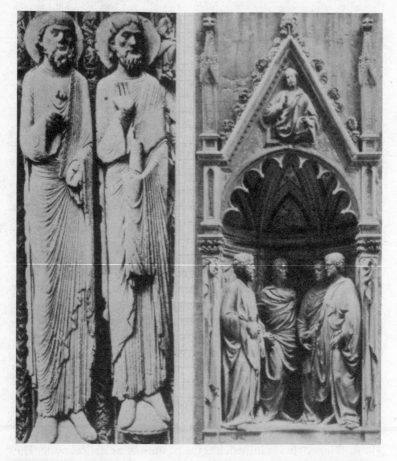

CHARTRES CATHEDRAL
SCULPTURE, 1140

NANNI DI BANCO, OR SAN MICHELE,
FLORENCE, 1413

Notice how sculpture emerged from the shadows of church architecture. At Chartres, the stiff column-like figures are embedded in the Gothic wall—entirely supportive of the architecture. Nanni's "Four Saints" have Renaissance solidity but are still niched deep within the wall. Nanni was on the cusp of the revolution. Twenty years later, Donatello's "David" stood on his own in the light of day— to be admired as a work of art and of man. (next page)

laxed, strong yet refined, active yet Christian.

These works were commissioned by the church and by civic organizations. But another work, paid for by a private citizen for private display, shows how much private patronage freed the artist from medieval constraints.

Donatello's "David" was the first free standing male nude since ancient times. In the Middle Ages it would have been condemned as a pagan idol. While the subject matter—the boy David killing the giant Goliath—comes from the Bible, it's just an excuse for a classical study of a male nude. The focus is on the curves of the body (and the body is no longer a dirty thing), not the action or the facial expression. The statue serves no religious or civic purpose. It is a simple appreciation of beauty. Art for art's sake.

DONATELLO'S "DAVID,"
FLORENCE, 1430

The first male nude sculpted in 1,000 years, this Early Renaissance masterpiece, along with much of the period's finest sculpture, is in Florence's Bargello museum.

Painting

Freestanding classical sculpture was the basis of the fanatic three-dimensionality we see in Renaissance painting. The leading painters of the period, like Leonardo and Michelangelo, were sculptors who saw sculptural depth in their painted subjects.

Giotto (pron. ZHOTT-o, 1267-1337), preceding the High Renaissance by 200 years, made the first radical break with the medieval past. He is the father of modern painting. Nothing like his astonishing paintings

GIOTTO, "RETURN OF JOACHIM TO THE SHEEPFOLD," PADUA, 1305

had been seen in a thousand years. Medieval figures were stiff, two-dimensional, with no sense of movement. There were no backgrounds to give the illusion of depth. Medieval artists were happy to tell the religious story with symbols, ignoring realism.

But Giotto takes us right to the scene of the action. He places his figures on a three-dimensional landscape, giving them depth, weight, and individuality. It's as though he created small theatre vignettes, designing the stage scenery, then peopling it with actors. His art was believable.

Much of his art reflects the Byzantine and Gothic styles of his age—pointed arches, gold-leaf backgrounds, halos, no visible light source and unrealistic scale—but he made great strides towards realism. The

MASACCIO, "TRIBUTE MONEY" (DETAIL), FLORENCE, 1425

Here we see Giotto's realism and "sculptural" figures developed further. Masaccio was the first painter to fully master the newly discovered laws of perspective.

Byzantine influence gave Giotto the classical techniques of light and shading (which the East had stored in an artistic time-capsule since the fall of Rome), and of foreshortening—to give the illusion of depth. His style excited the West and stimulated a renewed desire to study the classics.

Giotto was famous and in demand throughout Italy. This popularity for a painter was as revolutionary as his work. Medieval artists had been

PAOLO UCELLO, "BATTLE OF SAN ROMANO"
c.1455—Louvre, Paris, versions also in London's Tate Gallery and Florence's Uffizi.

71

anonymous craftsmen. No one cared about them. But Giotto made it in all the gossip columns. Anecdotes were told about his skill as a painter as well as his social wit.

Masaccio carried Giotto's techniques further. He used light and shadow to picture depth and drama. While Brunelleschi discovered the mathematical laws of perspective, Masaccio mastered these techniques of portraying objects receding into the distance (a tree-lined road, for example). Masaccio, another Florentine, who died young at 27, was more influential than he was famous. The anatomical realism and dramatic power of paintings like "The Expulsion From Eden" inspired many masters who followed.

After Masaccio, there was a decline, as lesser painters grappled with the new problems of perspective. Paolo Ucello's "Battle of San Romano" looks like a crowded, colorful, two-dimensional work in the medieval

ANDREA MANTEGNA, "DEAD CHRIST,"
MILAN, 1466

A Renaissance experiment in extreme foreshortening that succeeds in bringing the viewer right to the scene of the action. The psychological effect of seeing the body from this intimate viewpoint is exciting.

style. It's only when we look closer that we see it as a study in perspective—all the fallen weapons form a three-dimensional grid superimposed onto the background. The fallen soldier is smaller than life in Ucello's awkward attempt at foreshortening. All in all, it's a fascinating but weak transition from two-dimensional Gothic to three-dimensional perspective.

Medieval Church of St. Michael. Hildesheim, Germany, ca. 1015.

Masaccio, Florence, 1425

Michelangelo, The Vatican, Sistine Chapel, 1510.

THREE LOOKS AT THE EXPULSION FROM EDEN

The same scene in Medieval, Early Renaissance and High Renaissance style. Note the artistic differences, as well as the different views of Man. On the bronze doors of St. Michael's Church, Adam and Eve are puny and twisted, ashamed of their nakedness. Man is a helpless creature before the supernatural. Masaccio shows more human drama and respect for the body (the fig leaves were added later). Michelangelo shows a strong Adam with a gesture that almost says, "All right, already, we're going!" We know Adam and Eve will survive.

73

Perspective was mastered by relief artists of the period like Donatello and Lorenzo Ghiberti. Donatello achieved the effect of infinite background in his low-relief, "St. George and the Dragon," beneath the statue at Or San Michele. In Ghiberti's famed bronze doors of Florence's Baptistry we see Brunelleschi's influence. "The Story of Jacob and Esau" (one of ten Bible scenes on the door) has imaginary Brunelleschian architectural forms in the background receding into the distance according to mathematical perspective.

LORENZO GHIBERTI, "STORY OF JACOB & ESAU,"
FLORENCE, CA.1430

The contest to decorate the bronze doors of Florence's Baptistry excited and encouraged artists throughout the city. Here, the winning artist shows mastery of depth and perspective. Panels by the two finalists in the contest, Ghiberti and Brunelleschi stand side by side in the Bargello museum. You be the judge.

Botticelli (pron. Bott-e-CHELL-ee, 1445-1510) excelled in color, detail and line. Not as sculptural as Masaccio, Michelangelo and other Renaissance artists, Botticelli's figures have a pure, direct, yet dreamy quality. He mixes Gothic grace and fleshy classicism in his popular and wonderfully restored masterpieces "Primavera" and "Birth of Venus" (in Florence's Uffizi Gallery). Botticelli was a master in the Renaissance

skill of diplomacy; he did justice to the "pagan" classical scenes he loved while not offending the religious powers with too much flesh.

Artists throughout the ages have struggled with spiritual problems. During the Renaissance, Florence fell into the grips of Savonarola, a fanatic monk who preached against the secular Renaissance. Botticelli was just one of many creative people who tossed their "pagan" paintings and artistic works on the bonfires of medieval Florence's Jerry Falwell. It's interesting to see how the inner struggles of great artists (like Botticelli, Michelangelo, Rembrandt, Goya, Chopin, El Greco, and John Lennon) show through in their art.

SANDRO BOTTICELLI, "THE BIRTH OF VENUS" (DETAIL),
FLORENCE, CA. 1480

Botticelli's Venus is more graceful, thin and flowing than the massive figures of Masaccio and Michelangelo. The long neck and smooth skin are almost medieval looking.

75

Leonardo, Michelangelo, Raphael

The "Big Three"—Leonardo, Michelangelo and Raphael—were the culmination of the Renaissance. Their tremendous output came from their personal genius, spurred on by a huge demand for quality art. Never before had artists been asked to do so much and been given so much money and freedom to do it. Cities wanted monuments and public buildings. Wealthy individuals wanted palaces and decorations. Popes wanted churches. All of them wanted Leonardo, Michelangelo or Raphael.

Leonardo da Vinci

Leonardo da Vinci (1452-1519), the oldest of the three, typifies the well-rounded "Renaissance Man." He was a painter, sculptor, engineer, musician and scientist. He learned from nature—not books—which made his observations often more accurate than those of contemporary scholars. From his notebooks—written backwards and inside out, so you need a mirror to decode them—we know that he dissected corpses, investigated the growth of children in the womb, formulated laws of

FROM LEONARDO'S NOTEBOOK

Notice the scientific fascination with the body and his extensive notes, written backwards (done possibly to hide his thoughts from Church authorities). In Leonardo we see the merging of art and science.

LEONARDO DA VINCI, "SELF-PORTRAIT"

waves and currents, diagrammed the flight of birds and insects, and followed the growth of plants. He also sketched many inventions, foreshadowing the development of the airplane and submarine.

Leonardo was most famous as a painter and sculptor. Princes and church authorities from all over Italy sought his work. Nevertheless, he was temperamental and often left works unfinished. He insisted on working at his own pace—not the pace dictated by the clink of coins. None of his sculpture and only about 20 paintings survive.

The "Last Supper" shows Leonardo's mastery of balance, realism and drama. Depicting Christ and his twelve disciples, it is painted on the wall of a church—designed to look like just another chapel extending off the aisle. The lines of the walls recede toward the horizon (following the laws of perspective), and come together right at Christ's head. All

LEONARDO DA VINCI, "LAST SUPPER"
(WITH SCHEMATIC LINES), MILAN, 1498

Leonardo combines human drama with geometrical perspective. All the receding lines (the upper edge of the tapestries, the ceiling tiles) point to the "fresco's" center—Christ's head. The twelve disciples, each with a unique personal expression, are grouped in threes. Even without understanding all the circles and lines, we see method in the artist's madness. Unfortunately, the original "fresco" has been damaged over the years. Careful restoration work is now in progress.

the motion of the picture flows toward that serene center. Leonardo composed the Twelve in groups of three, with each of them contributing a dramatic movement in a wave-like effect toward the central

figure of Jesus. (Groups of three symbolize the Trinity; four, the Gospels.)

Despite this complex composition, the picture is not forced or sterile, but highly emotional. The Lord has just said that one of the disciples will betray him. Leonardo paints a psychological portrait of each of them at the very moment they ask, "Lord, is it I?"

It's said that Leonardo would go whole days without painting a stroke—just staring at the work. Then, he'd grab a brush, rush up, flick a dab of paint on . . . and go back to staring. (When you visit this or any artistic sight in Italy, be sure to dial the tourist info box to English, put in a few coins and listen to the story of the masterpiece, complete with trivia.)

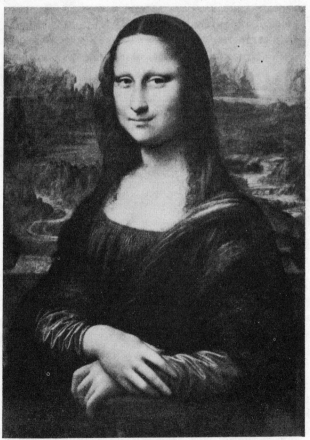

Leonardo's Mona Lisa, found in tourist shops throughout Paris.
(Oh yes. She's also in the Louvre, just follow the crowds.)

As many times as you may have seen the "Mona Lisa" in reprints or advertisements, she's fresh in the flesh. Every painting takes on life when you see it "in person." It's especially true of the Mona Lisa, thanks to a technique Leonardo worked out, called "sfumato." He blurred the outlines and mellowed the colors around the borders of the subject, letting the edge blend with the background. This is what makes Lisa so life-like and her smile so mysterious—try as you will, you can't actually see the corners of her mouth.

Michelangelo's 'Creation of Adam' from the Sistine Chapel, Rome.

Michelangelo

With Michelangelo, perhaps the greatest painter and sculptor of all time, the artist had mastered nature—what remained for him to do was master himself. Michelangelo's art reflects the inner turmoil of his personal and spiritual life. For the first time, an artists' biography is as important as his work; the two are intertwined, one influencing the other.

At the age of 15 Michelangelo Buonarroti (1475-1564) was a prodigy, a favorite of Florence's leading citizen, Lorenzo de Medici. After serving his apprenticeship, he became dissatisfied with book knowledge and set out to study nature first hand.

He had the curiosity and quick mind of Leonardo, but he applied them to just one subject—the human body. Mastering the techniques of the ancient Greeks and Romans, he added to them by actually dissecting corpses to learn anatomy. (Dissecting, which was strictly illegal,

was a key to understanding the body and portraying it realistically. After looking at another's work, Michelangelo could say, "You've dissected.") He was unsurpassed in his rendering of the human form.

Throughout his life, Michelangelo's talents were in great demand. Popes and princes vied for him to paint, sculpt or design churches and monuments. But even more than Leonardo, Michelangelo struggled to remain independent of his patrons' demands. He did what he wanted, how he wanted it. The remarkable thing is that patrons put up with this—the artist/patron relationship was turned upside down, finally with the artist on top.

Despite his great technical skill, Michelangelo thought that true creative genius came not from the rational planning of the artist, but from divine inspiration. He was one of the first "mad geniuses"—working only when he felt inspired, then going at it with the intensity of a madman.

He was influenced by the popular Neo-Platonist movement, which stressed Plato's division between the physical body and the divine spirit. Michelangelo took Plato's words to heart: "If anyone tries to be a poet (artist) without the madness of the Muses, persuaded that skill alone will make him good, then shall both he and his works of sanity be brought to nothing by the poetry of madness." (Plato, *Phaedrus*)

Michelangelo's statues show us this divine genius trapped within the body, struggling to get out. The works are outwardly calm, stable and balanced, but seem to be charged from within by a pent-up energy. They convey the inner restlessness and turmoil that marked Michelangelo's own life.

"David," sculpted when he was 26, has this blend of vibrant energy and calm. The posture is relaxed, but the alert, intense stare reminds us of Donatello's Christian warrior, "St. George." Like the earlier work, Michelangelo's "David" became a symbol of the ready-for-anything confidence of the Florentine Renaissance. It is a monumental work (13'5" tall) originally designed to stand on top of the Cathedral, until the city fathers elected to put it in a more visible spot (Palazzo Vecchio) outside the administrative center, as a symbol of civic pride. Today a copy stands in the square and the original is in the Academy, a 15-minute walk away.

When we compare this "David" with Donatello's earlier version (p. 69), we see how the Renaissance came into full bloom with Michelangelo. Donatello made David younger, more graceful, coyly gloating over the head of Goliath. By comparison, it's almost Gothic in its elegance and smooth lines. Michelangelo's, on the other hand, is

"DAVID"
By Michelangelo, Florence, 1504

Michelangelo's version of the giant-slayer shows the Renaissance Man in full bloom—alert, poised, cultured, ready to conquer his foe. Man has asserted himself. Compare with Donatello's earlier David—a graceful, playful Renaissance "boy." (p. 69)

more massive, heroic in size, superhuman in strength and power. The tensed right hand, holding the stones in readiness to hurl at Goliath, is much larger and more powerful than any human hand, it's symbolic of divine strength. The concentrated gaze is that of the reserved but intense Renaissance Man.

The inner power takes on a wrathful quality in "Moses," the Old Testament prophet whose calm but fierce expression demands attention. He

seems capable at any moment of angrily destroying the stone tablets of the Ten Commandments he holds in his hands. The artist shows more than just the physical body. He shows the moods and emotion of his subject.

Michelangelo must, at times, have felt cursed by the "divine genius" within him and the responsibility to create that went with it. The "Prisoners," two works that struggle to "free" themselves from the uncut stone around them, symbolize the Neo-Platonic struggle of the divine soul to free itself from the prison of the body. Don't miss them. They're right next to David in the Academy.

MICHELANGELO, "MOSES," ROME, 1515

Powerful, ready to leap up and smash the tablets on the rocks. You'll find Moses in Rome, in the church of St. Peter in Chains, a short walk from the Colosseum.

Michelangelo had a rather unique view of art. While many painters, including Leonardo, thought of themselves as almost divine creators, who could take a blank canvas and make a beautiful picture, Michelangelo, the sculptor, thought of himself only as a tool of God, gifted with an ability not to create but to reveal what God put into that stone. To Michelangelo, sculpture, not painting, was the most noble art form.

While painters like Leonardo and Raphael took great pride in their high class profession—painting in fine clothes, with fresh fruit, wine and maybe even some live music, washing up before dinner and enjoying a high society ball that evening—Michelangelo worked in a frenzy. In his sweaty work clothes, covered with marble dust, he'd often work doggedly, deep into the night—revealing.

MICHELANGELO'S "STUDY FOR ADAM FOR THE SISTINE CHAPEL," CA. 1510

The Florentines were sculptors at heart. Here Michelangelo's sculptural orientation shows through. Compare this with the finished product on p. 80.

Michelangelo, history's greatest body builder, always insisted that he was a sculptor, not a painter. Fortunately for us, his patrons felt otherwise. Pope Julius II, as part of a massive effort to return Rome and the papacy to its former splendor and prestige, bribed and pressured a hesitant Michelangelo into painting an enormous fresco (a painting on wet plaster) on the ceiling of the Sistine Chapel. Michelangelo worked

furiously for four years, producing a masterpiece of incredible proportions, unity and emotional power.

The Sistine Chapel chronicles the entire Christian history of the world, from the Creation, to the coming of Christ, to the Last Judgment. The several hundred figures not only tell the story, they also add up to a unified, rhythmically pleasing compositon. Their bodies are, as we'd expect, statue-like, in the tradition of Giotto and Masaccio. Also like Masaccio, they are dramatic and expressive.

The central scene shows the Creation of Man (p. 80), as Adam reaches out to receive the divine spark of life from God. We can see the tenderness between God and His creation, but the most striking thing about the relationship is its equality. Man is not cowering before a terrible God. He is strong and confident. Michelangelo shows us the essential goodness of man as the image of God, an important Renaissance ideal.

The Last Judgment, painted 25 years after the original work on the ceiling, is less optimistic. A wrathful God towers as mankind cowers. In the carcass held by St. Bartholomew there is a twisted face—it is Michelangelo himself, a self-portrait expressing guilt and unworthiness.

Michelangelo was also a great architect. The dome of St. Peter's in Rome is his. Influenced by Brunelleschi's Duomo in Florence, Michelangelo's dome was the grand model for almost all domes to follow.

The Campidoglio (the square above the Forum at the Top of the Capitoline Hill in Rome) was restructured by Michelangelo. The central feature is the ancient Roman statue of the Emperor Marcus Aurelius on horseback. (When the Christians gained power in ancient Rome, they destroyed many "pagan" images. This one was spared because they mistook it for Constantine—the first Christian emperor.) Around the statue, Michelangelo used the buildings on three sides to create the effect of an "outdoor room." The side "walls" are not quite parallel, direct-

ing energy forward as they get closer together at the Senator's Palace. Today these buildings house two fine ancient art and history museums.

Michelangelo was something of a contradiction—forceful and self-confident (almost arrogant), yet tormented by self-doubt and a feeling

CAMPIDOGLIO, CAPITOL HILL, ROME,
BY MICHELANGELO, CA. 1550

Michelangelo, typical of the Renaissance genius, was expected to sculpt, paint, and be a world-class architect on command. No problem.

of unworthiness. The contradiction, which blends so well in his early works, becomes more pronounced toward the end of his life. The inner turmoil rises to the surface, the bodies are more agonized. This is best seen in several later pietas (sculptures of the dead Jesus with his mother, Mary) in Florence and Milan.

Whether he died satisfied with his life's work we don't know. But he lived to almost 90 and was productive until the end. As a final show of independence and artistic devotion, he designed the great dome of St. Peter's and refused payment for his services.

Raphael

Raphael (1483-1520) is the best known single example of the harmony and pure beauty of the Renaissance style—a synthesis of the grace of Leonardo and the force of Michelangelo.

Raphael's "The School of Athens," embodies the spirit of the High

MICHAELANGELO'S APSE & DOME, ST. PETERS CATHEDRAL,
begun 1547

When asked to build the dome of St. Peter's Michelangelo said, "I can build one bigger but not more beautiful than the dome of my hometown, Florence." Climb to the top, 150 yards up, and judge for yourself. Matching the grandeur of ancient Rome, the builders of St. Peter's proudly "put the dome of the Pantheon atop the Basilica Maxentius."

Renaissance. Its subject is classical—Plato and Aristotle surrounded by other Greek philosophers engaged in highbrow jawing. The architecture of the school, unlike anything found in ancient Greece, is pure Renaissance use of classic forms.

The setting is like Leonardo's "Last Supper," with figures grouped rhythmically around a center of calm. The lines of sight meet at the "haloed" figures of the two philosophers, just as they did at Leonardo's Jesus. Each figure has an individual gesture, revealing his inner personality. The figure of Plato is none other than Leonardo—Raphael's tribute to the aging master—while Michelangelo is shown meditating sitting with his head in his hand in the foreground.

The fresco shows Michelangelo's influence in the solid, sculptural bodies and the dramatic power reminiscent of the Sistine Chapel. In fact, Raphael was working on this next door in the Vatican Palace while Michelangelo was climbing the walls in the Sistine Chapel. (This is one of many Raphael masterpieces that adorn the rooms just before the

RAPHAEL, "SCHOOL OF ATHENS,"
THE VATICAN, 1510

Renaissance thought brought together the church and the great classical philosophers. Notice the fantastic Renaissance architecture. As in Leonardo's "Last Supper," the receding lines of perspective meet at the heads of the central figures.

Sistine Chapel. Be sure to rent the radio headphones that will guide you through these rooms and the Sistine Chapel.)

Raphael's fame was equal to Michelangelo's, and his influence on subsequent generations was perhaps even greater. Periodically through the centuries, artists returned to the vision of ideal beauty seen by Raphael, who was known as the "Master of Grace." However, these imitators often ignored the realism and power of Raphael, turning out pretty pictures with little substance. It's tempting to blame Raphael for all those boring, sickly-sweet, dainty pictures by lesser painters you see in countless museums, but Raphael never flattered his subjects. He created a world that was idealized yet very real.

Raphael was the most loved Renaissance painter, until this century. Only in our generation have Michelangelo and Leonardo passed him in poster sales.

When Raphael died in 1520, the center of Renaissance painting shifted north to Venice.

RAPHAEL, "LA BELLE JARDINIERE,"
THE LOUVRE, 1507

*A typical pyramid or triangle composition by the
"Master of Grace." Most tourists burn out on the
very common "Madonna and Child" scene long
before they get to Raphael. Be sure to save time
and interest for Raphael—the master of this form.
See composition diagram page 318.*

Venetian Renaissance

While Florentine art is "sculptural," Venice entertains visitors with a
very splashy and colorful style—understandable in an elegant city of
lavish textiles and glittering canals.

In the art of Giovanni Bellini, an early Venetian master, we see the
delicate, atmospheric haze that characterizes Venetian art. It's as
though the picture was taken with a soft-focus lens on the camera,
making everything glow and blend together, bathing it in light. This is
Leonardo's sfumato taken one step further.

Giorgione's "The Tempest," with bright colors and a hazy quality similar to Bellini, marks a trend new to Italian painting—the landscape. Like painters from the North, Venetians enjoyed painting pleasantly detailed scenes showing a love of the natural world. This painting experiments with composition, using color, not just the figures, to balance and unify.

GIORGIONE, "THE TEMPEST" (DETAIL)
VENICE, 1505

While Florentine art tended to be sculptural with strong outlines, the Renaissance art of Venice was colorful and romantically atmospheric—like its home town.

The chief Venetian was Titian (that rhymes). One of the most prolific painters ever, he cranked out a painting a month for 80 years. Like it or not, you'll see plenty of Titians on your trip (especially in Venice). Titian often finished his paintings with layers of glaze (impasto technique) which over the years darkened, giving his work an unintended darkness. While they are darker than other Venetian works, Titian's canvases have the same richness of color and brilliance of light burning through the night.

When Raphael died, Titian became the most sought after portrait artist and Venice was Italy's art capital. Titian could capture a personality and endow it with a calm, meditative, serene air—a mood that pervades all Venetian painting (as well as many of its back streets

today). A famous example of Titian's prestige was that, once, when he dropped a brush during a sitting, his subject—the Emperor Charles V of Spain—picked it up for him.

TITIAN, "DANAE," KUNSTHISTORISCHE MUSEUM, VIENNA

Northern Renaissance

The Renaissance in the North countries was more an improvement on medieval art than a radical return to classical forms. Northern artists used Italian discoveries of perspective, anatomy and knowledge of classical forms, but kept their style distinctly Northern.

Late Gothic art is characterized by grace and lightness, delicate flowing lines and an appreciation for things that are just plain beautiful. Human bodies are slender and gently curved, with smooth, unmuscled skin. Colors are bright and pleasant.

91

Northern artists loved detail. Like craftsmen working on a fine Swiss watch or German cuckoo clock, they thought nothing of spending hours on end slaving over, say, the hairs on a dog's head to get it just right—even when the dog was just a minor figure in a large canvas. Their appreciation of the many wonders of nature shows in their work.

Medieval paintings often look crowded. Details abound—the more the better. Crammed with objects and minute details, these works are best viewed as they were painted, slowly and carefully.

Northern Renaissance art differs from the earlier medieval style only in the improved technique learned from the Italians. The detail and crowded composition is retained—but painted with greater skill.

Albrecht Durer (a German working about the same time as

"ARNOLFINI WEDDING" (DETAIL)
JAN VAN EYCK, NATIONAL GALLERY,
LONDON, 1434

This early masterpiece from the Northern Renaissance shows the characteristic medieval attention to detail and the down-to-earth personal style typical of Belgian and Dutch art. You can even see the couple's reflection in the round mirror in the rear.

"Wedding?" Well, maybe she's just fat . . . Actually, there was a time when women would wear a pillow to their wedding—to improve their chances of becoming pregnant.

Michelangelo) finished his apprenticeship and traveled to Venice to learn the techniques he'd heard so much about. When he returned home and achieved fame, he helped "Italianize" the Northern tradition. He has been called the "Leonardo of the North."

Durer (1471-1528) combines the laws of perspective and human anatomy from Italy with the German attention to detail. While he never quite mastered Michelangelo's ability to make a solid, statue-like body,

"FOUR HORSEMEN OF THE APOCALYPSE,"
WOODCUT BY DURER, BRITISH MUSEUM, 1498

Durer's woodcuts were the first mass-produced art Europe had seen. His mastery of lines and detail went well with this pains-taking medium. Notice his famous A.D. monogram at the bottom.

his paintings are astonishingly realistic. With the patience formed from the grueling process of engraving and woodcuts (sketching black lines on a white-painted block, then chipping off the white), he added detail upon detail until the block mirrored real life. This fascination with lines shows in his paintings as well as his woodcuts.

DURER, "SELF-PORTRAIT," PRADO, 1497

Durer was Europe's first top selling artist. A master of the woodcut and engraving, his works were reproduced in large quantities and were very popular.

Durer was impressed by the respect Italian artists enjoyed. Northern

artists had always been anonymous craftsmen, laboring in guilds. Durer helped change that. Keeping journals and writing books, he was convinced that his personal life and thoughts were as important as his handiwork. His famous self-portraits (a first) portray him as an elegant dandy.

Matthias Grunewald (1470-1528, pron. GROON-uh-vald) was a great but mysterious Northern Renaissance artist. (We're not even sure of his real name.) Like the style of the whole Northern Renaissance, his style grew out of the Gothic stage. His anonymity is medieval as is his gripping religious devotion. Grunewald often ignored realism (so important to Durer and the Italians) to make a religious point.

"ISENHEIM ALTARPIECE," GRUNEWALD,
COLMAR, FRANCE, 1515

This mysterious, late-Gothic master painted one of the most gripping crucifixions ever. Notice the weight of Christ's body bending the cross bar, his stiff fingers, mashed feet, dislocated elbows—and the grief on Mary's face (kneeling). Though Renaissance in its technique, there is still medieval symbolism—the lamb with a cross and cup, St. John holding a book and so on. Turn to page 319 for a closer look at this masterpiece.

His famous "Isenheim Altarpiece" in Colmar, France is one of Europe's most exciting and powerful masterpieces. In this set of scenes from Jesus' life, Grunewald uses distorted shapes and dazzling, unreal

colors to grab the emotions. You feel the agony of Christ twisted stiffly and heavily on the cross, the humility of Mary and the exuberance of the resurrected Christ springing almost psychedelically from the tomb as if shot out of a Roman candle.

"GARDEN OF DELIGHTS" (DETAIL),
BOSCH, PRADO, MADRID, 1510

In just a tiny bit of this monumental three-paneled altarpiece we see a self-portrait of Bosch with a broken egg-shell body, tree trunk legs, crashed-through wooden dinghies in a frozen lake with giant birds leading naked people around the brim of his hat. Nothing unusual—for Bosch.

Bosch

Another interesting artist was Hieronymous Bosch (1450-1516, pron. Bosh). We know almost nothing of him—except through his fantastic paintings. "Hieronymous the anonymous" painted medieval fears with modern skill. His huge canvases are crowded with grotesque, humorous and all-around bizarre people and creatures. Most of his themes are intriguing and were very meaningful to the medieval mind. You will notice some strange-looking plants and animals in many of his works. This was common among artists who painted during the years that Columbus and other explorers were bringing back strange creatures from the New World.

Today, while much of the meaning is lost, the intrigue remains.

After the Renaissance

Looking at the ceiling of the Sistine Chapel, I thought, "How could there be anything more beautiful?" Well, that's what artists after Michelangelo thought—and worried about—too. How could art advance beyond the great Renaissance Masters? They explored and conquered every facet of painting and sculpture—the human body, the laws of perspective—showing nature on the canvas flawlessly. It looked like the future of art would be little more than copying the forms and techniques of Michelangelo, Leonardo and Raphael.

The Renaissance was a hard act to follow and for awhile many artists were stuck in the rut (but what a beautiful rut!) of Michelangelo's style. We call this period Mannerism (1530-1600), because the art followed only the "manner" of the Renaissance Masters—often neglecting the spirit of their work.

Not content with this, many artists made bold—occasionally ridiculous—attempts to be original, to do something new. Using Renaissance techniques of portraying nature, they experimented with more complex composition, more striking colors, the contrast of light and shadow, and a greater display of emotion.

Caravaggio

The boldest and most successful was Caravaggio (1573-1610, pron. Carra-VAW-jee-o). He was the first artist to intentionally shock people with his paintings. He painted things "realistically," no matter how ugly or unpleasant the subject. He painted sacred Bible scenes in the context of the seedy, seamy side of his Roman neighborhood. Caravaggio lived

much of his life on the edge of society. Quick-tempered and very opinionated, he killed a man over a dispute in a tennis match and spent years as an outlaw.

What he may have lacked in sportsmanship, he made up for in his painting. The John McEnroe of art painted with a profound "pschological realism" that captures the inner feelings of the common people he used as subjects. It brings to mind Shakespeare's style (a contemporary of Caravaggio's) of acquainting himself with English low-life and incorporating it in his plays.

"DAVID WITH THE HEAD OF GOLIATH,"
CARAVAGGIO, VIENNA, CA. 1605

Using harsh exaggerated light/dark contrasts, Caravaggio powers his early Baroque paintings with emotion. The severed head is Caravaggio's self-portrait.

You'll recognize Caravaggio's work by the strong contrast between light and dark. Whole sections of canvas are in shadow with details obscured. When the light does shine on someone, it's a harsh, unflattering "third-degree interrogation" light that pierces through anything glorified or idealized, exposing the real person underneath. To Caravaggio, ugliness was a puddle to play in, and he seemed to enjoy rubbing other people's noses in it.

El Greco

While Caravaggio took realism to an extreme to create an original style, the Spanish painter, El Greco, abandoned the strict naturalism of

the Renaissance tradition. Born in Greece (El Greco, "The Greek," was his nickname), trained in Venice and caught up in the devout fervor of Spanish mysticism, he combined all of these influences—Greek iconography, Venetian color and Spanish Catholicism—to create an individual style.

"ST. MARTIN AND THE BEGGAR,"
EL GRECO, CA. 1600

El Greco gave his figures stretched, spritual-looking bodies. His skies were dark and tormented. Many people consider him the first to intentionally go beyond realism— the first "modern" painter. El Greco's best work is in Toledo and Madrid.

El Greco's people have unnaturally elongated, slightly curved bodies, as if they were swirling spirits. The serene faces are like the saints on a Byzantine icon. Yet it is obvious from the natural, personal details of his portraits that he learned Renaissance techniques. His splashy color schemes are very Venetian. El Greco is often called the first "modern" painter because he deliberately chose to tamper with realism to emotionalize a painting. Nature and realism had been mastered, and artists set about busily exploring new realms.

Spain and Portugal

Toledo, the historical and cultural capital of Spain, is a great place to gain an appreciation of the Spanish Renaissance. A tour of Toledo's cathedral, including 27 El Grecos and masterpieces from the greatest

Spanish artists of each era from Gothic to Baroque, will open your eyes to the fact that Italy didn't have a monopoly on artistic genius. Local pride shines through as your guide shows you what was going on in Spain while Michelangelo was in the Sistine Chapel.

Further west, in Portugal, art was also booming. In 1500, Vasco da Gama sailed around the southern tip of Africa, opening a profitable new trade route with the East. Up until this time Venice and Northern Italy had thrived, enjoying their monopoly on trade with the Orient. Within four years, Italy's trade dropped by 75% and Portugal's multiplied ten-fold.

From that point on, Italy stagnated, becoming an economic backwater and a political pawn of the stronger West European nations. The focus of European civilization shifted out to the Atlantic seaboard.

Portugal, with this new trade boom, enjoyed world power status. Predictably, a cultural flowering followed this economic boom. The 16th-century Manueline style in art and architecture is an exuberant combination of Gothic and Renaissance forms—decorated with shells, anchors, ropes and exotic nautical motifs—a tribute to its patron, the lucrative sea trade.

MONUMENT TO THE DISCOVERERS, LISBON

This modern statue honors the sea explorers who made Portugal a world power in the 1500s. An artistic "Renaissance" followed the economic boom.

Examples of this "Portuguese Renaissance" style are in the Lisbon suburb of Belem. The highlight here is the cloisters of the Jeronimos Monastery.

Relax . . .

You've just absorbed a direct hit from the most powerful cultural explosion in Europe's history.

take a break.

While you're sorting out the accomplishments of Leonardo, Michelangelo and company, take a closer look at Renaissance Florence and Venice. Here's a list of some related articles in the last half of the book:

Timeline
The Renaissance

The Renaissance started in Florence, then spread to Venice, Rome, Spain/Portugal and the Northern countries (Flanders, France and England) as each reached an economic level where it could support the arts.

The earliest Renaissance artists were Florentines during the time when the powerful banking family, the Medicis, ruled the city: Brunelleschi, Masaccio, Donatello and Botticelli. The High Renaissance shifted to Rome (Michelangelo and Raphael) and Venice (Titian).

Meanwhile, the rest of Europe was discovering new lands to trade with. Spain and Portugal broke Venice's monopoly on Eastern trade with new routes to the East. England, Holland and France had large merchant fleets and banking houses to trade in Europe and the New World. Ideas were exchanged as quickly as goods with the invention of the printing press.

Each of these countries had its own Renaissance—the Manueline architectural style of Portugal; Durer, Bosch and Bruegel in the North, and El Greco in Spain (via Venice).

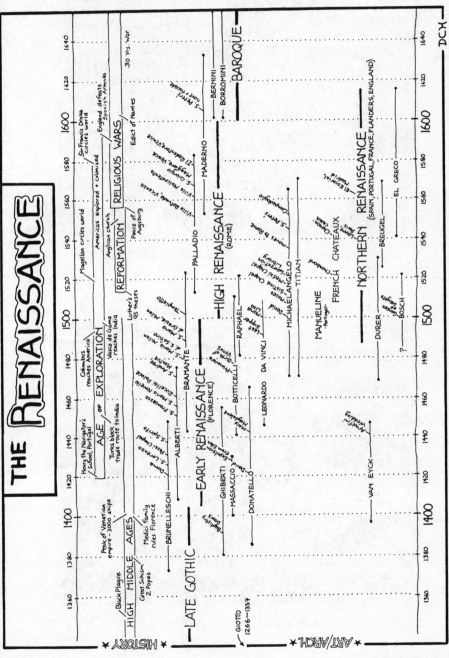

THE RENAISSANCE

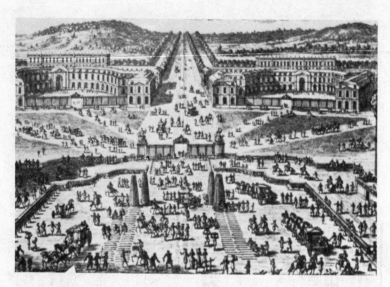

Versailles Palace, looking towards Paris. Engraving by Perelle. Bibliotheque Nationale, Paris.

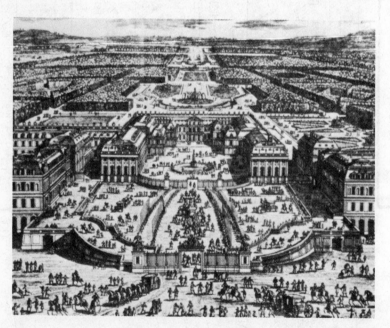

Versailles Palace, view towards garden. Engraving by Perelle. Bibliotheque Nationale, Paris.

The Early Modern World

The Reformation

Up until the Renaissance, the church was the richest, most powerful and best organized institution in Europe. Like a "Monastic Mafia," it was Europe's greatest landowner, collected "taxes" through tithes, patronized Renaissance art and influenced political decisions. Kings and princes needed papal support to maintain their political power. Average Europeans still identified themselves by their bishopric—not by citizenship of a particular country.

Nevertheless, the church's rich and worldly position caused discontent, and a reforming spirit grew. When political rivalries and jealousies were mixed in, this reforming turned to splitting. New churches were formed and, in the process, Europe experienced a chaotic period of political upheaval. This period of religious and political turmoil is called the Reformation. Much of what you'll see in Europe was shaped to some extent by this period.

Church Corruption

The church certainly needed reform. Many priests were illiterate and immoral. Powerful church offices were sold to the highest bidder, and dispensations (exemptions from church laws) were also sold.

In order to pay for Rome's facelift (Michelangelo and the Renaissance artists didn't come cheap), the pope sold indulgences. To anyone with enough money, the pope promised "forgiveness for all thy sins, transgressions and excesses, how enormous soever they may be so that when you die the gates of Hell shall be shut and the gates of Paradise shall open with delight."

Church corruption was the excuse for the Reformation, and the sale of those indulgences may have been the straw that broke the camel's back. But there were deeper causes: the decline of papal prestige, a new secularism, and stronger, more assertive national governments.

The pope had lost prestige among both kings and commoners. During their medieval heyday, the popes could make or break kings. But after the pope moved to Avignon in France to enjoy the protection

of the strong French king, he was seen as a French pope, and his international influence suffered. When a second pope appeared back in Rome and each of these popes excommunicated each other, their prestige sank further. After the papacy went back to Rome, united, it never quite recovered from what was called the "Babylonian Captivity" (1309–1377).

"I'd like two adulteries and a small order of lies to go."

TICKETS TO HEAVEN, THE SALE OF INDULGENCES, GERMANY, WOODCUT

People actually bought letters of forgiveness in the marketplace. A scene that bothered Martin Luther.

New Secular Forces

The church had to deal with a new secularism bolstered by the rise of capitalism and many new Renaissance ideas. The newly invented printing press sped the spread of new scientific discoveries and secular ideas. After Copernicus and Galileo disproved the church's traditional explanation of the earth-centered universe, nothing was accepted blindly. A new, more independent, scientific, economic and political world confronted the church.

Kings jumped on the reforming bandwagon out of political greed. They saw the church as a rival power within their borders. Tithes sent to Rome were taxes lost. The church was Europe's number one landowner. The clergy was exempt from taxes and could ignore local laws. Many kings wanted not only to reform the church—but to break with

it for good. The political rewards were obvious. Kings and princes encouraged spiritual people to challenge church authority.

Martin Luther

In the beginning, Martin Luther (1483-1546) was just a simple German monk trying to reform church abuses from within. He believed that the word of God lay not in the doctrine of the church—but in the Bible. The Bible talked of salvation by simple faith in God. Salvation was a free gift to believers—not something anyone could earn or buy. Church rituals, dispensations, and indulgences weren't mentioned.

Luther nailed a list of 95 ideas for debate to the door of the Wittenberg cathedral (in present East Germany). Not interested in debating, the church called Luther a heretic and sent him a "papal bull" of excommunication. Luther was not cowed, and burned the pope's letter—the Renaissance equivalent to burning your draft card, only much more serious.

Martin Luther's 500th birthday was commemorated by an American stamp.

Now a criminal as well as a heretic, Luther took refuge in a German prince's castle. From behind those walls he established the German church, translated the Bible into German (giving birth to the modern German language) and led the rebellion against the pope. Local kings confiscated church lands, established their own "protestant" (protesting) state churches and geared up to face the armies of nations loyal to the church.

The wars came, but luckily for the German Protestants, the pope's strongest defenders (the southern countries that remained Catholic) were preoccupied with internal problems and with fighting the invading Turks in eastern Europe. The result of this war (Treaty of Augsburg, 1555) was that each German prince could decide the religion of his territory.

107

CATHOLIC / PROTESTANT DIFFERENCES

The differences between Protestant and Catholic doctrines have divided Christians for centuries. Protestants emphasize a more direct relationship between the individual and God, rejecting church rituals and the necessity of ordained clergy for salvation. Bible study and personal prayer are seen as more valuable than sacraments presided over by a priest. Some of the Catholic practices rejected by Protestants are: celibate priests, veneration of saints and the Virgin Mary, use of Latin in church services, and holy orders (monks and nuns). The differences between Catholics and Protestants are not so great today, and a spirit of unity is growing.

Reformation Throughout Europe

The Reformation—and its violence—went beyond Germany. Geneva, Switzerland was ruled by a theocratic (religion-controlled) government under John Calvin (c. 1550). Calvinism, which stressed Luther's belief in salvation by God's grace, not rituals and good deeds, spread throughout Switzerland to France, the Netherlands and as far as Scotland.

England's break with the church had political roots. King Henry VIII wanted the pope's permission to divorce Catherine of Aragon to marry Anne Boleyn. The pope refused, so, to break all ties with Catherine, Henry broke all ties with Rome. He confiscated church lands, formed the Church of England—and married Anne. The Church of England, or Anglican Church, was basically an English Catholic church without a pope. For the next hundred years, England struggled as her kings and queens tried to impose their personal religion on the people.

Heretics, Protestants, Jews and others could be punished quite thoroughly by the church.

Counter-Reformation and Religious Wars

The Vatican countered the Protestant revolution with the "Counter-Reformation"—an attempt to put the universal Catholic church back together using both internal reform and war.

One of the church's weapons was the Inquisition, a network of church courts for trying and punishing heretics and sinners. The Inquisition, dating from medieval times, was set up to punish witches, devil worshippers and adulterers as well as Jews, Moslems and unorthodox Christians. Later, Protestants and heretic Catholics were hauled before the courts on the slightest evidence.

Torture, terror, imprisonment and confiscation of property were often used to extract confessions—standard judicial practice of the day. Once they confessed they were really punished. Punishments ranged from recitation of a certain number of prayers, fasting or almsgiving to

THE RELIGIOUS WARS, ca. 1520-1648

Europe fought a hundred years of bloody religious wars after the Reformation.

imprisonment or death. In Spain, the most fanatic region of the Inquisition, an estimated 2,000 heretics were burned at the stake during the tenure of one notorious Grand Inquisitor.

The religious wars between Catholics and Protestants were some of the bloodiest in European history. The kings generally fought for purely political reasons, but the fighters were powered by a religious fervor,

each side convinced that God was on its side. The grand finale was the "Thirty Years' War," Europe's first "World War," with mercenary warriors from just about every country taking part. When the wars ended in 1648 Europe was devastated, a third of Germany was dead, and Western civilization realized what it should have known from the start—that Catholics and Protestants would have to live together.

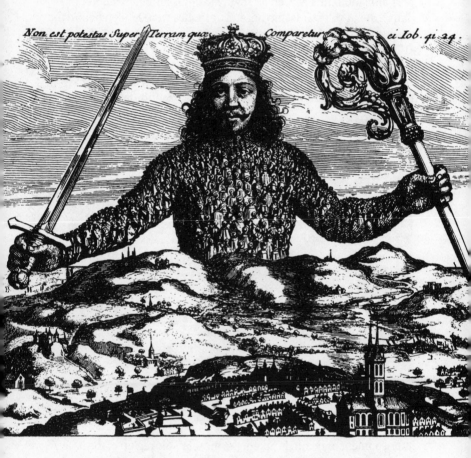

Non est potestas Super Terram quæ Comparetur ei Iob. 41. 24.

THE ABSOLUTE MONARCH—RULING LIKE A GOD ON EARTH

The 1600s and 1700s were a time of "divine" kings and absolutism. Many kings succeeded in convincing their people that they were deputized by God to rule with complete and unquestioned power.

Absolutism and the Divine Monarchs

The Thirty Years' War reshuffled Europe's political cards. The old-style monarchies were replaced by new, more modern governments headed by strong kings. In the Middle Ages, the "nation" had been a weak entity. Popes, nobles and petty kings bickered for power while the common man went about his business, ignoring the affairs of state.

Now government functions were specialized, bureaucrats were running things and the state took over many jobs that had been carried out by the church. A strong "divine" monarch was all-powerful, claiming that his right to rule came directly from God. More than ever, the government was "mother-in-lawing" its people.

This was the era of grand, Versailles-type palaces that should be high on any tourist's sightseeing list.

Growing Economy

The growing merchant class welcomed this strong central government. Traders needed stable governments, common currency, standard measures and fewer tariffs. Early medieval trade had been stifled by the chaos of local, rural feudal kingdoms. The trend towards unification begun in the High Middle Ages was paying off. Centralized governments and the wealthy urban middle class were natural allies.

Overseas trade gave these new governments wealth and strength. Newly discovered America and routes to the Far East opened up a floodgate of raw materials and luxury goods. Spain, England, France and the Netherlands built large merchant fleets to exploit this wealth, which required navies to protect them, which required more taxes to maintain—which required more efficient governments to collect and administer the money. The state grew.

Louis XIV and Versailles

France's Louis XIV (reigned 1643-1715) was Europe's king of kings—the absolute example of an absolute monarch. He ruled for 70 years, making France the political and cultural heartbeat of Europe. He strengthened the military, expanded France's borders, stimulated trade, and built a large and effective government.

Louis moved his court to Versailles, 12 miles outside of Paris. There he built Europe's greatest palace, at the cost of six months' worth of the entire income of France. Swamps were filled in, hills were moved and a river was re-routed to give Louis a palace fit for a divine monarch. He establish-

ed a magnificent court, the Oz and Hollywood of Europe, attracting the leading artists, thinkers and nobles of the day. Versailles was the social, cultural and intellectual capital of Europe.

Louis called himself the "Sun King." State medallions showed the light and warmth of the sun bouncing off his chest onto the people of France. To make their "divine authority" more believable, divine monarchs like Louis went to great lengths to control Nature. For instance, he had an orange grove on wheels which he rolled out of his greenhouse on sunny days. His people would stroll through the finely manicured gardens of

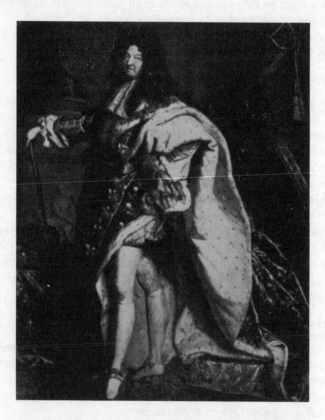

LOUIS XIV, PORTRAIT BY RIGAUD, IN THE LOUVRE

Louis XIV, the premier monarch of Europe, was every king's model of how to live and reign. He ruled the "Oz" and "Hollywood" of Europe for over five decades and, even as an old man, had a fine set of gams.

Versailles, proud to be ruled by such a wonderful king, deputized by God—and the only one who could grow oranges in chilly Paris.

Louis "domesticated" his nobles so they wouldn't threaten his absolute power. His trick was to reduce them to petty socialites, more concerned with their position at court than with political issues. It worked so well that Louis had the high and mighty dukes and earls of France bickering over who would get to hold the candle while he slipped into his royal jammies. The tremendous cost of court life weakened the nobility economically, so Louis really had them in a state of loyal servitude.

As Louis himself said, "L'etat, c'est moi," (I am the state).

Other Absolute Monarchs

Louis was every king's model. Every nation in Europe had its "Louis" and its own "Versailles." As you travel you'll notice most palaces are modeled after Versailles, with sculpted gardens and Halls of Mirrors—all trying, with none succeeding, to match the splendor of Louis' palace of palaces.

In Vienna the Hapsburg king, Leopold, built the impressive Schonbrunn Palace. A musician at heart, he established Vienna as the music capital of Europe which later produced Haydn, Mozart, Beethoven and many of the Classical superstars who lived, worked, taught—and occasionally jammed—together in Vienna.

King Frederick William of Prussia (eastern Germany) copied France's centralized government and turned his loose collection of baronies into a monolithic European power. The "goose-step" and Germany's strong military tradition came from Prussia.

England also had strong monarchs, but her people insisted on constitutional limits. Henry VIII's daughter, Elizabeth I, made England the world's top naval power and enjoyed the loyalty and support of nobles and commoners alike. Her successors however, the Scottish Stuart family, alienated the English with their "divine right" style. The English Parliament rebelled against King Charles (Stuart), and a civil war broke out (mid-1600's). In the end, the king was beheaded and a member of Parliament, Oliver Cromwell, took power. When Cromwell died the monarchy was restored, but its power came from Parliament—not from God.

(England hadn't seen the last of Cromwell. The new king, Charles II, dug up Cromwell's remains and hung them from the gibbet in the town square—for the good of the realm.)

APOLLO AND DAPHNE BY BERNINI,
ROME, CA. 1624
Bernini, the father of the Baroque
movement, captures the exciting
moment when Apollo thinks he's
got the nymph Daphne—but
she turns into a tree.

Baroque Art

After 100 years of wars and squabbles over who would rule whom and who would worship which way, Europe chose religious toleration, strong, stable "absolute" monarchs and a pro-status-quo art. The art of this period is Baroque. (Like Gothic, Baroque was an insulting term meaning "irregular"—given to it by the people of the next period.) Baroque is an ornate style best summed up as "controlled exuberance."

Compared to the simplicity and balance of Renaissance art, Baroque really is irregular. It was propaganda art. Artists built respect for the church and king by using the most complex, dazzling and moving effects ever. Ornamentation abounds. Abundance abounds. Church decoration became a cooperative adventure, with painters, sculptors, stucco- and metal-workers, all teaming up to portray Heaven itself. The common man would step into a world of glittering gold, precious stones, a ceiling painted as if it opened up to the sky, with angels, saints, babies that looked like clouds and clouds that looked like babies—all of them (in the better Baroque) balanced into a unified whole.

Bernini—Father of Baroque

Baroque was born in Rome. Its father was Lorenzo Bernini (1598-1680), its mother, the wealthy Catholic Church. Rome bubbles

ST. THERESA IN ECSTASY, BERNINI, BAROQUE, ROME, CA. 1650

with Bernini fountains and sculpture. He was a master of all the Renaissance techniques but wasn't chained by its classical "rules" of simplicity.

His art maximizes emotion—in the subject as well as the viewer. His famous statue of the mystic nun, St. Theresa, is a perfect example of complex-but-unified composition, expressive portraiture, and details suggesting movement and passion—all adding up to a very theatrical and emotional work. Bernini shows her with a heart pierced by an angel's arrow. Theresa described the feeling as "a pain so great that I screamed aloud; but simultaneously I felt such infinite sweetness that I wished the pain would last forever." As we gaze at the statue Bernini makes us feel the same ecstasy, the same "sweet pain."

Rubens—"The Fury of the Brush"

Bernini's painting counterpart was Peter Paul Rubens (1577-1640), from Catholic Flanders (Belgium). He studied in Rome where he picked

THE RAPE OF THE DAUGHTERS OF LEUCIPPUS, RUBENS, CA. 1617

Rubens' typically robust, energetic style, fleshy women, and "fury of the brush" were his trademarks. Compare this Baroque vibrance to the Renaissance composure of the Raphael on p. 89 or Mona Lisa on p. 79.

up the Italian fad of painting giant compositions on huge canvases.

He could arrange a "pig-pile" of many figures into a harmonious unit. Each painting was powered with an energy and gaiety people called his "fury of the brush."

Rubens' work, while very colorful, intricate, and light-hearted, was always robust, strong, and solid. Like Bernini, Rubens draped clothing on his subjects in a way to suggest rippling motion and energy—a popular Baroque trick.

Rubens, a famous scholar and diplomat, was welcome at any royal court in Catholic Europe. His Antwerp house (now a fine museum) was designed to mass-produce his grand masterpieces. After he laid out a painting his apprentices painted the background and filled in the minor details. Rubens orchestrated the production from a balcony, and before a painting was carried out his tall, narrow door he would put on the finishing touches—bringing each figure to life with a flick of his furious brush.

Royal Art—Court Painters

Van Dyck (1599-1644), a follower of Rubens, set the standard for portraits of the absolute monarchs. The court painter for the Catholic King Charles I of England, he portrayed him for what he was—elegant, scholarly and aristocratic. Lesser painters of this period exaggerated

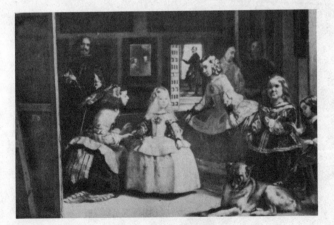

"THE MAIDS OF HONOR,"
VELAZQUEZ, PRADO, 1656

The Spanish court and the painter himself (at left) shown in a realistic way, without emotion.

117

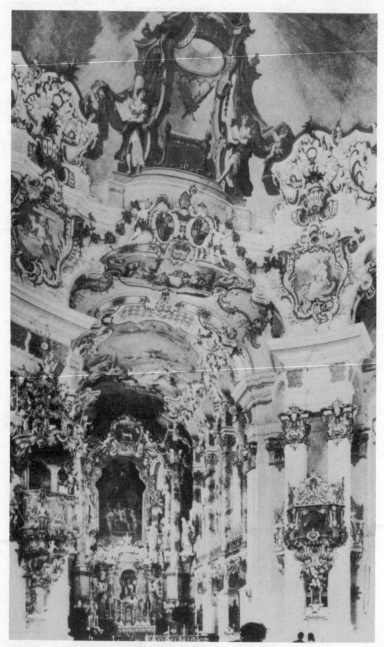

DIE WIES, CHURCH IN BAVARIA, ROCOCO

This beautiful example of Bavarian Rococo is near Oberammergau and Fussen in Southern Germany.

118

this elegance, flattering their subjects unnaturally (like the pantyhose portrait of Louis XIV on page 112).

Diego Velazquez (1599-1660, pron. vel-LOSS-kess), the Spanish royal court painter, was more realistic—influenced by Caravaggio's "objective naturalism." He painted without showy emotion or "baroque" ornamentation. His work appears intricately detailed, but if you look closely, you'll see a new technique in brushwork. Velazquez just suggested details with a quick stroke of the brush—a bit like Rubens, but also a peek into the future.

Baroque Versailles—Controlled Exuberance

The Baroque movement spread from Rome throughout Catholic Europe, finding its center in the court of Louis XIV at Versailles.

Europe's greatest palace, Versailles symbolized Louis' divine and absolute power. It was designed to inspire awe in all who visited. It did, and still does—make sure you get your share of awe. Its facade and the interior decorations are High Baroque. The immense grounds are a sculptured forest, a king's playground. The manicured gardens, orange grove, and lavish fountains showed Louis' power over Nature itself.

Rococo—Uncontrolled Exuberance

Louis' great-grandson, Louis XV, championed a style related to Baroque, but more so—Rococo. Rococo (pron. Ro-KO-ko) was more ornamental and less symmetrical even than the "irregular" Baroque, but it was lighter and daintier, without the Renaissance-like robustness and balance of Baroque. Light pastel colors, ivory, gold, mirrors and slender columns with curvy frills characterize Rococo interior decoration. This style of decoration almost to the obliteration of form spread quickly from Paris to Germany and Austria during the 1700s. The Petit Chateau at Chantilly, Wies Church near Munich and the Munich Residenz are excellent examples of this "ultra-Baroque" style.

Christopher Wren

England never really liked Baroque elegance, but still built its share of impressive architecture. The chance to make a radical break with the medieval past came when London was flattened by the Great Fire of 1666. A young architect, Christopher Wren, was ready and eager and was commissioned to help rebuild London.

Wren's style shows Baroque and Gothic influences (Gothic remained

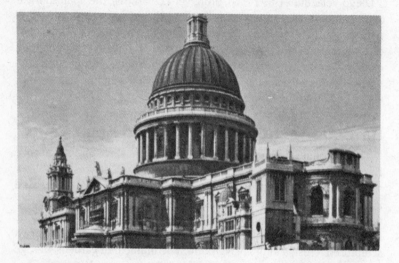

ST. PAUL'S CATHEDRAL, LONDON, CHRISTOPHER WREN, 1675-1710

popular in England long after the Middle Ages) but many classical features were also included.

While better examples of Wren's architectural genius are found in smaller churches nearby, his most famous masterpiece is St. Paul's Cathedral. In studying St. Paul's you'll find a central Baroque cupola lined with classical columns flanked by Gothic towers. The overall effect, however, is not one of Baroque movement, tension or exuberance, but of classical restraint and stability.

Northern Protestant Art

As you travel through Northern Europe, you'll notice an entirely different style. While the art of Versailles and the Baroque movement was Catholic, most of Northern Europe was Protestant, and art in these countries showed it. Protestants didn't have the rich and powerful Catholic Church as a constant patron. They looked down on elaborate ritual and anything with even a hint of idolatry. Religious art fell out of favor.

During this period many northern churches channeled their artistic energy into elaborate church organs. Choirmaster, composer, organists (like J.S. Bach) enjoyed a new higher status.

The wealthy merchants and burghers of the prosperous middle class became the new patrons of Northern art. These city rich were playing ketchup with the ruling class, and a great way for a burgher to rise above society's small fries was to have a distinguished portrait painted.

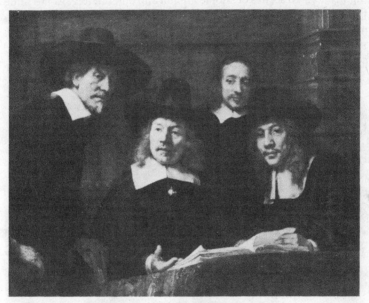

"STAALMEESTERS," REMBRANDT
That's not Dutch for "cigar."

New Patronage, New Art

Sadly, these merchants were tight-fisted—more interested in value for their money than in encouraging good art. Great artists often wasted their talents on unimaginative works just to earn a meager living from the fickle patronage of a nouveau riche whose taste was in its mouth.

The only alternative was for artists to sell their work on the open market—an art history first. Art was sold in marketplaces, fairs and through art dealers.

This new "patronage" pointed art in new directions. Along with portraits, artists painted scenes the average person would like—and buy— such as landscapes, seascapes, slices of daily life, and crazy and funny

121

looks at human folly. Small, fun and affordable paintings boomed.

Bruegel and Slice of Life Art

Pieter Bruegel (1564-1638) epitomized this new middle class art. He used Italian techniques to depict Dutch peasant life. A townsman himself, painting for fellow townsmen, he painted peasants as peasants, simple, happy—but also as hicks worth laughing at. His complex and brightly colored scenes of people are fun and entertaining. At the same time, we can sympathize with his characters, seeing a bit of ourselves in their actions. His paintings were very popular and often imitated. (The Museum of Ancient Art in Brussels has one of Europe's best collections of Bruegel and Bruegel-style art.) A great way for travelers to get a glimpse of old peasant life styles is to study these paintings.

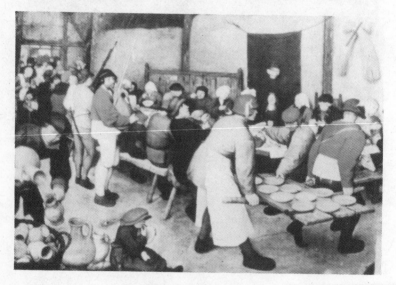

"PEASANT WEDDING,"
BRUEGEL, c. 1565

Crowded, colorful, detailed look at everyday peasant life. These scenes were popular with the urban middle class who bought art.

In a more serious style, Jan Vermeer perfected the art of simple, straightforward representation of ordinary, everyday things. Northern artists enjoyed the natural beauty in common people and objects and did not limit themselves to painting just "picturesque" things. Their still lifes and tranquil landscapes were very popular.

The commissioned portrait was the artists's bread and butter. North-

ern artists made portraits come alive without the artificial or flattering poses of Baroque artists. From Hans Holbein (see his portrait of Henry VIII, p. 267) to Frans Hals to Rembrandt, portraitists got better and better at capturing the real character of the subject in a relaxed, "unposed" pose.

"KITCHEN MAID,"
JAN VERMEER, 1658

Vermeer captured stillness and simple ordinary beauty. The Rijksmuseum in Amsterdam has the greatest collection of Vermeer and other 17th-century Dutch painters. Start your visit with the Rijksmuseum's great (and free) introductory movie which plays every twenty minutes near the entrance.

DETAIL OF "CIVIL GUARD," FRANS HALS

The Northern artists of the 17th century earned their living by painting portraits. Frans Hals was very successful, with a knack for "posing" his subjects in a candid way.

123

"SELF-PORTRAIT," REMBRANDT
NATIONAL GALLERY, LONDON, 1669

Rembrandt

The plight of the creative artist at the mercy of unenlightened patrons is seen in the life of the Dutch genius, Rembrandt van Rijn (1606-69). Young, successful and famous as a portrait painter for wealthy merchants, he fell out of favor because he had a mind of his own and refused to compromise in his portraits. If the painting's composition required it (or if he didn't like someone), he would paint patrons in the shadow, or even with an arm in front of their face. Nobody would invest in a wonderful—but risky—Rembrandt portrait. He spent his last years painting himself and poor street people—and died in poverty.

The silver lining in this story is that, without commissions, Rembrandt was free to paint more interesting and challenging subjects. A religious man, his Bible scenes come alive before your eyes. Like Caravaggio, he refused to idealize or beautify his subjects. His religious scenes are group portraits of the common people of Amsterdam.

Also like Caravaggio, Rembrandt can be recognized by his experimentation with contrasting light and shade. He played around with the source of light and how it illuminated his figures, generally on a dark brown background. These effects create a powerful setting and

mood for the action portrayed—they're never just experimentation for its own sake.

Europe's greatest collection of Rembrandt masterpieces is in Amsterdam's Rijksmuseum. His Amsterdam home is also worthwhile.

SUPPER AT EMMAUS, REMBRANDT, THE LOUVRE, 1648

Christ's face shining bright out of the dark brown surroundings. Rembrandt often chose the commoners of Amsterdam as his religious subjects.

The Age of Enlightenment

The scientific experimentation of the Middle Ages and Renaissance finally bloomed in the 1600s. Galileo, Copernicus, Kepler and Newton explained the solar system, disproving the church's view that the earth was the center of the universe. The "scientific method" was seen as a way to solve all problems: if man could discover the motion of the planets and explain the circulation of the blood in his body by science, he should be able to use this enlightened thinking to answer moral and political questions as well.

The philosophers of the Enlightenment (1700s) thought that all of Nature's laws could be understood by reason. Every institution and every established school of thought was given the "test of reason." Superstition and ignorance were attacked. The "Old Regime" (divine monarchs, feudalism, serfdom, etc.) was picked to pieces by the movement's articulate proponents, the "philosophes." These thinkers and writers proposed a complete reorganization of society determined by reason, not by accident of birth.

125

Enlightened Thinkers

England and France produced the social philosophies that laid the foundations of modern thought. Adam Smith established the basis for "laissez faire," the free economy of capitalism. Rousseau wrote about the "Social Contract" saying that the government is the servant of the people, and that a people's revolution is justified when their government screws up. A kind of "religion of reason" was created and for the first time, many people—respected people—were saying Christianity was stupid.

John Locke and Voltaire wrote of "natural laws" and "self-evident truths" in human relationships that required a more democratic form of government. Many of Locke's actual phrases are found in the American Declaration of Independence, a document based on the ideals of the Enlightenment. Thomas Jefferson prided himself in being a part of this enlightened movement.

The kings of this period are called "enlightened despots." They ruled efficient, modern states and supported many ideas of the Enlightenment. While royal parlor talk may have been "enlightened," the kings of this period were still despots, refusing to share power with the lower classes. The growing urban middle class, often as wealthy and educated as the nobility, wanted a bigger slice of the governmental pie. But the Old Regime lived on, and people were divided into the rulers and the ruled by birth—not by ability or wealth.

In the Enlightenment, a new world had been conceived. Europe was fast outgrowing its archaic shell. Enlightened thoughts would soon become violent actions.

The French Revolution

As these enlightened seeds sprouted, European society was revolutionized. In France, the decay of the Old Regime made especially fertile conditions for the modern world to blossom.

With the rise of the cities and strong monarchs, the Old Regime became the dying regime. The three-part feudal order of nobility, clergy and peasantry had to deal with two new social forces: the merchant class and Europe's national monarchs.

Nationalism

Basic loyalties had shifted over the centuries, from tribe to church to monarch to nation. Nationalism was the "ism" of the 19th century.

Nationalism and the democratic ideas of the Enlightenment were tested and proven practical and possible by the American Revolution. The USA was the first truly modern nation based on individual rights, freedom of religion and democracy. In 1776, Europe's eager revolutionaries were taking careful notes.

France, the home of the Enlightenment ruled by a very unenlightened government, was ripe for revolt. Two percent of the country—the nobles and clergy—owned a third of the land and paid no taxes. The ambitious middle class, or bourgeoisie, was strong economically, but weak politically. They were unhappy with a society based on a divinely ordained division of people into rulers and ruled led by corrupt political and religious organizations.

France's National Assembly First Step to Revolution

The restless middle class got its chance when King Louis XVI (the "Sun King's" great-great-great-grandson) called an assembly of

representatives to raise taxes. (Ironically, part of this was for French aid to the American Revolution.)

The parliament (1789) met as three "estates," or classes—nobility, clergy and peasants. The merchant class, newcomers to the social scene, were lumped in with the peasants as part of the "Third Estate." Historically, the estates voted as a unit and the nobility and the clergy always out-voted the peasantry two to one. The middle class demanded that the assembly be restructured so that the vote would be general rather than by estate. Since the peasant estate was more numerous, this would break the first and second estates' monopoly on power. After a six-week deadlock on this issue, the Third Estate declared itself the National Assembly—whether the other two liked it or not— and vowed not to go home until a modern constitution had been created.

This was a revolutionary step. The king called out 18,000 troops—an act which the commoners perceived as the king's support of the nobles. Traditionally, the king was seen as anti-feudal and pro-people. The masses felt betrayed. Sides were drawn and royal orders were boldly defied.

The National Assembly became a forum for all kinds of democratic ideas. The privileged classes protested feebly as the slogan "Liberte, Egalite, Fraternite" (liberty, equality and brotherhood) was born.

Mass Revolution

Like most revolutions, the French one started moderately, then snowballed. The masses had been awakened and, before they knew it, the rich and liberal middle class leaders of the Third Estate were riding out of control on a lower class revolutionary stallion.

The masses were hungry and restless after several bad harvests. The rulers had ignored the first rule in keeping the people happy, allowing the price of bread to climb to record heights. (Even today, authoritarian governments subsidize the price of bread to pacify the masses.) When the mad mobs of Paris demanded cheaper bread, Queen Marie Antoinette further enraged them with her famous solution "Let them eat cake." ("Cake" is the crusty remains that line the bread ovens.) The hungry masses said "no."

The Bastille

On July 14, 1789, angry Parisians stormed the Bastille, a fortress which symbolized the Old Regime. (Today it's a famous non-sight. Don't look for it.) The Revolution escalated as prisoners were released, the

mayor of Paris was beheaded with a dagger, and the mob paraded through the streets with his head on a pole. (Bastille Day, the French "Fourth of July," is celebrated today with comparable pageantry and local color.)

Angered by a lavish and well-publicized party at Versailles, the hungry women of Paris marched on the palace. The king was taken back to Paris where the government had come under the control of the radical city elements.

REVOLUTIONARY GOVERNMENT OF FRANCE, WORKING

Throughout the countryside the peasants went on a mysteriously spontaneous rampage, sacking chateaus, rousting the nobility and burning the feudal documents that tied them to the land. Overnight the manorial system (serfdom) was physically destroyed. The National Assembly followed by legally abolishing serfdom, manorialism, tithes, and tax loopholes.

Feudalism was dead in France and shock waves rippled throughout Europe. Royalty quivered, nobility shivered and the middle classes and peasantry drooled with excitement as the French created the "Declaration of the Rights of Man and of the Citizen."

Europe Supports the "Old Regime" — War

Much of France's ruling class took refuge in foreign palaces. These emigres pushed for war, telling their European counterparts that they would be the next to go if they didn't do something quick.

The Revolutionaries running France also wanted a war—to establish and solidify their new republic by banding against a common enemy, and to spread their enlightened revolutionary gospel.

By 1793, it was France against the rest of Europe. A "levee en masse,"

or complete mobilization of the society, fueled by tremendous national patriotism and led by brash young risk-taking generals, enabled France to win the war.

Reign of Terror—Heads Roll

On the home front pressures of the war and economic problems drove the Revolution to wild extremes. During this "Reign of Terror" (1793-94), the king and queen were beheaded and wave after wave of people went to the guillotine. Political factions accused each other of

THE HEAD OF KING LOUIS XVI

Thousands of heads rolled in the early 1790s. The guillotine was set up on Paris' Place de la Concorde.

halting the progress of the Revolution. Enemies of the current ruling party were executed in public demonstrations in Paris' Place de la Concorde. People were sent to the "national razor" if they were even "suspected of insufficient patriotism." Flags waved furiously as the blade dropped on over 17,000 heads.

The Revolution snowballed until the raging fanatic liberal, Robespierre, was made a foot shorter at the top by the guillotine. Paris cooled off when it realized that their Revolution was out of control and actually eating itself up. This reaction caused people to even consider reinstating the monarchy.

The Revolution struggled along for five years. After so much chaos, the French people were talking about restoring the monarchy. At the same time the French heir to the throne was calling for revenge from his Italian refuge. To keep the Revolution alive, the Revolutionary leaders decided to give the army control rather than lose everything to an Old Regime king. They needed a revolutionary hero—an enlightened, charismatic, dashing general—a short guy who kept his hand inside his shirt. In 1799, a 30-year-old general named Napoleon took power. He promised to govern according to the principles of the Revolution.

Napoleon

While Napoleon was basically a dictator (who later proclaimed himself emperor), and many civil liberties were suspended during his reign, he was true to his promise to carry out what the Revolution had proclaimed. Church lands were confiscated and sold, privileged classes were abolished, and feudalism was finally buried.

Paris, the "New Rome"

Napoleon (ruled 1799-1814) carried the Revolution by war to the rest of Europe. Europe's most populous, rich and educated state was his arsenal. With the barriers of class and privilege smashed, he was able to tap the wealth and talent of France. The French army had grown strong and tough in the wars of the Revolution, and Napoleon had no

Neoclassicism was more than an art style. It was the modern way of life around 1800. In Paris, women dressed neoclassically.

trouble conquering Europe. A grand Napoleonic Empire was created, and many people talked of the "New Rome."

To some Europeans, Napoleon was a genius, a hero, a friend of the common man and an enemy of oppression. To others he was pompous, vain and egotistical, suppressing a desire to be like the royalty he opposed.

Russia, Waterloo, the Revolution Ends

Napoleon's empire didn't last long. In 1812 he led about half a million soldiers into Russia. The vastness of Russia, "a scorched earth" policy (where Russia retreats, destroying everything as she sucks back) and her special ally, the horribly cold winter, spelled disaster for the Grand Army. Only 10,000 Frenchmen returned to France. The nightmares of that invasion haunted soldiers' minds for generations to come. Europe's best military museum is in Paris, "Les Invalides," next to Napoleon's tomb.

With Napoleon reeling, all of Europe called for a pig-pile on France, vowing to fight for 20 years, if necessary, until France was defeated. The French people took the hint, toppling Napoleon's government and giving him a permanent vacation on the island of Elba, off the Italian coast.

As evidence of Napoleon's personal charisma, he returned from his exile-in-disgrace, bared his breast to the French people and said, "Strike me down or follow me." They followed him into one last military fling. It was only after the crushing defeat at Waterloo (Belgium) in 1815 that Napoleon was finished.

He was exiled to a tiny island in the south Atlantic and France was ruled by a "modern" king. The French kings after Napoleon were limited by a constitution. They went to work every day like any businessman in a suit, carrying a briefcase.

Neoclassicism

Baroque was the art of the Old Regime—divine right monarchs, powerful clergy and landed aristocracy. The French Revolution killed that regime and its art, replacing it with a style more in tune with the Enlightenment. This new art was modeled not on the aristocratic extravagance of Versailles, but on the "democratic" simplicity of ancient Greece and Rome—"Neo-Classical."

Archeological discoveries heightened interest in the classical world. Pompeii, the Roman city buried by a volcano in AD 79, was unearthed,

giving Europe its best look ever at Roman daily life, dress, customs, art and architecture. Books on Roman and Greek life were very popular. Parisian women wore Pompeii hairdos. Artists carefully studied ancient art. They found that the art of the Renaissance was not truly "classical," and they tried to capture the true Greek style. Ancient became modern, and classical was in.

Throughout Europe—but especially in Paris—tourists are fooled by classical-looking buildings which are actually Neoclassical—only 200 years old.

French Art of the "New Rome"

In France, the official style of the Revolution and Napoleonic eras was Neo-classical. The French thought of themselves as citizens of the New Rome and wanted art to match. In Paris the Pantheon and the Arc de Triomphe look like grand Roman monuments—built by Napoleon. Napoleon had himself crowned emperor in Notre Dame Cathedral in the style of the Caesars. Classical backdrops masked the Gothic columns of the cathedral so the emperor could be crowned as "Romanly" as possible.

CORONATION OF NAPOLEON I, BY DAVID (Detail)
In the Louvre, with another version at Versailles.

The great painter, Jacque-Louis David (1748-1825, pron. Dah-VEED), was in charge of art, culture and fashion throughout this period. He was France's virtual dictator of fashion. Marriage ceremonies, clothing styles, hairdos and giant government propaganda spectacles were done according to David's Neoclassicism.

David's painting style was realistic, dignified and simple—like a classical statue. He bathed France in classical grandeur, always drawing parallels to the glory of Rome.

Neoclassicism, like the Enlightenment was international. Thomas Jefferson, a child of the Age of Reason, designed the Neoclassical Monticello. The national Capitol of the USA and many state capitols are Neoclassical. Napoleon's armies spread Neoclassicism throughout Europe. "Enlightened" people everywhere rejected the gaudy ornaments of Baroque in favor of austere arches and pure columns.

New Patronage—The Academy

The French Revolution and the rise of democracy in Europe changed the economics of art as the Reformation had done earlier in the Protestant countries of the North. Art became less and less the domain of the elite classes and the church and more the domain of the middle class. Commissions were rare and the gap between the artist and his patron widened.

Previously artists studied as apprentices with a master who was employed by a wealthy patron. Now they went to "Academies" (pompously named after Plato's Academy of Philosophy in Athens) to study art history, theory and technique. Here artists were free to pursue and paint their own idea of beauty—not that of whoever was paying them.

Artists went beyond decoration. Art was an expression of individuality—not a craft, but Art, with a capital "A."

Relax . . .

You've just survived the wars, despots and revolutions of Europe's Early Modern Age. Next we have the wars, despots and revolutions of the Modern World. But first,

take a break.

While you're pondering how all this applies to you and your trip, take a look at a few subjects of special importance to the tourist. Here's a list of some related "tangents" in the last half of the book:

Meanwhile . . . Events Outside Europe

Early Modern World: 1600-1700

—Australia discovered (1606).

—Shogun Tokugawa unifies warring Japan (1603).

—English settlement at Jamestown, Virginia (1607). Pilgrims at Plymouth, Massachusetts (1620).

—Ottoman Turks lay siege to Vienna but are repelled (1683).

—Shah Jahan, Moslem ruler of India, builds Taj Mahal as tomb for his wife (1650).

Contemporaries ca. 1600: Shakespeare, Cervantes, Galileo, Pocahantas, Shogun Tokugawa, Ben Jonson, Johannes Kepler, Francis Bacon.

Contemporaries ca. 1680: Isaac Newton, Descartes, Moliere, William Harvey, Thomas Hobbes, John Locke, Peter the Great, Louis XIV, Anton von Leeuwenhoek.

Enlightenment and Revolution: 1700s

—Ben Franklin experiments with electricity (1750).

—French and Indian War in America (part of France vs. England's Seven Years' War) (1750).

—Steam engine patented (1769).

—Declaration of Independence and successful American Revolution, USA (1776).

Contemporaries ca. 1750: Voltaire, Rousseau, Ben Franklin, George Washington, Thomas Jefferson, Adam Smith, Catherine the Great (tsarina of Russia), Haydn.

Timeline
Early Modern Europe

The Reformation and religious wars split Europe into two camps: the Protestant North and the Catholic South. In general, the Northern countries, relying on a strong middle merchant class, were also more democratic. The South tended towards absolute (and occasionally enlightened) despots. In succeeding centuries the democratic ideals of the Enlightenment sank in, and the old regimes gave way to more modern governments.

This same historical journey from religious division to absolute monarchy to democracy is apparent also in art styles (lower half of the timeline). The lavish Baroque style, associated with the Catholic church and absolute monarchs like France's Louis XIV, was centered in Italy and France. At the same time the middle-class Northern Protestant countries (Holland and England) had a less grand style in Rembrandt and Christopher Wren. As both North and South moved toward democracy, a new style appeared, reflecting the ideals of the ancient world—Neoclassicism. This was the dominant style of the French Revolution and the reign of Napoleon—the emperor of the "New Rome."

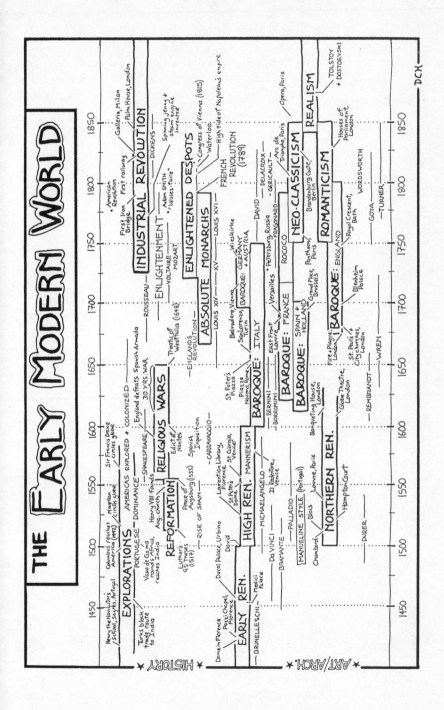

THE EARLY MODERN WORLD

★ HISTORY ★

1450 — 1500 — 1550 — 1600 — 1650 — 1700 — 1750 — 1800 — 1850

Henry the Navigators School, Sagres, Portugal
Turks block trade route to India

EXPLORATIONS
Columbus reaches America (1492)
Magellan circles globe
Sir Francis Drake circles globe

— PORTUGESE — DOMINANCE —
Vasco de Gama rounds Africa, reaches India
AMERICAS EXPLORED + COLONIZED

REFORMATION
Henry VIII founds Ang. church
Peace of Augsburg (1555)
Luther's 95 Theses (1517)
— RISE OF SPAIN —

RELIGIOUS WARS
SHAKESPEARE
England defeats Spanish Armada
30 YRS. WAR
Edict of Nantes
Spanish Inquisition
Treaty of Westfalia (1648)
— ENGLAND'S REVOLUTION —

INDUSTRIAL REVOLUTION
American Revolution
First Iron Bridge
First railway
Galleria, Milan
Palm House, London
ROUSSEAU
DICKENS

ENLIGHTENMENT
VOLTAIRE
MOZART
Adam Smith "laissez-faire"
Spinning jenny + steam engine invented

ABSOLUTE MONARCHS
LOUIS XIV
XV
LOUIS XVI

ENLIGHTENED DESPOTS
— GERMANY + AUSTRIA —

FRENCH REVOLUTION (1789)
Congress of Vienna (1815)
Waterloo
High tide of Napoleon's empire

REALISM
TOLSTOY + DOSTOEVSKI

★ ART/ARCH. ★

1450 — 1500 — 1550 — 1600 — 1650 — 1700 — 1750 — 1800 — 1850

Dome in Florence
Pazzi Chapl, Florence
BRUNELLESCHI

EARLY REN.
Ducal Palace, Urbino
David
Medici Palace

DA VINCI
BRAMANTE
PALLADIO

HIGH REN.
MICHAELANGELO
Il Redentore, Venice
Laurentian Library, Florence
St Peter's Dome

MANNERISM
St Giorgio, Venice
CARAVAGGIO

BAROQUE: ITALY
BERNINI
BORROMINI
St Peter's Piazza
Piazza Navona, Rome
San Lorenzo, Turin
Belvedere, Vienna
Wieskirche
BAROQUE: GERMANY

BAROQUE: FRANCE
East Front, Louvre
Versailles
Pantheon, Paris
St Petersburg, Russia
Grand Place, Brussels
ROCOCO
FRAGONARD

NEO-CLASSICISM
DAVID
DELACROIX
GERICAULT
Arc de Triomphe, Paris
Brandenburg Gate, Berlin
Opera, Paris

BAROQUE: SPAIN + HOLLAND
Banqueting House, London
Fire + Plague, London
St Paul's + City churches, London
BAROQUE: ENGLAND
Blenheim Palace
WREN

NORTHERN REN.
MANUELINE STYLE (Portugal)
Chambord
Blois
Louvre, Paris
Hampton Court
Globe Theatre, London
DÜRER
REMBRANDT

ROMANTICISM
GOYA
TURNER
WORDSWORTH
Royal Crescent, Bath
House of Parliament, London

DCX

The Modern World
1815 - Today

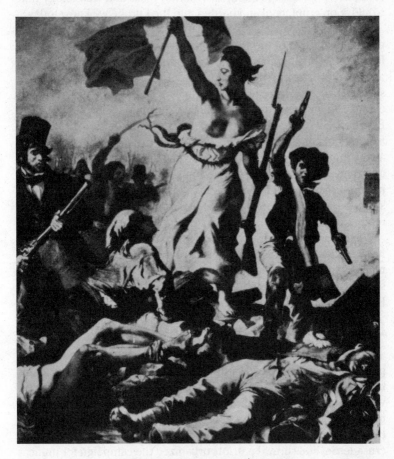

"LIBERTY ON THE BARRICADES,"
DELACROIX, LOUVRE, 1830

This dramatic scene captures the spirit of nationalism. "Liberty," in the form of a woman, carries a gun in one hand and a flag in the other—the winning combination for 19th-century nationalist movements.

Age of Nationalism

Europe entered the modern world walking backwards. After the French Revolution and Napoleon were crushed, European royalty tried to return to the archaic world of feudalism and the Old Regime, ignoring the rights of individuals and nations. Beneath this conservative crust, however, Europe bubbled with new ideas and technology that would soon erupt, cool and harden into the Europe we know today.

Nationalism, a patriotic desire for national unity, was the dream and the political drive of the 1800s. The democratic ideals of the French Revolution, spread by Napoleon, were popular among the middle class and intellectuals throughout Europe. The people were no longer satisfied to be ruled by a royal family that, most likely, was from another country. In the previous century most of Europe had been ruled by the Bourbon, Hapsburg and Hohenzollern families. The king often spoke a different language than the people he ruled. Now people insisted on a government that reflected their will, including their language, culture and religion. Man now identified himself as a citizen of a particular nation—even if his nation was not yet a political reality. The stove was switched from simmer to high and Europe's nationalistic stew was ready to boil over.

When you travel in Europe keep in mind that 130 years ago Germany, Italy, Austria and Yugoslavia were just local dreams—not places on the map. As you tour castles, treasuries and palaces in these nations you're seeing the "White Houses" and crown jewels of such "countries" as Piedmont, Saxony, Slovenia and Bavaria.

Unification of Italy

In the mid-1800s the petty kingdoms and city-states of the Italian peninsula began a move towards unity. The governments were content but the people weren't, and talk of the "Resurgence" of national pride was everywhere. As national revolts were crushed by local governments patriotism grew. The liberals of Europe supported the Italian cause, and a local writer, Mazzini, made unification almost a holy crusade. Several shrewd patriots organized the campaign for unification, channeling nationalistic fervor into the formation of Italy.

The logical first king of Italy was the only native monarch of the region, Victor Emmanuel II, King of Sardinia. His prime minister, Cavour, a cunning politician, liberal yet realistic, orchestrated the unification of Italy. By joining the Crimean War to get allies so he could start his own war with Austria (that he couldn't win without allies),

Cavour wrested Italian Lombardy (North Italy) from Austria. That, combined with many local revolutions which were legitimized by plebiscites (local votes of popular support), brought most of Northern Italy together by 1860.

A powerful revolutionary general, Garibaldi, sailed with 1000 "red shirts" to Sicily where they were joined by local revolutionaries in annexing the Kingdom of Two Sicilies into the New Italian State.

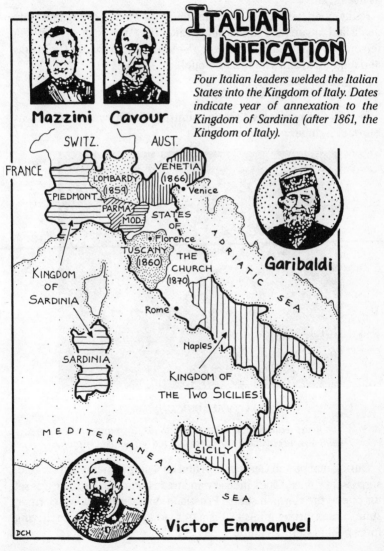

ITALIAN UNIFICATION

Mazzini Cavour

Four Italian leaders welded the Italian States into the Kingdom of Italy. Dates indicate year of annexation to the Kingdom of Sardinia (after 1861, the Kingdom of Italy).

Garibaldi

Victor Emmanuel

143

National pride was fueled by the Romantic movement. Artists returned to their ethnic roots, incorporating folklore into their novels and folk music into symphonies. In Italy, Verdi used the opera to champion the unification movement. Opera houses rang with the sound of patriots singing along with his anthem-like choruses. (Verdi's name was used as a nationalistic slogan: <u>V</u>ictor <u>E</u>mmanuel, <u>R</u>oi (king) <u>di</u> <u>I</u>talia.)

In 1861 the Kingdom of Italy was proclaimed with Victor Emmanuel as its first king.

Remember the names of these Italian patriots. Throughout Italy you'll find squares and streets named after the "Washingtons" and "Jeffersons" of the Italian "Resurgence"—Via Cavours, Piazza Garibaldis and monuments to Victor Emmanuel.

Unification of Germany

In 1850 Germany was 39 little countries. Twenty years later it was Europe's number one power.

OTTO VON BISMARCK (1815-1898)

The great realistic politician of the 1800s, Bismarck created what no one outside his country wanted—a united Germany.

During that period German iron and coal output multiplied six-fold, surpassing France. Cities, industry and trade boomed. The stage was set for one of the German states, Prussia (a militaristic Eastern German state), under prime minister Bismarck, to assert itself as the driving force behind German unity.

Otto von Bismarck, the great realist and practitioner of "realpolitik," is my nomination for the greatest political genius of all time. He said, "Not by speeches and majority votes are the great questions of the day decided—but by blood and iron." For him, the great issue was German unification—under Prussia.

Bismarck united Germany as if he were reading from a great political recipe book. He used a logical, calculated, step-by-step approach, and when he finished he had created the dish nobody in Europe wanted—a united Germany.

It's a long and complex recipe, well worth studying. Bismarck had three objectives which he accomplished by starting and winning three wars after carefully isolating each opponent. He would make an alliance simply to break it with an excuse to fight. After wiping out his opponent he would make a fast and generous peace so he could "work with" that country in the future. He made concessions to the liberals of his parliament to become their hero. He levied—and collected—unconstitutional taxes to build up his armies. He winked at Europe's great leaders, gained their confidence, and proceeded to make them history's fools. He leaked inflammatory comments to the press to twist public opinion into just the political pretzel he needed.

He did whatever he had to, and in the end he got exactly what he set out to get. The fragmented Germany that Europe had used for centuries as a tromping ground became a Prussian-dominated conservative and militaristic German Empire. In 1871 Germany emerged as Europe's most powerful nation. The leaders of Europe were concerned. The balance of power had been disturbed. They hoped the unification of Germany would not lead to a large war—or two.

Romantic Art

The artistic movement known as "Romanticism" seemed to go hand-in-hand with nationalism—rules and authority were thrown out the window as individuals asserted their right of personal expression. Could it be that just as national groups could not be suppressed by Old Regime aristocratic rulers, Romantic artists refused to conform their powerful inner feelings to society's code?

Romanticism was a reaction to the stern logic and reason of the Neoclassical movement. Like Neoclassicism (which carried on through much of the Romantic period) it was more than an art form. It was a way of living. In art it meant feeling over intellect, content over form, color over outline, and passion over restrained judgment—the extreme

NEUSCHWANSTEIN CASTLE
BAVARIA, 1886

The fairytale castle of Bavaria's "Mad King," Ludwig II, is typical of the Romantic period. It was built on a hilltop in medieval style long after castles had lost their function as fortresses. Ludwig put it here only to fulfill his Romantic dream.

opposite of Neoclassicism. The rules of Neoclassicism were replaced by a spirit that encouraged artists to be emotional and paint not just what the eyes saw but what the heart felt.

The fairytale castle of Neuschwanstein is a perfect example of romantic emotion dominating over intellect. Built by King Ludwig II of Bavaria, it served no military purpose—but offered a grand view. The king was a romantic. His best friends were artists, poets and musicians. Scenes from Wagner's Romantic operas decorated his castles. His dreams were not of empires and big armies, but of fairytale castles and candle-lit concerts.

He is known as the "Mad" King Ludwig because of his romantic excesses. He drowned mysteriously before his Neuschwanstein castle could become his dream come true.

While Ludwig almost bankrupted Bavaria building his Disney-esque castles, the country is being paid back today with interest as huge crowds of tourists from all over the world pay to see Europe's most popular castle. Get there by 9:00 a.m. or you may spend more time in line than in the castle.

"THE THIRD OF MAY, 1808"
GOYA, PRADO, MADRID, 1815

Romanticism expresses itself here in a powerful social statement against war and repression by faceless foreign invaders. The human victims are Spaniards dying for the cause of liberty.

Goya

Francisco de Goya was a great portraitist for the Spanish royal court. A Romantic painter, he has been called the first painter with a social conscience. His "Third of May" is a gripping combination of nationalism and Romanticism, showing a faceless government execution squad systematically gunning down very human victims with all the compassion of a lawn mower.

"KRONOS EATING HIS CHILDREN"
GOYA, PRADO, 1820

The emotions of Romanticism could be nightmarish. This example of a Goya "Dark Stage" painting symbolizes time eating us all.

Artistically, Goya (1746-1828) went through several stages. His last, after he lost his hearing and became bitter and disillusioned with life, is one of nightmarish fantasy. It's as if he bled blood on the canvas and let his innermost emotions fingerpaint grotesque and awesome figures mirroring the turmoil that racked his soul. (Romantic, huh?) The Prado Museum in Madrid has a room dedicated entirely to the bizarre visions of Goya's "Dark Stage." One of the most gripping is the painting of

"Kronos Eating His Children" detailing in ghastly, twisted lines and vivid, gloomy colors how time eventually "eats" us all. "Romantic" isn't only "mushy-kissy." This is Romanticism at its emotional best. No matter how cheery you are when you enter, you'll leave Goya's Dark Stage in a gloomy funk. (Don't plan a picnic right afterwards.)

Blake

William Blake of England was another master at putting inner visions on canvas. A mystic, nonconformist poet, he refused to paint posies for his supper. He made a living only through the charity of fellow artists who recognized his genius. Blake's watercolors (wonderfully displayed in London's Tate Gallery) with their bizarre composition, reveal how unschooled he was in classical technique. But his paintings grab the viewer emotionally—and that's what Romanticism is all about.

"CIRCLE OF THE LUSTFUL"
WILLIAM BLAKE, 1824

Romanticism - The Religion of Nature

Romantics made a religion of nature. Taking a walk in the woods, communing with nature, taught man about his true self—the primitive, "noble savage" beneath the intellectual crust.

The cultural heartbeat of this movement came not from the lavish Medici palace in Florence or the elegant salons of Paris, but from a hum-

ble log cabin in England's Windermere Lake District—William Words-
worth's "Dove Cottage." The English poets Blake, Coleridge and Words-
worth rejected the urban, intellectual, scientific world for simple cot-
tage life, soaking in the awesomeness of nature.

"BUTTERMERE LAKE" 1798, J.M.W. TURNER
TATE GALLERY, LONDON

The Rainbow
My heart leaps up when I behold
A rainbow in the sky:
So it was when my life began,
So is it now I am a man,
So be it when I shall grow old,
Or let me die!

—Wm. Wordsworth, 1807

At Oxford and Cambridge a walk in the woods was a part of every
scholar's day. Even today, the Lake District in Northern England is a
very popular retreat for nature lovers. It has more youth hostels per
square mile than any place on earth and they are perpetually booked
up, filled with rucksacked-Romantics there to worship the wonders of
nature—walking.

Until the Romantic era, mountains were seen only as troublesome
obstacles—now they attracted crowds of nature lovers drawn to their

rugged power. High-class resorts like Interlaken in the Swiss Alps were born. Why did people climb these mountains? Because they were there. Romanticism.

Romantic artists glorified nature. Landscapes illustrated nature's awesomeness and power. In the early 1800s, the Englishman John Constable painted nature honestly, unidealized, recognizing the beauty in "natural" nature. His contemporary, J.M.W. Turner, differed by charging his landscapes with his emotions, using bright super-"natural" colors and swirling brushwork. He personified nature, giving it the feelings and emotions of a Romantic human being. (The Tate Gallery has a great collection of Turner landscapes.)

Eugene Delacroix is a classic example of a Romantic painter (see page 141). Solitary, moody, emotional and endlessly imaginative, he broke all the Neoclassical rules. His exotic and emotional scenes, wild color schemes, and complex, unrestrained compositions bubble with enough movement and excitement to ring any viewer's emotional bells.

Theodore Gericault, in preparing gripping works like his "Raft of the Medusa" masterpiece, visited an insane asylum and slept in a morgue to effectively portray death and terror on the faces of his subjects. Nature was awesome, emotions were truth and the Romantic artists were the prophets of a new religion.

"RAFT OF THE MEDUSA" 1818
GERICAULT, LOUVRE

Gericault goes to great lengths to portray the death and suffering on this raft. At the same time a powerful pyramid of hope reaches up to flag down a distant ship.

The Industrial Revolution

The Industrial Revolution, along with the rise of nationalism and democratic governments, shot Europe into the modern world. While the scientific achievements of the Enlightenment broadened human

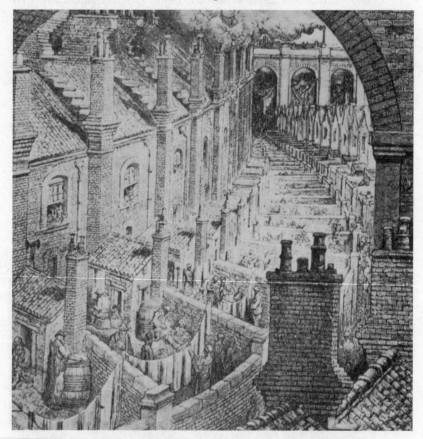

The riches of England's Industrial Revolution came with its problems. This 19th-century engraving shows poor, dirty and overcrowded slums housing masses of industrial workers under roaring smokestacks.

knowledge, practical inventions and applications didn't come until the 1800s.

This century of exciting technological advancement shifted nations from agricultural dependence to dependence on industry. Britain's textile industry led the way as new steam-powered factories drew people from the countryside to work in the cities.

(England's Industrial Revolution was born in the Iron Bridge Gorge. Today those first factories churn on for tourists to see in the fascinating Blists' Hill Open Air Museum, north of Stratford, near Coalport.)

The invention of the train shifted the revolution into high gear. More products could be shipped faster and huge new trade markets opened up. European nations were laced together with train tracks—no one was more than a day's journey from any one else in the country. From 1830-1860 one-sixth of all the world's track was laid. (And then came the Eurailpass. . .)

Europe's business energy could not be contained. Before long, most of the world was colonized by Europe. Europe collected raw materials and luxury goods from these underdeveloped nations. The development and resale of these raw materials brought great profits. While every European nation had a slice of the world economic quiche, Britain had the lion's share—at one point her colonial empire included a quarter of the world's land and one-fifth of its people. As that old saying goes, "The sun never sets on the British Empire." It was always daytime in at least one of her colonies.

The British Empire of the 19th century was the biggest, richest, and most powerful in history. Here, John Bull (the British Uncle Sam) is shown selfishly holding his swollen colonial empire.

Technological progress made people optimistic. Seeing how quickly technology could change nature and lifestyles, people figured it could answer the world's problems.

Unfortunately, technology was not the cure-all for Europe's problems. In fact, it brought many of its own—poverty, slums, polluted and overcrowded cities, child labor, unemployment, overwork, and the alienation of workers from the fruits of their labor.

Socialism and Communism

The socialist movement tried to solve these new social ills. The old laissez-faire policy of government non-intervention in business affairs was challenged. Socialists and trade unions worked to restrict the power of the factory owners and distribute all this new wealth more fairly. In his "Communist Manifesto," Karl Marx took a more extreme approach, advocating a worker (proletarian) revolution to overthrow the capitalist (bourgeois) establishment. Years later V.I. Lenin, using Marxist principles, led fellow Russian workers against the tsarist regime, giving birth to the Soviet Union.

The four giants of Soviet Marxism keep watch over a meeting of the Communist International, 1935.

(Left to right), Karl Marx (1818-1883) and Friedrich Engels (1820-1895), both from Germany, co-wrote the influential "Communist Manifesto" (1848), developing the theory that workers, not factory owners, should benefit most from industry. In the 19th century, communist and socialist organizations gained in power throughout Europe. Though there was never a classic "workers' revolution" as Marx and Engels had predicted, their ideas spurred reforms to benefit the working class.

Vladimir Lenin (1870-1924), a Russian, used Marxist ideas to plan the Bolshevik Revolution, overthrowing Russia's monarchy (1917). He had to adapt industrial Marxism to a country that, at the time, was still practicing medieval feudalism.

Josef Stalin (1879-1953) succeeded Lenin as ruler of the Soviet Union, instituting the iron rule we associate with Russian totalitarianism.

We saw how society was adjusted by the liberal French Revolution to accommodate the urban merchant and business class. Now a new social group, the workers, used socialist and communist ideas as bumper cars to gain their rightful spot in the class structure.

CRYSTAL PALACE INTERIOR,
LONDON, 1850

This huge iron and glass structure was built on a strict schedule, marveled at, and taken down on a schedule. Europe was feeling its industrial oats, and similar structures were built all over. You'll see many Crystal Palace-type train stations in your travels.

Industrial Revolution and Art

The Industrial Revolution put new tools and materials in the artist's hands. Concrete, iron and glass opened many new architectural doors. Man was proud of his "modernity" and his ability to build like never before. More buildings were raised in the 19th century than in all previous centuries put together.

At World's Fairs and Exhibitions giant structures of iron ribs and glass walls were proudly assembled and promptly disassembled on rigid time schedules—just to prove it could be done. People traveled from all over Europe to marvel at London's marvelous Crystal Palace. Then they took it apart. Paris, also feeling its industrial oats, built the Eiffel Tower celebrating the 100th birthday of the French Revolution. The French planned to take the Tower down but it became the symbol of Paris and they

155

decided to keep it. ("Who knows? Maybe someday that ugly erection will attract some tourists!")

As you travel around Europe you'll see huge iron and glass train stations—more products of Europe's early industrial muscle. It was the day after Christmas and Europe was a child with a colossal erector set.

EIFFEL TOWER, PARIS, 1889

But the Industrial Revolution also threatened art. New building techniques and materials made past architectural styles obsolete, except as decoration. A modern building, like the Neo-Gothic British Houses of Parliament would be built in a modern way, then decorated with "fake" Gothic arches or Renaissance columns. (Remember the ancient Roman use of Greek styles? Solid Roman engineering with Greek niceties for looks.) How could the artistic architect fit into this scheme? As an engineer? Or just a decorator, copying old forms at the request of unimaginative builders?

Painters were threatened by the newly invented camera (around 1830)—which could make a faster, cheaper and better portrait. (Sitting for a portrait had been a real pain in the wallet for the "time-is-money" businessman of the pre-camera age.) The challenge and incentive to portray nature was gone—a simple camera could do it better. The artist's traditional role as preserver of a particular moment, person or scene was obsolete.

Technology widened the gulf between the artist and the public. Modern man could get what he wanted from engineers, technicians and mass production. For their part, artists grew to disdain those who

**HOUSES OF PARLIAMENT,
1836-1860, LONDON**

This example of modern Gothic houses Great Britain's government. It's well worth touring.

put a price on art just as they did on pork, or kerosene or a day's work in the factory.

Paris was the artistic Mecca of 19th-century Europe. Young artists from all over the world went to Paris to study in academies, compare ideas, discuss and debate the meaning of "Art"—all hoping to have theirs hung in the salons that were Europe's artistic trendsetters. Struggling to come to terms with the modern industrial world, Art left technology behind, focusing the artistic lens of the western world on hazy frontiers of the future.

METRO STATION, PARIS.
*Curviness for the sake
of curviness.*

Art Nouveau

The Art Nouveau style (pron. new-VO) was a reaction against the mechanization and mass production of the Industrial Revolution. Longing for the beauty of the pre-industrial age, artists created art that was both useful and beautiful.

While industrial art and architecture were geometrical with rigid squares and rectangles, Art Nouveau, or "New Art," used delicate, flow-

ing lines like the curvey stems of plants. Iron grillwork became a new art form.

DRAWING BY AUBREY BEARDSLEY

Art Nouveau's flowing lines in graphic design.

CASA MILA APARTMENT HOUSE,
GAUDI, BARCELONA, 1905

This ice cream castle of a building does everything possible to disrupt the rigid angles of the industrial world.

Art Nouveau influenced architecture, painting, ironwork, furniture, graphic design, even women's fashion. In America, Louis Tiffany's natural-looking "flowerpetal" lamps were the rage.

Antonio Gaudi, born near Barcelona, adopted Art Nouveau in his distinctive style of architecture. Many architecture students make a pilgrimage to Barcelona where all his works are. He is considered a pioneer, a prophet and a dreamer who was lucky enough to see his dreams become concrete—no pun intended. (All right. I confess. It was intended.)

Art Nouveau's intentional curviness eventually gave way to the straight lines and rigidity we see in modern "International Style" skyscrapers, but its influence has been felt many times in the 20th century.

Impressionism

Impressionism was the greatest revolution in European art since the Renaissance and the first real "modern" style of art. The artist was in-

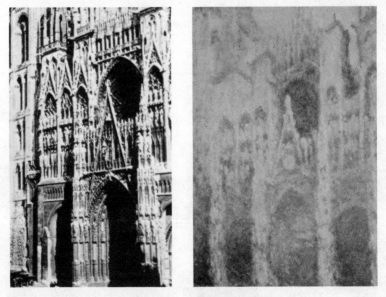

PHOTO OF ROUEN CATHEDRAL

IMPRESSIONIST PAINTING OF ROUEN BY MONET

We can see the artist's fascination with the play of light on the building. Detail fades away and we are left with a blurry, yet recognizable impression of the church.

terested only in the "impression" made by the light, shadows and atmosphere of a scene. Realism, in the traditional sense, was out.

Originally meant as an insult (like "Gothic" and "Baroque"), Impressionism is actually one of the few appropriate art labels. The artist, with a few quick brush strokes, captured a momentary "impression" of the subject, free from the shackles of a painstaking, detailed portrayal. Claude Monet (1840-1926), the movement's father, called it "instantaneity."

The realistic and the Impressionist styles are best illustrated by comparing Leonardo da Vinci and Monet each driving across the Nevada desert on a hot summer day. Ahead of his Ferrari, Leonardo sees heat rising from the asphalt, making the black road look like a bright shimmering patch of silver. In spite of how it appears, he knows the road is really black so he paints it that way—disregarding the momentary impression of silver.

Monet (pron. mo-NAY), an Impressionist, excitedly stops his Peugeot, sets up his easel and captures the *impression* of the shimmering heat waves cutting a silver slice through the yellows and browns of the desert.

Leonardo painted what his mind knew was there—the Impressionist painted what the eye saw.

Light and Color

"BATHERS AT ASNIERES," SEURAT,
TATE GALLERY, LONDON, 1883

Here Seurat uses Pointillism, a "mosaic" of colored dots with no lines. Pointillist motto: "Dots all, folks!"

Light plays endless games on the same subject and, to the Impressionist, that same subject is different with each time of day and atmospheric condition. Monet, the most "typical" Impressionist, often did a series on the same subject (e.g., Rouen Cathedral) at different times of day.

In capturing the moment, details and outlines are sacrificed to make the whole scene more effective. In fact, the subject matter is actually the light and the bright and glowing colors. Paint often is laid on thick, with heavy brush strokes. Sometimes the painter doesn't even bother to mix the colors on his palette—he just puts them side by side on the canvas, letting the viewer blend the colors in his mind. This brush technique was taken to extremes in Georges Seurat's "Pointillism"— a "mosaic" of colored dots with no lines at all. (If you look carefully at a newspaper photo, you'll see a mechanical form of Pointillism.)

From Ridicule to Acceptance

Impressionism was born in the "Salon of the Rejected," sort of the "Off-Off-Broadway" of struggling Paris artists. Initially people were outraged by this rough, messy style. One newspaper reported that after seeing an early Monet painting, "one visitor went mad, rushed out into the street and started biting innocent passerby." (Proceed with caution near Paris' modern art galleries.)

"REHEARSAL AT THE BALLET"
EDGAR DEGAS, 1885

Degas combined the Impressionist "quick sketch" approach with more traditional outlines. He used his knowledge of photography in his paintings, giving us a candid view of the dancers.

The stuffy board of Paris' Louvre Museum refused to admit the new art even after the public had accepted it. The nearby Jeu de Paume, a former indoor tennis court, was used to store the masterpieces of the movement. Later, Impressionism was completely accepted by the artistic community (the greatest Impressionist artists—Manet, Degas, Renoir and Rodin—had first-class classical backgrounds) but it remained in its little museum. Today people from all over the world tour the art of the Jeu de Paume which is now in the Musee d'Orsay and learn to appreciate and love that very impressive style of art—and no one bites anymore.

"Now where did I put my clothes?"

"THE THINKER," RODIN, PARIS, CA. 1885

Combining classical solidity with the "unfinished" look of Impressionism, Rodin shows man's struggle to use his reason.

In sculpture, Auguste Rodin (pron. ro-DAN) blended Impressionist ideas with his classical training to rechart the course of modern sculpture. He had the uncanny ability to capture the essence of a subject with his powerful yet sensitive technique. The rough "unfinished" surfaces of his works reflect the light like the thick brushwork of an Impressionist painting.

The Rodin Museum in Paris, near Les Invalides (where Napoleon is buried), is well worth an afternoon. It has one of Europe's finest collections of the work of a single artist.

Post-Impressionism

After Impressionism the modern artistic world never again was contained by any one style for long. Within 20 years, Impressionism had branched into two Post-Impressionist movements. One direction stressed form and order while the other was emotional and sensuous.

Paul Cezanne (pron. say-ZAWN), a man of independent means, ignored Paris, the critics and the buying public. He accepted the Impressionist approach of capturing what you saw, not what you knew was there, but he balanced this with the order, outline and solid forms of more traditional painting. Cezanne worked to create the best of both worlds—the instantaneity of Impressionism and the realistic depth and solidity of earlier styles.

"STILL LIFE: BASKET OF APPLES"
PAUL CEZANNE, 1894

Cezanne painted numerous still lifes in his experiments with form and composition. He once remarked that nature revealed itself in the geometric forms of cylinders, spheres and cones. In this painting we see cylindrical biscuits, spherical apples and a conical bottle.

The sensual side of Post-Impressionism was led by Paul Gauguin (pron. go-GAN), a stockbroker who "chucked it all" to become a painter. Like Cezanne, he left the artsy-fartsy folk of proud Paris for inspiration

163

in simple surroundings. He spent time with Van Gogh in Southern France—until Vincent attacked him in a fit of artistic rage—then sailed for Tahiti. Gauguin's bright and bold paintings of native scenes hit Europe like a coconut. He used "primitive" techniques—simple outlines, sharply contrasting colors, and a flat two-dimensional look—to create a naive and naturally expressive style that inspired many 20th-century artists.

"NAVE NAVE FENUA"
(The Delicious Earth)
PAUL GAUGUIN, 1894

In this woodcut we sense Gauguin's inner vision of a Tahitian paradise. The black and white simplicity emphasizes his passion for the primitive and exotic.

Van Gogh

The art of Vincent Van Gogh (1853-1890, pron. van-GO) is an expression of his inner feelings. He used Impressionist techniques powered with passion—painting not only what he saw but what he felt. For this reason, his art truly reflects his life.

His early life was religious, not artistic. Disillusioned with the shallow

values of the modern world, he served as a lay preacher for poor coal miners. In his late 20s, he turned to art and focused that same vision and spiritual intensity on his painting.

"ROAD WITH CYPRESS TREES"
VINCENT VAN GOGH, 1889

Vincent depicts the southern French countryside in his characteristic swirling style. Note how thickly the paint is applied, and the dramatic composition.

He moved to Southern France to cloister himself in his art. He did most of his great paintings there in the space of three years. They show the extreme loneliness, the emotional ecstasy and the spiritual struggles he went through. Several times his work was interrupted by mental illness. Finally, feeling that insanity was destroying his creative abilities, he killed himself.

Van Gogh's art is an oil on canvas translation of his soul, his genius and his emotions. The subjects were simple—common people and landscapes—and his style was untrained and crude. But he could distort and exaggerate certain colors and details to give them spirit and emotions.

Van Gogh's love of the common man shines in his paintings. They seem to glow with, as he put it, "that something of the eternal which the halo used to symbolize."

In the landscape "Road with Cypress Trees" we see a simple, peaceful scene "Van Gogh-ed" into a stormy sea of turbulence and emotion. He uses the strong, thick brush strokes and bright colors of the Impressionists, not to capture the light of the scene, but to churn it up with emotion. Wave-like wheat and flame-like trees vibrate with an inner force, which Van Gogh saw inhabiting all things.

Perhaps the best examples of Van Gogh's art are his self-portraits.

"SELF-PORTRAIT," VAN GOGH, 1889
The year before he shot himself.

These show the man as well as his talent. Haunted and haunting, we see in his burning eyes the passionate love of all things and the desire to put it onto the canvas.

Europe's Van Gogh treasure chest is the new Van Gogh Museum in Amsterdam (next door to the Rijksmuseum). Van Gogh's art is well displayed in chronological order with each stage related to events in his personal life. It's one of Europe's most enjoyable museums. The Musee d'Orsay in Paris also has some important Van Goghs.

"THE SCREAM," MUNCH,
OSLO, 1893

The Norwegian, Edvard Munch, led the way into the artistic movement aptly called Expressionism. These artists distorted reality to express the horror of the modern world. His museum in Oslo is excellent.

20th Century Art —
Reflecting a World in Turmoil

Twentieth-century art is such a confusing pile of styles and theories that only two generalizations can be made: 1) None of it looks like the real world, and 2) My dog could do better work on the carpet for half the price.

But, as we learned from ancient Egyptian art, you can't judge art simply by how well it copies reality. Artists distort the real world intentionally. Especially in 20th-century art, some of the messiest and least organized looking works ("It looks like a child's scribbling!") are very sophisticated, based on complex theories requiring knowledge of many art styles. If you don't understand it, you can't judge it. Learn about it first, understand the artist's purpose, then you can appreciate—or criticize—with gusto.

Speaking in very general terms, there are two different ways that modern artists have approached the "real" world. One way is to portray the real world, but exaggerate things to make them more expressive—like Van Gogh. The other is to abandon the visible world altogether, making basic lines and patches of color not meant to represent real objects, but meant for their own more basic beauty. These two approaches, the "expressive" and the "abstract" are found to varying degrees in all major modern art styles.

Expressionism

The fullest example of the "expressive" distortion of reality is a style called, incredibly enough, "Expressionism." It carries Van Gogh's emotionalism to its extreme. The epitome of Expressionism is "The

WOODCUT BY KIRCHNER, 1917

The Expressionist sees a distorted, twisted world—and shows it to us that way.

Scream." In it, the Norwegian artist Edvard Munch (pron. MOONCH) bends and twists everything into a landscape of unexplained terror. We "hear" the scream in the lines of the canvas—up from the twisted body, through the terrified skull and out to the sky, echoing until it fills the entire nightmare world of the painting.

We can appreciate the power of modern art by comparing "The Scream" with an earlier work, Gericault's "Raft of the Medusa (p. 151). Both are terror on canvas. But, while Gericault's terror comes from a realistic portrayal of a grotesque event, Munch simply distorts the appearance of an everyday scene, so we see it in a more powerful way, from a different emotional perspective.

"SPECULATING ON HEROIC DEATH"
THE DACHAU MUSEUM, 1934

The artist predicts the coming world war.

Expressionism flourished in Germany from 1905 to 1935. The artists show us the horror and injustice of the War years through their eyes. The garish colors, twisted lines and mask-like faces stress emotion over realism and classic restraint.

Expressionism lived on in Germany. The horrors of the World Wars

and the poverty and social injustice that followed were the subjects of concerned artists. The Dachau Museum, for instance, has some inspired Expressionist art that gripped me even more than the grisly photographs. The paintings of this period express the artist's sense of outrage and compassion for the suffering around him.

Abstract Art

The second strain of 20th-century art, "abstraction," is less understood than the "expressive" distortion of Munch or Van Gogh. Abstraction is simplification. When artists paint a tree, for example, they can never capture the infinite details of any individual tree. So they simplify, using lines and colors to show enough details to make the can-

"THE CARD PLAYERS"
PAUL CEZANNE, 1892

"CARD PLAYERS"
THEO VAN DOESBURG, 1916

Here is progression of abstraction based on Cezanne's Post-Impressionist painting. (top left)

(top right) The figures are flattened, the canvas reduced to a composition of geometric shapes. The subject matter is still apparent.

(below right) This later painting carries the process of abstraction further. Simplified into a jumble of puzzle pieces (similar to works by Mondrian), the "card players" are barely recognizable.

"CARD PLAYERS"
THEO VAN DOESBURG, 1917

vas look like a tree. In this sense, all art is, to some extent, an abstraction, or simplification, of the real world.

In the past, artists denied this fact, trying to make their two-dimensional canvases look as real as the three-dimensional world they painted. By the 20th century, painting of reality had been taken as far as possible and artists began to accept the abstract and artificial nature of a painting. In fact, they emphasized and enjoyed this abstraction, to the extent of neglecting the subject itself. They were free to experiment with the devices used to portray the subject—lines and colors, circles and squares. Not concerned with representing the real world, this art is called "non-representational."

The abstract artist is like a child with a set of brightly colored building blocks. Rather than use them to build a house or some recognizable object, they are fascinated by the blocks themselves. They spend hours placing them in arbitrary patterns that are pleasing for their own sake—not because they add up to something else.

This is how the abstract artist uses line and color—the "building blocks." Yet, unlike a child, the artist generally has years of training with which to plan the best arrangement of the "blocks."

So, to approach, appreciate and judge modern art, the viewer needs to know the rules—especially if the art can't be compared to reality.

Abstract Art = Visual Music

It's helpful to compare abstract art to pure instrumental music, which we all recognize as having rules of composition. While some music is designed to sound like something in nature (a storm, the call of a bird, etc.) or to express an emotion, most music is the perfect audio equivalent of abstract visual art. It simply plays with the beautiful "shapes and colors" of sound, the harmonious relationship of tones.

In the same way, art explores the relationships of lines and colors. The rules of these relationships are there for the trained eye, just as for the trained ear of the musician. But to the average viewer (or listener) abstract art (or music) is to be enjoyed—not analyzed. Music (abstract audio art) is enjoyable even if you don't understand the meter and scale that it's built upon. The same is true with visual abstract art. It's just plain beautiful.

In a painting by Piet Mondrian, for example, there is no attempt at all to represent our reality. It is simply a study of the relationships between geometrical segments of color. (Notice the similarity between the titles of works of abstract art and music—"Composition with Red, Yellow and Blue," "Sonata for Piano and Violin No. 1.")

What appears to be symmetrical regularity between the shapes, that any idiot with a pen and ruler could do, is actually drawn free-hand. The squares aren't exactly squares and the segments aren't exactly balanced. Mondrian must have agonized over just the right relationship between these blocks of color, following his own internal set of "rules."

"COMPOSITION WITH RED, YELLOW AND BLUE," MONDRIAN, 1921

Geometric patterns explore the relationship of lines and color—the "building blocks" of all art. (We hope this is right side up.)

"COMPOSITION 238: BRIGHT CIRCLE" KANDINSKY, 1921

Reality is tossed out the window as the artist calls on us to enjoy more basic shapes and colors.

Abstract artists have been criticized for avoiding reality—for playing with their building blocks, making patterns that only they can understand. Artists like Mondrian, Paul Klee and Wassily Kandinsky replied that what they painted *was* reality. Not the fleeting reality of the visible world that always changes and passes away, but the eternal, unchanging world of geometrical relationships (Plato again). Just as the ancient Egyptians preserved only the essential, simplified details of a subject for eternity, the abstract artist simplifies the world into timeless shapes and colors.

"Wild Beasts," The Fauves

Most modern art styles are a mix of pure "abstraction" and "expressive" distortions of reality.

One such style was "Primitivism," a return to the simplified (and therefore "abstract") style that we find in prehistoric cave paintings and pre-Greek art (see p. 223). Primitivists tried to paint the world through the eyes of primitive people, with a calculated crudeness. Their inspiration was Gauguin, who had rejected the sterile, modern, industrial world (and its sterile art) for the expressive and magical power of primitive images.

"JOY OF LIFE," MATISSE, 1905

Matisse simplifies reality so we can see it better—through primitive eyes. The 2-D "flatness" shows Gauguin's influence.

The "Fauves" (French for "wild beasts," pron. FOVES) shocked the modern art world with their exuberant use of primitive techniques—strong outlines, bright barbaric colors, two-dimensional "flatness."

Their leader was Henri Matisse (1869-1954, pron. mah-TEESS), a master of simplicity. Each of his subjects is boiled down to its essential details, portrayed with the fewest, simplest lines and colors.

Even though Matisse's work looks crude, his classical training is obvious. The "flat," primitive look is actually carefully planned 3-D. The bright colors that seem so bizarre are purposely placed to balance the composition. And, despite the minimum of lines, his figures are always accurate and expressive. The Fauves did not abandon the visible world, they simply distorted it so we could see it through more primitive eyes.

The French Riviera has some beautiful work by Matisse and is famous for its many top notch far-out galleries. Most European cities also have interesting modern art galleries. Important temporary exhibits constantly spice the European modern art scene. These aren't listed in guidebooks so check local periodical entertainment guides and ask at tourist information offices.

Picasso

The work of Pablo Picasso contains both the "expressive" and the "abstract." His long, prolific career spans several decades and art styles. Picasso was an innovator and a prime example of many things characteristic of 20th-century art.

When Picasso (1881-1973) was 19 he moved from Barcelona to Paris to be where the artistic action was. (His house in Barcelona has an exciting collection of his early works.) Picasso's early paintings are touching examples of Expressionism—beggars and other social outcasts—done with the sympathy and understanding of an artist who felt perhaps as much an outcast as his subjects. This is Picasso's "Blue Period" (c. 1905) because of the dominant color as well as the melancholy mood.

Picasso was jolted out of this style by the abstract methods of the Fauves. Intrigued with the paradox of painting a 3-D world on a 2-D canvas but disliking the 2-D flatness of Fauvism, he played with the "building blocks" (line and color) to find new ways to reconstruct the real world on canvas.

His solution is known as "Cubism," (c. 1910) because the painting looks like it was literally built with blocks. The chunks of light and shadow seem to stand out in 3-D, like shards of glass reflecting the light. In fact, Picasso experimented with actual 3-D collages, where everyday materials (rope, newspaper clippings, wallpaper) are pasted onto the

canvas in place of paint. The materials (the building blocks) are as meaningful in themselves as what they are meant to represent.

Picasso was still tied to the visible world. The anatomy may be jumbled, but it's all there. Picasso shattered the real world, then pieced it back together on the canvas—in his own way.

"THE FRUGAL MEAL"
PICASSO, 1904

Picasso, like most "far-out" modern artists, first mastered "normal" realism. He then explored beyond what the eye sees, evolving through several stages. This stage was melancholy, a style of Expressionism called Picasso's "Blue Period."

In the monumental mural, "Guernica," Picasso blends the abstract and the expressive. In the 1930s the Spanish town of Guernica was destroyed as a show of force by the Nazi-backed fascists of Spain. Picasso captures the horror of this event, not through a realistic portrayal, but with expressive images. The ambiguous, "abstract" nature of "Guernica" elevates the painting to a statement about all war. There are some clearly recognizable images of the agony of war: the grieving mother with her dead child at left (a modern Pieta); the dying warrior clutching a broken sword; the twisted horse's head. But the real power

175

of the work comes from the disjointed anatomy we saw in earlier Cubism—as if the bombs had shattered every belief, every moral principle, leaving civilization in a confused heap of rubble.

"AMBROISE VOLLARD"
PICASSO, 1909

In his "Cubist" period, Picasso experimented with three-dimensionality on the painted two-dimensional canvas. He breaks the subject into "cubes" of light, then rearranges them, showing us the man from several angles at once.

"GUERNICA," PICASSO,
MADRID, 1937

This masterpiece combines Cubism, Surrealism and abstractionism in black, gray and white to show the terror of the fascist air raid on a defenseless town during the Spanish Civil War. Today it is a virtual national monument of Spain and a comment on the futility and horror of war. This stirring painting is wonderfully displayed in a new annex to Madrid's Prado Museum.

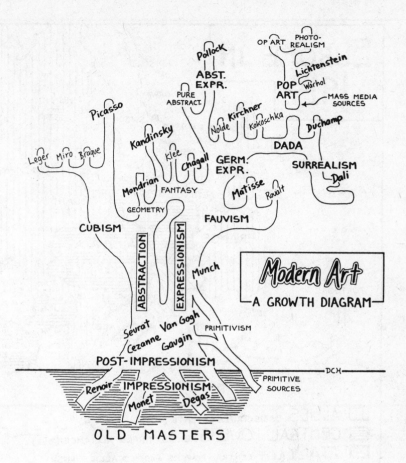

OP ART
PHOTO-REALISM
Pollock
ABST. EXPR.
Lichtenstein
POP ART
Warhol
PURE ABSTRACT.
MASS MEDIA SOURCES
Picasso
Kandinsky
Nolde Kirchner
Kokoschka
Duchamp
Klee
Chagall
GERM. EXPR.
DADA
Leger Miro Braque
SURREALISM
Dali
Mondrian
FANTASY
Matisse
Rault
GEOMETRY
FAUVISM
CUBISM
ABSTRACTION
EXPRESSIONISM
Munch
Modern Art
A GROWTH DIAGRAM
Seurat Van Gogh
PRIMITIVISM
Cezanne Gaugin
POST-IMPRESSIONISM
DCH
Renoir IMPRESSIONISM
PRIMITIVE SOURCES
Monet Degas
OLD MASTERS

Europe in the 20th Century

Contemporary Europe is just as exciting as historic Europe and doesn't need to take a back seat to Old Regime palaces and ancient ruins. While most of the sights tourists chase in Europe are pre-20th century, an understanding of our tumultuous century is important in understanding Europe's number one tourist attraction—its people.

The century started with the sort of easy happiness and nonchalance of a summer barbecue. The average person in 1910 felt very lucky to be living during those times.

Behind the scenes, however, the tension in Europe was growing. Germany's late entry onto the European economic gameboard caused competitive rivalries. Tension mounted as Germany grabbed for its "place in the sun," a colonial source of raw materials and a marketplace

EUROPE IN 1914

As we can see from this map, in 1914 Europe was inexplicably covered with
enormous horizontal, vertical and diagonal lines. Today only a few of these
remain.

for finished products. By this time, most of the underdeveloped world
was already controlled by some European power.

Diplomatically, Europe was weaving a complex web of alliances. No
one wanted to be left without an ally, so most countries dove headlong
into an international game of "Let's Make a Deal." Alliances were secret,
often conflicting, and no one knew for sure exactly where anyone else
stood.

The modern nationalities of Europe were awakening and, especially

in the vast Hapsburg Empire, national groups were working aggressively for independence.

World War I

Beneath its placid exterior, Europe was ready to burst. The spark required to blast it into war was the assassination of Archduke Ferdinand, heir to the Hapsburg throne, in 1914 by a Serbian nationalist.

One by one, Europe's nations were drawn by alliance into this regional dispute. The Hapsburg government jumped at the opportunity to crush the troublesome Serbs (modern Yugoslavia). Germany gave the Hapsburgs (Austria) a "blank check" of support. Russia, Slavic Serbia's big brother, aided Serbia. Germany knew that Russia was about to complete a new railroad mobilization plan that would give Russia first-strike capabilities. Many speculate that Germany thought a war at that time, while Russia was still slow to mobilize, was better than risking a lightning-quick Russian attack later. Germany knew that if Austria attacked Serbia, Russia and Germany would be drawn into the fray. Well, that's just what happened.

But when Austria attacked Serbia and the Russians mobilized, Germany invaded. . . France! France was allied to Russia, and Germany hoped to wipe out France by surprise rather than wage a two-front war. (Isn't it frightening how easily wars can start? History 101 should be required of all world leaders.)

Well, it didn't work out quite like Germany had planned. Germany and France bogged down on their common border digging trenches to hold their positions. England joined in. (The USA didn't join until the late stages, in 1917.) Russia and Germany fought a very fluid war with the help of trains on the Eastern front. Meanwhile, Austria had trouble with the stubborn Serbs.

Europe dove into this "War to End All Wars" expecting a quick finish. It took four bloody years for the Allies (France, England, Russia and ultimately the USA) to defeat Germany and Austria. When the Treaty of Versailles was signed in 1919, nine million of the 65 million soldiers who fought were dead. Germany lay crushed and saddled with demoralizing war debts. Once-mighty Austria was reduced to a poor, tiny, landlocked country with a navy of three police boats on the Danube. Half of all Frenchmen between 15 and 30 were dead. Europe lay dazed and horrified at the unthinkable—which had just happened.

With a little study you could fill a whole tour with World War I (and II) "sights." In Northern France and Alsace you can tour bits of the Magi-

not Line and visit moving memorials at famous battle sights like Verdun near Reims.

After the War, the map of Europe was redrawn. The old ruling families —the Hapsburgs of Austria, the Romanovs of Russia, the Hohenzollerns of Germany and the Ottoman rulers of present-day Turkey—were finished. New democratic nations were created according to cultural and ethnic boundaries. (Finland, Austria, Hungary, Czechoslovakia, Poland, Yugoslavia, Latvia, Estonia, Lithuania.) The provinces of Alsace and Lorraine were handed over to France from Germany. The United States emerged as the dominant, seemingly boundless superpower. By 1929 the USA boasted a whopping 42% of the entire world's industrial output.

Between the Wars — Totalitarianism

After the "Great War" the big question was, would Germany be democratic or communist? Russia had just had its Communist Revolution and was now the Soviet Union. According to Marxist theory, Germany was the perfect candidate to lead the world into communism. But the victorious Allies (USA, Great Britain and France) managed to install the Western-style "Weimar" government, and the German Communist Party was literally buried one night when the top 1,000 Reds, including leaders Rosa Luxemburg and Karl Liebknecht, were shot.

This stamp from Ethiopia, overrun by Italy in 1935, shows the fascist alliance of Hitler and Mussolini. The slogan says, "Two peoples, one war."

The German people associated their new Western government with the hated Treaty of Versailles. While the Weimar government was

technically a modern constitutional democracy, behind the scenes was the old ruling order—the army and anti-Semitic powers—scheming to reverse the war's outcome and revive Germany as Europe's number one power. Many people view WWII as the logical continuation and conclusion of WWI and its short-sighted Treaty of Versailles.

Meanwhile in Italy, a violent, melodramatic nationalism and an anti-intellectual movement called fascism were born. Benito Mussolini led the fascist party, stressing unity and authority. He capitalized on Italy's corrupt government, miserable economy and high unemployment to rise easily to power. The rich and the businessmen saw fascism as distasteful, but supported it as the only alternative to Europe's rising red tide of communism.

In 1922 Mussolini was given the reins of government. He went right to work, filling the government with fascists, organizing the strong-man "squadrisi" to "encourage" Italians to support him, and building a strong, super-nationalistic, self-sufficient fascist Italy.

While Mussolini's government had its problems, it was the only strong rule Italy has seen in this century. As a tourist you will drive on a system of super-freeways or "autostrada" started by "Il Duce." Many of Rome's buildings, including the Olympic Games complex and his planned futuristic suburb of EUR, are fascist in style. EUR (10 minutes by subway from Rome's Colosseum), with its bold and powerful architecture, is well worth exploring.

The promises of a charismatic "fuhrer" were just what an angry frustrated post-WWI Germany wanted to hear.

Hitler

The rise of Hitler and Nazism in Germany is a fascinating topic. While there are not a lot of "Hitler sights," this is an era that is part of Germany and its people and should be understood.

NAZI POLITICAL
CAMPAIGN POSTER

This political ad tells voters how they can free Germany from its chains—by voting for Hitler.

The roots of Adolf Hitler's success lie in Germany's anger. After WWI, when the people hated the Treaty of Versailles and the Weimar government and when inflation ripped ever deeper into Germany's moral fabric, Hitler and his party leaped into the news. When the value of the mark went from four to a dollar to four trillion to a dollar in 1923, the hard-working German middle class lost faith in society. All debts, sav-

ings and retirement were wiped out. (It took a wheelbarrow full of paper marks to buy a large pretzel.) People were eager to hear the promises of a charismatic madman.

Hitler was a master of capitalizing on society's woes, finding scapegoats for problems that he couldn't solve. His party boomed until Germany did. When Germany entered its happy-go-lucky cabaret years, people wrote off Hitler and other political extremists as lunatics on the fringe.

NAZI PROPAGANDA

Translation: "All Jews are thieves." Signs like this were commonplace in Hitler's Germany.

When the Great Depression hit in 1929, Hitler rose again. With his political genius, terror tactics, scapegoating of the Jews, and the support of the rich elite of the day, who saw fascism as the only defense against communism, Hitler became Germany's dictator.

In 1933 he proclaimed the "Third Reich" to last a thousand years (the first two strong "states" were the medieval Holy Roman Empire and pre-WWI Germany (1871-1918).) He tried to turn Germany into a monolithic slab of nationalistic rock. There were no states, no parties, no classes, no questions—only Germany. The Nazi party was purged, the Gestapo kept the flags waving, concentration camps housed dissenters who weren't killed, and Nazism became the religion of state.

In his own frothy way, Hitler was a genius. Germany prospered. The economy boomed, everyone was employed and complete self-sufficiency (necessary to wage a World War) was just around the corner.

Hitler said, "Space must be fought for and maintained. People who are lazy have no right to the soil. Soil is for him who tills it and protects it. If a nation loses in the defense of its soil, then the individual loses. There is no higher justice that decrees that a people must starve. There is only power, which creates justice...

"Parliaments do not create all of the rights on this earth; force also creates rights. The question is whether we wish to live or die. We have more right to soil than all the other nations because we are so thickly populated. I am of the opinion that in this respect, too, the principle can be applied. God helps him who helps himself."

And people followed him.

Totalitarianism was the fastest growing form of government in Europe in the 1930s, gaining power in Germany, Italy and Spain, as well as in the Stalinist USSR. In her great book *The Origins of Totalitarianism*, Hannah Arendt describes this harsh form of government:

"The very ethics of totalitarianism were violent and neopagan. It declared that men should live dangerously, avoid the flabby weakness of too much thought, throw themselves with red-blooded vigor into a life of action. The new regimes all instituted youth movements. They appealed to a kind of juvenile idealism, in which young people believed that by joining some kind of squad, donning some kind of uniform, and getting into the fresh air they contributed to a great moral resurgence

NAZI MASS MEETING
NUREMBURG, 1937

50,000 Nazis attend a rally to hear Hitler rant and rave in a setting with the air of a grandiose Hollywood epic. Like Napoleon earlier, Hitler dreamed of a reunited Roman Empire.

DACHAU CONCENTRATION CAMP - WWII

The 20th century saw inhuman slaughter and suffering on an unprecedented scale. Modern totalitarian governments proved they could turn people into meaningless numbers.

185

of their country. Young men were taught to value their bodies but not their minds, to be tough and hard, to regard mass gymnastics as patriotic demonstrations, and camping trips as a preparation for the world of the future. Young women were taught to breed large families without complaint, to be content in the kitchen, and to look with awe upon their virile mates. The body-cult flourished while the mind decayed. The ideal was to turn the German people into a race of splendid animals, pink-cheeked, Nordic, and upstanding. Contrariwise, euthanasia was adopted for the insane and was proposed for the aged. Later, in WWII, when the Nazis overran Eastern Europe, they committed Jews to the gas chambers, destroying some 6,000,000 human beings by the most scientific methods. Animals were animals; one bred the kind one wanted and killed the kind one did not."

World War II

The peace in Europe following the Treaty of Versailles was unstable. It couldn't last. WWII was inevitable.

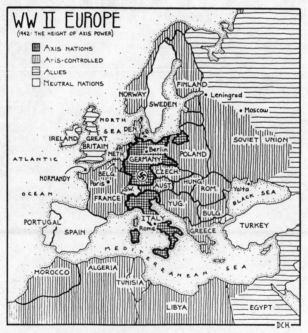

While most of Europe between the Wars was pacifist and isolationist, Hitler waged a careful campaign of "gradual encroachment." Each year he would rant and rave and threaten to go wild. Then he would take just

a little, while the world stood by and watched, hoping he was satisfied. These imperialistic fits happened each October and came to be known as his "October surprises."

Even the most naive pacifist couldn't ignore Germany's invasion of Poland in 1939. England and France declared war and it was one big pig pile again.

The first year saw Hitler's very successful "blitzkrieg." These ingenious Nazi lightning attacks succeeded in conquering most of Central and Northern Europe.

Winston Churchill took the English helm offering, "Nothing but blood, toil, tears and sweat . . . but a faith in ultimate victory." He successfully inspired and led England through the furious airborne "Battle of Britain."

LONDON DURING "THE BLITZ," 1942

Nazi air raids destroyed buildings close to St. Paul's Cathedral in downtown London.

Frustrated by British planes and the English Channel, Hitler turned east and sank his iron teeth deep into vast Russia. The Soviets suffered, but a harsh winter and the Russian "scorched earth" policy thwarted the

Nazis, just as it had defeated Napoleon 130 years earlier.

The war raged in Africa as well, while in Asia, Japan grabbed a million square miles. After Japan's unprovoked attack on Pearl Harbor, the USA joined in.

Once again, America's fresh forces and underestimated industrial might turned the tide.

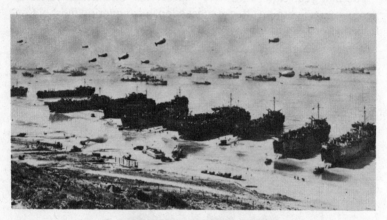

D-DAY, NORMANDY, FRANCE, 1944

The largest sea invasion ever. Bayeaux is the best homebase for explorations of the D-Day beaches, museums and memorials.

The Allies took North Africa and invaded Italy. They crossed the English Channel to Normandy on "D-Day" (1944), gaining a vital toehold in France from which to attack Germany. Russia made great advances while the Allies gained complete air control of German skies, bombing its cities almost at will. By May 1945, Hitler was dead and Germany had ceased to struggle.

The tourist today sees very few sights produced by the World Wars— their importance lies in what the tourist *doesn't* see. You won't see the wonders of Dresden, Germany, at one time one of the most beautiful medieval cities in Europe. You won't see the lovely churches and architecture of Berlin, Cologne or Rotterdam. All these cities were leveled by air raids during the War, and have been rebuilt in modern style.

The best reminders of this terrible war are found in the resistance museums in Oslo and Copenhagen, at Anne Frank's house in Amsterdam, the concentration camps at Dachau (near Munich) and Auschwitz (Poland)—and in the memories of the older Europeans.

Modern Art

Why is modern art so bizarre? Better to ask, why is the modern world so bizarre? The world changed by leaps and bounds in the 20th century and so did the artist's place in it. Strange as some art may seem, it is often the honest representation of our strange world.

The World Wars devastated Europe. No one could have foreseen the extent of the senseless slaughter. Artists especially were shocked, disgusted and disillusioned. As old moral values were challenged by the horror of war and our rapidly changing society, so were artistic ones.

THE SURVIVORS, KATHE KOLLWITZ

Dada

The Jazz Age of the '20s, when Europe tried to drown the memory of the War in wine and cynicism, produced "Dada-ism." The name was purposely nonsensical and childish—made up to poke fun at the pompous art styles, theories and "-isms" of pre-War times. The one rule of Dada theory was that there are no rules. The Mona Lisa with a moustache; a snow shovel signed by the artist; a collage of shredded paper dropped on the canvas. These were the Dadaists' contributions to Art— a summation of the rebelliousness and disgust of the Roaring '20s.

A change in patronage also changed artists' views of the world they painted. Handmade art became an economic dinosaur, as rich people could buy beautiful objects and furnishings right off the production line. Artists found themselves on the outside of industrial society with its emphasis on utility, not aesthetics.

Without a patron to please, modern artists had no one to please but themselves and fellow artists. They turned to subjects of interest only to artists—studies in color, brushwork, textures. Originality and innovation were more important than beauty. Modern artists face the same

"FOUNTAIN," MARCEL DUCHAMP, 1917

Duchamp, the daddy of Dada, placed this urinal in a New York exhibit. By taking a common object, giving it a title and calling it art, he makes us think about the object in a new way.

challenge as Michelangelo's followers—be original at all costs. If you can't please the public—shock it.

"THE PERSISTENCE OF MEMORY" SALVADOR DALI, 1931

This tiny work (9½ × 13") sums up the Surrealists' attempt to shock us by altering familiar objects (i.e., the rubbery watches) and placing them in a familiar context.

Surrealism and Beyond

Dada's successor for shock value was Surrealism (the name implies "beyond realism"—as if reality wasn't weird enough already). Inspired by the psychiatric theories of Sigmund Freud, Surrealism explored the inner world of the subconscious mind. The canvases of Salvador Dali are "dreamscapes"—a landscape of primal, troubling dream images. In dreams, objects appear in weird combinations, constantly changing in shape and meaning. A cat becomes a woman, then I am the cat, and so on.

Marc Chagall (pron. shuh-GAWL) (1887-1985) though not a Surrealist, has the same scrambling of several images. Born in Russia, Chagall layered memories of the folk life of his childhood onto his art. His paintings are a colorful fantasy of images. Chagall also did some beautiful stained glass in the cathedral of Reims.

"SELF-PORTRAIT WITH SEVEN FINGERS,"
CHAGALL, 1912

191

While Surrealists painted recognizable objects, though often twisted or in unusual contexts, other artists continued the trend of purely abstract work.

As Europe struggled to rebuild and recover, the post-war focus of art shifted to America.

Jackson Pollock (1912-56) explored the power of paint. His canvases consist of paint dripped or tossed on almost at random. We must appreciate these paintings like we would a sunset or cloud formation—for the blend of colors and patterns that nature creates by chance. Pollock let the elements of chance and spontaneity create art through him.

ACTION PAINTING: JACKSON POLLOCK AT WORK, 1950

Pollock is the best known of America's Abstract Expressionists. Here we see him at work, using the technique he pioneered—"action painting." What distinguishes this as art (as opposed to a child's random finger painting) is a blend of accidental and deliberate drips of paint in the hands of an experienced artist.

"Pop Art" of the 50s and 60s, like Dada of the Jazz Age, challenges the old rules of what constitutes "Art." The everyday products of commercial society—toothpaste, soup cans, comic books and advertisements—are displayed as Art. We are forced to look at these objects in a new way, reflecting on the value our society places on them.

Modern artists experiment with modern materials. Beginning with Cubist collages, artists began replacing paint with all kinds of things. "Mixed-media" creations confront all the senses, even smell.

"WHAAM," ROY LICHTENSTEIN
TATE GALLERY, LONDON, 1963

A child's comic book becomes a 70-square-foot piece of art—"Pop Art." What would Raphael think?!

"BIRD IN SPACE"
CONSTANTIN BRANCUSI, 1924

"THE KISS"
CONSTANTIN BRANCUSI

Two examples of "minimalist" modern sculpture.
(left) Brancusi captures the grace and beauty of flight in this highly abstract, polished bronze piece.
(right) This simple yet . . . gripping work shows the influence of primitive art.

193

Painting has been the most creative of the visual arts in this century, and sculpture follows some of the same trends. The Primitivism of the Fauves affected Constantin Brancusi, whose sculptures are the equivalent of Matisse's "minimal" paintings. Only the slightest changes have been made in the original stone.

There is Cubist sculpture, Dada, Surrealism, Pop and Abstract. With collages and "assemblages" of diverse materials, the line between painting and sculpture has begun to blur.

Modern Architecture

The ready availability of the steel frame, reinforced concrete and high quality, mass-produced glass at the turn of the century challenged designers to create new forms.

"Form follows function" was the catch phrase of early 20th-century architecture. While visual artists (painters and sculptors) need only be concerned with how good their artwork looks (form), architects must be concerned also with how their buildings work (function). Using the new materials, architects began stripping a building down to its barest elements—focusing on function first and letting it dictate form.

♪ *"Bauhaus—is a very very very fine house."* ♫

"BAUHAUS," GROPIUS
DESSAU, GERMANY, 1925

Modern architecture—more functional than good looking. This purely geometric building set the style for almost every skyscraper since.

The "International Style" developed in the twenties, following the lead of the Bauhaus, a German arts school. This blocky building emphasized industrial design and functionalism in architecture. Rectangular outlines, flat roofs, no ornamentation, white walls and lots of glass were "Bauhaus favorites." When the Nazis closed the Bauhaus, its director moved to the USA where the style spread.

Fast-growing American cities like Chicago and New York provided fertile foundations for the International Style. Frank Lloyd Wright, an important 20th-century American architect, blended these ideas with his own organic roots.

Another major force in 20th-century European architecture was Le Corbusier. He was an innovative leader in city planning and putting buildings on pillars to free the space below. The church he designed at Ronchamp is a pilgrimage church for architecture students.

CHAPEL AT RONCHAMP, FRANCE
LE CORBUSIER, CA. 1955

A far cry from Gothic, this highly expressive church is one of the gems of modern architecture. Located atop a hill in the Vosges Mountains.

Scandinavian architects, like Alvar Aalto from Finland, developed their own style based on simplicity and clean lines. These traits carry over into the Scandinavian furniture and lighting designs popular in America today.

Architects became more concerned with town planning, housing and schools as they dealt with the large-scale reconstruction of European cities flattened by the war. Rotterdam and Cologne are examples of cities literally built from scratch in the last 40 years.

Scandinavia is Europe's pioneer in planned suburbs. Outside of Stockholm you'll find Vallingby and Farsta, striving for the ultimate in Swedish order and efficiency. Tapiola, east of Helsinki, is Finland's attempt at a futuristic utopia.

The streets of Europe's cities are becoming people places. Most large cities (Copenhagen and Florence, for example) have traffic-free pedestrian areas full of shops and cafes, providing a perfect opportunity for that great European pastime—people watching.

195

Contemporary European architecture has taken several directions. An extreme example of "form follows function" is the Georges Pompidou Museum of Modern Art in Paris. This huge exo-skeletal structure has its "guts" on the outside. All plumbing, heating ducts and wiring are brightly color-coded and draped in full view, freeing the interior to function as a spacious museum. The art it stores is as refreshing as the art it is.

Munich also has its modern architectural treats. The buildings for the 1972 Olympic games are an interesting experiment in tent forms. During your visit you can swim in the pool where Mark Spitz won his chestful of gold medals. Just across the street is the BMW headquarters and museum, housed in a futuristic cylindrical glass skyscraper.

Faced with ever dwindling space, rising populations, and dynamic societal changes, European architects and city planners have come up with some creative solutions.

Today's architecture is, as it has been from the caveman to Egypt and from Rome to the Renaissance, a product of available materials and technology, climate and the needs of the people.

Social Realism

Eastern Europe and the USSR are totalitarian societies. The government attempts to control all and uses whatever it can towards that end—including the media and art.

Its art is propaganda. Called "Social Realism," the style draws repeatedly on a few socialist or Marxist-Leninist themes. The noble muscular worker is constantly bashing the chains of capitalism and overcoming the evils of the bourgeois world. Family ideals, socialist morality, flags blowing heroically in the wind, and an undying respect for the fathers of that ideology and, of course, the USSR are found in the murals, paintings, statues and galleries throughout the region.

Russia is featured everywhere as the liberator—liberation from the Turks, from the Nazis, or from the evil West.

While art as propaganda is nothing new, only in the sphere of the Soviet Union has creativity been so channeled. Abstract art, which serves no purpose in inspiring the masses, is discouraged. Even artistic mediums as nebulous as music are censored for what they do or do not promote.

SOVIET PROPAGANDA POSTER

"Social Realism" art designed to rouse nationalist and class feelings against the "threat" of the capitalist West. Here the workers are shown victorious through passionate dedication to their state, industry and military. Soviet art is a broken record of "worker triumph" propaganda.

Europe Today

As you feel the fjords and caress the castles remember Europe is alive—coping, groping—and more interested in the future than in its past.

As tourists, we often forget that quaintness, cute old thatched roof houses and yodeling are not concerns of the average European. Of course, it's exciting to find odd remnants of Europe's old world that somehow missed the 20th-century bus. But much of what we see touted as the "real thing" culturally is actually just a pile of cultural cliches kept alive for the tourist.

As you travel seek out contemporary Europe as well as its past. Have curiosity for the concerns and issues of today.

Present-day Europe is dethroned, split and uneasy about a future it

can't control. Even before the dust of WWII settled it was obvious that post-War Europe would have its problems. The world was now dominated by superpowers and Europe was divided into two spheres—East and West, dominated by the USSR and the USA.

In the last year of the War, the Soviets "liberated" the Eastern European nations from the Nazis, installing Moscow-trained governments in each capital. Germany and the city of Berlin were split in two, with the eastern halves controlled by the Soviets. They drew an "Iron Curtain" of strict control along the borders of their satellite countries to keep their people in and Western democratic ideas out. Travel to these countries is still subject to government restrictions, visa hassles, money-changing regulations, and plenty of frustration.

While relatively few Americans brave the red tape and uncertainties of travel in Eastern Europe, it is rewarding. Go to Eastern Europe to see socialism in action (or inaction). A day in East Berlin is a great way to compare East and West, and it's just a walk through "Checkpoint Charlie" from West Berlin. Don't go to museums there, just become a temporary local for a day. Go shopping, dining, joyriding on a city bus, dancing or people-watching in a park.

Budapest, three hours from Vienna, in Hungary, is the "Las Vegas" or fun city of Eastern Europe. This is a great place to enjoy socialistic hedonism.

Yugoslavia is the only Eastern Bloc country to really establish its independence from Moscow. Yugoslavia is a fascinating mix of nationalities, religions, folk cultures and social systems. From a tourist's point of view, it's as open to travelers as its Western neighbors.

While the countries of Eastern Europe are dominated by the USSR, the USA leads the North Atlantic Treaty Organization (NATO), formed after the War to counteract Soviet encroachment in Europe.

Throughout the '50s and '60s the USA and USSR "fought" a "Cold War"—a clash of words and ideologies. There was no actual fighting between the two, but they each used force or threat of force to gain influence in strategic areas of the globe.

The tension between the superpowers is still a burden on the mind of every European, especially since the development of nuclear weapons with their potential to destroy the world—windmills, castles, pubs and all. Europe feels powerless, and many think the next war will involve her only as a fighting ground. With the horrors of two devastating wars in her recent past and many one-legged pensioners and tombstone-covered hills as a reminder, Europe has developed a very strong peace movement.

The giant powers from outside are a constant concern, but little powers from within are also troublesome. No European country has perfect national homogeneity. Small nationalities—without a nation— are struggling to assert themselves as a people—or at least survive. France, for instance, has the Basques, the Corsicans and the Celtic peo-

KELLOGG'S
CORN FLAKES
direkt aus dem
Paket in den Teller
schütten, nach Geschmack Zucker
darüber, frische Milch dazu — fertig!

Töm
KELLOGG'S
CORN FLAKES
i en
tallrik och servera med
mjölk och socker.

Versez les
KELLOGG'S
CORN FLAKES
directement dans
l'assiette ou le bol, saupoudrez de
sucre, arrosez de lait et c'est prêt!

Kom
KELLOGG'S
CORN FLAKES
lige fra pakken
i en tallerken og server
med frisk mælk og sukker — parat!

KELLOGG'S
CORN FLAKES
in een bord
strooien, wat
suiker bij naar smaak, koude melk
over gieten — dat is alles!

KELLOGG'S
CORN FLAKES'it
kaadetaan suoraan
paketista lautaselle,
lisätään maun mukaan sokeria ja
maitoa — siinä kaikki!

Pour
KELLOGG'S
CORN FLAKES
into a bowl,
add milk and sugar — ready!

Töm
KELLOGG'S
CORN FLAKES
i en tallerken
og server den med melk og sukker.

Echar
KELLOGG'S
CORN FLAKES
directamente del
paquete al plato, añadir a gusto
azúcar, además leche fresca — acabado!

Αδειάστε
ΚΕΛΛΟΓΚΣ
ΚΟΡΝ ΦΛΕΪΚΣ
απο το πακετο
κατ' ευθειαν στο πιατο, προσθετετε κατ' επιθυ
μιαν ζαχαρη, κατοπιν φρεσκο γαλα — ετοιμο!

Versate i
KELLOGG'S
CORN FLAKES
nel piatto e
aggiungete latte e zucchero — ecco tutto!

فـرّغ رزمة الـ كيلو غـس كورن فلاكيس مباشرة
في الصحن وضع فوقه الـسكر حسب ذوقك
ثم صب عليه الحليب الطازج ـ طعام جاهز ·

KELLOGG'S
CORN FLAKES
diretamente do
pacote para o
prato, açúcar e leite a gôsto - e pronto!

کورن فلاکس کلوگ را
بیکراست از بسته نوی
بشقاب بریزید ـ باندازه
دلخواه شکر بآن اضافه
کنید و شیر تازه روی آن بریزید ـ تمام !

ple of Brittany, who see themselves as un-French parts of a French em- pire ruled from Paris. The George Washingtons and Nathan Hales of these little neglected nationalities are busy making news in Europe.

Despite these divisive forces, Europe is becoming more and more like

a single nation. The European Economic Community (EEC) was created to give the Continent a chance to "keep it in the family" economically, exchanging competition for a policy of freer and easier trade within the Continent. Nowadays, crossing national borders in most of Europe is no more difficult than crossing state borders in our country.

Europe's past domination of the world, culturally and economically, is fading. Like the USA, Europe enjoys one of the world's highest standards of living but, also like the USA, it is opening its eyes to the fact that the unreasonable affluence of the '60s and '70s is over.

The colonial empires have crumbled and the world's economic muscle is now in the USA and Japan. Europe is feeling "colonialism in reverse" as many people from the Third World are finding, or are hoping to find, their land of promise in Europe. In London, for instance, "white people" are now a minority.

There was a time when Germany and Switzerland were so strong economically that they imported Turks and Yugoslavians to take their undesirable jobs. Now, with unemployment a problem and the economy weak, racial tensions plague these countries, and the "gastarbeiter" (guest workers) problem is a pain in the national neck.

As the world hurtles toward 100 billion McDonald's hamburgers served, Europe is looking more and more American. Fast food, American rock-and-roll, English phrases, international corporate media blitzes and Hollywood are shaping the culture of the young. It seems that when all the wrinkled old ladies in black die, they will be replaced by a Europe of Coca Cola, skyscrapers, Walkmans, computers and Top-40 tunes.

The most encouraging aspect of our future is that as the world grows smaller, more people will travel and rub shoulders. As this happens we begin to see our globe as the home of five billion equally precious people and we'll all feel a little less American, British, Japanese or French and a little more like a brotherhood of mankind. With this sort of grassroots understanding of our very human world we may eventually undercut the tendencies of governments to fuel tensions that, given our incredible powers of destruction, make this a frightening time to live.

The lessons of history apply—even today. It's easy to think that we are in a grand new age with no precedent, one that follows no rules. Every generation has thought this and we're just the latest in a long line of pioneers in time. History is happening now, and plenty of excitement lurks just around the corner. If we can see ourselves in historical perspective, seeing how yesterday shaped today, we will better understand—and hopefully shape—the events of tomorrow.

Relax...Congratulations!

You've just finished the story of Europe. Before you pack your bags, tie things together with a look at our general tangents.

These are articles of special interest to travelers and anyone who wants a broad understanding of European culture. In the last section of the book you'll find:

Timeline
The Modern World

The Industrial Revolution brought Europe into the modern age. Nationalist movements created the modern European nations as we know them. Colonialism in Africa, Asia and South America made Europe the number one economic center of the world.

Each of these trends had a counterpart in the world of art. The Industrial Revolution put new building materials in artists' hands—The Eiffel Tower would have been unthinkable before the age of iron. The current International Style of architecture, emphasizing function over decoration, is the direct descendant of the Industrial Style. Still, many builders didn't know how to use these new materials, choosing instead to revive old styles for new structures—like the Neo-Gothic/Neo-Baroque/Neo-Classical Houses of Parliament.

Romanticism helped the nationalist cause by praising the individual and reviving folk art—the art of the unspoiled peasant. National groups became aware of their common identities through revival of folk songs and themes in high-brow music and art.

Colonialism brought unprecedented prosperity that allowed great experimentation in art. The Impressionist and Post-Impressionist movements in painting are products of these experiments. For the first time artists became concerned with purely artistic problems, disregarding the buying public.

World War I was the great dividing point. The harshness and pointlessness of the War (and its sequel, WWII) shook the art world. Artists tried to show the destruction of the time-honored social values. Rules of art—like those in the political realm—went out the window. It remains to be seen what new, lasting rules (if any) will come out of today's broad range of styles.

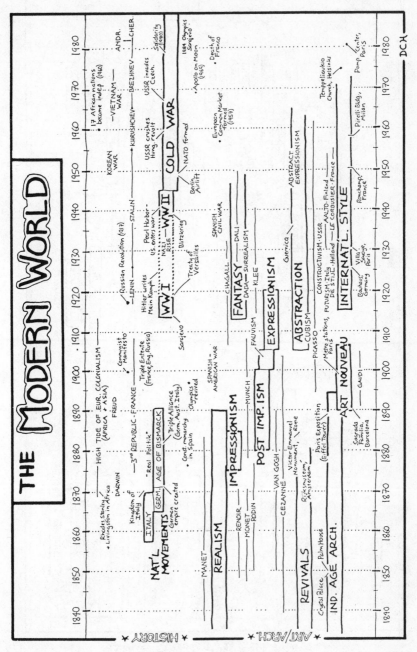

THE MODERN WORLD

203

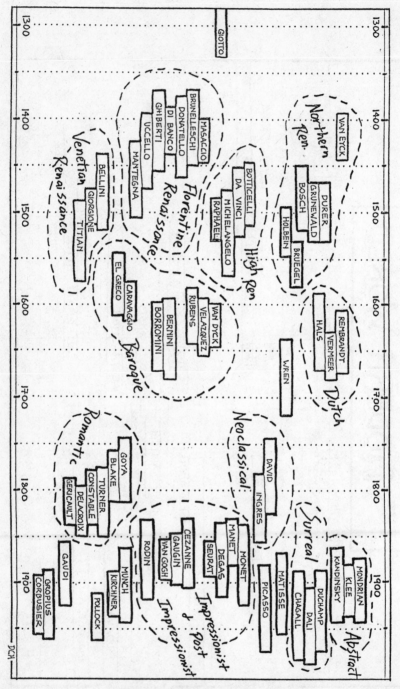

Artist Timeline: 1300—1985

Part 2—TANGENTS

**Articles developing areas
of special interest to travelers.**

Ancient World

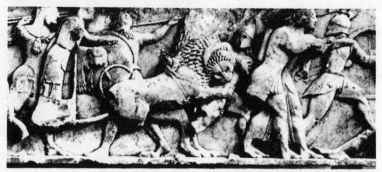

Life Slice—Ancient Greece

It's hard to imagine a Greece without rubble, without ruins; when statues had arms, when buildings had roofs; when the grey marble columns were painted bright colors; when flesh and blood people bought and sold in the marketplaces, worshipped at the temples, and attended plays and festivals in the amphitheater. Yet there was a time when Greece was more than a museum filled with dead and crumbling ruins. In fact, ancient Greece during the Golden Age was probably more similar to modern America than are many societies today.

After God created the world, he found a heap of stones left over. He threw them into the sea and they became Greece. Greece is a rocky collection of islands and isolated valleys. A civilization's physical environment influences how its people live—and Greece is a "classic" example.

Farming was a tough row to hoe in such rocky soil. The Greeks soon learned to trade with people in more fertile areas. They specialized in wine, olive oil and crafts, especially pottery, and traded these with neighboring countries for grain.

Another valuable "commodity" was a slave. It's estimated that as many as one in three Athenians during the reign of Pericles (around 440 BC) was a slave. Most were prisoners of war. In general, they were treated well, performing household tasks much like a paid domestic today.

Democracy

Besides being slaveholders, the ancient Greeks were great democrats. Greece was divided by mountains and water into many small, self-

governing democratic city-states run by common vote of the citizens. In Athens any citizen could vote. Citizens were adult, land-owning males. (These restrictions were lenient compared to most ancient societies.)

The citizens were expected to take part in public affairs, though day-to-day decisions were made by an elected council. The General Assembly met about twice a month. When the agenda was dull, the police had to herd eligible citizens to the amphitheater, with ropes dipped in wet paint to encourage stragglers. (Talk about getting out the vote.)

Pericles was the "president" of Athens during the Golden Age. A great orator, general and administrator, he rebuilt Athens after the devastating Persian War. He was often opposed by rival council members, but the people loved him and re-elected him every time. When he retired after 30 years of public service, an audit showed that not one drachma was misused for personal gain.

GREEK TOWN MEETING

The Greeks participated directly in their governments. A city-state was small enough to make this "town meeting" style of government possible.

The Greeks loved to get together and talk about politics and life in general (as they still do). The agora—the main square surrounded by covered porches—was the center of activity where farmers, merchants, sailors, refugees and philosophers met to exchange goods and ideas. In fact, the Stoics, a Greek and Roman philosophical school, got their name from hanging out under the "stoas," the shaded porches in the agora.

While the men congregated to discuss public affairs, the women were in charge of the home. For the wealthy this meant directing household slaves, who did the cleaning, cooking and shopping. With all their wealth, the Golden Age Athenians still lived quite simply. For dress, both men and women wore a simple, loose tunic, over which they draped a heavier wool wrapping for decoration and warmth.

Golden Mean—Nothing to Excess

Athenians tried to live the "golden mean," a balance between body and mind. The children learned three subjects in school that taught this balance. The first was the three R's, which included memorization of Homer and other poems. Many an educated Greek could recite the entire Iliad (a work as long as this book—and nearly as important). This may astound us today, but before the printed word, memorization was the best way to pass on knowledge. (Think of the number of popular song lyrics you've committed to memory without even trying. You may be surprised.)

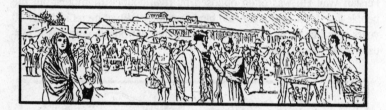

GREEK AGORA, OR MARKET

The agora, or marketplace, was the civic, commercial and social center of ancient Greek towns (like the forum was to Roman towns).

Children also learned music, played on a seven-string lyre or harp, with lyrics and as an accompaniment to dancing. Plato said, "Rhythm and harmony sink deep into the caverns of the soul and take the strongest hold there, bringing the grace of body and mind found only in one who is brought up the right way,"—in other words, with music.

Athletics was the third subject, with wrestling, riding and Olympic-style events, as well as dance-like exercise to teach grace.

An essential part of many boys' education was a "patron," an older man who provided money and advice. Homosexuality was accepted (even encouraged) between the young man and his patron, though such a relationship between two adult peers was considered silly.

We see the idea of the "golden mean" demonstrated in the Greeks' two main leisure activities, sports and the arts. It's well known that wars were halted to hold the Olympic Games every four years. All weapons were confiscated within a ten-mile radius of the stadium.

Events included many of the running, jumping and throwing events we have today, plus the ever-popular four-horse chariot races. In wrestling and boxing, the normally stately Greeks played for keeps—most wrestling was no-holds-barred (and remember, they fought in the raw!).

One event combined wrestling, boxing and kicking, and was fought until one contestant cried "uncle" or couldn't cry at all.

The Games were technically amateur and the only prizes were the thrill of victory and a wreath of wild laurel leaves. But, like many modern "amateur" athletes, the Greeks were often trained with state funds and rewarded with good jobs if they represented their city-state well. No doubt winners cashed in on their fame by endorsing body oil and after-shave.

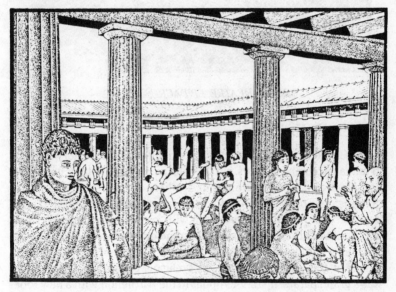

Boys wrestling gaily under the watch of their patrons, chatting in the shade.

The Greeks' other great passion was the theater. Plays were performed during the annual spring planting festivals celebrating Dionysius, the god of wine. The singing, dancing and poems of the earliest festivals gradually developed into full-length plays. In Athens, city-dwellers celebrated with three days of play-going in the open-air Theater of Dionysius, which seated 15,000. (Every summer Athens has a drama and music festival. And even today, many performances are held in the old outdoor theater.)

The "celebration" must have included a few tears, for the Greeks were famous for writing tragedies. The three greatest tragedians up until Shakespeare were 5th-century BC Greeks. Comedies were popular as well, poking fun at contemporary celebrities and morals.

GREEK THEATRE, EPIDAURUS, 350 B.C.

Greek Religion

The Greeks of the Golden Age were among the first in history to glory in human accomplishments, but they still paid tribute to their gods. The gods, living on Mount Olympus in Northern Greece, were like super-humans, immortal but with human jealousies and quarrels. It was necessary for men to appease them with food and livestock offerings in order to get them on their side in some endeavor.

Athena, goddess of wisdom, was the patroness of Athens. Her temple on the Acropolis was the city's religious center. Every year, there was a grand parade up the Acropolis to the Parthenon with a new robe for the huge, painted statue of Athena—men on horseback and riding chariots; boys leading oxen for sacrifice; girls with incense and wine to pour out as libations; the leading citizens in their finest clothes; and musicians playing flutes and lyres. Each city-state had a similar annual procession to its own acropolis to worship their patron god.

Greeks from all over made pilgrimages to Delphi, where the god Apollo spoke to people through a medium. The temple of the oracle was built over a sulphur spring. The oracle, an old woman, became intoxicated by the fumes, fell into a trance and began speaking the god's answer to a pilgrim's question. The answer—usually gibberish to the customer—was interpreted by the temple priests. The oracle saved Athens from defeat by the invading Persians, advising them to abandon the wooden fort on the Acropolis (the Persians burned it) and attack with their ships.

Some Greeks believed in an afterlife rather than the dreary under-

world of ghosts portrayed in myth. The Eleusinian Mysteries was an annual ritual to initiate candidates into the mysteries of life and death. (Exactly what they were remains a mystery to this day.) It was open to all Greeks, and wars were interrupted for this ritual just as they were for the Games.

Candidates walked from Athens to Eleusis (a day's journey) and were left there to wander the shores that night with torches. The next night, they were led blindfolded to a great hall filled with thousands of spectators. After being warned to prepare to "pass through death," they were guided through a kind of haunted house, given quick glimpses of terrible scenes before being blindfolded again. Fainting was common, especially among girls. Finally, the blindfolds were removed and, in a blinding light, the goddess Persephone appeared and said: "Here is the secret—that death is a passage and no more."

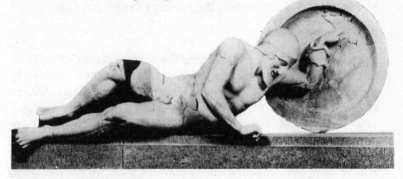

Spartan Sparta

Athens' great rival was the city-state Sparta. They shared a common language and were allies against the Persians, but the similarities stopped there.

Sparta was a war machine whose livelihood depended on forcing other people to do its work. The citizen lived to serve the state. Marriages were usually arranged to breed the best fighting offspring. At birth, the baby was washed with wine and inspected—if unhealthy, it was thrown from a cliff.

Spartan boys were sent to training camps at age seven for a regimen of physical exercise, along with some reading and writing. (It's interesting to note that as a result of this great emphasis on physical prowess, Sparta produced no great thinkers or artists.) The boys were given only one light garment to wear, even in winter, and they slept on the ground without blankets. At mealtime, each squad of boys might be

expected to fend for itself, hunting or stealing for food. Stealing was not a crime, but getting caught was. The historian Plutarch (ca. AD 100) reports: "A boy, having stolen a young fox and hidden it under his cloak, let it tear out his very bowels and died on the spot, rather than let it be discovered." Historians also report a religious ceremony in which boys were whipped to see how long they could take it before crying out.

Not surprisingly, the Spartans were fierce warriors. Retreat was not in their strategy. Mothers instructed their sons to return from battle "with your shield, or on it." During wartime, they grew their hair long. As King Lycurgus put it: "A large head of hair adds beauty to a good face and terror to an ugly one."

Still, the secret of the Spartan toughness was not in their training, reports one visitor of the time. The Spartans ate their meals, cafeteria-style at a common table. After enduring an awful meal of porridge, the visitor said, "Now I know why the Spartans don't fear death,"

Corinth

Corinth, a sea-trading town, tipped the balance of the Golden Mean to the other extreme. It was a rich city of luxury whose philosophy embodied the pursuit of pleasure as life's chief purpose. Aphrodite, the goddess of love, was the city's patroness. The priestess of the temple practiced the arts of love for all the faithful—for a tithe. The Corinthian women achieved fame and notoriety throughout the ancient world as sex goddesses. There was a Roman saying used when, say, someone had to work late while the others played: "Well, we can't all go to Corinth!"

Greece Lives On

Much of ancient Greece and its accomplishments live on in our modern world. Here are just a few areas where the Greek culture can be found.
1) Language—words like history, arithmetic, hero, -ology words (take a look at your dictionary to see just how many of our words have Greek origins).
2) Architecture styles in government buildings, banks, etc.
3) Democracy.
4) The Olympics.
5) Literature, theater, arts.
6) Science, math, philosophy.
7) Ideas of beauty—aesthetics.

Five Favorite Greek Ruins

Greece has a lifetime of crumbled old ruins to explore. It's very important, as you plan your Greek itinerary, not to assume that everything built before Christ is worth your energy. Be selective. Don't burn out on the mediocre. Choose as much antiquity as you can absorb—then concentrate on absorbing the sun, food and drink of a country with many dimensions.

Here are my five favorite Greek ruins. If I could see only these, I wouldn't worry about the rest.

Athens' Acropolis

Of course, this is the average tourist's image of a Greek ruin. While I think the city of Athens is overrated, its Acropolis is not.

The Parthenon, the climax of the Acropolis and Greece's finest Doric temple, is worth really studying. Along with its famous temples, this historic hilltop has a fine museum that's helpful in mentally reconstructing the original magnificence of the Acropolis.

Below the Acropolis is the ancient Agora, Athens' civic center and market. Most important among many sights here is the Temple of Hephaistos, or Theseum, the best preserved classical Greek temple anywhere.

Delos

Without Delos, Athens' Acropolis may not have been built. During Greece's "Golden Age" the treasury of the Athens-dominated Greek alliance was located on this little island near Mykonos. The Athenians financed the architectural glorification of their city by looting this treasury.

Delos, an easy half-day sidetrip from Mykonos, has its share of glories. Delos was the legendary birthplace of Apollo, and therefore the most sacred Cycladic Island. Today it is uninhabited except for daily boatloads of visitors. See the famous "Lions of Delos," wander through nearly a square mile of crumbled greatness, and climb to the island's summit for a picnic. From the peak of Delos you'll enjoy a grand 360 degree view of the Greek Isles with the Fort Knox of ancient Greece at your feet.

Olympia

For over a thousand years the Olympic Games were held, logically,

213

in Olympia. What was once the most important sanctuary of Zeus in all of Greece is now a very thought-provoking spot—and a popular tourist attraction.

Most tourists sail to Greece from Italy. The boat (free with a Eurailpass) lands in Patras, and the hordes stampede on into Athens. Be different. Head south from Patras to Olympia, then explore the Peloponnesian interior on your way to Athens.

Olympia at its height was fantastic. Its Temple of Zeus was the Eiffel Tower of the Greek world, boasting a then-world-famous forty-foot statue of Zeus by the great sculptor, Phidias. It was one of the Seven Wonders of the Ancient World.

Olympia can still knock you on your discus. Get there very early (before the tour buses), buy a guidebook and use it, along with the Olympia Museum, to refill the stadium with 40,000 fans and resurrect the wonders of these sacred stones and silent starting blocks.

Delphi

Once upon a time, Zeus, the king of all the gods, threw out two eagles. Where they met after circling the earth was called the world's navel, or belly button. This was the center of the universe in the days of Socrates and the home of the Oracle of Delphi.

Here the gods communicated with mortals through a priestess. This made Delphi politically powerful, religiously righteous and very rich.

Today its staggering setting does more than its history to make this four-hour sidetrip from Athens worthwhile. Along with plenty of photogenic ruins to explore, Delphi has one of Greece's best archeological museums.

Ephesus

The ruins of what was Asia Minor's largest metropolis and the home of the Ephesians of New Testament fame is, of all the Greek ruins, my favorite.

Ephesus is actually on the Turkish mainland, just a 90-minute boat ride from my nomination for the most beautiful Greek island, Samos.

At Ephesus you can explore a giant 25,000-seat outdoor theater, park your chariot outside a stadium that held 70,000, and hike up the marble-cobbled main street lined with buildings that are in a perfect state of ruin, with fragile remnants somehow surviving century after century. You can even sit on a 2,000-year-old toilet.

A trip to Efes (Turkish for Ephesus) is a great excuse to sample a slice of Turkey. Remember, if you're looking for cultural thrills, the difference

culturally between Turkey and Greece is much greater than that which separates Greece and the USA.

Athens' National Museum of Archeology

It's useful to preface the ancient wonders of Greece by a visit to the National Archeological Museum in Athens.

Athens (like Mexico City and Cairo) has hoarded the lion's share of its artistic heritage under one grand roof. Take this museum as seriously as you can. Trace the evolution of Greek art, study a guidebook, take a guided tour, examine the ancient lifestyles painted on the vases. With a rudimentary knowledge of Greek art you can, for example, date to the decade statues you've never seen before. With a little background you'll see more than rubble in the ruins.

I should caution you, Greece is the most touristed but least explored country in Europe. It seems that at any point in time, 90% of its tourists are crowding into its top 10 or 12 sights. Here, more than just about anywhere else in Europe, you should expect trouble finding rooms without reservations. Do what you can to minimize tourist crowd problems.

Greece is peppered with ancient sights, each offering something unique. But, as with paintings in a big museum, Gothic cathedrals or German castles, you can't and shouldn't try to see and appreciate them all. Be comfortable with selective savoring.

Life Slice—Ancient Rome

America minus electricity equals Rome. Ancient Rome is often compared to modern America. While it can be dangerous to assume that all people throughout history lived, thought and acted just like us despite different technologies—let's call that the "Flintstones Fallacy"—the Romans lived much like we do.

Wealthy Romans had all the comforts of modern living. The excellent trade and communication lines during the Pax Romana put the treasures of the known world at their fingertips: silk from China for dresses; spices, ebony, diamonds and precious jewels from India; copper, tin and lead from Britain; gold and silver from Spain; ostriches and peacocks for exotic banquets, and ice from the North provinces (to chill the wine).

For all their wealth, the Romans were actually practical, hard-working people who hated decadence or useless frills. We remember them best for their accomplishments in engineering and administration. A look at some Roman ruins gives a good idea of what their society valued.

They built 53,000 miles of paved roads (modern-day Sweden has 48,000), stretching from Scotland to Turkey, Egypt to Portugal. Made of several layers of stone and concrete four feet thick, they were as much as 40 feet wide. Many still exist today. When the terrain was rough, tunnels and switchbacks were built by skilled army engineers. The Romans' proudest achievement was their bridge building. The Emperor Trajan built the most famous one—the 3400-foot stone arch bridge over the Danube in Romania. (It's more than twice the length of the Brooklyn Bridge.)

The roads were lined with inns and taverns to accommodate travelers, mostly merchants with goods from other lands. Horses, mules and ox-wagons were the main vehicles, with an occasional two-wheeled chariot in the fast lane. Augustus started a "pony express" system for conducting official business. Riders rode horses in a relay from station to station at high speed. Even distant cities like Lyon, France, were little more than a business week away.

The City

Most cities of the empire were built on a similar pattern. The business center was the forum, an open square surrounded by shaded porches

where merchants set up shop. On one side was the basilica, a large covered building for judicial assemblies. On holidays, the forum served as the parade ground and festival center.

If the forum was the business center, the baths were the recreational center. Physical exercise and a daily bath were part of the everyday routine, but few people had private baths in their homes, so large, cheap, public houses (like Turkish baths) were vital to every town. They consisted of a series of rooms with hot and cold pools for sweating and cooling off. The floors and walls were hollow, with furnaces below to heat the pools.

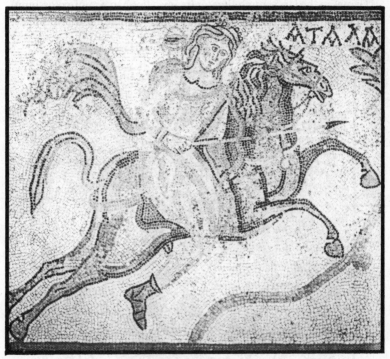

A ROMAN MOSAIC

Very little Roman painting survives. Fine mosaics cover Roman floors and walls from England to Jordan, giving us an appreciation of this grand civilization's style and splendor. Some of the most important mosaics are exhibited in Europe's leading museums.

The baths were an important social center for conducting business, discussing politics or philosophy, gambling (a popular pastime), and just plain relaxing. Most bathhouses had bowling alleys, swimming pools,

ball courts, masseurs and refreshments to meet their customers' every need.

The writer Seneca, who lived near a bath, gives us an idea of the goings-on: "What is it like to live near one? Just imagine every conceivable kind of noise that can offend the ear. That's what it's like."

The theater and amphitheater were the next important buildings in the Roman city. Music and drama weren't often highbrow entertainment. It was more like vaudeville—jugglers, mimes, tightrope walkers, farces, and big production numbers with flashy costumes and effects. Occasionally, a classic Greek play was revived—usually for a small audience swallowed up by a 2,000-seat theater.

Games in the large amphitheater (many cities had a mini-colosseum) were more to the average Roman's liking. Gladiators, wild animals,

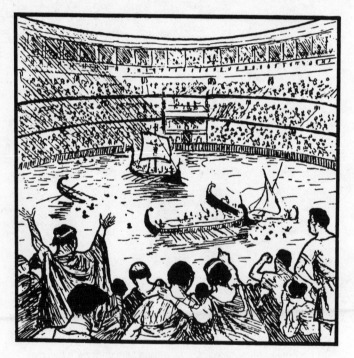

ROME'S COLOSSEUM

The Romans flooded their colosseum to enjoy mock naval battles.

prisoners, criminals and Christians were pitted against each other in various and interesting combinations. Fights to the death were the exception, however.

Rome's favorite pastime was chariot racing. In the city of Rome itself, chariot fans were divided among several teams—Reds, Whites, Blues and Greens. Competition was fierce—in the stands as well as on the field. In Pompeii, the amphitheater was closed to games for ten years after a massive stone-throwing free-for-all broke out between rival fans.

The public buildings were grand, but they weren't immune to the bane of all monuments—graffiti. "Marcus loves Spandusa" reads one wall in Pompeii. The amphitheaters had names and pictures of favorite gladiators in their triumphs. Advertising and election campaign slogans cluttered columns in the forum—"Vote for Claudius as magistrate—the watchdog of the treasury." And, of course, the all-purpose verse, such as this one found on numerous ruins: "I wonder you have not fallen, O walls / Beneath the weight of so many scrawls." Not very clever, true, but no worse than our modern-day, "Here I sit, broken-hearted . . ."

INSIDE A ROMAN HOUSE

While they somehow managed without video games, MTV and electricity, the Roman households could be surprisingly comfortable. Pompeii had hot tubs, running water, even pornographic wallpaper.

The typical city home consisted of rooms built around a central garden—the "yard" was in the center of the house. Leading up to the garden from the front door was the atrium, a large hall with an open ceiling to let in sun and precious rain. The central garden, often with a bubbling fountain fed from the community aqueduct, was a welcome break from the heat and noise of the city.

Of course, to talk of a "typical" house or "typical" family is always difficult, but especially so in sharply divided Roman society. At the top were the Roman citizens, a privileged title allowed to only a few (usually wealthy) men. The Christian missionary, St. Paul, often boasted of his citizenship and the legal and business advantages it gave him (Acts 16 & 22).

Next on the pecking order were citizens of the local community. Besides citizens, there were many free men without citizenship—the "middle class." Women were excluded from the rights and responsibilities of citizenship, though they often played key roles behind the political scenes.

ROMAN PORTRAIT BUSTS —THREE GENERATIONS

The Romans worshipped the father. Portrait busts were important in their religion and it was one area of art where they excelled. Here we see three generations of heads—sculpted in 50 BC, 40 BC and 20 BC—all plugged into a body done in AD 15. The Museo Capitolino on Rome's Capitol Hill has more heads than a cabbage patch.

Slaves were the bottom rung, even when they were as educated and "free" as their masters. Slaves were usually prisoners of war, debtors, or

their children. While they had no legal rights, they were generally treated well. Many owners freed loyal slaves and even remembered them in their wills.

A Day in the Life

Let's look at a "typical" well-to-do Roman citizen and his family over the course of a day.

In the early morning, Nebulus reviews the finances of the country farm with his caretaker/accountant/slave. At mid-morning he is interrupted by a "client," one of many poorer people dependent upon him for favors. The client, a shoemaker, wants permission from the government to open a new shop. He asks Nebulus to cut through red tape for him. Nebulus promises to see a lawyer friend in the basilica about the matter.

After a light lunch and siesta, he walks to the baths for a work-out and steam. There, he discusses plans for donating money to build a new aqueduct for the city.

Back home, his wife, Vapid, tends to the household affairs. The servants clean the house and send clothing to the laundry. Usual dress is a simple woolen tunic—two pieces of cloth, front and back, sewn together at the sides. But tonight they will attend a dinner party. She will wear silk, with a wreath of flowers. Nebulus will wear his toga—a 20-foot-long white cloth wrapped around the body and draped over one shoulder. It's heavy and hard to put on, but it's the rage.

The children, Raucus and Ubiquitus, say good-bye to the pet dog and bird and head off to school in the Forum. On the way, they stop at the bakery for fresh-baked bread. Once with the teacher, fun ends. They learn their basic three R's—or else. Discipline is severe. They'll be whipped if they step out of line. When they get older, they may study literature, Greek and rhetoric—public speaking. (The saving grace of this dreary education is they don't have to take Latin!)

At the evening dinner party, Vapid marvels over the chef's creation—ham filled with honey, pasted in flour and baked. Romans love good food and wine. Beef and cow's milk are considered inferior to pork and goat's milk. The wine is the finest the world has to offer—Roman merchants use wine as a staple trading product. They toast each other with wine glasses and clay goblets bearing inscriptions like "Fill me up," "Little water, undiluted wine," and "Love me, baby!"

The Roman orgy has become legend, but the legend is merely legendary. For the most part, they advocated moderation and sexual fidelity. If anything, stuffiness and business sense were the rule at such affairs. The family unit was considered sacred.

221

Roman Religion

Religion permeated Roman life. The gods were powers you bargained or dealt with. If you wanted a favor, you prayed and sacrificed to the proper god, either at home on a small altar or at the local temple. For guidance, you might see a seer who would rip open an animal to check the shape of the entrails for predictions of the future.

Jupiter was the king of the gods, based—like all the Roman gods— on his Greek counterpart, Zeus. Each profession had its patron god or goddess. For example, Betty Crocker would pray to Vesta—the goddess of the hearth. There was no moral obligation to worship the gods; you did it to gain a favor. Here's one prayer that has survived: "I beseech you to avenge the theft committed against me. Punish with a terrible death whoever stole these articles—six tunics, two cloaks, etc."

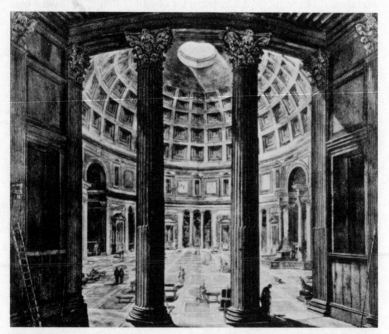

The Pantheon, with its famous and lovely skylight, is probably the one sight that will give you the best feel for the magnificence and splendor of Rome. It is built of concrete, and is 140 feet high and 140 feet wide. A domed temple dedicated to all Roman gods, it was the wonder of its time and inspired Renaissance artists. The huge domes of the Florence cathedral and St. Peter's in Rome were modeled on this early architectural triumph.

Europe Before History

European "prehistory" began with the dawn of homo sapiens and lasted at least until the coming of the Romans and Christianity. In popular folklore and place names, it lives on even today. The clash between Europe's barbarians and the civilized Romans in the Christian era produced the cultures and languages of medieval Europe.

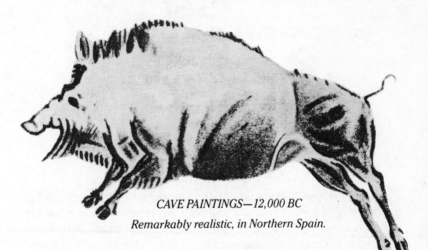

CAVE PAINTINGS—12,000 BC

Remarkably realistic, in Northern Spain.

As early as half a million years ago, people were using crude tools, and had developed the basics of language. The first signs of culture were "doodles" made by human fingers on wet clay cave walls in 30,000 BC. Over the years these doodles developed, with later cultures patterning them into pictures.

Paleolithic Art

Europe's first art came during the latest in a series of Ice Ages when people lived in tents and lean-tos on the bare icy plains, hunting wild animals like woolly mammoths. (Perhaps our modern culture is only a brief flowering between cold spells.) The finest examples of this art, on cave walls at Altamira, Spain and Lascaux, France, from around 12,000 BC, are startlingly realistic drawings of animals made with charcoal, ochre and other natural pigments. (Altamira and Lascaux are closed to tourists due to heat and humidity caused by modern crowds. The best

example of prehistoric cave painting open to tourists is the Pileta Caves, near Ronda, in southern Spain.) Some of these paintings have the look of our modern art—in fact, many modernists have adopted primitive techniques. One wall at Altamira shows bison decorated impressionistically with human handprints; the artists placed their hands inside the borders and blew colored dust around them through a hollow bone "spray gun."

Exactly why and how these hunters produced such dazzling art is something of a mystery, but it probably involved a magical ritual for good hunting. Regardless of how they did it, the naturalism of the figures is so good that it makes us think twice about how "primitive" these people actually were.

This "hunter-style" of art, most common in the caves of southwest France and northeast Spain, is found as far north as Scandinavia. Throughout Europe, there are ancient drawings of animals and, occasionally, the hunters themselves, chiseled and sanded on open rocks or dug into hillsides. Again, their purpose was probably not to decorate, but to bring them luck in the hunt—capturing the likeness of the animal was like capturing it in the flesh.

As the ice fields slowly receded (beginning around 8,000 BC), prehistoric people changed. The frozen plains were replaced by forests and plants, and food-gathering, farming and herding became more profitable in the warmer climate, replacing hunting. The wandering hunter tribes began to settle down. Europe entered a new era.

Historians divide prehistory into convenient "Ages" to show man's progression from stone tools and crude possessions to more sophisticated metals. The main Stone Age periods are the Paleolithic ("lithos" = stone, from Latin), 40,000-8,000 BC, the end of the Ice Age;

Mesolithic, 8,000-4,500; and Neolithic, 4,500-2,000. Then came the use of metals—the Copper Age, 3,000-1,800 BC; the Bronze Age, 1,800-500; and so on until Roman times. These are very rough categories, determined by many other cultural features besides what the tools were made of. Not all Europe progressed at the same rate, either—Scandinavia was still enveloped in ice long after the Continent had turned to forest, and its inhabitants had a simpler technology. Many present-day tribes—the bushmen of Africa, Australia's aborigines, the Eskimos, and England's punk-rockers—still have Stone Age technologies.

Neolithic Art

The main art trend as Europe passed from Paleolithic ("Old" Stone Age) to Neolithic ("New" Stone Age) was the loss of realism. Figures became more and more stylized and simplified. The artwork merely symbolized what it was supposed to represent in order to make the magic work—it wasn't an exact, realistic rendering.

THE VENUS OF WILLENDORF—30,000 BC

This 4 1/8" high limestone fertility symbol was one of many such statues made by prehistoric Europeans. This one was found in present-day Austria.

This trend is especially obvious in the small "Venus" statues so popular in the ancient world. Since man's life depended on the fertility of the earth, he worshipped "Mother Nature" in the form of a fertile woman. Paleolithic Venuses were realistic portrayals of a female. As time went on, though, they began to exaggerate the most feminine features—big breasts, hips, butt and genitals. By late Neolithic times they were more stylized still—a "Venus" might just be a stick with two lumps for breasts.

Megalithic Art

The most impressive remains of Neolithic culture are the massive megalithic ("big stone") ruins, like Stonehenge in England. Built from

stones weighing up to 400 tons, these structures were awe-inspiring to Europeans in the Middle Ages who thought they were built by a race of giants. Another Celtic story (from pre-Roman Britain) said that in ancient times, fierce warriors who were forced into a last-ditch battle faced the enemy so steadfastly they turned to stone.

The megaliths are of three types—tombs, "statues," and religious sanctuaries. The tombs, similar in purpose to the pyramids of ancient Egypt, were burial chambers for the great warrior-aristocrats of the time, carrying them into the realm of the dead. Under the theory that you *can* take it with you, the warriors were buried with all their possessions. Found throughout Europe, the tombs are most common in France which has some 6,000.

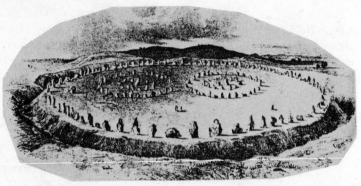

THE STONE CIRCLES OF AVEBURY - 3,000 BC

These stones were erected as a temple to the sun about the time the Egyptians built their first pyramid. They are in England, north of Stonehenge, and well worth a visit. The town of Avebury has grown up inside the large circle. (Artist's reconstruction.)

Some stones—called menhirs—were designed to stand alone, as statues. Often, they have relief carving of a stylized human being.

The final type of megalithic structure—the sanctuary—is the most impressive and most mysterious. There was usually a central circle of stones, possibly arranged for astronomical observations. For example, Stonehenge's pillars are placed so that the rising sun on the longest day of the year (the summer solstice) filters through and strikes the Altar Stones. Leading up to the sanctuary was an avenue of stones, able to accommodate huge crowds. The exact purpose of the structures is still mysterious, but we can imagine solemn, somewhat terrifying rituals for a god with great power—symbolized by the huge slabs of rock in an open moor.

In England, the building of megaliths extended into the Bronze Age (1,800-500 BC). The people of this time were farmers and herdsmen. They had increasing contact and trade with the more civilized Mediterranean world. We are fortunate these people were buried with their goods, for we now have a large store of both ritual and commonplace objects—weapons, pottery, jewelry, statuettes (Venus figures) and masks—that show a remarkable level of handicraft. The trend toward stylization in art continued in the metal ages. It culminated in the highly abstract, intricate, ornamental designs used for decoration by the Celts, the ancient peoples of Britain and France conquered by the Romans around the time of Christ.

Egyptian Symbols and Hieroglyphs

"They are religious to excess, far beyond any other race of men."
—Herodotus, ancient Greek historian

Religion permeated Egyptian life. An obsession with death and the hereafter, and the belief that the pharaoh was god on earth are found in almost all Egyptian art. The art is symbolic rather than realistic. Each stylized figure stands for some god or abstract idea.

Amen-Ra was the King of the Gods, the god of the sun. He is usually shown as a man with a beard, with a double-plumed headdress, and a scepter in his right hand. Like all the gods, this wasn't meant as a literal representation of what he looked like; the Egyptians recognized him by his symbolic dress and scepter.

Anubis was the Messenger of the Gods whose duty was to conduct the souls of men to the underworld after death. He is pictured as having the head of a jackal. Horus, God of the Sky, appropriately has a hawk's head. The pharaoh was supposedly Horus on earth.

The most popular myths involved Osiris, the God of the Afterworld, his wife Isis (whose cult spread throughout the later Roman Empire), and the evil Seth, God of Violence. These myths were told not in words but in pictures, with each figure representing some action or idea.

Symbols show the strict hierarchy in Egyptian society. A beard on a figure of art meant that figure was royalty. (Even Queen Hatshepsut is

SYMBOLIC CROWNS OF EGYPT

Upper and Lower Egypt were symbolized by crown types. The left crown is of Lower Egypt, the middle is Upper Egypt's, and the one on the right symbolizes the unity of both under one pharaoh—like the intertwined lotus and papyrus.

painted wearing one.) A leopard skin is a symbol of priesthood. Anyone barefoot is from an inferior class. Important people are shown bigger than commoners. A bull advertises a great military victory by the pharaoh. Egypt's two halves were represented by a lotus and papyrus plant. When a pharaoh united Egypt, the art of his reign included the lotus and the papyrus intertwined.

Pictures symbolized abstract religious concepts. The ankh was the symbol of life. The "ba," or soul, was shown as a bird, flying from the body at death.

Even Egyptian writing, called "hieroglyphs," used pictures to symbolize ideas. It combined two elements: 1) pictures that stood for sounds (phonograms), like our letters of the alphabet, and 2) pictures representing things and ideas (ideograms), like ancient Chinese writing.

Note how hieroglyphs are essentially pictures:

〰 WATER	𓀴 MAN	♀ ANKH
☉ SUN	◁𓁐 WOMAN	⬯ MOUTH
⌓ EARTH	𓅭 SON	▽ EVERYTHING
⊡ HOUSE	⊙ DO, MAKE	〰 OF 𓉘 RULER

THESE CAN BE COMBINED TO CREATE NEW MEANINGS:

SON **+** WOMAN **=** DAUGHTER

MAN **+** EVERYTHING **=** LORD

MOUTH **+** OF **=** NAME

EARTH **+** EARTH **=** EGYPT

(THE TWO LANDS)

(By the way, English has some words of Egyptian origin, via Greece: ebony, gum, sack, oasis and ammonite—from the mineral offered the god Amen-Ra.)

Hieroglyphic writing, with a different picture for each word, required memorization of a great number of symbols. Scribes had to be highly educated and enjoyed great prestige. In a society that valued eternal life, they had a head start—their writings lived on even if they didn't. As one ancient text puts it: "A book is more profitable than a tombstone."

While you're probably not quite fluent in your understanding of Egyptian symbolism and hieroglyphs after this brief lesson, at least when you see the 4,000-year-old masterpieces in Europe's many impressive collections of Egyptian art, you'll know that each squiggle has a meaning, and that . . .

-IAN AND MANY S AGO

EGYPTIAN GODS—ON PAPYRUS

The god Osiris sits in judgment as the jackal-headed god, Anubis, weighs the heart of a lady temple musician against a feather.

Ancient Britain

The Isle of Britain was a mysterious thing to General Julius Caesar as he stared across the Channel from France. Curtained in mist, separated from the civilized Continent by an arm of ocean, peopled by strange, savage tribes who sacrificed human beings to their gods—this was nearly all that was known of the island when Caesar set sail in 55 BC to conquer it.

The 45-year-old general had conquered Gaul (modern France), but wanted one more conquest to impress the folks back home so that when he returned to Rome they would invite him to rule the empire.

His invading ships approached Dover to find the cliffs lined with screaming, war-painted, spear-carrying Britons. After beaching, Caesar led a swift charge, driving the Britons back. The Romans huddled near the coast and waited for reinforcements, which were delayed by stormy weather. They were harassed by daring native soldiers in war chariots, who would dash up to the camp balanced on the yoke, wreak havoc and ride away.

As soon as new ships arrived, a weary Caesar packed up and re- turned to Gaul. His "invasion" was hailed a triumph in Rome—the Senate proclaimed an unprecedented 20 days of public thanksgiving.

The next year, better prepared, Caesar tried again, this time march- ing inland as far as modern London. He won battles, took hostages, ex- acted tribute and made treaties. He left England having brought the mysterious land into its first contact with "civilization."

Celts

The Celtic (pron. "KELL-tik" except in Boston) tribes Caesar found weren't as uncivilized as people thought. There were perhaps 100,000 Britons scattered in small, isolated tribes. A number of towns had 500 people, with present-day Colchester the largest with 1000 people. Still, most were rural farming-hunting-herding tribes under a local chieftain. Trade goods were carried over a few rough paths (Icknield Way is still visible), and there was some trade across the Channel with the Gauls. Most buildings were small ones of wood, but there were a few large castles, notably Hod Hill and Maiden Castle, both in Dorset.

The Celts (which include Gaels, Picts, Scots and many small peoples and tribes) migrated to England and Ireland from the Continent, start- ing around 500 BC. They conquered and blended with the prehistoric inhabitants (the even-more-mysterious people who built Stonehenge with huge rocks from 100 miles away and traded goods as far as ancient

231

Greece). The Celtic language survives today in modern Gaelic (Scotland), Erse (Ireland), Welsh (guess) and Breton (Western France). About half of present-day Great Britain is of Celtic-Pictish blood.

The Celts' nasty reputation in the Roman mind came from the Druids. These witch-doctor priests presided over rituals to appease the gods,

STONEHENGE, ENGLAND

Ancient Britain has many wonders. Stonehenge, a 4,000-year-old celestial calendar made of giant stones, is one. (Artist's reconstruction.)

spirits and demons that inhabited the countryside. There were ghosts and spirits everywhere; one could feel them in the gloom of a dark forest or in the power of a rushing waterfall. The Druids, painted all in blue, sacrificed and decapitated animals, and occasionally humans, offering the head to a local god or one of the more powerful fertility or war gods. Then they tore the body apart, using the disposition of the entrails to predict the future. They also practiced voodoo magic, cursing someone by making a statue of them and burning or mutilating it.

The Romans, tolerant as they were, tried to stamp out Druidism. Since the Druids were also tribal aristocrats trying to preserve tradition, they posed a political threat to the Romans. The Druids maintained power for a century after Caesar's brief invasions.

Romans

Then in 43 AD the Emperor Claudius ordered a massive invasion which overwhelmed the courageous but outmatched Celts. Claudius personally rode north from Rome for the victory procession through Colchester, accompanied by the Praetorian Guard, a host of Roman aristocrats and the imperial elephant corps to impress the natives. The Romans had arrived.

Claudius left after two weeks with the simple order, "Conquer the rest." It took 40 years, but finally all the lowland areas of England and Wales, plus lower Scotland were in Roman hands where they would remain for four centuries. The fiercely independent herdsmen of the Scottish highlands, though nominally Roman, never were assimilated into "civilized" Roman society (and, some would say, have yet to be assimilated into British society).

The conquest wasn't without resistance. In 60 AD, after a dispute with a local kingdom, Roman soldiers took the palace, flogged the queen, raped her daughters and seized the royal treasury. The outraged Celts banded together under Queen Boadicea and set out burning and looting Roman towns. The rebels took "Londinium" (London), burned it to the ground and offered the Romanized inhabitants as human sacrifices to the Celtic god of war. "Blood-hungry with success" they turned east on the Roman road of Watling Street and burned St. Albans. It took months for the Romans to beat down the rebellion. The winter was a bleak one for Britain as the Romans wreaked violent revenge. Boadicea and her family took poison to escape reprisal.

The Romans learned a lesson, however, and instituted policies to keep the Celts happy. Government was in the hands of a Roman, but he allowed local chieftains to retain power so long as they cooperated. Local customs and religious practices were generally accepted.

Around their forts the Romans planned towns in the familiar Roman pattern—a rectangular street plan with the forum (marketplace) and basilica (courthouse) in the center, temples, baths and a piped water system. Later, earthwork walls were built, defining their growth limit through the Middle Ages. Some towns grew as large as 1,000 inhabitants.

To connect towns and forts, and to facilitate trade and communication, they built roads, many of which still stand. Latin was taught, and soon it was as popular (in urban centers) as Celtic. When marriage was legalized for Roman soldiers, they often married local girls, and their sons grew up to join the ranks. The line between "Roman" and "Briton" grew fuzzier and fuzzier. By 200 AD the urban centers of southeast England were as "civilized" as any part of the empire. The population of Roman Britain grew to two million.

Londinium (London) was the Roman center of the country, the capital, trade center and hub of the road system. It was surrounded by a stone wall (parts of which are still visible). From here, Britain traded with the Continent, exporting wool, metals, hunting dogs, corn and oysters. In return they got all the luxuries of the Roman world: pottery, wine, glassware, lamps, jewelry, and the latest fashions in clothes, fur-

niture, silverware and so on.

The northern tribes of Scotland weren't so impressed with what the Romans had to offer, preferring independence to the niceties of Latin culture. Roman soldiers had to protect settlements from periodic raids by the northerners. They conquered as far north as the present border of Scotland, then built a wall to keep the Scots out. Hadrian's Wall (built while Hadrian was emperor, ca. AD 130) stands 20' high and 8' thick (wide enough for a chariot), stretching from the east to the west coast of northern England. It was manned by 20,000 men in forts spaced one mile apart ("mile castles") all along the wall. For over three centuries it kept the Scots at bay, and much of it stands today, a tribute to Roman military engineering.

(Hadrian's Wall is well worth a visit. The best preserved section is in Northumberland National Park along Military Road between Choller-ford and Gilsland. A youth hostel called Once Brewed is just a short walk from the best museum of the wall and a Roman "mile castle" built to defend the wall.)

Christianity came with the Romans. Rome, always tolerant of local religions, accepted many of the local Druid gods, giving them new Latin names. (The superstitious Roman soldiers, assigned to a distant outpost near a dreary forest, were careful not to offend any fierce spirits that might dwell there.) Nevertheless, the sterile Roman religion with its abstract gods and reverence for the state was no replacement for the personal power of the Druids. So the Britons, like many Romans throughout the empire, turned to Eastern mystery religions: Mithraism, the Cult of Isis, and Christianity.

Legend has it that Christianity was brought by Joseph of Arimathea, the man who paid for Jesus' burial. He converted the Britons with a miracle—he planted his staff in the ground and it took root, becoming a Glastonbury thorn tree which is said to bloom every Christmas.

Christianity became a powerful force—probably the number one religion—during the Roman occupation. Celtic, Roman, Eastern and Christian religions were all a part of Roman society. (Our evidence of Christianity's strength comes from reports of vandalism by Christians on Mithraic temples that went unpunished.) As late as 400 AD Celtic temples were built, and many Druidic rituals survived among the peasants up until modern times.

As Rome fell, so fell Roman Britain. The combination of internal dissension and external enemies that caused Rome's collapse forced them to slowly withdraw troops and administrators from Britain. Over the centuries, even the Roman governors and generals became

"Britonized" and drifted away from Rome. Some generals went so far as to secede from the empire, declaring themselves kings of Britain. Without Rome's strength and organization, the island was easy prey for invaders. In 409 AD the emperor in Rome was forced to completely abandon Britain.

The Anglo-Saxons

The invaders came from Germany and Denmark, tribes called Angles, Saxons, Jutes and worse names by the Britons. They came not as conquerors but as refugees, leaving behind a crowded, bleak homeland for the fertile farmlands of Britain. As early as 250 AD, small groups in longboats began arriving on the northeast coast. The Roman Britons fought them off when they could, and tolerated them when they couldn't. As Roman support waned, the invasion/migrations increased. The 6th century AD saw the Anglo-Saxons pushing the Celts and Romanized Britons west. This is the period of the real King Arthur, most likely a Christian Romanized British general valiantly fighting the invading tribes.

By 600 AD the southeast part of the island was "Angle-land" (England), the land of the Angles. The Roman world slowly fell apart, the towns dwindled, the roads were little traveled. The invaders were a rough, savage people compared to the Romans, with no central government or economy. Each tribe had its own chief and council of elders. The society was bound by a code of hierarchy and personal loyalty similar to the later medieval feudal system.

England had entered the Dark Ages. The economy was poor, life was harsh, and justice was severe. The "wergild," a system worked out to recompense relatives of people murdered in feuds, gives us a look at the value placed on human life in those harsh times. If a noble was killed, the murderer's clan had to pay the victim's clan 1200 shillings; a "thane" (knight) was worth 300; a "churl" (free peasant), 200; killing a serf required no recompense at all. Women of equal position were worth less than their male counterparts. (Hmmmm. This has a familiar ring . . .)

The Anglo-Saxon pagan religion replaced Christianity in many places. Some of these Norse gods are familiar to us today: Tiw, Woden (King of the Gods), Thor (with his hammer), Frig. Not familiar? How about "Tiw's-day," "Woden's-day," "Thor's-day" and "Frig's-day"? They also celebrated a spring festival to the goddess Eostre (Easter).

Christianity re-entered England with missionaries from both Ireland and Rome. When the Saxon king Aethelbert of Kent was converted (around 600 AD) the tide was turned. Within a hundred years, England

was again mostly Christian, though not by much. Pagans continued to rule in many kingdoms throughout the Dark Ages.

One of the Christian kings, Offa (ca. 780), brought some stability to the warring Anglo-Saxon tribes. The time of peace brought a renaissance of learning, and the English language took its earliest form. The poem "Beowulf," written in England but incorporating Norse mythology, was written at this time. Offa printed coins with his portrait on them, advancing the notion that the many Anglo-Saxon tribes were part of a single nation. (Offa built a trench to separate England from the Celtic Welsh. This "moat," the length of the English-Welsh border, is called "Offa's Dyke" today and is a popular hike among young locals.)

True unity didn't come until another set of invasions—this time from the Vikings, the Anglo-Saxons' distant cousins from Denmark. Alfred the Great (ca. 880) rallied the local chieftains just when it looked like the Vikings would overrun the island. Alfred is considered the first English king. His reign was enlightened and compassionate.

As it was, the Anglo-Saxons had to learn to coexist with the Danish Vikings. The two groups warred, made peace, and mingled during the next few centuries. This was the period of rulers with names like Harold Harefoot, Eric Bloodaxe, Edgar the Peacock, Ethelred the Unready and Edward the Confessor, who built Westminster Abbey.

The stew of peoples that make up present-day England was nearly complete—from prehistory to the Celts, the Romans, the Anglo-Saxons and finally the Danes. Next came the Normans (descendants of the Vikings or "North-men" who settled in northern France). William the Conqueror invaded from across the Channel, defeating the Saxon king Harold at the Battle of Hastings (1066). This marks England's escape from the Dark Ages, and her entry into the "High Middle Ages."

TANGENTS
Medieval World

Life Slice—Ye Olde Dark Ages

The Fall of Rome was like a great stone column falling across the Continent, burying Europe and scattering the light of civilization like so much dust. It was 500 years before the dazed Europeans began to pick themselves up from the rubble and build a new world. In the meantime, they lived lives of hardship, fear and ignorance.

During the Dark Ages, as the philosopher Hobbes described it, life was "nasty, brutish and short" (but then, so was Hobbes). Skeletons unearthed by archeologists show a people chronically undernourished. Farming techniques of the time, which had been developed in warmer, dryer regions of Southern Europe, were ineffective in the cold, wet North. Infant and child mortality was high. Average life expectancy was only 30 years.

Whatever civilization the Romans had brought to the "barbarians" of Northern Europe died. The roads and cities crumbled, used as quarries by local peasants. There were few large towns and little trade; the economy was subsistence farming clustered around small villages. A bad harvest meant famine and death for a local community isolated from outside help.

The Roman communication grapevine withered as fewer and fewer people learned to read and write. Priests and monks alone were literate or capable of even the simplest arithmetic. The easiest way to tell whether or not a man was a true cleric (churchman) was to shove a

book in his hands and say, "Read!" (Our modern word "clerk"—someone who works with words or numbers—comes from "cleric.")

There was no central governing authority—"king" was more an honorary title than a position of power. Government was in the hands of local nobles, barons, dukes, knights and petty lords.

Society was a feudal hierarchy with each group filling a certain role. The nobles provided land and protection for the peasants; the peasants in return gave the nobles part of their harvest. It sounds like a nice ar-

THE DARK AGE PEASANT SUPPORTING HIS LORD

A few people lived high on the medieval hog, but the vast majority of Europeans were serfs—bound to the land, barely subsisting, illiterate, superstitious, and waiting for a glorious life after death.

rangement, but in fact the peasant was legally bound to the land and to the noble. Nobles often created harsh and arbitrary taxes the peasant had to pay. The peasant was required to use the grinding mill and other farm implements owned by the lord, and at a high cost. Worst of all, the

"protection" promised by the noble is reminiscent of the Mafia—protection from violence in a feud started by the noble himself in which the peasant had no choice but to fight or die.

Nobles hardly lived lives of luxury, either. Their castles were crude structures—cold, damp and dark, with little privacy or warmth. Nobles were illiterate, even to the point of looking down on educated people. The younger sons and daughters of nobles (who received no inheritance) were forced to become clergy. The rest lived lives revolving around war, training for war, hunting and feasting. Their feasts often became week-long bouts of drinking and rowdiness. Medieval life was "regulated by a calendar of feasts which governed the relations between the living and the dead, old and young, men and women—blending technology, magic, work, religion, work-days and feast days into a satisfying whole."—Friederich Heer, *The Medieval World.*

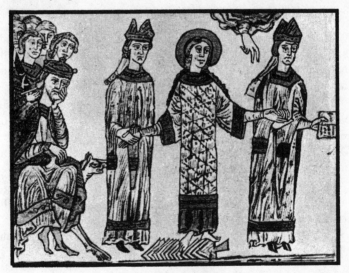

TRIAL BY ORDEAL

The ancient "Trial by Ordeal" survived well into the Middle Ages. Here, two bishops lead a queen barefoot over a red-hot grate to see if she has been true to her husband (left). Notice the hand of God "overseeing" things.

As if economic hardships weren't enough, the people of the Dark Ages had other things to fear. The "barbarian" invasions from Scandinavia (the Vikings), Hungary (Magyars), Central Asia (Huns) and Spain (Moslems) threatened Europe from all sides. The Dark Ages were a time of migration of tribes fleeing from danger and resettling in more hospitable lands.

They also had to contend with demons, devils, spirits of the woods and rocks, mischievous saints and a jealous God. Magic and local folklore intertwined with Christianity. Witches were burned. A sword could be put on trial for falling off the wall, as if a spirit had inhabited it. The hideous gargoyles that adorn Romanesque churches are right out of the imagination of these superstitious and frightened people.

Justice was meted out in "trial by ordeal." The accused might be asked to grab a red-hot iron or to pull a stone from a cauldron of boiling water; if he was unharmed or the wound healed miraculously in a few days, he was innocent. If not, he was really punished. These ordeals were usually held in or near the church, with the priest in attendance.

Look at a 9th-century "history book" and you can see the mix of magic, fear, fantasy, harshness and ignorance of the Dark Ages. The years are boiled down to a few terrible and miraculous events, all told matter-of-factly. Some excerpts:

"Account of the year AD 837: A gigantic whirlwind broke out and a comet appeared, emitting streams of light three cubits long before the amazed spectators. The pagans devastated Walicrum and abducted many women there, taking also huge sums of money.

"The year 852: The steel of the pagans grew white hot: an excessive heat of the sun: famine followed: there was no fodder for the beasts, but the feeding of pigs flourished.

"The year 853: Great hunger in Saxony with the result that many ate horses.

"The year 857: A great plague with swelling of the bladder raged among the people and destroyed them with horrible festering, so that their limbs dropped off and fell away before death.

"The year 860: On Feb. 5th thunder was heard; and the king returned from Gaul, finding his entire kingdom plundered."

The church was the refuge from this awful and fearful world. God was a god of power, like an earthly noble, to fight the forces of evil. God's weapons were prayer, Mass and other rituals which, in the minds of the peasants, had magical power. Romanesque churches stood like strong castles in the war against Satan. To the peasant, the church was a refuge from his dreary life and a hint of the glories that awaited him in heaven.

The popular religion didn't change much with the coming of Christianity; it just put new names on old folk gods. Christian churches were built on holy pagan sites. The "good spirits" of folklore became the "saints" of the church, powers to be bargained with for earthly favors.

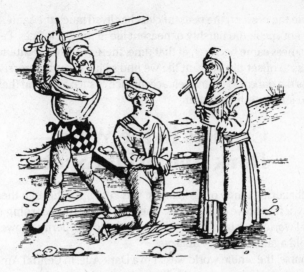

Finally, the church calendar, which established holy days (hence the word "holiday"), patterned itself after old pagan feast days. Even today, we celebrate Christmas much as the Druids of Britain celebrated the winter solstice, with trees and mistletoe.

It has been said that the one continuous thread in history has been the life of the peasant. In almost every society, from the late Stone Age

Feudal terms:

fealty = loyalty

fief = land, in return for fealty

lord = man above on feudal ladder

vassal = man below on feudal ladder

king = top rung of feudal ladder

serfs = near slaves who worked the land of the lowest lord. This was **manoralism**. The manor house was the lords palace.

knight = moves up two and over one. Worth about as much as a bishop.

almost to the present, the peasant class has lived much the same. So we should not speak too harshly of peasant life in the Dark Ages. Perhaps the darkness came because, at that time, there was no enlightened upper class to offset the peasant life we find so harsh and repressive. Or, perhaps the darkness lay in their acceptance of such a life and their lack of hope for something better.

Candles in the Wind — Dark Age Bright Spots

The flickering flame of civilization was kept alive through the Dark Ages by a few brave individuals. They preserved the learning of the classical world for a later time, when economic prosperity allowed it to take hold again in society at large.

Of course, the whole world wasn't in a Dark Age. In Central America, the Mayas and Toltecs were building great cities and doing complex astronomical work. In China, the T'ang dynasty was flourishing. Many of the technological inventions that spurred Europe's recovery from the Dark Ages came from China—paper, clockwork, looms, spinning wheels and gunpowder.

On the fringes of Europe, other cultures kept Greco-Roman learning alive. The Byzantine Empire—the Eastern half of the Roman Empire—lasted until early Renaissance times, and was always a stronghold of culture during Europe's Dark Ages.

The Islamic countries, from the Middle East to North Africa to Spain, fostered science, literature and a spirit of religious toleration while Europe was still groping for the light switch. In Baghdad (modern Iraq), the Abbasid dynasty of caliphs created an enlightened court for poets, astronomers, mathematicians and Greek scholars. This court, from the same time as Charlemagne, is immortalized in the "1001 Arabian Nights" (around AD 800).

Even within Europe, not all areas were in complete darkness. Italy, closest to the source of Roman influence, kept in touch with the classical world even after its fall to the barbarians. It was always linked by trade with the enlightened Byzantine world. Italy was even united briefly with the Eastern Empire under the Emperor Justinian (AD 550).

Boethius

Boethius (Bo-EE-thee-us, AD 480-524), the father of medieval scholarship, lived when Rome fell to the barbarian Ostrogoths. An

aristocrat, poet and scholar, he was chosen by the invading king, Theodoric, to help in the transition to foreign rule. These were chaotic times, with much bloodshed, disease and moral decay, as an entire culture was turned upside-down by invading forces.

Boethius took it upon himself to translate and transmit for posterity many of the ancient Greek writings (especially Aristotle and Plato). Unfortunately, he was cut off in his prime by court intriguers who accused him (as a suspicious Roman who also spoke even-more-suspicious Greek) of treason and dealing with evil spirits. He fell out of favor with the king, was imprisoned and executed.

The fate of Boethius, a learned man in a dark world, must have struck a chord with many intellectuals in the Dark Ages. His translations and commentaries were standard texts for medieval monks, and were part of the revival of Aristotle in the later Middle Ages.

Boethius' mystical book praising the value of learning, _The Consolation of Philosophy,_ was the number two best-seller during the Dark Ages (after the Bible). It must have given consolation to many learned men laboring under the chains of darkness and misunderstanding.

Spain and the Moors

Spain had its own Boethius—Archbishop Isidore of Seville (560-636)—who wrote a massive encyclopedia containing the sum of Latin knowledge. Isidore's work was the standard reference book for medieval monks and scholars.

When Spain fell to the Moslem invaders from North Africa its importance as an intellectual center increased. Islam was a strict religion, but its record on tolerating other religions was better than that of medieval Christianity. In Spain, both Christians and Jews were allowed freedom and relative equality (though for a fee). The interaction between the three cultures sparked inquiry and debate, and produced some of the Middle Ages' finest scholars. The Jews contributed the mental discipline of rabbinical schools; the Arabs brought astronomy, mathematics and ancient Greek texts; the Christians had knowledge of classical Roman culture.

In AD 950 the library at Cordoba, Spain, held some 600,000 manuscripts—in the same year there were only 5,000 in all of France! When Toledo was recaptured by Christians in 1105, they set about reopening the Arab libraries throughout Spain. This wealth of knowledge from ancient Greece and Rome was translated into Latin and made available to Europe in the later Middle Ages.

These Moors, or Arabs, ruled at least part of Spain from 711 until 1492

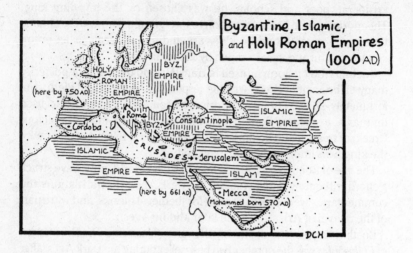

when Christian forces finally threw them from their last stronghold, the Alhambra in Granada. All over Spain and Portugal, but especially in Granada and Cordoba, you'll see impressive buildings that remind us of a leading medieval civilization, the Moors.

Monks — the Medieval Brains

Compared to the Southern countries of Italy and Spain, Northern Europe was a blind man in a coal mine. The light of civilization was carried by monks in the long process of converting pagans to Christianity.

We usually assume Europe was Christian from the time of the Roman Emperor Constantine, but it's not true. The faith was slow to penetrate the northern countries, and total conversion was interrupted by the Viking and Hungarian invasions of the 8th and 9th centuries. It's not until 1000 that Europe could be considered thoroughly Christian.

Monks alone could read or write or do simple arithmetic in a time when words, letters and numbers had magical power for the unlearned. The monastery was the local refuge and fortress against the evil demons of the world. Until the popes got the church organized into a central system (around AD 1000), the loose chain of monasteries was the "center" of Christianity.

The monks ran the mail system—carrying ecclesiastical business from kingdom to barony. They were also the keepers of technological knowledge—clocks, waterwheels, accounting, wine-making, foundries,

Intellectual life survived the Dark Ages in monasteries. Copying and translating Greek and Roman writings were common tasks for monks.

THE ROMANESQUE-STYLE MONASTERY AT CLUNY, FRANCE (Artist's reconstruction)

This was the largest church in medieval Europe. Now it is mostly in ruins.

grinding mills, textiles and agricultural techniques. The later Cistercian monasteries were leaders in the "Medieval Industrial Revolution" of the later Middle Ages.

Ireland

Fleeing the Barbarian chaos of Continental Europe, missionary monks carried civilization to the western fringe of the known world. Ireland was the northern intellectual capital. When St. Patrick (ca. 400s), a Christian monk from Romanized England, established the faith in Ireland, he found many excellent schools of the native Celtic tribes teaching classical subjects. Patrick's successors kept these schools open, mixing in Christianity. Latin learning was reinfused into England and the Continent (as far away as Switzerland) by Irish missionaries. Be sure to visit Cashel, near Tipperary, an impressive ecclesiastical center of Ireland during this period.

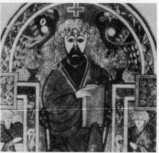

A page from the Book of Kells, Trinity College, Dublin. The "illuminated manuscript" was Dark Age Europe's greatest pictorial art form.

The *Book of Kells* (Trinity College, Dublin) and the *Lindisfarne Gospels* (British Museum) are the best examples of this Irish flowering from AD 500-900. Both are illuminated (illustrated) Gospels showing classical, Celtic and even Byzantine influences. Lindisfarne, or Holy Island, is the small isle off England's Northumberland coast, the site of a Christian outpost which lasted until the Viking invasions in 875.

Bede of England

England's great beacon was Bede (pron. Beed, ca. 700), an Anglo-Saxon monk. Raised in a monastery from the age of seven, he visited Lindisfarne, then settled down in York to write the *Ecclesiastical History of the English People* from Julius Caesar to his own day, one of the first history books since ancient times. Bede died in AD 735—AD means "Anno Domini," or "year of our Lord." (I stress this because it is from Bede's history that we get the current method of dating from the birth of Christ.)

Charlemagne's Renaissance

One of Bede's pupils founded a school at York, which produced the great scholar, Alcuin. Alcuin was renowned as the most learned man of his time, but he quite likely expected to live out his life in the obscurity of provincial York. But then came an invitation from Charlemagne, king of the Franks, to visit his court at Aix-la-Chapelle (modern Aachen in West Germany) and give it some class.

The reign of Charlemagne is the turning point in the early Middle Ages. Before his time, it appeared that darkness might dominate forever. Afterward, the hope returned that learning and civilization might be restored.

Charlemagne (crowned, AD 800) united the Frankish tribes and kingdoms into the largest European empire since Rome. Furthermore, he personally set about to improve the lot of his people. He instituted trial by judge, replacing the barbaric "ordeal"; he revised the monetary system, built schools and churches and advanced the Christian faith. Perhaps most important, his foot became the standard form of measurement—the "foot"—so goes the legend.

With Alcuin and other scholars, artists and educators at Aachen, the court became the model for all lesser kings and tribes of Europe. Charlemagne himself took classes set up by Alcuin, studying Latin, Greek and third-grade arithmetic.

Despite the "Carolingian Renaissance," we shouldn't forget that these were still the Dark Ages. Charlemagne was an enlightened but ruthless leader. He is responsible for the conversion of the pagan German tribes to Christianity. His chosen instrument of persuasion was the same used by later Crusaders—the sword. He invaded Germany, conquered it tribe by tribe and gave the leaders a choice—convert or die. Apparently it was not an easy choice, as many chose martyrdom and guerrilla resistance. Charlemagne responded by chopping down the sacred tree trunk said by pagan myth to support the world. The pagan world, however, didn't tumble with it. The Franks built "churches" that were really military outposts in the conquered lands. Resistance died hard, and the resisters died even harder; it's said that Charlemagne once ordered the decapitation of 4500 pagans in one day.

England's Alfred the Great

When Charlemagne died, his hard-fought empire quickly broke apart. But the spirit of his "Renaissance" lived on, embodied in the first great English king, Alfred the Great.

Alfred (849-899) united the scattered Anglo-Saxon tribes of England to ward off the Viking invaders. After establishing peace, he turned to matters closer to his heart. Having been raised a younger son, he never expected to become king, so he studied poetry and Latin, even visiting Rome in his teens.

When called upon to lead the Anglo-Saxons, he took it as his personal responsibility to defeat the Vikings (who were believed to be a punishment from God) and educate his people so they could learn God's will. He reformed the government and built schools, teaching English as well as Latin. As a scholar, he personally translated Boethius' *Consolation* into English, and had Bede's history translated as well. Alfred deserves his reputation as the model English king—strong, learned and compassionate.

Into the Light

In AD 1000, when Europe passed out of the Dark Ages, the pope was a French scholar named Gerbert (zhehr-BAYR) (his assumed papal name was Silvester II). Born a commoner, he received the best education the church had to offer, and supplemented it with study in Spain. By the time he was elected pope, his was the most renowned mind of Europe.

Gerbert was fascinated by secular knowledge. He introduced the abacus to Europe, popularized clocks and developed astronomical instruments, as well as collecting ancient classical writings. Like Boethius five centuries earlier, Gerbert was often accused because of his great knowledge of being a sorcerer or witch. But this time, the authority of the papal throne itself protected him. It's fitting that Gerbert was in power as the millennium turned and Europe emerged into the light.

Knights, Ladies, Love and War

When we think of medieval knights, we think immediately of King Arthur and the Knights of the Round Table. How appropriate that this symbol of chivalry is a myth—Arthur and the knights are pure fiction based on a minor historical figure—for chivalry itself existed more in the story books than it did in real life. Nevertheless, it played a big role in medieval thinking.

Knights and Chivalry

Knights of the Middle Ages followed an unwritten code of honor—chivalry—that demanded valor in battle and service to their king, God

and lady-love. Originally intended for knights alone, it was quickly accepted by all nobility in Europe, whose lives revolved around war, religion, loyalty and (sometimes) love.

Knights were warriors who pledged their fighting skills to some powerful lord in return for land and a title, or just money. Knights on horseback were much more important than the average mercenary foot soldier. With the invention of stirrups the rider could "dig in" and put force behind the lance he carried. A single knight could charge and break the ranks of dozens of foot soldiers. Dressed in a heavily armored suit (so heavy that, if he fell off, he was as helpless as a turtle on his back), a mounted knight was like a tank among infantry.

Later descendants carried the title of "knight" earned by their warrior forefathers even when they themselves took no part in war. The code of chivalry still applied to these gentlemen of high society. In fact, the word for "gentleman" in several languages (French—chevalier; Spanish—caballero; Italian—cavaliere), like the word chivalry itself, comes from the Latin word for "horseman."

When there were no real wars to prove their courage and skill, knights held tournaments, fighting each other in teams and individually. The most common event, the joust, sent two knights charging at each other on horseback each determined to unseat his opponent with a lance. Sure enough, many knights died in these "sporting" contests. Later tournaments tried to minimize injury by using blunted or wooden weapons, saving the sport but dropping the danger (like modern fencing). Still, as late as 1559, France lost a king (Henri II) when a wooden splinter pierced his visor during a joust. Medieval pageantry and contests like the jousts are re-enacted very energetically in many of Europe's colorful festivals. Try to work a few of these festivals into your itinerary. (See list on p. 358.)

Troubadors

The heroic deeds of knighthood were proclaimed in story and song by troubadors, the poet-singer-storytellers of the Middle Ages. These men were not journalists, by any means—they didn't tell of real men performing real deeds. Instead, they created an ideal world where men were always brave and women always lovely. Their stories set the pattern of behavior for medieval lords and ladies.

King Arthur and the Knights of the Round Table—Lancelot, Galahad, Gawain and Perceval—exemplified the ideal chivalrous society. Troubadors took these old Celtic folk legends and reworked them to fit the morals and mores of the time.

"Camelot" — Henry and Eleanor

The closest Europe ever came to a real "Camelot" was the court of King Henry II and Queen Eleanor of Aquitaine, rulers of England and France during the short-lived Angevin Empire (1150-1200). Henry was the perfect Arthur—strong and intelligent, with a dominating personality. Eleanor was the refined, strong-willed and beautiful Guinevere—with a healthy dose of political savvy thrown in. Their son, Richard the Lionhearted, was all the Knights of the Round Table rolled into one. As one contemporary described him: "He was tall in stature, of handsome appearance, his hair between red and reddish yellow. . . Assuredly he surpassed all others both in his good character and in his great strength."

Their court was Europe's center for troubadors and young knights, for days spent in jousting, and nights under the stars listening to stories and songs.

Women and Courtly Love

It was here that a new element was added to the old warrior's code of chivalry—love. The knight of this period not only had to be valiant in war, but gentle in love as well. The new code was known as "courtly love."

Love was a radical notion in a society where marriages were arranged by parents for monetary and political gain. It was the brainchild of highly educated ladies of the court tired of being treated as bargaining chips in the marriage game. They insisted that both parties, the man and the woman, must consent for a marriage to be valid.

Queen Eleanor had strong personal reasons for opposing male dominance with courtly love. She and Henry had become estranged when Henry took a mistress, and no one thought twice about it. She was also aware of the fate of a young kinswoman, Alais, who had been given to young Richard for a bride. Since Richard was away on Crusade, Henry thought nothing of taking Alais for his own, keeping her a prisoner for 25 years. At his death, she was freed—only to be married off to a lesser courtier.

Women were considered impure and dangerous to men, the descendants of the first woman, Eve, who had caused Adam to sin against God. As one 12th-century poet put it, "If I had the eloquent tongue of Ovid, still I could not put into words how cunning an evil woman is, how treacherous, how shrewd, how destructive . . ."

If women were so maligned, how did they succeed in championing the cause of romantic love? For one thing, they had a ready audience in the landless gentry of Northern Europe. Nobles passed on most of their lands and titles to the oldest son—the others got virtually nothing. Most became monks. With nothing to gain from the old feudal system, these younger sons flocked to Eleanor's court of beautiful people, consoling themselves that money, land and position meant nothing next to true love.

The Rules of Love

The new code of chivalry demanded that the knight serve his lady first— next in importance came service to God and king. In tournaments and battles, it was customary for the knight to wear a token of the lady, perhaps a kerchief or a flower.

The main theme of the troubadors' songs of love (chansons d'amour) was unconsummated love. The knight is head over heels for the lady but, alas, she is married or somehow else beyond his reach. Never-

theless, the knight accepts this hopeless situation, pining for his true love and doing all in his power to please her, while knowing she can never be his. The songs alternate between the ecstasy of love and the bitterness of longing.

In the court of Queen Eleanor, "rules" of love were drawn up to "educate" the young men about how they should act towards the lady. Knights had to give up their baser passions, thinking always of what would please their lady. Here are some of the court's "Twelve Rules of Love":

Marrying for money should be avoided like a deadly pestilence.

Thou shalt keep thyself chaste for the sake of thy beloved. (A radical idea for the time.)

Thou shalt be obedient in all things to the command of ladies, and strive in the service of Love.

Thou shalt not be a revealer of love affairs.

Thou shalt be in all things polite and courteous.

In 'practicing the solaces of love' thou shalt not exceed the desires of thy lover.

—*The Art of Courtly Love* by Andreas Capellanus, 12th century.

Eleanor actually organized judicial "courts of love," to publicly "try" young men as to whether their love for a lady was genuine according to the rules. Several young women, ages 25-30, sat in judgment while

the young man and other witnesses poured out their emotions for all to hear. These courts had no legal authority, of course, and they didn't overthrow the practice of contracted marriages, but they shaped the thinking of future generations of nobility who carried the "rules of love" back to their own courts.

Chivalry After the Age of Chivalry

Historical fact shatters any illusions that Henry and Eleanor created a real-life Camelot. In 1173, Henry put Eleanor in prison for turning his sons against him. As one historian put it: "Whether it happened from unhappy marriage or for the punishment of the father's sins, there was never any agreement either of the father with his sons, or of the sons with their parent, or between themselves."

When Henry died, exhausted and bitter from family fighting, Eleanor maneuvered Richard the Lionhearted—her favorite—onto the throne. At Richard's death, his weak brother John Lackland (who was later forced to sign the Magna Carta) assumed power, and the once-great Angevin Empire crumbled. Never again would England and France be united.

Chivalry itself did not die, however. The "Man of Steel and Velvet" was an ideal for gentlemen long after knighthood lost its warring function. The 17th-century English gentleman and the "gentilhomme" of France owed much to the medieval code. The duel replaced the tournament as a test of courage.

Still, the idealism of chivalry became tarnished over the years. The Renaissance gentleman used medieval courtesy—but only as long as it helped him succeed. And the last gasp of true romantic chivalry in literature was the tragi-comic figure of Don Quixote (written 1610). Ridiculed by his contemporaries, he held fast to the old ideals, jousting with windmills when there were no other true knights left to fight.

Castle Life

"Like a tortoise fighting a stone"—that was medieval warfare when impregnable castles dotted Europe's landscape. War was a drawn-out, costly, defensive struggle as one side laid siege to the other. The only good thing to be said was that casualties were few and far between. Boredom was the common enemy of attacker and attacked.

The medieval castle was a simple structure consisting of a central "keep," or main building, surrounded by a wall. The keep was usually built on a hill, cliff, or mound of earth. The wall enclosed the castle yard, or "bailey," where the people lived. This "motte (mound) and bailey" pattern was the basis of all medieval castles.

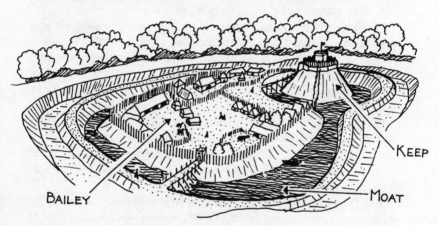

MOTTE AND BAILEY CASTLE

Later castles were much bigger, with more rings of walls (and more baileys) as much as 20 feet thick. The Crusaders had been impressed by the massive castles and walled cities of the Byzantines, and applied many of their techniques to the motte and bailey plan.

Outside the walls was the moat, a ditch filled with water (they only put alligators in them in fairy tales). The moat was spanned by a draw-bridge, pulled up during attacks. The main gate was made of oak, plated with iron, and often protected by a portcullis, or iron grille. Above the gate were twin towers, often four stories high, with small windows for shooting at the enemy.

The keep was the headquarters and home of the lord, used as a dining hall, ballroom and as a last resort when the outer walls fell in an attack. Despite their impressive architecture, castles were cold, damp and

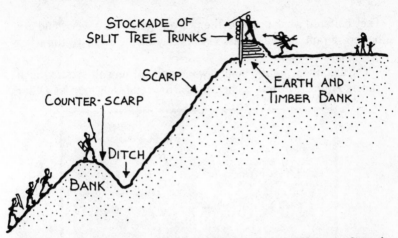

Early castles evolved from primitive ditch and stockade fortifications. Sites offering a natural fortification, like a hilltop surrounded by a river, were preferred. As ditches became moats and stockades became stone walls, castles took the form we think of today.

uncomfortable. A lord who commanded thousands had fewer animal comforts than a modern suburbanite.

The Siege, Military Patience

Against such a formidable structure, an attacker's main weapon was hunger. The enemy camped around the castle and waited—waited for supplies to run out. This often took years, and given the poor communication and supply lines of the period, the attacker might well run out first.

During a siege of Carcassonne (Europe's greatest walled fortress city) in Southern France, the city ran desperately low of food and was about to surrender. The attackers, after waiting for years, were losing patience and about to give up, too. In a stroke of genius, the queen of the city fed the last of the food to the last pig, and threw the pig over the wall. When the invaders saw how well-fed the pig was, they figured the people inside had plenty of food, so they packed up and headed home.

But the patience of military men wears thin, and later on, castles were stormed with a number of ingenious weapons. Catapults, powered by tension or counterweights, flung huge boulders or red-hot irons over the walls. Under cover of archers armed with crossbows and 6-foot longbows, the armies approached the castle, filling in the moat with dirt. Then they wheeled up the "storming towers," built of wood and covered with wet hides (for fire-resistance), and climbed over the walls.

They battered weak points in the wall and gate with a wood and iron battering ram. And as a last resort, they might even try tunneling beneath the walls.

The defenders poured boiling water and burning pitch onto the invaders. From the turrets, archers fired arrows and flung missiles. Others

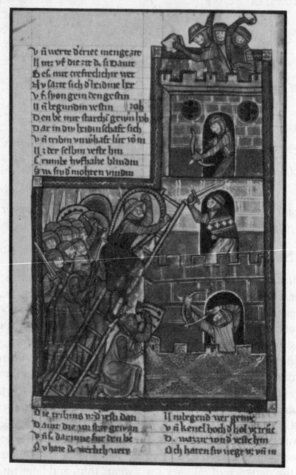

MEDIEVAL CASTLES
GAVE DEFENDERS THE EDGE

Some castles were just avoided, written off as unconquerable. Any decent castle was a real pain to attack. The "starve 'em out siege" approach was the most common. Some of these sieges lasted several years. The advent of gunpowder brought the era of castles as fortresses to an end.

were stationed along the walls to overturn ladders and storming towers. Once the attackers got inside the castle, battle was fierce hand-to-hand. More likely, though, the defenders simply retreated behind the next inner wall to start the process over again.

So it went, and would go still, but the sword outlasts the sheath and new weapons always overcome old defenses. When the Turks sieged Constantinople in 1453, they had a new weapon—a 19-ton cannon that fired 1500-pound rocks more than a mile into the air. The era of gunpowder had arrived, and the castle walls of Europe fell. Within a century, the siege style of warfare that had gone on almost unchanged for 2,000 years was a thing of the past.

AZAY LE RIDEAU, LOIRE VALLEY CHATEAU

Castles gradually lost their military purpose. The more modern ones were built purely as luxury residences.

Many of the castles in Europe today never had a military function. After 1500, lords built castle-forts for protection and castle-palaces for domestic life. In the Romantic era of the 1800s, many castles, like those of Bavaria's Mad King Ludwig, had no practical purpose other than as fantasy abodes.

The Black Death

"When was such a disaster ever seen? Even heard of? Houses were emptied, cities abandoned, countrysides untilled, fields heaped with corpses, and a vast, dreadful silence over all the world. . ." (Petrarch, Italian writer, 14th century).

Nuclear holocaust? No, the medieval equivalent—the bubonic plague, or "Black Death," which killed a fourth of Europe in three long years (1347-50). The disease spread quickly, killed horribly and then moved on, leaving whole cities devastated in its wake. The economic, physical and emotional shock is unsurpassed in European history. Most saw the plague as not just a disease, but a heavenly curse "sent down upon mankind for our correction by the just wrath of God." Whatever the cause, it killed with such power and swiftness that "the living could scarcely bury the dead."

The Disease and Its Symptoms

The plague came out of Central Asia, passing to Marseilles on an infested Genovese ship. The disease is a bacteria carried by fleas (which travel on rats). Humans get it when bitten by the fleas, then spread it by coughing. The unsanitary conditions in medieval Europe allowed the disease to move rapidly north. London, Vienna, Florence and Avignon (the papal city at the time) were particularly hard hit. In Florence alone, 100,000 died within four months. In some cities, 90% of the population was wiped out.

The symptoms were quick and harsh—lumps, or "buboes" (hence, "bubonic"), in the groin or armpits, fever, constant vomiting (often blood), diarrhea, pneumonia and, almost inevitably, death within three days.

So many died so quickly that there was no place to bury them. They resorted to mass graves. "After the churchyards were full, they made vast trenches where bodies were laid by the hundreds, heaped therein by layers, like goods are stored aboard ship, then covered with a little earth till such time as they reached the top of the trench." Many died unattended in their houses, their deaths known to their neighbors "only by the stench of their rotting bodies." (Boccaccio, Italian writer, 14th century.)

The disease was so infectious that it seemed impossible to avoid. "In their bones they bore so virulent a disease that anyone who only spoke to them was seized by a mortal illness and in no manner could evade

death," wrote one eyewitness. "The mere touching of the clothes or of anything else used by the sick appeared to spread the malady to the toucher," wrote another.

SCENES FROM THE LONDON PLAGUE, 1665

Wheelbarrows of corpses, not enough coffins and overcrowded graveyards. Up to one fourth of Europe died during the years 1347-1350.

The ugliest part was that nothing could be done to help the afflicted and they were abandoned by the healthy to avoid its spread. "Brother forsook brother; uncle forsook nephew; sister, brother; and often wife, husband; nay, what is more incredible still, fathers and mothers refused to visit or tend their very children, as if they had not been theirs," wrote Bóccaccio, whose own father succumbed to the plague in Italy.

No Room to Bury the Dead

"Soon the corpses were lying forsaken in the houses. No ecclesiastic, no son, no father and no relation dared to enter, but they paid hired servants with high wages to bury the dead. The houses of the deceased remained open with all their valuables, with gold and jewels; anyone who chose to enter met with no impediment" except fear of being contaminated by the goods they stole. (Michael Platiensis, Franciscan friar, describing Sicily—1347.)

And De Mussis' description of his hometown, Piacenza, Italy: "I do not know where I can begin. Everywhere wailing and lamenting arose. The bodies of the dead without number to be buried . . . they made dit-

ches by the piazza and the courtyards where never tombs existed. The great and noble were hurled into the same grave with the vile and the abject, because the dead were all alike . . . Husband and wife who placidly shared the marriage bed now separated . . . And when the spirit left, the mother often refused to touch the child, the husband the wife—the victim lay sick alone at home—the physician did not enter; the thunderstruck priest administered the ecclesiastical sacraments timidly. What are we to do, oh good Jesus?"

Europe Goes Into Shock

How does one react to such a mysterious, deadly affliction? Many tried to flee from infested areas, but "the disease clung to the fugitives, who fell down by the roadside and dragged themselves into the fields and bushes to expire."

The Diseases and Casualties this Week.

Abortive	6	Kingsevil	10
Aged	54	Lethargy	1
Apoplexie	1	Murthered at Stepney	1
Bedridden	1	Palsie	1
Cancer	2	Plague	3880
Childbed	23	Plurisie	1
Chrisomes	15	Quinsie	6
Collick	1	Rickets	23
Consumption	174	Riting of the Lights	19
Convulsion	88	Rupture	2
Dropsie	40	Sciatica	1
Drownd two, one at St.Kath. Tower, and one at Lambeth	2	Scowring	13
		Scurvy	1
Feaver	353	Sore legge	1
Fistula	1	Spotted Feaver and Purples	190
Flox and Small-pox	10	Starved at Nurse	1
Flux	2	Stilborn	8
Found dead in the Street at St.Bartholomew the Less	1	Stone	2
Frighted	1	Stopping of the stomach	16
Gangrene	1	Strangury	1
Gowt	1	Suddenly	1
Grief	1	Surfeit	87
Griping in the Guts	74	Teeth	113
Jaundies	3	Thrush	3
Imposthume	18	Tissick	6
Infants	21	Ulcer	2
Killed by a fall down stairs at St. Thomas Apostle	1	Vomiting	7
		Winde	8
		Wormes	18

Christned { Males — 81, Females — 81, In all — 166 } Buried { Males — 2656, Females — 2663, In all — 5319 } Plague — 3880

Increased in the Burials this Week — 1289

Parishes clear of the Plague — 34 Parishes Infected — 96

The Assize of Bread set forth by Order of the Lord Maior and Court of Aldermen, A penny Wheaten Loaf to contain Nine Ounces and a half, and three half-penny White Loaves the like weight.

People died many ways, but the plague dominated them all. This list dates from London's plague, 1665.

Those with the money withdrew to country houses and locked themselves in where they "abode with music and such other diversions,

never suffering themselves to speak with any outsiders, or choosing to hear any news from without of death or sick folks." Boccaccio's book, *The Decameron*, is a collection of stories told by such people to pass the time while hiding from the plague.

"Others, inclining to the contrary opinion," writes Boccaccio, "maintained that the best remedy was to carouse and make merry and go about singing and frolicking and satisfy the appetite in everything possible and laugh and scoff at whatever might happen. They went about day and night, now to this tavern, now to that, drinking without stint or measure and breaking into abandoned houses, the laws having no effect due to the lack of ministers and executors."

Fallout—the After-Effects

The "fallout" from the devastation was felt for a century to come. First was the economic hardship. An English historian of the time wrote: "A disease among cattle followed closely on the pestilence; then the crops died; then the land remained untilled on account of the scarcity of farmers, who were wiped out. And such misery followed these disasters that the world never afterward had an opportunity of returning to its former state." (Thomas Walsingham, 14th century.)

The emotional scars on Europe took even longer to heal. As one historian put it: "The mental shock sustained by all nations during the Black Plague is without parallel and beyond description." The survivors were left without hope for the future. They "closed their accounts with the world" and waited for death and the afterlife.

Convinced the plague was a punishment from God, certain fanatics thought worldwide repentance was necessary. The "Brotherhood of the Flagellents" tried to take the sins of Europe upon themselves. They marched through the cities, calling on the citizens to join them as they scourged themselves with whips. They became more popular in some areas than the priests, whose rituals had been powerless before the plague.

Jews were persecuted, blamed for poisoning wells, and thus causing the pestilence. In Basle, Switzerland, the city's Jews were rounded up, locked in a specially-built wooden structure and burned alive.

Europe Recovers

Strange as it may sound, some good came out of all the loss of life, creating the economy that would support the Renaissance more than a century later. In 1450, Europe's population was half what it had been before the plague. This meant that labor was scarce, and the common

man could demand a better wage for his work. Technology itself had not been affected by the plague, and there were now fewer people to divide the fruits of that technology.

Europeans went on a buying spree, trying to forget the horrors they'd seen. Luxury goods were in high demand—gay clothes, good food and drink, lavish houses, entertainment. For the first time, the lower classes enjoyed "luxury items" like chairs, individual dishes and fireplaces.

The Plague Today

Could the Black Death ever strike again? Bubonic plague has struck before and since. Historical records indicate it may have hit the Greeks during the Trojan War (1200 BC), the Philistines (1141 BC—see 1 Samuel 5-6 in the Bible) and the Assyrians (700 BC—see 2 Kings 19). In Europe, there was the terrible Plague of Justinian (AD 550); the Yellow Plague of Ireland and England (664 AD); and the Great Plague of London (1665). These bubonic plagues should not be confused with the numerous other "plagues"—typhus, smallpox, measles, etc.

The most recent epidemic in the West was the 160 cases in San Francisco, U.S.A., in 1900.

Even when the disease is not widespread there are occasional small outbreaks. Today, you can count on several hundred cases worldwide each year. The U.S. reports a handful every few years, mostly in the Southwestern states. With improved rodent and flea controls, the number is steadily declining. The disease can now be treated with antibiotics (tetracycline and streptomycin), and death is uncommon.

The words of Petrarch, who witnessed the horror of the plague years, may be prophetic: "Posterity, will you believe what we who lived through it can hardly accept? . . . Oh how happy will be future times, unacquainted with such miseries, perhaps counting our testimony as a mere fable . . . !"

English Kings and Queens

"For God's sake, let us sit upon the ground
And tell sad stories of the death of kings . . . "
*(*Richard II, *Shakespeare).*

The history of England's royalty is full of violence, corruption, treason, sex, scandal, power and greed. Remarkably, the country survived its rulers.

"French" Kings—Normans

Medieval England begins with William the Conqueror crossing the Channel from Normandy and defeating the Saxon forces at Hastings. He was crowned King of England on Christmas Day, 1066 in London's Westminster Abbey, where future kings and queens would be crowned. A harsh but efficient ruler, he united the British lords and established a feudal society. (The complex of buildings known as the Tower of London, where so many leaders were executed, was begun by William.)

THE TOWER OF LONDON

The prison and execution site for those accused of crimes against the monarchy. Admission tickets include a very informative and entertaining tour by a Beefeater.

Neither he nor his Norman successors were ever very popular with the common people. They were foreign invaders who spoke French and followed French customs.

His son, William II, called "Rufus" (the Red) because of his ruddy complexion, was even less well-liked. A vain, arbitrary tyrant, he made

no attempt to mix with the English people. He died in a hunting "accident"—an arrow in the back. His brother Henry just happened to be in the hunting party—in back of him. He immediately rode to Winchester, seized the treasury and was crowned king the next day.

More "French" Kings—Angevins

The French kings expanded their empire. By the time Henry II took power (1154) at the age of 21, his Angevin Empire stretched from Scotland to northern Spain. His long and hard-fought rule consolidated the empire.

Henry was a good soldier, a fair diplomat, well-read (for a king), and was possessed with restless energy and a violent temper. The beginning of his reign was marked by optimism. He and his wife Eleanor, the most beautiful and accomplished lady of the time, established a court where chivalrous knights, ladies, troubadors and scholars met. Henry built numerous castles throughout the empire.

*THE MURDER OF THOMAS BECKET
IN CANTERBURY CATHEDRAL*

But then things went bad, and it seemed everyone in the world was fighting Henry. He waged war with the Welsh, the Scots and French rebels; he quarreled with the English barons over taxes; his sons, supported by Eleanor, tried to overthrow him. Perhaps the most painful betrayal was that of his close friend and adviser, Thomas Becket, whom he appointed Archbishop of Canterbury. When Becket's strong, independent policy threatened the king's power, Henry's knights murdered him in Canterbury Cathedral. Becket became an instant martyr to the English people and the cathedral became a popular pilgrimage site. Henry now had even his people against him.

Henry II died a broken man, and his son Richard the Lionhearted assumed power. Richard was the model of the chivalrous knight—a good soldier, poet, musician, handsome and a valiant Crusader. He was also a Frenchman. He hated England (he once said, "I would sell London if I could find a buyer"), and in his ten-year reign, he spent only six months in the country he ruled.

Everyone hated Richard's successor, his brother John Lackland. Everyone. He is unanimously considered the worst king England ever had. Devious and weak, he had an uncanny ability to make enemies of everyone—barons, popes, the English and the French. He murdered his own nephew in a drunken rage. He waged war in France and lost miserably, and the Angevin Empire collapsed. He overtaxed and bullied the English barons. All in all, he was very much the evil King John of the Robin Hood legend—perhaps the one true character in the myth.

John's place in history was assured by signing the Magna Carta ("Great Charter") forced on him by unhappy barons. This was the first step of many in English history to limit the power of kings and increase that of the nobles and common people.

Two Troublesome Centuries—1200-1400

"Some have been deposed; some slain in war;
Some haunted by the ghosts they have deposed . . .
All murder'd . . . " (Richard II).

The next two centuries gave Shakespeare enough regicide (killing of kings), rebellion and treason for eight plays. In that time, four kings were murdered, two died from battle, civil wars were rampant and two lines of kings were overthrown.

Edward I (reigned 1271-1307) started things off well. He was the ideal medieval king—strong, wise in government and "the best lance in the

world." But then England's troubles began.

Edward II, a tyrant, was opposed by Roger Mortimer—his wife's lover. Edward was captured and murdered in a manner so brutal that to describe it would exceed this book's standard of good taste. Well, okay, if you insist. Suffice to say it involved a red-hot poker, Edward's backside, and a thrusting motion. Ooh.

His son, Edward III (reigned 1327-77), avenged his father's death in a relatively civilized manner by merely having Mortimer hanged, drawn and quartered. Edward's good rule (aided by his chivalrous son, the famous "Black Prince") included early victories in the Hundred Years' War with the French, in which England initially conquered, then slowly lost France.

The next monarch, Richard II (1377-99), ruled poorly and was finally overthrown by an upstart baron, who locked him in the Tower. The long line of French-English kings came to an end.

The House of Lancaster

Henry IV (reigned 1399-1413), the usurper, of the house of Lancaster, was the first completely English king—the son of English parents who spoke no French. Handsome, athletic, a musician and scholar, he invited the poet Geoffrey Chaucer to his court. Yet, like so many others, when he died he was bitter and broken; worn out by years of opposition and civil war.

His son, the "Prince Hal" of Shakespeare's plays, was said to have lived a wasted youth, carousing, gambling and thieving with commoners and prostitutes. Whether true or not, when he became Henry V he was cold, stern and very capable. His victory at the Battle of Agincourt (1415) put most of France under English rule.

All his gains became losses in the weak hands of Henry VI, however. Henry VI's attempts to hold France were foiled by a young French peasant girl—Joan of Arc. She claimed to hear voices of saints and angels who told her where to lead the French armies. She was eventually captured and burned as a witch by the English, but not before the tide was turned.

War of the Roses

The inept Henry VI of the Lancaster family was opposed by the York family, and a long civil war broke out—the "War of the Roses," named for the white and red roses that each family used as its symbol. Edward IV, a York, locked poor, old and quite mad Henry in the Tower, later

executing him. Edward himself died young at the age of 40, reportedly "worn out by his sexual excesses."

Two of Edward's excesses survived him, but not by much. His sons, the heirs to the throne, were kidnapped and murdered in the Tower by Richard III (Edward's own brother), and both houses decided the bloody war must end. When a petty noble from the house of Tudor defeated Richard's armies and killed him in battle, all of England was prepared to rally round him as the new king. Henry VII was crowned, a diplomatic marriage was arranged, and England was united.

Tudor Rule

Henry VII (reigned 1485-1509) was shrewd and efficient; he was England's first "modern" chief executive. He united the country and built up a huge treasury. (To protect himself from traitors he established a royal bodyguard—the Beefeaters).

HENRY VIII, BY HANS HOLBEIN

When his 18-year-old son took over he inherited a nation solvent, strong and at peace. Henry VIII (reigned 1509-47) was the English version of a Renaissance prince—tall, handsome, athletic, a poet and

musician, well-read in secular learning and theology. He was charismatic, but he could also be arrogant, cruel, gluttonous, erratic and paranoid. (Quite the well-rounded man . . .)

The most notorious event of his reign was his break with the Catholic Church (and his establishment of the nearly-identical Church of England). This arose over his forbidden divorce of his first wife, Catherine of Aragon (the daughter of Ferdinand and Isabella of Spain) and subsequent marriage to the beautiful and lively Anne Boleyn. Henry was determined to get a wife who could give him a son. For whatever reasons—love, desire for an heir, diplomacy or sheer lust— Henry went through six wives, divorcing, imprisoning or beheading them when they no longer served his purpose.

Henry faced enemies in England over his break with Catholicism, and he dealt with them in a characteristic way—with the axe. Among those beheaded at the Tower for holding fast to their convictions was Thomas More, Henry's chancellor and author of the famous political tract, *Utopia*.

The Tudor kings settled England's War of the Roses but replaced it with religious quarrels. While the Reformation wars raged on the Continent, England had troubles of its own. After the brief but weak reign of Henry's long-awaited male heir, the stage was set for Henry's daughters.

Mary I (reigned 1553-58), daughter of his first wife, Catherine, had her mother's fanatic Spanish Catholic devotion (the same kind that gave us the Inquisition). She was convinced her mission was to return England to the Roman Church come Hell or high water. In her zeal, she burned at the stake over 300 men, women and teenagers, and executed the innocent 17-year-old Lady Jane Grey. Compared with the tens of thousands killed in other countries it seems like nothing, but it shocked the English enough that they turned their backs on Catholicism for good, giving their queen the nickname, "Bloody Mary."

Mary's successor, Elizabeth I (1558-1603), Henry's daughter by the fiery Anne Boleyn, had absorbed the lesson of religious fanaticism. She was herself a Protestant, but also a product of a broad Renaissance education. Her tolerant policies and prudent nature brought peace at home and victory abroad, making England a true European power for the first time. Among her conquests, Elizabeth subdued Ireland, beginning that country's centuries of strife.

The English navy defeated the famed Spanish Armada and soon ruled the waves. Explorers and traders explored the New World and Asia, bringing back spoils and luxury goods. (Sir Walter Raleigh

introduced tobacco from America to a skeptical Queen Elizabeth.)

Where Elizabeth was golden-haired, prudent, and a "Virgin Queen," her cousin Mary, Queen of Scots, was dark, lively, a lover of dance and music, and highly sexed. Mary (not "Bloody Mary"), a Catholic from the Stuart family, represented the opposition to Elizabeth and the Protestant regime. After Mary was implicated in an anti-crown plot, Elizabeth imprisoned her for 19 long years. But Mary never bowed. Fat, wrinkled, and wearing a wig to cover her balding head, she was led to the Tower's execution block. "So perish all the Queen's enemies," and the axe fell.

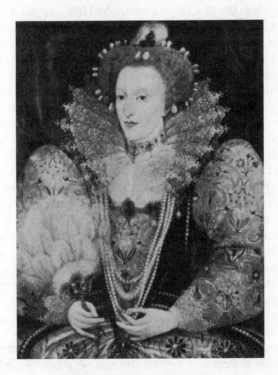

QUEEN ELIZABETH I (1558-1603)

The Elizabethan era was England's High Renaissance, especially in literature. Shakespeare, Raleigh, John Donne, Christopher Marlowe and many others shaped the course of English literature and the English language itself.

The Stuarts

When Elizabeth died, presumably still a virgin and definitely without an heir, the Tudor throne passed to the Stuarts—Mary Queen of Scots' son, James I. James (reigned 1603-25) was a capable man who was incapable of proving it—"the most learned fool in Christendom," said one contemporary. He was vain and arrogant, a "foreigner" (from Scotland) and a Catholic to boot, who succeeded in alienating both the English people and Parliament.

James insisted he ruled by "divine right," and was therefore above Parliament and human laws. On the way to his coronation, a man accused of thievery was brought to him. James had him hanged on the spot without trial—thus alienating himself instantly from the commoners.

The one lasting achievement of his reign was the "King James" version of the Bible, a landmark work in both theology and literature, the culmination of the Elizabethan Renaissance.

It's said that James steered the state toward the rocks, then left his son to wreck it. Throughout the 17th century, the haughty Catholic Stuart kings were at odds with Parliament, until Parliament got fed up, rebelled and established a "constitutional monarchy" where the king's power was limited by law.

Charles I (reigned 1625-49) was his father's son in every way, but even more so—he was pompous, vain, anti-Protestant and anti-Parliament. When Parliament refused to grant him more money, he dissolved the body for over ten years. Parliament (consisting mostly of nobles) responded by raising its own army and declaring war on the king. Their leader, Oliver Cromwell, vowed, "We will cut off the King's head—with the crown on it." Civil war had begun.

Parliament defeated the troops loyal to the king, deposed him and set up a Commonwealth ruled by Parliament. Charles was executed as Cromwell had promised. (The one mark of distinction in Charles' undignified reign was that he faced his death with dignity.)

Cromwell, a Puritan gentleman farmer elected to Parliament, soon assumed the powers of a dictator. He was very capable, religiously tolerant and kept a steady hand in a troubled time. On the other hand, he himself suspended Parliament "a la" Charles when it disagreed with him.

When Cromwell died, in order to prevent another civil war in the struggle for power, Parliament invited Charles II to reign—on condition he follow rules set out by Parliament.

One hundred and thirty years later the French would experience a

similar cycle: The royalty abuses its power. Parliament takes matters into its own bloody hands, beheading the king. After a dictator's enlightened but harsh rule, the king is invited back. Now he's allowed to rule—with constitutional or parliamentarian limitations.

Charles II and Restoration

The "Restoration" of the monarchy (1660) was reason to celebrate in England. After decades of civil war and Puritan rule (with all the negative things "puritan" implies) it was nice to have the pomp, ceremony, luxury, and even decadence of the Stuart kings. Charles II (1660-85) had spent his exile in the magnificent court of Louis XIV. He returned to London with the latest fashions.

Charles had a series of dazzling mistresses that shocked the Puritan Parliament and titillated the public. (There were so many, most of them Catholics, that one of them took to identifying herself, "I'm the *Protestant* whore.") During Charles' reign, London was devastated by a plague and burned to the ground in the Great Fire of 1666. The rebuilding, with architect Christopher Wren, reflects Charles' baroque influence (from Versailles).

Charles' son, James II, lived up to the Stuart name by persecuting Protestants and plotting against Parliament. He was thrown out in the "Glorious Revolution." Parliament invited James' daughter and her husband to rule—again, according to the dictates of Parliament. William and Mary were followed by the unremarkable Queen Anne.

The House of Hanover

In 1714, the Stuart line was exhausted, and so were the English people, worn out by religious strife. Parliament chose the king least likely to stir up trouble, George I (1714-21) of Germany. George was 54 years old, spoke no English and had no interest in politics. His chancellor, Sir Robert Walpole, essentially ran the country. George II (1727-60) was the appropriately-named sequel to this bland state of affairs.

George III (1760-1820) was the first truly English ruler in 50 years. He took the throne with high hopes, then ran right into the American Revolutionary War, the French Revolution and Napoleon. The world changed too fast for him, and in 1810 he slipped into madness—diagnosed at the time as "flying gout" that had settled in his brain. England was left with "an old, mad, blind, despised and dying king" (Shelley's "England in 1819").

His son, George IV, acted as regent to his father, then took over his

father's reactionary, stubborn ways. But England was changing rapidly, the Industrial Revolution was creating a whole new society, and England's monarchy knew it would meet the same fate as its French counterpart if it didn't modernize.

Victoria

Fortunately, along came Queen Victoria (reigned 1837-1901), the first of England's modern "figurehead" monarchs. She had little interest and less influence in government. Her husband, Prince Albert, took some part in promoting science and industry (especially in organizing the Great Exhibition of 1851), but after his death things were run by Parliament and active prime ministers (Disraeli and Gladstone).

Victoria herself was under 5 feet tall, but radiated a regal aura. She was strong, bearing nine children that she married off to other European royal houses. (Kaiser Wilhelm and Tsarina Alexandria of WWI fame were her grandchildren). She hated Georgian excesses and was notoriously prudish (hence, our word "Victorian").

The Victorian period saw England rise to its zenith. Its colonial empire was the largest in the world, its technology was the envy of Europe—yet its pockets of poverty were worse than many of its colonies.

Victoria's son, Edward VII (reigned 1901-10), was born and raised in the lap of Victorian luxury but never quite grew up, assuming the throne as a "child" of 60. The Edwardian period before World War I was the last golden (though fading) age of English optimism and civility. The horrors of the Great War shattered that forever.

The House of Windsor

Edward's son, George V Windsor, ruled in the "modern" style (subservient to law and Parliament) until 1936, when he was succeeded by his son, Edward VIII. Edward (the Duke of Windsor), in the most-talked-about action of modern royalty, abdicated the throne in order to marry a commoner, the twice-divorced American, Mrs. Simpson. Edward's brother, George VI, ruled until his popular daughter, Elizabeth II, took the throne with her husband, Phillip Mountbatten, Duke of Edinburgh. Charles, Prince of Wales (of National Enquirer fame), is our generation's entry in the parade of English kings and queens.

As you travel through England you'll hear plenty of news about Charles, Lady Di and the British royalty of today. If you're alert and even if you're not, there's a good chance you'll get at least a fleeting glimpse of England's busy first family. While their kings and queens don't come cheap and are only figureheads, most of the British thoroughly enjoy having a royal family.

TANGENTS
Renaissance

Renaissance Florence

Carnival time in 15th-century Florence brought out the best and the worst in the city. St. John's Day capped two months of nearly-continuous partying that began on May Day. The festivities included cultural activities like plays, music, and the dedication of great works of art. Less refined were the spectacular parades, the fireworks displays and the football (soccer) games. Then there was the drinking, the dancing and bawdy songs; the jugglers, shysters and "giants" on stilts; the horse races through the streets (trampling spectators and riders alike); the public executions—hanging, drawing and quartering, burning at the stake; the boxing matches, where the fighters stood literally toe-to-toe and whaled on each other until one dropped; and the usual crime and prostitution of a busy, cosmopolitan city.

It's easy to overlook the crudeness and "medieval" atmosphere of the town where Michelangelo, Leonardo, Raphael, Lorenzo the Magnificent, Botticelli and Machiavelli all lived and worked. Florence's contributions to Western culture are immense: the whole revival of the arts, humanism and science; the modern Italian language (which grew out of the popular Florentine dialect); and Amerigo Vespucci, who gave his name to America. But Florence, even in her golden age, was always a

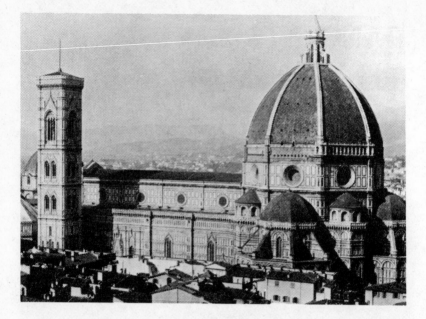

mixture of lustiness and refinement. The streets were filled with tough-talking, hardened, illiterate merchants who went about singing verses from Dante's *Divine Comedy*.

Florence's money—and hence, her culture—came from wool and silk factories and from banking. The "bankers" soon broke the farm-based feudal lords by being pawnbrokers for them—loaning money at exorbitant rates, then taking their lands when they couldn't pay up. Technically, Florence was a republic, ruled by elected citizens rather than a nobility. There was a relatively large middle class and some opportunity for upward mobility. The Florentines took great pride in this.

In actual fact, however, power was in the hands of a few wealthy banking families, the most powerful being the Medici family. The Medici bank had ten branches throughout Europe including London, Bruges (Belgium), Lyon and Rome, where the pope banked. The Florentine florin was the monetary standard of the Continent.

Florence dominated Italy economically and culturally, but not militarily. There was a loose "Italian League" alliance of city-states, but Italy was to remain scattered until the nationalist movement four centuries later. (When someone suggested to the Renaissance Florentine, Niccolo Machiavelli, that the Italian city-states might unite against their common enemy, France, he wrote back: "Don't make me laugh.")

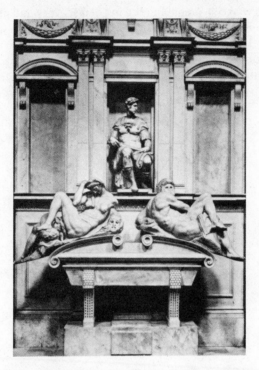

MICHELANGELO, TOMB OF GIULIANO DE MEDICI, FLORENCE, 1524-34

Lorenzo de Medici (1449-92), inheritor of the family's wealth and power, was the central figure of the golden age. He was young—20 when he took power—athletic, intelligent, a poet, horseman, musician and leader of men. He wrote love songs and humorous dirty songs to be sung loudly and badly at carnival time. His marathon drinking bouts and illicit love affairs were legend. He learned Greek and Latin and read the classics, yet his great passion was hunting. He was the Renaissance Man—the man of knowledge and action, the scholar and man of the world, the patron of the arts and the shrewd businessman. He was Lorenzo the Magnificent.

Lorenzo epitomized the Florentine spirit of optimism. Born on New Year's Day and raised in the lap of luxury (Donatello's "David" stood in the family courtyard) by loving parents, he grew up with the feeling that there was nothing he couldn't do. All Florentines saw themselves as

275

part of a "new age", a great undertaking of discovery and progress in man's history. They boasted that within the city walls there were more "nobly-gifted souls than the world has seen in the entire thousand years before." These were the people who invented the term "Dark Ages" for the time that went before.

LORENZO THE MAGNIFICENT

(A MEDICI)

Lorenzo surrounded himself with Florence's best and brightest. They formed an informal "Platonic Academy," based on that of ancient Greece, to meet over a glass of wine under the stars at the Medici villa and discuss literature, art, music, politics—witty conversation was considered an art in itself. Their "Neo-Platonic" philosophy stressed the goodness of man and the created world; they saw a common Truth (sounds like one of Plato's "Forms") behind all religion. The Academy was more than just an excuse to go out with the guys—they were convinced that these discussions were changing the world and improving their very souls.

Art and Artists

Botticelli was a member of the Academy. He painted the classical myths that the group read, weaving contemporary figures and events into the ancient subjects. He gloried in the nude body, God's greatest creation. In Botticelli's art we see the lightness, gaiety and optimism of Lorenzo's "court."

Another of Lorenzo's proteges was the young Michelangelo. Impress-

ed with his work, he took the poor, unlearned 14-year-old boy into the Medici household and treated him like a son. Michelangelo's playmates were the Medici children, later to become Popes Leo X and Clement VII, who would give him important commissions. For all the encouragement, education and contacts Michelangelo received, the most important gift from Lorenzo was simply his place at the dinner table, where he could absorb the words of the great men of the time and their love of art for art's sake.

Artists thrived on the patronage of wealthy individuals, government, church groups and guilds, or labor unions. For a single work, Botticelli commanded up to 100 florins, enough to live for a year in high style—which he did, by the way, for many years. Artists mingled with scholars and men of wealth, a far cry from earlier generations when artists were anonymous craftsmen.

With all the money spent on art, Lorenzo was one of the few among a group of bourgeois families (with bourgeois tastes) who truly had an interest in culture. His father, Piero, in a tasteless display of wealth, commissioned a lavish marble work for the church of Santissima Annunziata on which he boastfully had carved: "4,000 florins for the marble alone."

Artists were sought-after in high society, but they could be rather odd ducks. Leonardo, though very learned and witty, was considered something of a flake who never finished his projects. (Lorenzo only knew him as an interesting and talented lute player. Leonardo had to leave Florence to achieve fame.) Michelangelo put people off by acting superior to them. Piero di Cosimo shunned society, hiding in his room, subsisting on hard-boiled eggs, living "the life of a wild beast rather than that of a man." The image of the artist as the lone genius—"solitary, strange, melancholy and poor"—was forming.

The great Masters were friends and rivals. When the established Leonardo and the young genius Michelangelo competed for the commission to paint a battle mural in the town hall, all eyes were upon them. (Raphael even interrupted his studies to visit Florence for the event.) Both submitted much-admired "cartoons," or rough sketches. Competition between their fans was fierce—Michelangelo's cartoon was ripped up in jealousy by one of Leonardo's pupils—but the artists respected each other. (We see Raphael's admiration for Leonardo, the Renaissance Man, in his painting "The School of Athens"—Raphael's Plato is a portrait of Leonardo.)

Competition and jealousy showed itself in other ways, however. Vasari, the painter and biographer, insulted Leonardo's slow working pace and bragged that he himself had done the entire Roman

chancellor's palace in 100 days. (Michelangelo responded: "It's obvious.")

Savonarola—Return to the Middle Ages

Even with all the art and philosophy of the Renaissance, violence, disease and warfare were present in medieval portions. For the lower classes, life was as harsh as it had always been. Many artists and scholars wore swords and daggers as part of everyday dress. This was the time of the ruthless tactics of the Borgia and other families battling for power. Lorenzo himself barely escaped assassination during Mass (the attack was signalled by the bells at the most sacred part of the service); he wrapped his cloak around his arm, drew his sword and backed into the sacristy. The conspirators were publicly hanged, beheaded and quartered, with one of the bodies paraded through the streets on a spit—past the watchful eyes of some of the greatest statues created by man.

In fact, 15th-century Florence was decaying. The Medici banks began to fold due to mismanagement and political troubles. The city's wealth had brought decadence and corruption. Even Lorenzo got caught with his hand in the till. To many it was time for a "renaissance" of good old-fashioned medieval values.

Into Florence rode a Dominican monk named Savonarola preaching fire and brimstone and the sinfulness of wealth, worldly art and secular humanism. He was a magnetic speaker, drawing huge crowds, whipping them to a frenzy with sharp images of the corruption of the world and the horror of hell it led to. "Down, down with all gold and decoration," he roared, "down where the body is food for the worms." He presided over huge bonfires where they burned "vanities"—clothes, cosmetics, jewelry, wigs, as well as classic books and paintings.

When Lorenzo died, the worldly Medicis were thrown out, replaced by a theocracy with Jesus Christ at its head—and Savonarola ruling in His absence. The theocracy (1494-98) was a grim time for the Renaissance. Many leading scholars and artists followed Savonarola's call and gave up their worldly pursuits. "Vice squads" of boys and girls roamed the streets chastising drinkers, gamblers and overdressed women. Even so, the promised governmental and church reforms were never accomplished.

As the atmosphere of general fanaticism faded, so did Savonarola's popularity. In April 1498, to prove his saintliness and regain public support, he offered to undergo ordeal by fire—to be burned at the stake and escape unharmed. At the last minute, he got cold feet, backed out

and was arrested. He had no choice—he was hanged and burned at the stake in the town square—and did not escape unharmed. (A plaque on Florence's main square marks the spot.) The Medicis returned.

Florence in 1500 was a more sober place than during the gay days of Lorenzo. Botticelli, under Savonarola's spell, had given up his nudes and pagan scenes, letting the melancholy side of his personality come out. It's said he even burned some of his "sinful" works on the bonfires. Fra Bartolommeo gave up painting altogether, retiring to a monastery.

Pico della Mirandola, the most brilliant young mind of the Platonic Academy, also joined a monastery. This is the same man who, in a fit of passion, had tried to run off with a beautiful commoner engaged to another man. Pico rode into town, swept her onto his horse and carried her off, leaving 15 dead in his wake. Lorenzo had to bail him out of jail and give him a good talking to. But he was more affected by the words of Savonarola; he gave up on the world and his belief in a common Truth, entering a monastery to scourge himself and die an old young man.

Rome gradually became the Renaissance center, but the artists were mostly Florentine. In the 15th century the Holy City of Rome was a dirty, decaying, crime-infested place, unfit for the hordes of pilgrims that visited each year. The once-glorious Forum was a cow pasture. Then a series of popes, including Lorenzo's son and nephew, launched a building and beautification campaign. They lured Michelangelo, Raphael and others to Rome with lucrative commissions (and outright "orders"). The Florentine Renaissance—far from over—moved south.

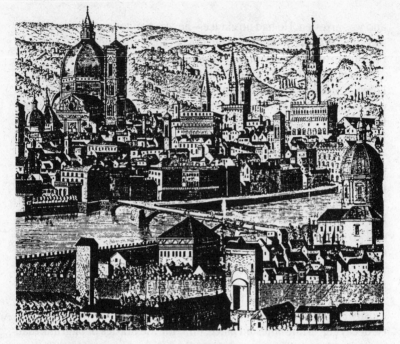

A Walk Through Florence Today

Florence is rightly called Europe's art capital. Any visit to this great city requires a logical game plan or strategy of touristic attack.

Great and rich as Florence may be, it's easily covered on foot. Here is probably the most exciting one-day art tour anywhere in the world.

Start at the Accademia when the doors open at 9:00. This is the house of Michelangelo's ever-popular "David." Listen to a few tour guides tell the story of the giant marble. Study the unfinished "Prisoners" on your way out. These four muscle-bound men look as if they're struggling to free themselves from the marble. Across the street is the best art book and poster shop I've found in Florence.

The Duomo

The grand cathedral, or Duomo, is just down the street. Brunelleschi's dome was the model for many to follow—including Michelangelo's dome for St. Peter's. The church itself is actually Gothic but the dome is practically *the* symbol of the Renaissance. Across the square is the Baptistry with its carved bronze doors by Ghiberti. Michelangelo called these doors "The Gates of Paradise." The Baptistry's interior shim-

mers with medieval mosaics, a good example of pre-Renaissance art. Note the contrast.

Across the street from the Baptistry towards the river is a tourist information center. Double check Florence's constantly changing museum hours here and pick up a city map.

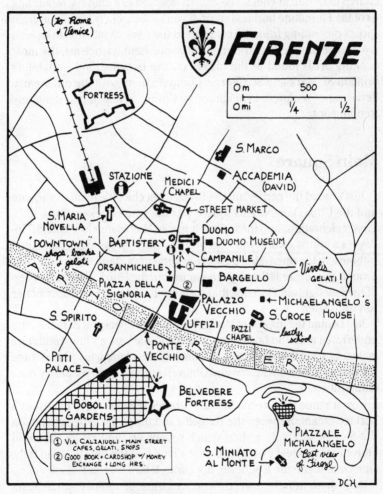

Map of Florence (Firenze)

While you can climb the dome, it's easier to climb the bell tower, often called "Giotto's Tower." From this perch you'll enjoy the best view possible of Florence's dome—and the city itself.

Behind the church at number 9 is the Museum of the Duomo. This houses some of Florence's top sculpture including many Donatellos and a late Michelangelo Pieta.

Walking further towards the river you'll pass the often-missed old church of Or San Michele. The church doubled as a granary, reminding us of the Florentine business spirit. If you look carefully, you'll see grain spouts protruding from the columns in the nave. While the altarpiece is a great example of two-dimensional pre-Renaissance art, the most exciting art is found in the niches on the outside. Find Donatello's brilliant St. Mark and St. George. Compare them with the other early Renaissance sculpture in neighboring Gothic niches. Man is definitely stepping out.

Main Square

Just around the corner are the Palazzo Vecchio, the main city square and the Uffizi Gallery. This square was the scene of executions, riots, great celebrations and the former home of Michelangelo's "David." Today it's a tourist's world with pigeons, postcards, horsebuggies and tired hubbies. In the open-air loggia are several important statues, and just around the corner is the city's top museum, the Uffizi. The Uffizi is one of the few sights in Florence that stays open all day. It's probably better to visit it later.

Just behind the imposing Medici fortress is the peaceful Bargello. This underrated museum houses much of the Renaissance's finest sculpture including several Michelangelos, Donatellos (including his "David") and the pieces that Brunelleschi and Ghiberti entered in the Baptistry door competition.

Now it's time for a gelato break. Florence is supposed to have Italy's best ice cream. Between the Bargello and the Santa Croce church on Via Stinche is Vivoli, a shop which scoops up the best ice cream in Florence. I was leery of reports that Vivoli had the best gelati in Italy. One cone made me a believer. Six cones later I was still a believer.

Refreshed, wander over to Florence's most beautiful church, Santa Croce. Along with the tombs of Michelangelo, Galileo and Machiavelli, you'll see Giotto frescoes and the neighboring Pazzi Chapel by Brunelleschi, one of the best examples of Renaissance architecture anywhere.

Uffizi Gallery

By now you should be starved and exhausted. You are surrounded by restaurants, self-service cafeterias, pizza places, and leather, gold and silver shops. (Some of the best deals in Florentine leather are found at the leather school located inside the Santa Croce church.) After a rest, a meal and possibly a little shopping, head back to the Uffizi Gallery, which is open until 7:00 pm Tuesday through Saturday.

The Uffizi has Europe's greatest collection of Renaissance paintings. With several of Botticelli's best, Michelangelo's only easel painting and masterpieces by nearly all the Renaissance superstars, this museum is the single most important sight in Florence.

When you're finished wander through its courtyard surrounded by statues of all the famous Renaissance artists and young present-day artists doing portraits, to the river bank. From here you can look downstream to the historic old bridge, Ponte Vecchio, and ponder the cultural richness of Europe's art capital—Florence.

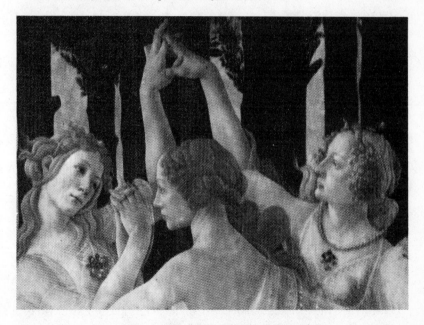

SANDRO BOTTICELLI, "PRIMAVERA" (DETAIL),
FLORENCE, CA.1478

Venice - Europe's Rich Middleman

For over 500 years Venice was "The Bride of the Sea" and the envy of all Europe. Venice's economy, her glorious buildings, her art and gay way of life all depended on trading. Every year on an important feast day the leader of Venice, after pronouncing a solemn promise, tossed an elegant ring into the Adriatic Sea. This symbolized the marriage between the sea and its bride.

Venice was founded 1500 years ago by Italians fleeing from German barbarians after the fall of Rome. They settled on a series of islands in a lagoon that no one would care to conquer. They built on the mud, pounding in literally millions of tree trunks for support. They dredged canals for passageways, rather than trying to build solid roads.

Farming was impossible in the mud, so the Venetians learned quickly to trade fish and salt (for preserving meat) with their neighbors for grain and other agricultural products. Gradually, their trading took them to more and more distant lands. They were situated perfectly to link Europe with the wealthy Byzantine Empire and the treasures of the East. When the Crusades created a demand in Europe for Eastern luxury goods, Venice became the middleman.

Products from as far away as Scotland and India passed through Venetian warehouses. The Rialto Bridge area was the world's busiest trading center. Iron, copper and woven textiles from Northern Europe; raisins, pepper, wines, lemons, silk, Persian rugs, leathers, precious stones, per-

fumes and spices from the East. Venice did no overland trading. Instead, she had a chain of ports and friendly cities in the eastern Mediterranean. The goods arrived (sometimes by camel caravan) and the Venetians shipped them west where European land traders picked them up.

Venice was the largest city in Europe with 150,000 in 1500. (Paris had 100,000.) The ducat, because of its stability and high gold content, became the monetary standard for the Eastern world (the Florence florin was the West's). The Gross "National" Product of this city was 50% greater than the entire country of France.

Her sea-trading spawned other industries as well—shipbuilding, warehousing, insurance, accounting and sailing. The Arsenal, the largest single factory in Europe, employed 16,000 people at its peak, and could crank out a ship a day.

DOGE'S PALACE, VENICE, 1340

A good example of Venetian Gothic, this building (often called the tablecloth) was the political center of the most prosperous city in Europe for several centuries. Today it is packed with art masterpieces, history. . .and tourists.

Besides expanding its commercial empire, Venice hired generals to conquer many of the cities in Northern Italy. (The famous equestrian statue by Verrochio is of Colleoni, a mercenary general.)

All this wealth did not go to waste. The 15th century was a time of massive building and rebuilding. The earliest structures show a Byzantine influence—St. Mark's Cathedral is the best example. The most distinctive, however, are "Venetian Gothic," like the Duke's Palace. They have Gothic pointed arches, but they're much gayer and fanciful than the Gothic churches of Northern Europe. Later structures are Renaissance style with rounded Roman arches.

The Rialto Bridge spanning the Grand Canal was still a covered wooden drawbridge at this time. All the small bridges were rebuilt in an arched style. Before this, they were straight wooden planks, allowing horses and mules to pass over. With the new arched bridges installed, all horses were banned from the city—just as cars are today.

The empire was controlled by an oligarchy of wealthy families comprising about 5% of the population. They elected a council of rulers led by a man who served for life, known as the "Doge" (not pron. doggie) (from Italian "duce," pronounced "DOO-chay," meaning "duke." Mussolini was known as "Il Duce.")

Next in line came the "citizens," the middle class of lawyers, merchants, doctors and intellectuals comprising another 5%. The rest of the population had no political rights, but they were well-treated and prosperous. Until 1423 the people had final veto power over election of the Doge, when the council presented him in St. Mark's Square saying, "This is your Doge, if it please you." They invariably approved the election by cheering—until one Doge-elect, an unpopular man, feared he might *not* please them. From then on, they said only, "This is your Doge."

Venetian society was rigidly structured, but it was also quite tolerant. It was a cosmopolitan city, where traders from all over the world rubbed elbows. Some foreigners were even allowed to settle there—Turks, Dalmatians, Arabs. (The bell at St. Mark's is rung by two statues of Moors.) There was a Jewish community—giving us our word "ghetto," meaning a neighborhood set aside for minorities. The largest foreign group was the Greeks, especially after the disastrous sack of Constantinople by the European Crusaders (1204) and the city's fall to the Turks (1453). There were some 5,000 Greeks, one of whom was Domenico Theotocopoulis—who became a famous painter in Spain as El Greco ("The Greek").

The Catholic Church was often at odds with Venice, partly because of her close ties with the rival Greek Orthodox Christians. The Venetians thought of themselves as "Catholics," not "Roman Catholics."

St. Mark's Cathedral

St. Mark's Cathedral, one of the world's most famous, is the best example of "Venetian Byzantine" architecture with its Eastern domes and interior mosaics. But the style might better be called "Early Ransack"—the cathedral is a treasure chest of artifacts looted from other cities during Venice's heyday.

ST. MARK'S CATHEDRAL, VENICE
Mark Twain called it a "warty bug taking a walk."

Even Venice's patron saint, Mark, was stolen. In 829 a band of merchants trading in Alexandria, Egypt, stole the body of the dead Evangelist (a writer of one of the New Testament Gospels) from Alexandria's Moslem rulers. On the return trip, Mark supposedly saved them from a deadly storm at sea. His body was housed in St. Mark's and his symbol, the lion, became the symbol of the Venetian Republic.

Elegant Decay — The Cinquecento

The year 1450 marked the height of Venice's economic power. Then a series of world events set in motion three centuries of slow decline.

In 1453 the Moslem Turks captured and looted Constantinople. Uninterested in trading with the West, they began attacking Venice's foreign ports. Venice not only lost its links with the East, it was forced to fight costly wars with the Turks.

The next blows came from the West, when explorers from Spain and Portugal discovered America and new sea trade routes to the East. By 1500 Portugal was using Vasco da Gama's route around South Africa to trade with the Moluccas and India. Venice's Eastern monopoly was broken.

The period of decline was perhaps Venice's most glorious, however. Like so many cultures past their peak of economic expansion, Venice turned from business to the arts, from war to diplomacy, from sternness to partying. The "Cinquecento" (pronounced CHINK-kwa-CHEN-to), as the Italians call the century of the 1500s, was a time of merrymaking and festivity that was legendary in Europe. The rich wore bright, colorful velvet and satin clothing. For awhile, the men's fashion was to wear two different colored hose, say, a red left stocking and a blue one on the right. At night, they attended the theater, where comedy was the rage, or perhaps one of the city's famous masked balls.

The middle class, dressed more soberly, still enjoyed the fruits of the lingering trade. They might pass the time eating seafood in one of the numerous *trattoria*. At the next table might be two lovers sharing long looks and a bowl of peaches soaked in wine. Across the way, you might see one of Venice's famous courtesans on a balcony, bleaching her hair in the midday sun. In later years Venice was the "fun city" of Europe, as popular for tourists in the 17th century as today. There is some speculation that Shakespeare (who described the city so well in the *Merchant of Venice*) took a trip there.

The poor had the usual hard life, but never so bad that life wasn't worth laughing at. There are no major riots, uprisings or strikes in Venice's long history.

The Cinquecento produced some of the greatest Renaissance art. Bellini, Titian, Giorgione, Tintoretto and Veronese forged a distinct Venetian style that emphasized color over outline. (Their work embellishes churches, palaces and museums throughout the city.) Whereas Florentine painters drew massive sculptural figures with a strong outline, Venetians used gradations of color to blend figures into the background. The result was a lighter, more refined and graceful look. (When Michelangelo met the great Titian, whose fame rivaled his own, he praised his work, then said, "But it's a pity you Venetians cannot draw.")

The happy-go-lucky Venetian attitude can be seen in Paolo Veronese,

who once painted Jesus' "Last Supper" as if it were a typical Venetian dinner party. We see drunks, buffoons, dwarves, a German mercenary soldier, dogs, a cat and a parrot. The authorities were so shocked that they demanded he repaint it in a more sombre mood. Rather than repaint it, he just retitled it—we know it as "Feast of the House of Levi."

Venice's economic decline went hand in hand with political corruption and repression. Venice had never been a democracy, though ruled in the past by an elected Doge and council members known as "the Ten." In later years, those Ten were whittled down to "the Three," with sweeping powers. The people had a saying: "The Ten send you to the torture chamber; the Three to your grave." Venice's torture chambers were infamous.

THE DOGE'S PALACE AND THE PRISONS—
CONNECTED BY THE COVERED BRIDGE OF SIGHS

Venice looks just like this today (without top hats & tails).

Casanova, the renowned rogue, spent time in a Venetian prison, which he describes: "Those subterranean prisons are precisely like tombs, but they call them "Wells" because they contain about two feet of filthy water which penetrates from the sea. Condemned to live in

these sewers, they are given every morning some thin soup and a ration of bread which they have to eat immediately or it becomes the prey of enormous rats. A villain who died while I was there had spent 37 years in the Wells."

The famous Bridge of Sighs (rebuilt in 1600) connected the lawyers' offices with the judgment chambers. Prisoners could be brought from the prisons, tried in closed court and sentenced without the public knowing about it. As they passed over the bridge to their deaths, they got one last look at their beloved city—hence, the "Bridge of Sighs."

The long, glorious decline was hastened by two brutal plagues which devastated the population. When Napoleon arrived in 1797, the city was defenseless. He ended the Republic, throwing the city into even worse chaos. It became a possession of various European powers until 1866 when it joined the newly-united Italian nation.

The city today is older, crumbling and sinking, but it looks much the same as it did during the grand days of the Renaissance. For that we can thank Venice's economic decline—they were simply too poor to rebuild. Venice is Europe's best-preserved big city. It is the toast of the High Middle Ages and Renaissance—in an elegant state of decay.

Many people actually avoid Venice because of its famous "smelly canals." So you'll know how serious this problem is, we've recreated that Venetian stench here so you can scratch and sniff—and decide for yourself.

scratch n' sniff
—Venice—

TANGENTS
Early Modern World

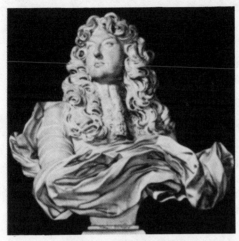

BERNINI, "LOUIS XIV," VERSAILLES, 1665

Versailles - Europe's Palace of Palaces

"If Louis XIV had not existed,
it would have been necessary to invent him."
—Voltaire

Enormous palaces dwarfed by endless gardens. Great halls decorated in the "Grand Style" with chandeliers and mirrored walls. Tapestries, gold leaf and silver plating. Fountains, pools and manicured shrubs. We can marvel at these today at Versailles, but they hardly give a full picture of the glory—and decadence—of everyday life under the Sun King, Louis XIV.

What we don't see: the thousand orange trees planted in silver tubs, rolled from room to room on wheeled contraptions; the zoo with exotic animals in cages; the sedan-chair taxis for hire to shuttle nobles from chateau to chateau; the 1500 fountains (only 300 remain); the Leonardos, Raphaels, Titians, Rubens' and Caravaggios (now in the Louvre) that hung in halls and bedrooms; the gondolas from Venice poling along the canals at night, accompanied by barges with musicians; the grand halls when

lit by hundreds of thousands of candles for a ball. Most of all, we don't see the thousands of finely dressed nobles and their servants—and the center of all the gaiety, Louis himself.

As you walk through the luxurious halls and royal gardens of this pinnacle of European splendor, let your imagination bring it alive.

Louis XIV, the Sun King

Louis took over as King in 1661 at age 23. While he was neither tall (5'5") nor handsome, he seemed to strike everyone that way. He was charming, a great conversationalist, a great horseman; played the harpsichord and guitar (acoustic), and loved ballroom dancing. He was perhaps the most polite king of all time—he always listened closely to his courtiers and tipped his hat to everyone on the street. Most of all, he was an outdoorsman, and that love made him want his palace in the countryside, not in stuffy Paris.

The France Louis inherited was the strongest nation in Europe, with 18 million people (England at this time had only 5.5 million). The economy, directed by minister Colbert (the first man to take a balance sheet seriously), was strong at home and spreading, with a large merchant marine, to the luxurious Indies, East and West. Louis organized an efficient bureaucracy for gathering taxes, yet he himself remained at the controls. He was no scholar—in fact, he was "extra ordinarily unlearned"—but as a ruler he was unsurpassed.

The Royal Schedule

Louis lived his life like it was a work of art to be admired by all. He rose late and was dressed not by servants but by nobles and barons. Around noon was breakfast, then he attended Mass. In the afternoon, Louis worked—and worked hard—meeting with advisers, generals and bishops. At 5:00 he ate dinner, either alone or with the Queen, though he wasn't ever really alone—every action was a public ritual attended by nobles of the court. Louis had an enormous appetite. A typical dinner consisted of four different soups, two whole fowl stuffed with truffles, a huge salad, mutton, ham slices, fruit, pastry, compotes and preserves. Louis' favorite pastime was hunting. Whenever possible, he was out of doors. Nighttime was spent in one of many pleasurable pastimes for which Versailles is renowned. Louis then had a late supper (near midnight) and retired.

"The Sweet Pleasure of Doing Nothing"

Louis' life of leisure was nothing compared with the nobility who had absolutely nothing to do day after day except play. They had no government function in France's "modern" bureaucracy except to attend to Louis' daily rituals. They survived on favors from the King—pensions, military and church appointments and arranged marriages with wealthy noblemen. It was essential to be liked by the King or you were lost. If Louis didn't look at you for weeks on end, you knew you must seek an audience with him and apologize—with many tears and much hugging of the royal knees. Compare the position of France's weakened nobility with that of England at the same time—the lords in Parliament

FRENCH FASHIONS FROM THE DAYS OF LOUIS XIV

had just beheaded one king, thrown another out and were choosing his successor.

Versailles in its heyday had 5,000 of these domesticated nobles (with at least as many dependents) buzzing about the grounds seeking favors. Business was conducted while at play—billiards, dances, concerts, receptions and the most common pastime, gambling (usually a version of "21"). Large gambling debts made many nobles still more dependent on Louis.

Dressing properly was part of the favor-seeking game. Men shaved their rough beards and put on stockings and silk clothes. Big curly wigs became the rage when Louis was seen wearing them—after he started

to go bald. A contemporary wrote: "It was possible to tell the women from the men only when it was time to go to bed." (These days, that's when the confusion begins.)

One of the "fashions" was adultery, an accepted—almost obligatory—social ritual. Louis' succession of mistresses has become legend. Still, he remained faithful to the institution of marriage itself, and fulfilled his obligation to the Queen, Marie-Therese of Spain, by sleeping with her every night (after a rendezvous with one of his lovers) and even making love to her twice a month. (This is history here, not idle gossip!)

Versailles wasn't all fun and games. Most nobles didn't want to be there—rural Versailles was "the sticks" compared with the old court at the Louvre. It was expensive to live there and keep up with the latest fashion. Lodging was scarce and unbelievably crude, without enough "facilities" for the crowds of inhabitants. Since standing in line was beneath such dignified nobles, they simply stepped behind staircases and curtains instead.

In fact, many nobles were right off the farm themselves—crude, ex-feudal lords more used to fighting than fashion. They learned to wear the fancy clothes—but still didn't bathe or shave regularly. Forks were still a new-fangled invention. Spitting was common. Cheating at cards was allowed, even encouraged, and losers didn't bother to lose gracefully—they screamed and tore their hair out. Many of the ridiculous characters of Moliere's plays are right out of the court in which he lived.

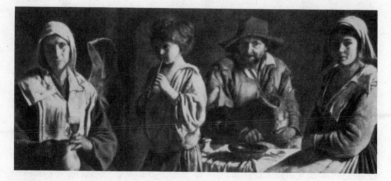

Life Outside Versailles—Poverty

Versailles, even in those less democratic days, was always open to the public. Only a few rooms were off limits. Thieves, "courtesans," merchants and (as today) many, many tourists from all over the world thronged the palaces.

The court was the envy of Europe, but the opulence was never shared with the common Frenchman who continued to live the same wretched peasant life. The three decades of war Louis waged over succession to the Spanish crown was expensive and bloody for France and its people.

Personally, Louis disliked even hearing about poverty—it was a subject one simply didn't bring up in his presence—and Versailles may have been his escape from it. In his own way, Louis had brief brushes with poverty that may have shocked him into an uncommon love of wealth. As a child-king under the protection of a regent, he and his mother were ill-treated by the powerful parliament of lords which forced them to live on a miserly budget unfit for a king. Louis had to wear clothes that he'd outgrown, sleep on torn bedding and eat bad food.

As an adult, there were hardships brought on by the costs of war. One popular story tells of Louis attending the housewarming for the luxurious Chateau de Vaux-le-Vicomte (the model for Versailles, and exciting to visit today) built by an extremely wealthy count. Everything was unbelievably expensive. Louis was more than amazed—he was

TOURIST CROWDS AT VERSAILLES

jealous. The final straw was when the count served dinner on pure gold service. Louis had just finished hocking his own gold service to help fund the Thirty Years' religious wars. The king said nothing. He simply went home, then sent his men back to arrest the count and appropriate his wealth. Then he began to build Versailles.

If "living well is the best revenge," Louis certainly got his. Versailles allowed the perfect escape from life's harsh realities. Even in his choice of art, Louis preferred grandeur and idealized beauty to simplicity and realism. He detested the naturalism of the Dutch and Flemish masters and encouraged Baroque opulence.

Still, on his deathbed, he gave this advice to his 5-year-old great-grandson, Louis XV: "Don't imitate my extravagance. Alleviate the suffering of your people and do all the things I was unfortunate enough not to do." Perhaps little Louis was too young to understand, for he, too, succumbed to the lure of wealth. For whatever reason, the Sun King's words went unheeded, and his successors in the Old Regime at Versailles continued in their gambling, fashion shows and playing—oblivious to the world changing around them—right up to the French Revolution.

Versailles—Sightseeing Tips

Versailles is the Palace of Palaces. If you visit only one palace in Europe—make it Versailles.

The home of France's most splendid "divine monarchs" is an easy one-dollar 12-mile train ride from downtown Paris.

Louis XIV built Versailles. He was the epitome of an absolute monarch, a deputy of God, and the trend-setter for European royalty to follow. He was, in his opinion, the King of Kings. Many great European palaces were obvious attempts to match the unmatchable splendor of Versailles.

Prepare for Versailles

To appreciate Versailles give yourself a pre-trip history lesson. Versailles is just one busy century of French history, from 1682-1789. Some background in Greek mythology will be helpful in appreciating the palace art, since much of it tells symbolic stories of Zeus and his Olympian family. Louis XIV called himself the "Sun King." Apollo was also the Sun King. The art style of the palace is Baroque, controlled exuberance. You'll find much of that exuberance just barely controlled on the ceilings in magnificent paintings—most dealing with mythological subjects.

For an expert's opinion, I interviewed a palace historian and guide. She recommended this basic strategy. Buy a guidebook at the entrance. The small two-dollar book is fine. A book is important because you're on your own to explore most of the palace. The book will give you plenty of information on the state rooms and the Hall of Mirrors. The King's

Rooms are a must and are shown only with a special guided tour that you can pick up inside the palace. Be sure to see the more intimate Queen's apartments and the Royal Opera as well.

My guide was quick to answer my questions about tourists' most common mistakes: "They go too fast. They aren't prepared. And they don't know how to look. Forget about the present—really see things by losing yourself in the history. Soak it in. Soak in it. Be influenced. Be sensitive to what pleases you. Too many people walk through the palace reading their guidebook—they forget to look! Sit outside, read the book, then enter and look—absorb."

The guides are historians and educators. My guide told me, "We are not merely people who have learned what to say in each room. When the people are really interested we are very happy and can enjoy the tour. English and American visitors are our favorites. They really get excited about Versailles—and so do we."

The grounds surrounding Versailles are a sculptured forest, a king's playground. Explore the backyard. Marie Antoinette's little Hamlet (le Hameau) will give any historian or romantic goosebumps. This is where the Queen (who eventually laid her head under the "national razor" during the Revolution) would escape the rigors of palace life and pretend she was a peasant girl, tending her manicured garden and perfumed sheep.

Versailles can have horrifying crowd problems. I've survived waking nightmares when tour bus crowds crushed in and hysteria broke out. People were screaming, separated forcibly from their children—and not enjoying Versailles. It made a pre-Rolling Stones concert crowd look like monks in a lunch line. The palace is packed on Tuesdays when most Parisian museums are closed. Versailles is closed on Mondays. Beat the crowds by arriving before the 9:45 opening time. It is easiest to reach Versailles by taking the train from Les Invalides station in Paris to Versailles R.G., the end of the line. The palace is just three blocks from the station. Bring a picnic.

Europe's Royal Families

Up until World War I Europe was ruled by a few very powerful families. Territory passed from one royal family to another with each war and royal wedding. While the Hohenzollern family of Prussia goose-stepped its way militarily across the map, the Austrian Hapsburgs "conquered" Europe by making babies, not war.

The Hapsburg Empire was Europe's largest, including the Austria-Hungary region, Spain and much more. The vast holdings of these royal families paid very little attention to national borders. Many kings and queens couldn't speak the languages of the people they ruled. It wasn't until the 1800s that rulers took "nationalities" seriously.

Maria Theresa (1717-80) started a baby boom of her own by having 12 kids. She married most of them off to other European royal families. For instance, her daughter Marie Antoinette, by marrying Louis XVI, became the Queen of France—and subsequently lost her head in the Revolution.

The Romanov family ruled Russia until the Bolshevik Revolution in 1917 created the Soviet Union—which had no room for a tsar.

The Ottomans, ruling their huge empire from Istanbul in present-day Turkey, did their best to carry the torch of Byzantine greatness into the modern world. In its last years the decaying Ottoman Empire was called the "sick man of Europe."

The Louis's of France were of the Bourbon family. They were Europe's model of royal splendor for many years. But the French Revolution interrupted their reign violently. They were invited back in the mid-1800s, but as modern kings, without the Old Regime splendor.

The royal families of Europe had their day, but none of them survived World War I intact. Today Europe has a few figurehead constitutional monarchs (that do more for gossip magazines than politics) and a class of landowning aristocrats—generally impoverished by modern taxes and the high cost of maintaining their palaces. But the Europe you'll see as a tourist is, to a large extent, the Europe of the Kings and Queens of a grand old age.

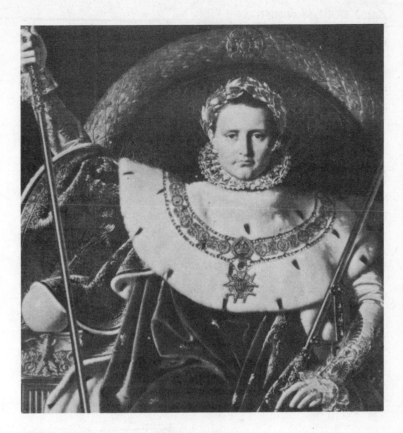

Napoleon

*"We must not leave this world without
leaving traces which remind
posterity of us."*
—Napoleon

*"Never was the possibility of universal monarchy more nearly realized
than in the person of the Corsican."*
—Lord Nelson, 1805

A short fat man with his hand in his coat. That's how we picture the man
who was nearly a "universal monarch"; a man considered the Antichrist by
some, the champion of freedom by others (see the opening line of Tolstoy's
War and Peace); a man whose reputation scared English children into obe-
dience (". . .or else Bonaparte will eat you alive."); a man exalted and damn-
ed by contemporaries and historians alike.

The Complex Corsican

Napoleon's personality was as complex as his place in history. He was actually of average height, thin (until age and high living put on the pounds), with brown hair and eyes and a classic, intense profile. He was well-read, a good writer and charming conversationalist who could win friends and influence people with ease. He had few of the vices that plague world conquerors—he cared little for good food and drink or fancy clothes, and he worked himself as hard as he worked others. Nevertheless, he could be cold and distant and ruthless with his enemies.

Above all else, he was egotistical and power hungry, convinced of his inherent right to rule over others. Yet he backed it up with a genius for military and political administration. Although he was easily flattered, he never let it cloud his judgment. His letters and diaries are sprinkled with objective self-criticism like, "In the last analysis, I blame myself."

From Foreigner to Emperor

Born on the Mediterranean isle of Corsica (the year after it became French) of Italian parents, he was educated in French military schools. Originally an outsider, he quickly lost his accent and rose through the ranks of the army during the chaotic French Revolution. He was brash, daring and always successful at a time when the old order was being turned upside down. His success as a general against the Allied powers

ARC DE TRIOMPHE, PARIS
Napoleon wanted to transform Paris into the "New Rome," complete with Neoclassical monuments such as this.

in Italy and Egypt brought him popularity back home in a France hungry for strong leadership. In 1799 he was elected First Consul, and was soon a virtual dictator. He was 29.

Napoleon crowned himself emperor in an elaborate ceremony staged in Notre Dame. The pope attended, recalling the glory of the days of

Charlemagne and Imperial Rome. Paris was the "New Rome," Napoleon the new Caesar. With the spoils of his conquests in Europe, the city was rebuilt, with gas lamps and new bridges. The Arc de Triomphe, like Rome's monuments to her emperors, completed the return to classical glory.

Europe's opinion of the upstart "emperor" was divided. To many, he was a heroic figure, fighting for the ideals of democracy. Beethoven had planned to dedicate his Eroica ("Heroic") Symphony to him, but became disillusioned by his ruthlessness. To others, Bonaparte was a power-mad ogre, without scruples, to be stopped at all costs. Finally, there were those who simply laughed at his imperial airs, thinking him a charlatan duping a gullible public.

Napoleon certainly was no slave to ideology. He was a Machiavellian realist who could proclaim the cause of democracy while suppressing civil rights and courting royalty.

Wives and Mistresses

Napoleon's passion for women is legendary. He fell for the elegant, fickle—and ultimately unfaithful—Josephine Beauharnais, whose charms and connections were useful in his rise to power.

For all his amorous dealings, Napoleon treated women matter-of-factly. He could faint in passion in his mistress's arms (causing a scandal in Paris), yet he could also divorce Josephine because she failed to bear him an heir. He had a fairytale affair (and a son) with a Polish countess, but he also arranged a purely political marriage into the royal Austrian Hapsburg family. Regardless of diapers and other domestic affairs, when the troops moved out, so did Napoleon.

Defeat, Exile, Waterloo

On the battlefield, Napoleon was not content to simply protect the nation from counter-Revolutionaries—he was bent on conquest. As his minister Talleyrand said, "The French people are civilized—their Emperor is not."

Napoleon's diastrous invasion of Russia marked the beginning of the end. After the long march into Russia, the French found Moscow in flames, torched by the Russians themselves. During the longer march back—in the dead of winter, weighted down by their plunder, savaged by wolves and Russian guerrilla fighters—the army was devastated. Of the 450,000 that went in, only 10,000 came back. Napoleon abandoned his troops and hurried home to a hot bath and hotter waters politically.

With enemies on every side, France had no choice but to depose her

emperor, giving him a dignified retirement/exile on the Mediterranean island of Elba. (It's a tribute to the civility of the period that no one, either in France or among the Allies, insisted on his execution.) Napoleon, disgraced, tried to poison himself and barely survived.

But Napoleon had too many dreams and too many friends left to remain in exile. Within a year, dressed in his familiar grey overcoat, he sailed to France and challenged the people, "Strike me down or follow me." They followed—and he led them to one final, grand defeat at Waterloo (Belgium).

Finally banished for good to the remote island of St. Helena, his last years were not awful, but they must have been awfully boring. Having once been the most powerful, most adored, hated and influential man in the world, he must have paced like a caged animal. He used the time to write his memoirs, creating his own legend to remain after he himself was gone. (As you travel, you'll see traces of the Bonaparte legacy throughout Europe, from Trafalgar Square to Rome.)

Napoleon was the last of the "enlightened despots" of the Old Regime and the first of the modern popular dictators. He was a rationalist and agnostic of the passing age of Voltaire and the model heroic individual of the future Romantic world. Napoleon accomplished what few conquerors ever do; he not only dominated Europe—he changed it.

Musical Vienna

Vienna at the turn of the 19th century was for music what ancient Athens and Renaissance Florence were for painting and sculpture. Never before nor since have so many great composers and musicians worked and competed side by side—Haydn, Mozart, Beethoven and Schubert all worked in Vienna at roughly the same time (1775-1825). Their works changed music forever, raising it from simple entertainment to High Art.

Why Vienna? A walk through the city explains part of it. The peaceful gardens, the architecture, the surrounding countryside were inspiration for composers, many of whom wrote tunes in their head as they strolled through the streets. Beethoven was a familiar sight, striding quickly, his hands behind his back, staring straight ahead with a brooding look on his face. He claimed he did his best writing away from the piano.

Money Makes Music

But the true root of all musical inspiration in Vienna was (as with most art) money. The aristocracy found music more interesting than politics. The concert was the social hub of high society. Many leading families had their own private orchestras to play at parties. Some nobles were excellent amateur musicians—the Emperor Joseph II played both violin and cello; Maria Theresa was a noted soprano.

Still, professionals were needed to perform, conduct, compose and give lessons. Musicians from all over Europe flocked to Vienna where their talents were rewarded with money and honor.

Before 1750, music was considered a common craft—like shoemaking—and musicians were treated accordingly. Composers wrote music made-to-order, expecting it to be played once and thrown away, like kleenex. The new breed of composers, however, beginning with Haydn, saw music as a lasting art, on a par with painting and sculpture.

They began to demand equal treatment from their employers. Beethoven, in fact, considered himself superior to them—he was an artist, they were merely royalty. When Mozart became composer-in-residence for a Viennese prince, he was paid a princely sum . . . and then told to eat his meals with the servants. Mozart turned on his heel and walked out, refusing from then on to ever seek any official position.

Unappreciated Geniuses

Vienna fawned over its composers, but only so long as they cranked

PORTRAIT OF THE CHILD PRODIGY, MOZART

It's said Wolfgang was kissed by more queens than anyone in history.

out pleasant tunes. The minute they'd try something new, daring or difficult, the public would turn on them.

Mozart was adored as a cute, clever six-year-old who could play harpsichord as well as anyone in Europe. He won the hearts of the nobility by declaring he wanted to marry the Princess Marie Antoinette. But as a grown man, writing mature and difficult works, he was often maligned and neglected. When he died, broke, at 35 his body was buried in an unmarked grave. Only later was his genius fully appreciated and a statue erected to honor him. As the saying goes, "To be popular in Vienna, it helps to be dead."

Beethoven, like Michelangelo before him, played the role of the temperamental genius to the hilt. His music and personality were uncompromising. A bachelor, he lived in rented rooms all his life—69 different ones, at last count. He had several bad habits that explain this migratory existence—playing the piano at two in the morning, or pouring a bucket of water on himself to cool off, rather than going outside. His rooms were always a mess, with music, uneaten meals and unemptied chamberpots strewn about.

Beethoven, Mozart and Hadyn knew each other, despite their age differences. "Papa" Hadyn (so-called because of his way with younger musicians) encouraged Mozart and gave lessons to Beethoven.

Beethoven also learned from Antonio Salieri, Mozart's composing rival, who (according to legend) poisoned Mozart. Music in Vienna couldn't help but flourish with so many talented people rubbing elbows and engaging in such healthy competition.

Musical Renaissance II

The only music scene that can compare with the Vienna of 1775-1825 is the Vienna of 1860-1910: Brahms, Mahler, Bruckner and Richard Strauss, as well as the young pioneers of 20th-century music, Schoenberg, Berg and Webern. These were the Romantic composers, writing big, intense, passionate works that often as not were booed or laughed at. A riot nearly broke out at the debut of Mahler's Fourth Symphony with the crowd taking sides over the piece's merit. Viennese crowds loved what was safe. The most popular works were those of the Classical masters of the earlier period—works that had been derided as too daring in their own day.

Strauss Waltzes

And then there was Strauss. The waltz craze swept through Vienna in the early 19th century and has continued unabated to the present. The two leading composers and conductors of the waltz were father and son—Johann Strauss, Sr. and Jr. (unrelated to composer Richard Strauss).

The waltz was the Beatlemania of its time. Many considered it decadent because of the close contact of the partners and the passion of the music. Dances lasted literally from dusk to dawn, night after night. Johann the Elder played violin and conducted simultaneously with wild gestures, whipping the crowd to "bewildering heights of frenzy till they were frantic with delight and emitting groans of ecstasy," according to composer Richard Wagner who visited Vienna.

Young Johann took the baton at his father's death and raised the waltz to respectability. His "Tales from the Vienna Woods" and "Blue Danube" immortalized his beloved hometown.

We can imagine the lavish balls of the "Golden Age" under Emperor Franz Joseph where this music was played. Chandeliers, carriages, mirrored halls, sumptuous costumes. Ceremony and white-gloved ritual were the heart and soul of the conservative aristocracy. Franz Joseph of the royal Hapsburg house was not merely king, he was Emperor of the Holy Roman Empire—namely, Austria and Hungary. With such a stress on tradition, it's easy to see why avant-garde composers often went unnoticed until after their deaths.

The Vienna of today clings to the elegance of its past and maintains much of that musical tradition. The Ministry of Culture and Education is the new patron. The State Opera, the Philharmonic Orchestra, the Vienna Boys' Choir and the Society of Friends of Music still thrive as they did in Beethoven's time. There are statues for all the famous composers who were misunderstood in their day. And, if you dial Tel. #1509, you will hear a perfect A-note (440 Hz.) for tuning your instrument.

Music Appreciation

Music, like all art forms, develops and changes according to the cultural mood and environment of the time. It's easy to trace the course of musical history as it marches arm in arm with painting, architecture, sculpture, philosophy and lifestyles in general. Society travels from Baroque to Neoclassical to Romantic to Impressionistic and into the "no holds barred" artistic world of our century.

As we trace this evolution of musical styles through post-Renaissance history, let's use this chapter as a review of the progression of art styles in general since the Baroque days of Louis, Bernini and Bach.

The Baroque world was controlled exuberance, glory to man and his God-blessed accomplishments. In other words, "Let's shine and enjoy our success—without rocking the boat." Music, like art, was brilliant, bright, alive and decorated with frills, flutters, and ornamentation—like the powdered-wigged, perfumed and elegantly-gowned musicians who wrote and performed it.

But the frills rested on a strong foundation. While a two-part Bach invention, Handel's Messiah or a Scarlatti sonata may sparkle with bright and happy ornaments, they are carefully based on a mathematical or calculated structure. An analysis of Bach's work shows many patterns, staircase-type series and a grand plan, keeping all the musical ribbons and bows together.

Bach, Handel and Scarlatti, all born in 1685, were the great musical masters of the Baroque period.

The Neoclassical movement was a "back to pure clean basics" movement artistically and culturally. It was a stern reaction to the "clutter" of Baroque. Buildings were built with clean and true domes, circles and squares. The age of reason had arrived, and beauty was best found in simplicity. A good example of how music played along with the Neoclassical movement, is found in the art of Mozart. *The* Classical composer, he wrote pieces of powerfully simple beauty. Grand and frilly were out. A Mozart sonata, while very difficult to play well, is in-

tended to sound easy. Classical music, like the dome on our capitol building, is a search for basic, naked beauty.

The Romantic movement refused to stifle its heart and emotions to logical, realistic, calculated, T-square beauty. Music's grand metronome had swung back again. The Romantics were awe-struck by the wonders of nature and strove to be overcome by its power and immensity. They expressed emotions—good or bad—for the sake of emotions. Composers loved it. A series of pieces by Chopin, Wagner or Schumann can take you through an emotional wringer. The pieces, often with names reflecting their tale of glee or woe (Ase's Death, Pleading Child, Raindrops Prelude, Dreaming), are an effort to affect the listener more than to merely entertain.

In the 1800s reason and logic were dethroned and Nature, in its inexplicable and wondrous self, became a religion. Grieg's fjord hideaway, Verdi's nationalism, Beethoven's deafness and Chopin's battered heart, all inspired the masterpieces of this era.

As art reaches beyond mere realism, we enter the Impressionist era. While Monet and Renoir were catching sun beams, leafy reflections and the fuzzy warmth of that second glass of wine, composers like Debussy and Ravel were doing the same thing on the keyboard or with orchestras. Artists struggled to capture basic shapes, colors and moods. A blue moment, the crashing sea, a fleeting rainbow or an enchanted cathedral were targets of the artist's mind, the painter's brush and the composer's pen.

Frustration over a mass-produced world, techno-fascism and our current media madness (with public tastes shaped by teenagers in tight jeans on TV), has led many artists of the 20th century to give up on pleasing the people, enjoying instead the personally stimulating world of artistic esoterica. Paintings are abstract, and music is atonal.

Atonal music is a style freed from tonality, or worry about "what key are we in?" There is no key, no meter or consistent beat pattern (like 2/4 or 3/4 time), and the only real rule is that artists should not be bound by the rules of others.

Recognizing that music is only organized sounds, modern composers experiment with new sounds and new organizations, even doing away with the common scale. As with modern visual art, it's hard to tell just what "style" will come next—when the artists are trying so hard to reject the rules of style altogether.

Victorian London

"It was the best of times, it was the worst of times . . ."
— *A Tale of Two Cities*, Charles Dickens

Dickens' words best describe his own city of London in the 19th century. With some four million people, it was the world's largest. It was the busiest, the richest, the most productive, the hub of the most industrialized nation on earth and the capital of a colonial empire covering a fourth of the world's land surface. But the seamy underside of London was like a different city—dirty, poor, disease-ridden and dangerous.

This contrast was everywhere. You could buy any commodity in the world on London's docks—and get it stolen just as quickly. It was the center of industrial growth—yet it was choked with coal dust and industrial filth. London hosted the lavish social life of gay Prince Edward—as well as thousands of homeless urchins begging, stealing and sleeping in the streets. Palaces and townhouses contrasted with sagging tenements, and well-lit cafes with seedy pubs where the poor indulged in one of their few pastimes, drunkenness.

This was the Victorian period—that is, during the time of Queen Victoria (1837-1901)—but it might better be called "Albertian" London. Victoria's husband, Prince Albert from Germany, shaped the morals, interests and attitudes of his subjects. Handsome, intelligent, progressive and extremely proper, Victoria adored him. He was the model of the ideal gentleman.

The Great Exhibition and London's Growth

It was one of Albert's projects that spurred London's remarkable growth. He was fascinated with science and technology and proposed

CRYSTAL PALACE, LONDON

Iron and glass, built on schedule, enjoyed, and taken down on schedule, just to prove it could be done.

a Great Exhibition "uniting the industry and art of all nations"—in other words, a World's Fair. Held in 1851 in Hyde Park, it was the talk of Europe.

Over six million visitors jammed London's streets. (Over a million bottles of lemonade were sold at the fair.) The main attraction was the amazing Crystal Palace, a steel and glass structure covering 19 square acres with 300,000 window panes—the symbol of the new and glorious Industrial Age. The Exhibition was a smashing success, and many of the visitors returned to settle down in London.

The Victorian Age was a building time: the Houses of Parliament, the Law Courts in the Strand, railroad stations (to accommodate a revolutionary form of transportation), churches, office buildings and townhouses. Unfortunately, this abundance of building was not accompanied by a similar abundance of good taste. Most was rather bland Neo-Gothic and Neo-Classical. The one truly Victorian style was the use of ornamental ironwork, inspired by Joseph Paxton's Crystal Palace. There was wrought-iron everywhere—everything had a railing, whether it needed one or not.

On a typical business day, London traffic moved as fast as the narrow streets would allow. Double-decker buses—horse-drawn—were as vital then as now. Efficient two-wheeled cabs sped recklessly through the streets. For the less fortunate, the bicycle brought new mobility. On the streets were merchants of all kinds, each one singing a song to advertise his wares; the popular muffin-man, ringing his bell to attract children at tea time; the quack doctor hawking his "Elixir of Life;" the fishmonger; the delivery boy, lamplighter, prostitute, pick-pocket and bobby.

The Rich

On the busy streets, London looked to be a real melting-pot of humanity, but Victorian society was rigidly hierarchical—rich, middle-class, and poor. The rich spent part of the time on their country estates, coming to London only for "the season," the prescribed period of socializing and parties. The main purpose of these events, besides having fun, was to arrange marriages for the children. Most marriages were business arrangements, involving large dowries. The moral code was very strict. It was, well . . . "Victorian."

The rich attended the opera, theater or parties dressed in their finest. The women wore skirts with huge bustles and covered themselves almost from head to toe. (Double-decker buses were equipped with "decency boards" on the stairways, so ladies needn't expose even a bit of leg when they climbed up.) The men looked dashing in cloak, cane, top-hat and lavender gloves. In their conversation at these events, they discussed business, gossip and world affairs, or debated the merits of socialism, "free love" or Darwin.

Every rich family had servants. The husband and wife each had personal attendants to dress them, advise them and keep their social calendar. Besides these, there were the cooks and maids. Victorian servants worked hard—the old saying about cleanliness and godliness was taken seriously back then.

19th-century London was referred to as "two worlds, one rich and one poor." This view of the wealthy at a horse race contrasts sharply with the picture on page 312.

Middle Class

The middle-class families, while trying to keep up with the wealthy, were most influenced by the example of Victoria and Albert. The royal couple were the model of domestic happiness—proper, hard-working and devoted to their many children. So it was throughout middle-class London. The wife was lord and master of the house, the husband was lord and master of the wife. He came home from work to find his slippers and velvet jacket warming by the fire. After dinner he'd play with the kids, do some reading aloud, listen to his wife play the piano and go to bed early.

Some middle-class families aspired to live like the rich. They might be able to afford a servant or two. They encouraged their children in school, hoping they could by chance attend one of the upper-class colleges. In fact, one of the characteristics of the Victorian Age was the advance of the middle class. They lived in nice homes equipped with that new-fangled invention, the toilet. They were well-educated, infected with Albert's interest in science and the arts. The popularity of Dickens' works attests to this. His stories were serialized in pulp magazines that reached literally millions of people.

The Poor

Progress did not filter down to London's wretched lower classes, however. The amazing thing is that the upper classes were so oblivious to the lifestyle of the urban poor. It was a different world that they didn't care to know about.

In the East End (and St. Gile's and Clare Market), people lived in decaying, crowded buildings crawling with rats. Where a middle-class family of ten (most Victorians had large families) lived in a spacious ten-room house, the poorest lived ten to a single room. Human waste lined the streets. The gas-lighting hardly cut through the dark on a foggy night in narrow alleyways where cutthroats lurked. Brothels, gambling-dens and pubs were the major businesses in these districts.

Work was scarce, especially for the hordes of unskilled country folk that packed up their dreams and rushed to the big city. A man might haul garbage, shovel coal or make deliveries, but that was about it. Women and children labored in the factories for pennies. For those in debt, there was the workhouse, which was much like a prison work camp. For some, the alternatives were drunkenness or the Queen's Army—recruiting sergeants stood outside the pubs with a shilling in their hand as bait for the down-and-out.

Private charities did little good. It wasn't until major government reforms at the end of the century that the slums got some relief. The reforming spirit got a boost from the writings of Dickens, a poor boy who made good but who never forgot where he came from.

Pleasures Great and Small

Leisure activities were segregated by class. Both rich and poor attended the theater, but there were two different kinds of theater. The rich visited the legitimate stage which included serious drama and opera. Previously, these were places for the upper crust to gossip, chat, see and be seen. But when Prince Albert went to actually listen to what was going on, it started a fad of culture. Besides Shakespeare revivals, there were the witty operettas of Gilbert and Sullivan and sophisticated comedies by Oscar Wilde.

The masses were content with the music halls, a combination of melodrama and vaudeville. Here comedians, jugglers, villains and singers put on cheap (occasionally noteworthy) shows. The patrons went away humming the latest tune sung by the latest idol.

Other cheap activities were a visit to the zoo (including an elephant ride) or an afternoon on the Thames in a pleasure boat with your sweetheart.

If there was nothing else to do, the poor cockneys spent the day watching the rich play at cricket or compete in rowing races. Every Sunday after church the big event was to go to Hyde Park to watch the well-to-do parade around in their fine clothes and carriages. A German

tourist guidebook from the period recommended this as one of London's supreme sights.

Victorian London was a strictly hierarchical society, but all the classes had one thing in common—a spirit of optimism. There was a vitality to the city that even the poor felt. It was a sense that technology could bring about a better life for all. That hard work and right living would be rewarded just as surely as laziness and vice were punished. London was a busy hard-driving, shrewd city that still maintained an outer face of gentility, grace and good cheer.

TANGENTS
General

Art Appreciation

*"Only through art can we get outside
ourselves and know another's view of the universe."
(Marcel Proust)*

Appreciation is Understanding

Getting to know art is like getting to know another person. First impressions mean a lot, but true understanding comes only after a long relationship. By opening your mind to the other's viewpoint, you become fast friends.

In art as with people, it's wrong to judge something before you understand it. As they say, "Don't criticize what you can't understand." Learn about it first (then you can really run it into the ground). Saying. "I don't understand it," is usually more accurate than "I don't like it."

This section looks at the two-step process of appreciating art—understanding it, and then judging it.

A VICTIM OF THE LOUVRE

Understanding the Artist's Purpose

Every work of art has two different "subjects": 1) the subject matter itself (a chair, a nude woman, a country landscape), and 2) the mood or message it conveys to the viewer. To understand the artist's purpose, we need to see both "subjects."

The artist might purposely change or distort reality (the actual subject matter) in order to enhance the mood ("subject" #2). We can't judge the work simply by how realistic the portrayal is. We must understand the reason for the distortion of reality—the mood that distortion creates in us.

A painting is like the image burned onto the retina of the artist's eye as the artist sees the scene—we see the world through the artist's eyes, with his or her perspective and emotions. The distortion of reality comes from seeing things from a different perspective—like looking through someone else's prescription glasses. Such purposeful distortion by the artist is sometimes called "artistic license." (Some artists should have their licenses revoked—or at least retake the eye exam.)

Understanding the Artist

Each artist has a style as individual as a signature. Learn to spot the common features of your favorite artist.

Once you can find one artist's work, compare it with others of the same period. You'll find many similarities, especially when compared with art done hundreds of years earlier or later. With a little practice, the style of each period will be as distinct as that of the individual artist.

Knowing a little something about artists' lives makes their art more interesting and sometimes easier to understand. Find out where the artist was and what the inspiration was for a certain painting. Their personal perspective on life is a clue to the meaning of their art.

Here are some thumbnail descriptions of individual artists' styles:

Renaissance

Botticelli	Graceful, linear; pagan themes
Michelangelo	Sculptural, muscular bodies
Titian	Rich, red background; glazed, dark finish

Northern Art

Durer	Accurate detail, lines; woodcuts
Bruegel	Busy, happy, everyday peasant scenes
Rembrandt	Light sources, brown tones
Bosch	Medieval fantasy, cast of thousands
Hals	Portraits of Dutch merchants

Baroque

Rubens	Fat, robust ladies; swirling composition
El Greco	Elongated, "spiritual" bodies
Caravaggio	Harsh dark-light contrasts; dramatic, intentionally shocking
Bernini	Capturing emotion and movement in sculpture

Neoclassical

David	Historical scenes

Post-Impressionist

Van Gogh	Rough texture; short, thick brush strokes
Gauguin	Primitive, tropical, bright colors
Matisse	Looks like wallpaper

20th-Century

Dali	Surrealistic, dreamscapes

Understanding the Artist's Techniques: Composition, Line and Color

When you look at a painting, what catches your eye? Artists know what will attract your attention. They use this knowledge to punch the right emotional buttons to get their message across. (Modern advertisers have made a science of this—they know which colors provoke what moods, what images make you feel good, what causes tension, and so on, in order to persuade you to buy their detergent. Let's just hope that art is less manipulative in its approach.) Here are some of the techniques used to attract your attention and produce an emotional response.

Composition

Composition—how the parts relate to each other—is the skeleton of the work. Imagine a painter planning out a scene on grid-lined graph paper. He calculates how big the main characters will be and where to place them. Let's say the artist decides to arrange the figures into a geometrical pattern, say a pyramid, like this:

317

It doesn't look like much in rough form; but flesh out this skeleton composition with neat lines and real-life colors and you have Raphael's "La Belle Jardiniere." The geometrical composition is what makes the picture so harmonious and pleasing to the eye.

(Note: Look at this skeleton pattern. See how much forethought has gone into the composition, how orderly and "beautiful" the shapes are in and of themselves. Imagine these rough shapes colored in. It would look something like modern art, no? Can you see the appeal of abstract art, which uses the same rules of composition, line and color but doesn't portray "real-life" subjects?)

You can find the compositional scheme of any painting. Put a blank piece of paper over your favorite work and trace the major geometrical patterns and lines.

Line

The second technique, line, directs the motion of the eye. The eye will naturally follow the curve of a line until it's broken by a line running in another direction. The artist uses this eye movement to create movement and rhythm in the scene—which, in turn, creates a mood of tension or rest in the viewer. At their own pace, trained artists guide you from one figure to the next.

In the Isenheim Altarpiece, Grunewald directs all the motion towards Christ's agonized face. From John's pointing finger the eye travels to the face, then up Christ's arm to the crossbar, down to the grieving figures

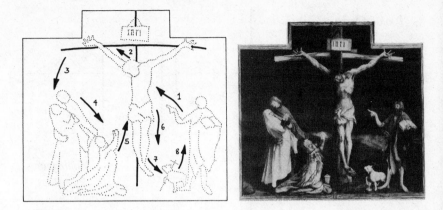

at the left, down their slanted bodies to the kneeling Mary, then up her arm, pointing again to Christ's head. Grunewald moves our attention full circle, always returning to the central figure of Jesus where the lines intersect.

Perspective

Lines are governed by the laws of perspective—that is, how to paint three-dimensional objects on a two-dimensional surface. When you draw receding lines to turn a square into a 3-D box, you've followed the laws of perspective. If the lines of the box were continued, they'd eventually converge on the horizon at what is called the "vanishing point."

Perspective and the vanishing point.

Using perspective and the vanishing point, an artist can place the viewer of a painting right in the middle of the action. Think of the picture frame as a window through which you are viewing the painted scene. Where are you in relation to the main figures? The artist lets you know, subconsciously, with the vanishing point.

319

Looking down

Looking up

Look for the vanishing point—the point where all the receding parallel lines of the painting would converge if they were extended (like those in the box illustration). This is eye level. Some of the figures are above this imaginary line, others below. You can judge your position and distance from them by reference to this subtle vanishing point.

The vanishing point is also the compositional center of the work. In Leonardo's famous "Last Supper" (p. 78) the lines converge at the center of the canvas, which is also the focal point of the subject matter—Christ's head. All the linear motion flows to and from this center of calm.

Architecture usually has a vertical line that serves as the center of order, dividing the building into symmetrical halves, left and right.

In sculpture there is a center of motion, too, and a "frame" like a picture frame. The imaginary square block of marble (or wood, etc.) from which the sculpture was carved serves as a "frame" surrounding the figure.

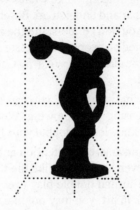

One final aspect of line technique—brushwork. Some painters make broad outlines of figures, then fill them in with smooth color (like a coloring book). Giotto (p. 70) is a good example of this. Van Gogh, on the other hand, uses almost no outlines whatsoever. His paintings are more like a mosaic of minute patches of color applied by quick strokes of the brush.

Color

Color is the flesh on the compositional skeleton, bringing the figures to life—yet it, too, plays a role in bringing order to art. When we buy clothes, we make sure the colors don't clash. In art, they must go together as well. The artist can make the picture peaceful with harmonious colors, or tense by using colors that clash.

Red, yellow and blue are the primary colors—we get the rest by blending these three. Red is associated with passion, action, intensity. Yellow is warm, the sun, peace. Blue is melancholy, thoughtful, the sea and sky. Some colors complement each other (red and green), while others contrast (yellow and orange). Obviously, the various combinations and moods available to the artist are endless.

VAN GOGH, ABOUT HIS PAINTING,
"THE NIGHT CAFE"

"I have tried to express the terrible passions
of humanity by means of red and green."

Understanding is Appreciation

When people—admitting their ignorance of art—say, " . . . But I know what I like," they usually mean, "I like what I know." It's easier to like something that's familiar and understood. Baseball is the most boring game in the world if you don't understand the rules or players. Good food and wine are wasted on people whose taste is all in their stomachs. You can't appreciate the classic lines of a '56 Chevy if you don't know a Volvo from an Edsel.

Listen. If you like what you know, you can usually increase your liking by simply increasing your knowing. What could be more enjoyable? Double your knowledge, double your fun.

When you understand an artist's intention and techniques, you can appreciate the work even if you don't like the result. In baseball, you can *appreciate* a well-turned double play even if you don't *like* it (it made your team lose). In art, you may not like what was painted—it may be an unusual or startling or bland scene—but you may appreciate the artist's composition or use of line and color.

Learn as much as you can about art history, artists, styles, theories, etc.—but the best aid to art appreciation is simply an open mind. Check out a book from the library with nice color prints. Relax in your favorite chair. Light a fire. Open some wine. Then, alone or with a friend, leaf slowly through the book. Don't bother much with names, dates or commentary. Just look for a painting or two you like. Play a game where you pick your favorite from each chapter, then compare notes with a friend. (If, after two glasses of wine you still can't find anything you like, no sense in pushing it. Turn on the TV.)

Once you find a good one, ask yourself *why* you like it. Is it the bright colors? The story it tells? The emotional effect on you? Does it make you feel good? Or sad? Or angry? *Any* reason for liking art is a good one. Just try to recognize what it is.

Look for other works by an artist you like. If you also like another work maybe that means you like that *style*. What is it the two works have in common?

Try to understand what went through the artists' mind while painting the scene in that way. Did the artist feel the same way painting it as you do looking at it? Always give the artist the benefit of the doubt. Even if you don't see anything of worth, assume that he put a lot of thought and sweat into the work—he probably did.

Museum-Going

Use the same open-minded approach when you enter a museum (where, unfortunately, you'll have to leave your bottle of wine at home). Read up ahead of time, but don't let your knowledge overwhelm your enjoyment.

Don't go to the Louvre to say you've seen the "Mona Lisa"—go to _see_ the "Mona Lisa." Don't take a check-list of important art that you can forget about once you've seen it. Don't rush through a museum just to say you've seen it all. Spend your time on a few things you can really appreciate. Quality is more important than quantity when it comes to art. Take your time. Savor, understand and enjoy.

Works of art will look different "in the flesh" than reproductions you may have seen in books. They also will be different from descriptions and commentaries by art historians. Drop your expectations. Look at the art as if you'd never seen it or heard anything about it. Let it speak to you in its own words. Don't categorize it, label it and file it away—see it.

A word on snobbery. The more you know, the better you can appreciate and judge art. I'm convinced of that. Still, don't be intimidated just because you're not an art expert. Good art can be appreciated on many levels. All it takes is interest and an open mind. If you're not interested before you see Europe's great art, I'll bet you will be afterwards.

Oh. One more thing. This section gives you a good basic background in art—but it doesn't qualify you to be a snob.

Museum Strategy

Europe is a treasure chest of great art. Many of the world's greatest museums will be a part of your trip. Here are a few hints on how to get the most out of these museums.

I have found that some studying before the trip makes the art I see in Europe much more exciting. It's criminal to visit Rome or Greece or Egypt with no background in the art of those civilizations. I remember touring the National Museum of Archeology in Athens as an obligation and being quite bored. I was convinced that those who were enjoying it were actually just faking it. Two years later, after a class in ancient art history, that same museum was a fascinating trip into the world of Pericles and Socrates—all because of some background knowledge.

A common misconception is that great museums have only great art. A museum like the Louvre in Paris is so big (the building was, at one time, the largest in Europe) you can't possibly cover everything proper-

ly in one visit—so don't try. Be selective. Only a fraction of a museum's pieces are really "greats," and, generally, it's best to use a guide or guidebook to show you what is considered the best two hours of a museum. Brief guide pamphlets recommending a basic visit are available in most of Europe's museums. With this selective strategy, you'll appreciate the highlights while you are fresh. If you still have any energy left, you can explore other areas that you are specifically interested in. For me, museum-going is the hardest work I do in Europe, and I'm rarely good for more than two or three hours.

If you are determined to cover a large museum thoroughly, the best strategy is to tackle one section a day for several days.

If you are especially interested in one piece of art, spend half an hour studying it and listening to each passing tour guide tell his or her story about "David" or the "Mona Lisa" or whatever. They each do their own research and come up with different information to share. There's really nothing wrong with this sort of tour freeloading. Just don't stand in the front and ask a lot of questions.

Before leaving I always thumb through a museum guidebook index or look through the postcards to make sure I haven't missed anything of importance to me. For instance, I love Dali. I thought I was finished with a museum, but in the postcards I found a painting by Dali. A museum guide was happy to show me where this Dali painting was hiding. I saved myself the agony of discovering after my trip was over that I was there but didn't see it.

Remember, most museums are closed one day during the week. Your local guidebook or tourist information should know when. Free admission days are usually the most crowded. In some cases it's worth the entrance fee to avoid the crowds.

The Louvre—A Talk with a Guide

The Louvre in Paris is considered by most art historians to be our civilization's finest art museum. Many people visit France solely to see this granddaddy of museums. Sadly, many of them leave disappointed. Overwhelmed by its enormous size and the thunder of its crowds, they take a quick look at the "Mona Lisa"—and flee. You can avoid this if you tackle the Louvre thoughtfully.

Catherine Bounout, a veteran Louvre guide and art historian, shared with me her intimate knowledge, respect and love of this building. There is no doubt, she stressed, that the more you know about the Louvre, the more you will enjoy it.

Avoid the crowds, especially during the peak months of July and

August. The Louvre, like most tourist attractions in Paris, is closed on Tuesdays. (Open other days from 9:45 to 5:00.) This makes it particularly crowded on Mondays and Wednesdays. Thursdays or Fridays are least crowded. Try to arrive just before the 9:45 opening time.

For the average visitor, a guided tour is the best way to approach the Louvre's enormous collection.Museum-going is very hard work. Big museum-going is slave labor. Many people set out on their own to cover the museum thoroughly, but run out of steam long before the Louvre runs out of art. I like an expert to show me the best two hours while I'm fresh. If you were to lay the Louvre's 208,500 works of art end to end, they would stretch from Paris to New York and back—at least that's what a drunk in a Dublin pub told me. Take advantage of the English tours which leave daily from 10:00 to 4:00 and cost less than $3. If you miss the tour (or are with a group) it's easy to hire a private Louvre guide for about $20 an hour. The guides enjoy private tours most because they can tailor the tour specifically to the group's interests. "If you want only paintings, you get only paintings."

Catherine, like most guides I met, maintains a fresh and enthusiastic delivery. She explains, "I like art and people. This job is a perfect mix. But if I don't see enthusiasm, I get bored. If people sleep in front of me, I sleep along with them. An enthusiastic group makes my job easier. I love them to ask questions. Then I can stop at a new painting and I will be soooo happy. I don't mind people who 'freeload' on my tours because they are usually more interested than those who pay."

When asked about her pet peeve she didn't hesitate to answer: "Tourists are too noisy. Please respect the art. Don't go just to see the "Mona Lisa." If someone wants to see the "Mona Lisa" we show them a poster."

Paris Art History Tour

Paris has dozens of museums, covering the entire spectrum of Western art. The artistic traveler with limited time and energy should plan selectively and efficiently. You can follow the evolution of Western art chronologically from start to finish by visiting the Louvre, Musee d'Orsay and the Georges Pompidou Centre, in that order.

The Louvre covers Western art very nicely through the 18th century. Impressionism was the style that followed. Europe's greatest collection of Impressionist art plus much more post-Louvre art is housed in the new Musee d'Orsay. This renovated train station became one of Europe's most praised museums as soon as it opened.

The Musee National d'Art Moderne (Who says you can't read French?) in the new Georges Pompidou Centre will bring you right up to the artistic present—and then some. This crazy, colorful, "exo-skeletal" building will refresh you with Europe's greatest collection of 20th-century art. After so much "old art" this place is a lot of fun. Where else can you see a piano smashed to bits and glued to a wall?

Art Patronage

Art does not belong in museums. Most of it was originally intended for churches, palaces and government buildings—depending on who paid for it. Michelangelo's "David," for example, was supposed to stand high above the ground on Florence's Cathedral. If his body looks out of proportion, it's because Michelangelo planned it that way to compensate for the angle it would be viewed at on top of the cathedral. Often, to understand the artist's purpose we have to look at the purposes of the people who are paying him—the patrons. In many cases, it is they, not the artist, who make crucial decisions in the art itself.

There are three types of patrons: church, state and private parties. The church and the state (often intertwined) were the major patrons until modern times. They would commission a particular work and specify how it should be done. This is how the great pagan temples, churches and public structures were built and decorated.

Lowly Artist Serves Church and State

It's only recently that artists have claimed the right to paint just what they want, just how they want it. In the ancient world, the artist had a low social status and was expected to do as he was told. Anyone who worked with his hands was simply a "common laborer," like a bricklayer. The ancient Egyptians, with their need for funerary art, encouraged painters and sculptors and paid them well for their services, but never gave them any special respect. (Architects had higher social status—they worked with their heads, not their hands. Imhotep, who designed the first pyramid in 2650 BC, was actually deified.)

In early Greece, most artists were slaves—again, the wealthy freemen didn't want to get their hands dirty. Gradually, though, artists gained

respect. By the time of the Golden Age they began to sign their works, rising above the level of the anonymous craftsman. Still, even the great sculptor, Phidias, was criticized for vanity when he tried to include his self-portrait (and that of Pericles) in one of his works on the Acropolis.

By the time of Alexander the Great, however, artists were freer to express their individual tastes. For the first time we see the private patron financing an artist to make works that are merely pleasing to the eye. Artists became respected and admired in the community. Alexander showered wealth and favors on his favorites. He once offered the great artist, Apelles, one of his own mistresses, he was so pleased with a painting.

The more practical Romans thought their artists should be paid but not pampered. As the writer Seneca put it, "Art should be enjoyed—artists should be disdained." Nevertheless, their society gave artists plenty of work: government buildings, temples, monuments to emperors and conquerors, coins, household goods, graven images of gods, and portraits. Roman artists were treated as anonymous skilled craftsmen who couldn't compare with the classical Greeks. The most popular artworks acquired by rich Romans were copies of Greek masterpieces.

Medieval Guilds

With the Fall of Rome and the resulting economic and cultural decline, there were no strong states and few wealthy individuals. What little art there was was in the hands of the church. Monks illustrated manuscripts of the Bible and sacred writings. For lay artists, virtually the only market for their talent was in churches and monasteries. "Lodges" of journeymen masons, carvers, sculptors and the like traveled from town to town, building religious structures.

Artists fought for economic security against the unstable patronage of the Middle Ages by forming "guilds." Half union, half co-op, the guilds trained artists, regulated quality standards (as well as moral standards) and served as middlemen between the artists and prospective buyers. In a sense, the guild often was the artist's patron—it told him where and when to work and gave him his percentage of the fee when the completed product was approved. As late as 1570 in Italy, artists were required to be members of a guild.

The guild underlined the artist's role as craftsman. The Guild of St. Luke in Holland included painters, carvers and goldsmiths—as well as plumbers, slate layers, printers and lantern makers. Most commissions

were collaborations between guild members—one covered the walls, another painted a design on them, another carved the ornaments, and so on.

Private Patrons—The Artist Triumphant

With the economic growth of the later Middle Ages there were more patrons willing to spend more money—individual artists were in high demand and art flourished. We see the same pattern throughout history—a culture prospers by economic or military expansion, creating a class of patrons with a taste for decoration. In ancient Egypt, this class was the ruling kings and priests who used art to maintain the political and religious status quo. In Greece and Rome the same trend continued, but with a new class of wealthy people who appreciated art apart from its propaganda purposes. In the early Middle Ages the church was the only patron, producing art only for its limited, spiritual purposes.

In the Renaissance all three patrons—church, state and private individuals—competed with their growing wealth for a few artists. This climate of healthy competition not only made artists wealthy, famous and respected, it also, for the first time in history, allowed them freedom to create art on their own terms, not according to the patron's specifications. With Michelangelo, the modern idea of the artist as a divinely-inspired genius had arrived.

Patronage and artist prestige reached its height during the Baroque period. Rubens and Bernini lived like princes, courted by kings, cardinals and intellectuals alike.

This contrasted with the financial picture in the Northern European countries. In northern trading cities a large middle class of merchants and bankers controlled the wealth. A steady patronage by the church and monarch was not available because the North was Protestant and more democratic. Northern artists had to turn to scenes that would interest the buying public: landscapes, domestic scenes, humorous incidents. They still did some works made-to-order, but more and more they began to complete works with no particular patron in mind. Art dealers then took the works for display at trade fairs, hoping to find a buyer. This set the precedent for modern patronage.

In the time of absolute monarchs like Louis XIV, artists were compelled to work for the king alone. Louis established the Royal Academy to train young artists for his service. They had less independence than their counterparts in free-market Holland and England, but more financial security. France soon became the center of European art.

The Modern, Independent Artist

The French Revolution was the (symbolic if not final) end of the "Old Regime" of church, state and aristocrats that had financed most of Europe's great art since the Middle Ages. Increasingly, artists worked alone, independent of the institutions that had previously supported them. They turned away from the propaganda art of church, kings and even so-called "lovers of freedom" like Napoleon.

In the 19th century art retreated into the museums and galleries. Artists didn't wait for a specific commission to decorate a particular palace, church or public square. Instead, they created what they wanted, then looked for a place to exhibit it. The Impressionists and the painter Courbet had to arrange their own exhibitions when the conservative galleries refused their controversial work. Some artists (like Cezanne) rejected all outside patronage or official schooling by financing themselves, or by simply refusing to sacrifice their artistic principles to the demands of the buying public. The bohemian artist, starving but true to himself, was born.

Of course, some forms of official patronage have filled the vacuum. Churches still commission artists and architects (the church at Ronchamp, France by Le Corbusier is one modern example, see p. 195). And governments are some of the steadiest sources for an artist. Eastern Bloc countries especially use art for propaganda purposes, with huge monuments and murals dedicated to Marxist leaders and ideals. Western governments budget funds for art in public places as well.

For all this "official" patronage, however, the modern artist insists on independence from monetary concerns. The artist's income usually comes from unknown buyers who negotiate through a middleman. Art buying has become a major investment area for businessmen with no interest in the art itself.

As you enjoy Europe's art, remember, it wasn't designed to embellish a museum. Some patron probably paid to employ that artist for a particular self-serving purpose.

Common Subjects and Symbols in Art

In a quick jaunt through any museum, you're bound to see many of the same subjects painted and sculpted in different ways by different artists. A little knowledge (a dangerous thing, but we'll trust you) of these common themes helps you appreciate the art much more.

The inspiration for most European art comes from the Bible and Greek/Roman mythology. For general background I'd recommend reading the Book of Matthew in the New Testament (about 35 pages long) and a children's book of Greek myths. Like they say, "You can't tell the players without a program."

Christian Themes and Symbols

The life of Jesus, the central figure in medieval European culture, is the most popular source of material. Here are some of the most commonly painted scenes from his life:

Born in a stable under miraculous circumstances, he was visited by shepherds and Wise Men (Nativity). His religious mission had earlier been announced to his mother, Mary, by the angel, Gabriel (Annunciation). Paintings of Mary and Baby Jesus (Madonna and Child) and with his father, Joseph, are common. He was raised to be a carpenter, but proved his teaching powers early on (Jesus Teaching in the Temple—Age 12).

At 30 he left home to preach the word of God, choosing twelve disciples, or apostles (The Calling of Matthew/Levi is the most common). He preached, performed miracles, healed people and antagonized the religious establishment (Sermon on the Mount, Feeding the 5,000, The Raising of Lazarus, Walking on the Water, etc.). He was eventually arrested, tried and executed (The Passion) (read Matthew, chapters 26-27).

Before his arrest, Jesus celebrated Jewish Passover with his disciples (Last Supper). He was identified to the Roman and Jewish authorities by a kiss from Judas, one of the Twelve (Betrayal/The Garden of Gethsemane). Arraigned before the Jewish elders and the Roman governor, Pilate, and mocked and whipped by Roman soldiers, he was given a crown of thorns and sentenced to die by crucifixion. They made him carry his own cross to the execution site.

FOUR DIFFERENT ARTISTS OF FOUR DIFFERENT ERAS
TACKLE THE SAME SUBJECT

Medieval: This 14th-century crucifix concentrates on the agony of Christ—his twisted, tortured body and drooping head.

Renaissance: Masaccio's Christ is solid, serene and triumphant—part of a majestic architectural setting presided over by God the Father.

Crucifixion was a Roman specialty. The victim often hung for days before dying. They stabbed Jesus in the side for good measure. Above the cross were the Roman initials I.N.R.I. for "*J*esus of *N*azareth—King (*R*ex) of the *J*ews." Mary was comforted at the foot of the cross by John, one of the disciples. After his death, the body was taken down (Descent from the Cross) and placed in a tomb.

After three days, Jesus came alive again (Resurrection) and visited many of his friends and disciples. Finally, he ascended into heaven (Ascension, of course).

This story is found in pictures and stained glass in churches throughout Europe. The masses were usually illiterate, so church paintings were their Bible.

An interesting thing to do in a museum or as you visit different churches, is to compare two different paintings or stained glass of the same subject. There are literally thousands of Crucifixions, but no two are the

Baroque: Rubens captures the drama and human emotion of the moment with the expression on Christ's face and the rippling energy of the surrounding figures.

Modern: Rouault breaks up the scene into its basic geometrical "abstract" forms. The only emotion is in the tilt of Christ's head. The heavy outlines and blocks of color are almost a return to medieval stained glass.

same. Some artists concentrate on Jesus' agony, some on his serenity. For some, it's a gruesome moment of defeat, for others a glorious triumph over sin.

Jesus is portrayed in different ways to emphasize different virtues. In one picture, he is the Good Shepherd—a handsome, kindly young man caring for men like a shepherd cares for his sheep. In another, he is a wise teacher. Or, he may be a king, crowned in majesty. He may even be a warrior. These differences tell a lot about how people viewed the Christian message at the time of the painting.

Besides the life of Jesus, other people and events from the Bible are also popular. Statues of the Twelve apostles, Old Testament prophets and the four Evangelists (writers of New Testament books) often adorn cathedral walls. They can be recognized (since no one knows what they looked like) by objects symbolizing, for example, the way they were martyred: Matthias carries an axe (he was beheaded); Bartholomew, a

skin (he was flayed alive); James the Less, a saw (cut in two); and so on.

Not all are so morbid. Peter, an apostle and the first bishop of Rome (from which the papacy derived), carries keys symbolizing the "Keys of the Kingdom" of God, given to him by Jesus. Keys are the symbol of popes (Roman bishops) in general.

Paul, the great Christian missionary, started out as a bitter persecutor of Christians. Then, while traveling to Damascus, he had a vision of Jesus which temporarily blinded him and permanently turned his life around. This startling event is a popular art subject.

The most popular stories from the Old Testament (before Jesus) are of Adam and Eve, and David and Goliath. Adam was the first man God created, Eve, his wife. They lived in a paradise Garden of Eden until they disobeyed God by eating forbidden fruit from a tree shown to them by a serpent. They were expelled from the Garden, which was guarded by an angel with a flaming sword (see p. 73).

David, who later became King of Israel, is shown killing the giant, Goliath, from an enemy nation. David was just a boy, but he slew the heavily armored Goliath with a slingshot. He then took Goliath's huge sword and cut off his head.

Much Christian art is symbolic. During medieval times, every animal, fruit, flower, color and number had some meaning. Apes symbolized man's baser nature; bees were a symbol of industriousness ("busy as a . . ."); a lamb was a sacrificial animal (like Jesus); a dolphin carried the souls of the blessed to heaven. Mythical beasts had meaning, too: dragons (Satan), griffins (power), unicorns (purity) and phoenixes (resurrection).

If you see a face in a crowd of saints, Church Fathers, and Bible figures that you don't recognize, chances are it doesn't really belong in such holy company, anyway. Patrons of works often insisted that they be included in the work—praising the Virgin Mary or what have you. If money couldn't buy them a spot in heaven, at least it could put them in a picture of heaven.

Greek and Roman Mythology

Renaissance artists not only revived classical techniques, they also painted classical subjects. After centuries of painting the same old God it must have been a great sense of freedom to paint new ones—and a whole pantheon of them, to boot.

The Greek gods (the Romans borrowed the Greeks' and gave them new names) were bigger-than-life human beings. They quarreled, boasted, loved and hated just as mortals do, yet they controlled the fates

of men. Classical mythology tells how the gods dealt with each other and with the mortals who asked them for favors. (The Greeks must have enjoyed hearing their own weaknesses glamorized, just as we do in our Hollywood stars.)

GREEK/ROMAN	POSITION/IDENTIFIERS
Zeus/Jupiter	King of the Gods, ruler of the skies (thunderbolt)
Hera/Juno	His wife
Apollo/Apollo	God of the Sun and the Arts (laurel wreath)
Aphrodite/Venus	Goddess of Beauty and Love (two arms, usually missing)
Hermes/Mercury	Messenger of the Gods (winged heels or helmet)
Eros/Cupid	God of Love (winged boy, bow & arrows)
Poseidon/Neptune	God of the Sea (trident & conch shell)
Dionysius/Bacchus	God of Wine (grapes, wine cup, good time)

Zeus had a nasty habit of turning himself into some earthly form to hustle unsuspecting females. You're as likely to see him portrayed as a bull, a cloud, a swan or a shower of gold as in his majestic human body.

Followers of the cult of Dionysius (Bacchus) held orgies. These pagan religious celebrations involved much wine, dancing and ecstatic merry-making. Such a scene must have intrigued and titillated Christians of later centuries, for they often painted what they imagined one must be like.

Christians had their angels, devils and dragons—the ancients had mythical beasts, too: satyrs (head and torso of a man, two goat legs, no horns, but very); centaurs (head and torso of a man, horse's body, very wise creatures); nymphs and naiads (beautiful, magical females that inhabited woods and streams); Pegasus (a winged horse); Minotaur (a monster with the head of a bull).

Historical Scenes

Modern artists, in search of new subjects, turned to famous scenes from history, trying to capture the glory or emotion of the moment. In the early 1800s Romantic artists tapped the patriotic fervor of their audiences with scenes of heroics against oppressors. Goya's "Third of

May" (p. 147) shows the murderous execution of Spanish nationals by Napoleon's troops. Delacroix painted a battle scene from a French anti-monarchy uprising. (p. 141) J.-L. David, a Neoclassicist, chronicled (and "Romanticized") the French Revolution and reign of Napoleon (p. 133).

Still Lifes

Scholars debate whether "Art imitates life" or "Life imitates art," but to a great extent, "Art imitates art." Artists often choose a subject already done by many previous artists in order to carry on and extend the tradition—to both learn from earlier Masters' versions and to try something new.

Perhaps the best example is the "still life," a painting of a set of motionless, common objects—fruit, cups, a knife, a chair, curtains, etc. It's a simple form, often undertaken by students practicing their drawing and simple composition, yet many great artists have shown their ingenuity by turning it into great art. Each successive artist is challenged to make the old style new again.

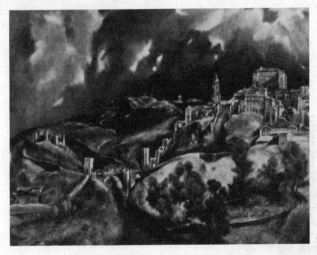

LANDSCAPE OF TOLEDO, EL GRECO

Landscapes

Other styles involve painting of places: landscapes, seascapes, domestic and rural scenes. The place may be completely different in two different paintings, but it's still interesting to compare each artist's approach.

Baroque artists often decorated churches with an interesting "landscape"—heaven. Ceilings seem to open up to the sky, with angels, chariots and winged babies (called "putti") flying by.

Portraits

Portraits are, of course, supposed to be accurate renditions of the person, but many try to glorify the subject, even at the expense of accuracy. Different portrait artists take different views in this matter—it's interesting to compare. Two particular types of portrait sculpture are the "bust" (neck and head only) and "equestrian" (riding a horse).

THREE DIFFERENT NUDES

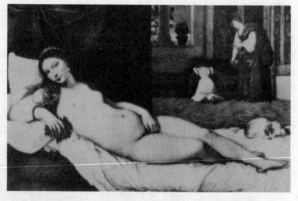

Renaissance, Titian: Sensual curves, rich colors, sexy gaze.

Neoclassical, Ingres: Pure, cool lines of the body blending with the lines of the drapes and sheets.

Modern, Picasso: Minimum number of lines necessary to capture the nude form.

The "nude" is another particular kind of portrait, concerned more with the shape of the body than specific identifying features. A good nude is not necessarily of the most beautiful body. It's up to the artist to pose the body just right—reclining or standing—to capture the most interesting and harmonious lines.

A classical style, the "contrapposto" (Italian for "counterpoise"), is a painting or sculpture of someone standing, resting their weight on one leg. The faint S-like curve of the body attracts the eye as much as any individual features. (Michelangelo's "David" is contrapposto.)

An understanding of the symbolic meaning and theme of a piece of art makes it more enjoyable.

Europe—A Babel of Tongues

Imagine if every state in the USA spoke its own language. Europe is about like that. It wasn't always that way. If you understand how Europe's languages evolved, you may not understand more words but at least you'll understand better what it is you don't understand. Understand?

Europe's languages can be arranged into a family tree. Most of them have the same grandparents, resembling each other more or less like you resemble your brothers, sisters and cousins. Occasionally, an odd-ball sneaks in that no one can explain, but most languages have common roots.

As you can see from the tree, the dominant European family branches are the Romance and Germanic language clans.

The Romance family evolved out of Latin, the language of the Roman Empire ("Romance" comes from "Roman"). Certainly, knowing Latin would be a real asset in your travels. But just knowing any of the modern Romance languages helps with the others. For example, high school Spanish lets you read common words in Portugal and Italy as well as Spain.

The Germanic languages, while influenced by Latin, are a product of the native tribes of Northern Europe—the "barbarians" of Roman days.

An understanding of how all these languages relate to each other on the linguistic tree as well as how they were shaped by historical events can help boost you over the language barrier. The following generalities are useful:

A knowledge of Greek and Latin roots used in our language is valuable not only in broadening your English vocabulary, but in

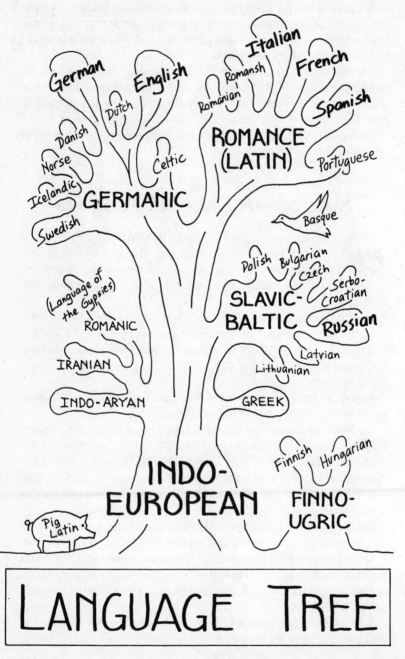

LANGUAGE TREE

making educated guesses at words in other languages as well.

The most valuable second languages to know in Europe are English, German, French and Spanish. English is the linguistic common denominator of most well-educated Europeans.

Germanic Countries

German is your most valuable second language in North and East Europe. It's spoken by all Germans and Austrians and most Swiss. You'll also find German-speaking enclaves in Italy, Czechoslovakia, Yugoslavia, Romania and other nearby countries. Anyone who went to school during the Nazi occupation (1940-45) probably studied—and tried not to learn—German.

German is easily the most valuable European language in Turkey. It seems every other Turk has "arbeitet in Deutschland fur zwei jahr" (worked in Germany for two years). They love to show off their German, which is probably as broken as yours—you'll get along great.

The people of Holland and Northern Belgium speak Dutch (called Flemish in Belgium), which is very closely related to German. A German can almost read a Dutch newspaper.

The Scandinavians can all read each other's magazines and enjoy their neighbors' TV shows. If you speak one Scandinavian language, you can get by in all those countries. Older Scandinavians are very likely to speak more German than English. English is the choice of Scandinavia's youth, and is probably spoken better here than anywhere else on the Continent.

Romance Countries—French and Spanish

German is the closest language to English, although sometimes it seems we share half our words with the French.

French is also spoken in parts of Switzerland and Southern Belgium (the Walloons). After English, it's the most popular second language in Central Europe and the Mediterranean world. In Morocco and other former French colonies, French is the standard second language. Colonial background determines the second language (and sometimes even the first language) of countries all over the world.

French is more international, but knowledge of any one of the Romance languages (Spanish, Italian, Portugese) will help you make some sense of the others in this linguistic family.

Odd Ducks

While Norwegians, Danes and Swedes can understand each other (at least as well as Shakespeare could understand Charlie Brown), the Finns, who are "Scandinavian" only geographically, have not even a hint of "Yah sure ya betcha" in their language. Finnish, like Hungarian and Estonian was somehow smuggled into Europe's linguistic family picnic from distant Central Asia. More Finns speak Swedish than English.

The Basques, struggling to survive in the area where Spain, France and the Atlantic all touch, are well aware that every year five languages die on our planet and that the cards are stacked against isolated groups like theirs.

Multi-lingual Regions

Linguistic boundaries are never as cut and dried as political borders. Europe has several officially multi-lingual states and generally fuzzy borders.

Switzerland speaks four languages: 67% of the people speak Swiss German (Schwyzertutsch), 20% speak French, 12% Italian (the area called Ticino), and 1% speak Romansh, a language related to ancient Latin. These people live in remote Southeastern Switzerland.

Alsace, another bilingual culture, is a French province on the German border. This disputed chunk of land happens to lie between the Rhine River (that the French claim is the natural boundary), and the Vosges Mountains that the Germans claim God created to divide these two peoples. Its people have been dragged through the mud during several French-German tug-of-wars. For the time being it's a part of France. Still, your German will be much more useful here than English.

Belgium is half French-speaking and half Flemish, or Dutch. The French-speaking Walloons of Southern Belgium and the Germanic people of Flanders in the North split their capital city linguistically. Brussels, like Belgium itself, is legally bilingual, but the French in Belgium—like those in Switzerland and Canada—often feel tongue-tied and abused linguistically.

Their problems pale, however, beside the linguistic and demographic mess in Yugoslavia. This country speaks five languages. Here, as in most of Eastern Europe, neighbors are generally enemies. This tendency for two groups of people to gang up on their mutual enemy ex-

plains the popular East European phrase, "My neighbor is my enemy; my neighbor's neighbor is my friend."

The Slavic people of Eastern Europe (Poland, Bulgaria, Czechoslovakia and Yugoslavia) speak languages related to Russian. While all students must study Russian—none learn it. Speaking Russian in Eastern Europe will get you nowhere. You'll be surprised how many English-speaking people you'll meet in the Warsaw Pact countries. There aren't actually all that many, but those who learned it did so in order to seek out foreigners—like you.

THE TOWER OF BABEL

A Berlitz nightmare. It never was finished because the builders suddenly started talking foreign languages. (Note: Don't look for this tower in Europe, try the Bible, instead.) (Another note: While this is a Bible story, I think Mr. Berlitz must have had something to do with it.)

England is surrounded by a "Celtic Crescent." In Wales, Scotland, Ireland and Brittany (Western France) you'll find bits and pieces of the old Celtic language. These survive mostly as a symbol of national spirit and a determination not to be completely subjugated culturally (as they are politically) by England or France. Seek out those diehard remnants of the old culture in militant bookstores, Gaelic or folk pubs, and the Gaeltachts (districts where the old culture is preserved by government).

Small linguistic groups like the Flemish and the Norwegians are quicker to jump on the English bandwagon. It's crucial for them to know a major language, and ours is the most major. I see these cultures melting more and more into the English sphere of linguistic influence, while large groups like the Spanish, French and Germans can get by without grasping English so readily.

Study the family tree of European languages. Imprint it on your mind and take it to Europe. These ideas will enable you to get the most communication mileage out of what bits and pieces of Europe's languages you do pick up.

Europe's Religious Boundaries

Religion is a link with Europe's medieval past. There are still isolated remnants of the mystery, devotion and superstition that ruled people's lives back then. In Drogheda, Ireland, you can walk into a church and see the head—yes, the head, only the head—of a venerated bishop preserved in a glass case for centuries. Mt. Athos in Greece is mottled with monasteries—the entire peninsula is closed off to females, including female animals. And Lourdes, France is the popular pilgrimage site that still reports miraculous healings each year.

Europe isn't any more religious than the U.S.—religion is just more apparent there. It goes back to medieval times when everyone belonged to one church, the Roman Catholic Church. Church and state were intertwined—a crime was a sin, and vice versa. Even after the Reformation in the 1500s, many of the Protestant offshoots were officially supported by their national governments. (One of the reasons for America's early popularity was that it offered complete freedom of worship and a revolutionary division of church and state.)

The Reformation divided Europe roughly in half—the North became Protestant, the South remained Catholic. Some countries in the middle were split in two. Switzerland, the stronghold of the Protestant reformer, John Calvin, is about 50/50 Catholic and Protestant. Germany remains split today along the lines of the original Peace of Augsburg (1555) which ended the religious warfare by establishing that the local prince could choose the denomination of his territory. Bavaria and the south is Catholic, the north is Protestant. Austria is almost exclusively Roman Catholic.

The Protestant North

The Northern countries—England, Scandinavia and Holland—are

almost exclusively Protestant. Most people in Norway, Sweden and Denmark belong to the national Lutheran Church which is supported by government funds. In Sweden, for example, every child born in the country is automatically a Lutheran—unless he or the parents petition to withdraw.

The strongest church in England is the Anglican Church, or the Church of England. Formed when Henry VIII divorced his first wife, causing a break with the pope in Rome, it retains many features of the Catholic Church. The changes included allowing priests to marry, de-emphasizing worship of saints and writing a Prayer book and rewriting the Mass. England also has a large population of other Protestant sects— Methodists, Presbyterians, non-affiliated Anglican "Free" churches, etc.

While Scotland has its official Church of Scotland, Wales marches to a different hymn. The Welsh are traditionally nonconformist. They are devout, but distrust elaborate rituals. There are few church institutions of strength.

The religious/political troubles of the Irish Isle are like a throwback to the Thirty Years' War. Ireland itself (the free nation in the south) is 95% Catholic.

Northern Ireland is a divided country, both in demographics and desires. The Catholics (located in the western and rural parts) want to be free of British/Protestant control like their southern neighbors, while Ulster Protestants want to maintain their ties with Britain. The Irish Republican Army (IRA) is their active organization, which occasionally engages in terrorist attacks against British troops. The industrial sections of Belfast are strictly segregated—one side of the street can be 100% Catholic, the other side 100% Protestant.

The Catholic South

It seems the farther south you go in Europe, the more openly religious the people are. It's in the Catholic countries that the real "medieval" Europe comes through. You'll see Spanish nuns who still dress in black from head to toe including black veils. Shopkeepers wear crosses and count prayers on rosary beads. The churches are elaborately decorated, and the services are lavish productions in Latin, sometimes with full orchestras providing the music. There are monasteries and shrines where pilgrims crawl up long staircases on their knees as an act of devotion.

Italy, Spain and Portugal are the countries where religion is most obvious in social and political life. The more northerly Catholic countries, like France and Belgium, are less openly devout.

Some "Unorthodox" Religions

Europe can give you a glimpse at some religions that are quite foreign to the American scene. Greece is mostly Greek Orthodox, the Christian faith that developed during the Byzantine Empire. You'll see their onion-dome churches and their priests, dressed in black gowns with grey beards and mortarboard-type caps. Much of Eastern Europe is Orthodox, though Catholicism is strong (especially Poland), and Protestantism has many followers in the north (E. Germany). A trip to Yugoslavia will give you a look at the Moslem faith, about 10% of the population. The Iron Curtain countries are officially atheist, but you'll see the relics of that "religion"—posters of Marxist leaders that stand like holy icons in shops, squares and other public places.

Coming Together—Ecumenism

The religious divisions outlined here are beginning to blur in our modern, secular age. While official church membership remains quite high, most adults do not participate actively. In France, only one in five adults attends Mass regularly. Central France is so lax it has been declared a "mission territory" by evangelical groups. In Germany, there is a growing body of agnostics, partly to avoid a state-imposed "church tax" requiring all church members to donate to their church. In Eastern Europe, Soviet-controlled governments are trying everything possible to undermine religion—for example, scheduling the year's only rock concert on Easter, to conflict with church services.

The positive side is that religious tolerance is on the rise. Every country—even those with an official state church—recognizes the right of free worship. Europe also has its Hare Krishna streetcorners and airport flower-givers.

Centuries of divisiveness between Catholics and Protestants (and between Protestants and other Protestants) that began with the Reformation are now being replaced by a growing spirit of unity. Roman Catholicism is becoming more "Protestant-ized." The Second Vatican Council (1962-65) made great changes in church rituals and attitudes: Latin is no longer required for saying Mass; there is more participation by the laity in church decisions; and, there is a de-emphasis on the belief that Catholicism is the "one true church," and all others heretical.

Nowadays, in Switzerland and Belgium, there are some churches where Catholics and Protestants worship side by side. (Although Switzerland also bans Catholic Jesuits from the country—a law dating from a time where these "fanatic" Catholics were considered danger-

ous.) Among Europe's Christians, there is the recognition that, in the modern world where God has been left behind in the wake of progress, Catholics and Protestants have more similarities than differences.

As the Classes Struggle— The Building Blocks of History

History is the story of people and their struggles. If people were perfectly content, history would be very bland. But people are not content. Society evolves as groups struggle. When new groups appear, any balance or order is disturbed and more struggling results. Wars, assassinations, movements of people, and new ways of living are just the natural consequences of our struggles. Mankind is like a person lying on a beach trying to get comfortable in the sand; squirm and wiggle as he might, he just can't arrange the sand properly, and he never really does get a chance to enjoy the sun.

An understanding of history requires an understanding of the power groups that wage the struggles. This brief listing of Europe's class struggles can also serve as a general framework of European history.

Middle Ages

Rome's was the first strong centralized state government in Europe. It ruled unchallenged for centuries. Unhappy groups like the unemployed urban mobs, Christians and barbarians helped bring about Rome's demise.

In the absence of a strong central power, Europe wallowed through several centuries of cultural darkness. The void created by the Roman government's fall was filled by feudalism. Feudalism, the socio-economic foundation of medieval Europe, was a two-way contract between the landowners of Europe, creating a hierarchy of power. There were three groups—the rich and powerful nobility (landed aristocracy), the clergy (church officials and educated elite) and the poor illiterate masses (the peasantry).

This social system survived as long as the peasantry—over 90% of the people—remained submissive and tied to the land.

As the cities grew the peasants had an alternative to farming. With an urban Europe growing, the new merchant city class allied itself with the national monarchs (previously very weak) against the clergy and the nobility. As society's wealth shifted to the cities, kings controlled (or, "domesticated") the nobility, workers were freed from serfdom, and a

new Europe emerged.

The popes, like early medieval kings, had their ups and downs. During the reign of Charlemagne both the king and the pope realized they needed each other. They worked together to establish their authority over the clergy, nobility and peasantry. Later popes (1150-1350), ruling a church more powerful than any single nation, had more wealth and prestige than any king.

Modern World

Europe grew more complex—and history got more interesting. By the dawn of the modern age (1500) we see kings, the papacy, the nobility, the city classes and the peasantry all struggling like five people in a flooded telephone booth trying to get to the top for air.

Louis XIV (ca. 1700) succeeded in controlling the nobility. The kings were riding high until the city classes grew strong enough to demand their share of the political pie. Europe shook as the French killed their king. The Revolution (1789-94) started with the rich city folk but deepened when the peasant class—the oppressed, formerly mute 90% of society—decided to put its collective foot down. The Old Regime was dead, and, in the early 1800s, an exciting modern future looked Europe in the eye.

As the city classes rose they had to have someone to walk on. Their doormat was the working class—the proletariat—and the 1800s gave birth to Marx and the socialist movement. Through violent revolution, or threat of revolution, this new element of society elbowed its way into history.

These movements are no longer limited to one geographical region. As our world shrinks and our appetites refuse to be satisfied, a new struggle emerges. The Third World is raising its head. It sees a modern world built upon exploitation of the undeveloped world—taking its raw materials, then selling them back as finished products. The developed Western world will either have to learn from history and make room for the newcomers, or one day the balance will tip and, just as it did in the French Revolution, the blade will fall.

Money Talks

Countries decorate their coins and currency with their own history and culture. Famous statesmen, authors, royalty, scientists, and even local art, mountains and animals are honored on foreign money just as Washington, Lincoln and Jefferson are on ours.

The painter Delacroix with one of his famous works (see p. 141) on the French 100-franc note.

If you're bored on a long train ride through Germany, pull out a two-mark coin and ask a native, "Who is this?" He'll tell you it's Konrad Adenauer, West Germany's first post-War chancellor.

Here's a quick look at some of Europe's money.

France puts "Liberte, Egalite, Fraternite" on just about everything. "Liberty, equality and brotherhood," the slogan of the Revolution, is alive and well in the France of today. Among many other great Frenchmen on France's paper money, you'll find the philosopher Voltaire and the scientist Louis Pasteur.

If you can't get to Holland's great Rijksmuseum, just look at the ten-guilder note. It shows a self-portrait of Frans Hals, a contemporary of Rembrandt and a top Dutch Master.

In Switzerland coins, bills, stamps, and even license plates refer to the country as "Helvetia," the name of the original Celtic inhabitants conquered by Julius Caesar. "CH," seen on stickers all over Switzerland, stands for "Confederation Helvetia."

Italy has fun money. Its 1,000-lira note, called a "mille" (pron. MEE-lay, and worth about fifty cents), features Giuseppe Verdi, the 19th-century operatic composer (e.g., Aida) whose stirring music helped inspire Italian unification (see p. 143). Columbus, born in Genova, is honored on the 5,000-lira note. Great art and artists like Michelangelo and Leonardo show up on other Italian bills.

Before you pay for your Norwegian cup of coffee look at the Arctic explorer Nansen on the ten-crown note. His boat, the Fram, is just across the harbor from Oslo. The same denomination in Denmark portrays Hans Christian Andersen, author of popular children's stories like "The Ugly Duckling" and "The Emperor's New Clothes." It will cost you

about ten crowns to visit the "Knott's Berry Farm"-type Hans Christian Andersen Center in his hometown of Odense.

Not only can you learn from a country's money, an attempt to do so is an easy way to make a foreign friend. Next time you're on a bus in Madrid, pull out a bill and ask your neighbor, "Who is this guy?" If he doesn't know, don't be surprised. Would you know Alexander Hamilton if you saw him on a ten-dollar bill?

Open Air Folk Museums

Many of us travel in search of the old life and traditional culture in action. While we book a round-trip ticket into the archaic past, those we photograph with the Old World balanced on their heads are struggling to dump that load and climb into our world. Many are succeeding.

More than ever, the easiest way to see the "real culture" is by exploring a country's open air folk museums. True, the culture there is about as real as Santa's Village in a one-stop climate-controlled shopping mall, but the future is becoming the past faster than ever, and, in many places, folk museums are the only Old World you're going to find.

An open air folk museum is a collection of traditional buildings from every corner of the country or region carefully reassembled in a park, usually near the capital or major city. These sprawling museums are the best bet for the hurried (or tired) tourist craving a walk through a country's past. Log cabins, thatched cottages, mills, old school houses, shops and farms come complete with original furnishings and usually a local person dressed in the traditional costume who's happy to answer any of your questions.

Folk museums buzz with colorful folk dances, live music performances and young craftspeople specializing in old crafts. Many traditional arts and crafts are dying and these artisans do what they can to keep the cuckoo clock from going the way of the dodo bird. Some of my favorite souvenirs are those I've watched being dyed, woven, or carved by folk museum craftspeople.

To get the most out of your visit pick up a list of special exhibits, events and activities at the Information Center and take advantage of any walking tours available. These sightseeing centers were popularized in Scandinavia, and they're now found all over the world.

The best folk museums I've seen are in the Nordic capitals. Oslo's, with 150 historic buildings and a 12th-century stave church, is just a quick boat ride across the harbor from the city hall. Skansen in Stockholm gets my first-place ribbon for its guided tours, feisty folk

entertainment and its Lapp camp complete with reindeer.

Switzerland's Ballenberg Open Air Museum near Interlaken is a good alternative when the Alps hide behind clouds.

The British Isles have no shortage of folk museums. For an unrivaled look at the Industrial Revolution be sure to spend a day at the new Blist's Hill Open Air Museum at Iron Bridge Gorge, north of Stratford. You can cross the world's first iron bridge to see the factories that lit the fuse of our modern age.

The "Knott's Berry Farm" of Bulgaria is in Gabrovo. This folk museum is a refreshing splash of free enterprise-type crafts in a rather cold, communal world.

Every year new folk museums open. Travel with a current guidebook and use tourist information centers abroad. Before your trip send a card to each country's National Tourist Office in San Francisco or New York (listed in *Europe Through the Back Door*, by Rick Steves). Request the general packet of trip-planning information and specifics like schedules of festivals and cultural events and lists of open air folk museums.

Folk museums teach traditional lifestyles better than any other kind of museum. As the world becomes more and more Westernized these musems will become even more important. Of course, they're as realistic as Santa's Village—but how else will you see the elves?

Here is a list of some of Europe's open air folk museums:

NORWAY

Norwegian Folk Museum, at Bygdoy near Oslo. *150 old buildings from all over Norway and a 12th-century stave church.*

Maihaugen Folk Museum, at Lillehammer. *Folk culture of the Gudbrandsdalen.*

Trondheim and Trondelag Folk Museum at Sverresborg fortress near Trondheim. *60 buildings showing old Trondheim, Lapp village and farm life.*

SWEDEN

Skansen, in Stockholm. *One of the best museums, with over 100 buildings from all over Sweden, craftspeople at work, live entertainment and a Lapp camp complete with reindeer.*

Kulturen, Lund. *Features Southern Sweden and Viking exhibits.*

FINLAND

Seurasaari Island, near Helsinki. *Buildings reconstructed from all over Finland.*

Handicrafts Museum, Turku. *The life and work of 19th-century craftspeople.*

DENMARK

Funen Village (Den Fynske Landsby), just south of Odense.

Old Town, Arhus. *60 houses and shops show Danish life from 1580-1850.*

Lyngby Park, north of Copenhagen.

Hjerl Hede Iron Age Village, 10 miles south of Skive in northern Jutland. *Lifestyles in prehistoric times.*

Oldtidsbyen Iron Age Village, near Roskilde.

GERMANY

Cloppenburg Open Air Museum, southwest of Bremen. *Traditional life in Lower Saxony, 17th and 18th centuries.*

Unterhuldingen Prehistoric Village, on the Boden Sea (Lake Constance).

SWITZERLAND

Ballenberg Swiss Open Air Museum, just northeast of Lake Brienz. *A fine collection of old Swiss buildings with furnished interiors.*

BENELUX

Netherlands Open Air Museum, north of Arnhem. *70 old Dutch buildings.*

De Zeven Marken Open Air Museum, in Schoonoord.

Bokrijk Open Air Museum, between Hasselt and Genk, in Belgium. *Old Flemish buildings and culture in a native reserve.*

GREAT BRITAIN

Blist's Hill Open Air Museum, near Coalport. *Shows life from the early days of the Industrial Revolution.*

Beamish Open Air Museum, northwest of Durham. *Life in Northeast England in 1900.*

Welsh Folk Museum, at St. Fagan's near Cardiff. *Old buildings and craftspeople illustrate traditional Welsh ways.*

Irish Open Air Folk Museum, at Cultra near Belfast. *Traditional Irish lifestyles. Buildings from all over Ireland.*

IRELAND

Bunratty Folk Park, near Limerick. *Buildings from the Shannon area and artisans at work.*

Glencolumbkille Folk Museum, Donegal. *Thatched cottages show life from 1700-1900. A Gaelic-speaking cooperative runs the folk village and a traditional crafts industry.*

BULGARIA

Gabrovo Folk Museum, Gabrovo. *Old buildings and skilled craftspeople.*

SPAIN

Pueblo Espanol, Barcelona. *Buildings from all over Spain depict regional architecture, costumes and folk craft.*

This is not a complete listing and new open air museums are being assembled every year. Ask for more information at European tourist offices.

EUROPE'S "TOP FIVES"
Gene's Dreams and Rick's Picks

Here is a list of "top fives" in different sightseeing categories. Obviously, there is no "absolute truth" when it comes to listing top fives—and we are not the High Commission on Good Taste in European Tour-

ism; still, this list is the fruit of a lengthy brainstorming session. Our criteria for choosing these sights are:

1) Historic or artistic importance.
2) Accessibility for the average tourist.
3) General popularity and fame.
4) How much we like it.

The exact numerical order is unimportant. We tried to mix things up geographically rather than list five German castles and five French Gothic cathedrals. Remember, when planning your itinerary, it is wise not to burn out on mediocre palaces, castles, cathedrals and museums if you have the biggies coming up. Sightsee selectively so you can absorb and enjoy with maximum energy. These sights are our favorites.

ROMAN RUINS OUTSIDE OF ROME

Bath, *England*
Nimes and Arles, *Southern France*
Aqueduct near Nimes *(Pont du Gard)*
Hadrian's Wall, *North England*
Aqueduct in Segovia, *Spain*

BYZANTINE SITES

St. Mark's, *Venice*
Many churches in *Ravenna, Italy*
Charlemagne's chapel, *Aachen, Germany*
Hagia Sophia, *Istanbul*
Sacre Coeur, neo-Byzantine church, *Paris*

CASTLES

Neuschwanstein, *Fussen, Germany*
Tower of London
Cochem, *Mosel Valley, Germany*
Your choice on the Rhine

ANCIENT ART MUSEUMS

British Museum, *London*
Louvre, *Paris*
National Museum of Archeology, *Athens*
Vatican Museum
National Museum *(near station), Rome*

ROMANESQUE ARCHITECTURE

Durham Cathedral, *England*
Cathedral of Pisa, *Italy*
Vezelay, *France*
Santiago de Compostela, *Spain*
Worms, *Germany*

GOTHIC CHURCHES (TOP 10)

Chartres, *France*
Sainte-Chapelle, *Paris*
Cologne, *Germany*
King's College Chapel, *Cambridge*
Reims, *France*
Salisbury, *England*
Toledo, *Spain*
Orvieto, *Italy*
Milan, *Italy*
Notre Dame, *Paris*

BEST PRESERVED MEDIEVAL TOWNS

(see separate chapter)

FESTIVALS

Salzburg Music Festival, *end of July through August*
Edinburgh, *late Aug.-early Sept.*
Dafni Wine Festival, *mid-July-early Sept. (near Athens)*
Munich beerhalls, *June 1st-May 31st*
Each country's national holiday: (e.g., French Bastille Day), p. 358.

ART MUSEUMS
(mostly painting)

Prado, *Madrid*
Louvre, *Paris*
Vatican, *Rome*
Uffizi, *Florence*
Rijksmuseum, *Amsterdam*

RENAISSANCE ARCHITECTURE

Pazzi Chapel, *Florence*
Tempietto, *Rome*
Dome of Florence Cathedral, *Florence*
Urbino Palace, *Urbino*
Several chateaus of the Loire Valley,
France

FAVORITE WORKS OF ART

Rick's:
Garden of Delights, Bosch, *Prado*
Isenheim Altarpiece, Grunewald,
Colmar
Primavera, Botticelli, *Florence*
Guernica, Picasso, *Madrid*
Pieta, Michelangelo, *Vatican*
David, Michelangelo, *Florence*
Virgin of the Roses, Schongauer,
Colmar
Swiss Alps, God
Toledo Cathedral
Sainte-Chapelle (church), *Paris*
St. John the Baptist, Donatello, *Venice*
Self-Portrait, Durer, *Prado*
The Scream, Munch, *Oslo*
Death of Murat, David, *Brussels*
Hand of God, Milles, *Stockholm*
Weeping Virgin Altarpiece, *Seville*

Gene's "lucky 13" picks (with apologies to no one):
Isenheim Altarpiece, Grunewald,
Colmar
The Tempest, Giorgione, *Venice*
Head of Christ Mosaic, Dafni, *Greece*
Interior of My Studio, Courbet, *Louvre*

Burial of Count Orgaz, El Greco,
Toldeo, *Spain*
School of Athens, Raphael, Vatican
Palace
Moses, Michelangelo, S. Pietro in Vincoli, *Rome*
Last Supper, Leonardo, *Milan*
Intrigue, James Ensor, Royal Museum,
Antwerp
Descent from the Cross, Rogier van
der Weyden, *Prado*
Grande Odalisque, Ingres, Louvre
Jacob Wrestling with the Angel,
Gauguin, National Gallery,
Edinburgh
St. Francis in Ecstasy, G. Bellini,
New York

HISTORICAL MUSEUMS

British Museum
London Museum
York Castle Museum
Deutsches Museum, *Munich*
Les Invalides, *Paris*

NATIONAL PALACES

Versailles, *Paris*
Royal Palace, *Madrid*
Schonbrunn, *Vienna*
Each Scandinavian capital
Residenz, *Munich*

BAROQUE BUILDINGS

Versailles
Schonbrunn, *Vienna*
"Die Wies," *Bavaria*
St. Paul's, *London*
The piazzas of Rome
St. Agnes, *Rome*

NORTHERN ART MUSEUMS

Rijksmuseum, *Amsterdam*
Ancient Art Museum, *Brussels*
Alte Pinakothek, *Munich*
Kunsthistorisches Museum, *Vienna*
Dahlem Museum, *Berlin*

NEOCLASSICAL ARCHITECTURE

British Museum, *London*
Arc de Triomphe, *Paris*
Pantheon, *Paris*
La Madeleine, *Paris*
Victor Emmanuel Monument, *Rome*

IMPRESSIONIST AND POST-IMPRESSIONIST MUSEUMS

Jeu de Paume, *Paris*
Van Gogh, *Amsterdam*
Palais de Tokyo, *Paris*
Munch Museum, *Oslo*
Rodin Museum, *Paris*

20TH CENTURY ART MUSEUMS

Pompidou Modern Art Gallery, *Paris*
Galleries on French Riviera
Louisiania, *Denmark*
Picasso's House, *Barcelona*
Oslo and Stockholm sculpture gardens
Pitti Palace, *Florence*
Tate Gallery, *London*

MODERN ARCHITECTURE

Chapel of Ronchamp, *France*
Georges Pompidou Gallery, *Paris*
EUR, *Rome*
Pirelli Building, *Milan*
Casa Mila, Apartment house by Gaudi, *Barcelona*
Les Halles, *Paris*
Termini Station, *Rome*
Temppelliankiu Church, *Helsinki*

MOST OVERRATED SIGHTS

Manneken-Pis, *Brussels*
Stonehenge, *England*
Atonium, *Brussels*

Glockenspiel, *Munich*
Mermaid, *Copenhagen*
Hitler's Bunker, *Berlin*
Spanish Steps and Trevi Fountain, *Rome*
Blarney Stone, *Ireland*
Land's End, *England*

MOST UNDERRATED SIGHTS

Ostia Antica, Rome's ancient port
Bath, England's finest city
Toledo Cathedral, Spanish Renaissance
Chantilly Chateau, near *Paris*
Schatzkammer (Treasury), *Munich*

MOST UNDERRATED MUSEUMS

Vatican Museum (before the Sistine)
Unterlinden Museum, *Colmar*
Groeninge Museum, *Brugge*
York Castle Museum, *York*
Costume Museum, *Bath*

FAVORITE CHURCHES

Charlemagne's chapel, *Aachen.*
Sacre Coeur, *Paris*
St. Peter's, *Vatican*
Toledo Cathedral, *Toledo*
Sainte-Chapelle, *Paris*

EVENING "SCENES"

Seville, flamenco street scenes
Piazza Navona, *Rome*
Mathauser's Beerhall, *Munich*
Jazz clubs, *Paris*
"Pub crawl," back streets of Venice, crossing empty St. Mark's Square at midnight
Tivoli, *Copenhagen*—fireworks
Any Italian hill town after the tour buses have left.

The Europeans

People talk about "traveling to Europe" as though "Europe" is a single culture. In fact, it's a complex web of peoples, languages, political systems, and lifestyles. Still, you don't have to be a demographic wiz to make sense of it all. Let's sort out Europe's cultures one region at a time.

Scandinavia (Norway, Sweden and Denmark)

Scandinavia is very well-organized, largely rural, and sparsely populated. Lutheran is the state religion. While it's Europe's most expensive region, you're not getting less for your dollar. . . there just aren't many alternatives to Scandinavian high quality and comfort. Norwegians, Swedes, and Danes are culturally and racially very close. Finns are not even distant cousins.

Germanic Countries (Germany, Austria, Switzerland)

West Germany is the size of Oregon state. It has 65 million people and produces nearly a third the output of the entire USA! While Germany is divided politically into east and west halves, there is a natural north-south division when it comes to dialects, religions and life styles. The North Germans are busy and relatively no-nonsense. They speak a more formal "High German" dialect.

Life in the southern part of Germany is more relaxed. Bavaria (the largest state of Germany's South), with its lederhosen, beerhalls, and ruddy-faced natives, is what most Americans think of when they think "Germany."

In general, Germany, like Europe, can be divided into a Protestant north and the Catholic south.

Austria is relaxed, like southern Germany. The Austrians are experts in the fine art of enjoying life, which they call "gemutlichkeit." Sunday strolls, coffee and pastries, and the shortest work week in Europe sum up their attitude to life. Consequently, the country is somewhat less prosperous—and cheaper for the tourist—than Germany. Austrians are mostly Catholic and speak a Bavarian-style German dialect.

Switzerland is a smorgasbord of several cultures. Because of its mountainous terrain, French- and German-style cultures exist almost side by side—separated by just a few mountainous miles.

Switzerland is very efficient, industrious and organized, and the people are cultured and polite. Protestants and Catholics often worship side by side, though Protestants are more numerous. As a rule of thumb, when looking at a small Swiss village in the distance, if you can see the church, the town's Catholic; if you can see the school, it's Protestant.

The Low Countries (Benelux = Belgium, Netherlands, Luxembourg)

These small countries have plenty of important distinctions but they're becoming increasingly unified politically, economically, and culturally. The region is called "low" because it's low—half of the Netherlands are below sea level, reclaimed from the sea. The population is Europe's densest (crowded, not stupid) and English is widely understood throughout.

The Netherlands dominate the region. The people speak Dutch and are Protestant. To call the Netherlands "Holland" is like calling the USA "Texas." Holland is the largest of several Dutch states.

Belgium, somewhat like Germany, is divided north/south. In the north are the Flemish (Dutch-speaking, Protestant) people, with the Walloons (French, Catholic) in the south.

The tiny country of Luxembourg (30 x 30 miles!) is French-speaking. Luxembourg joined Belgium and the Netherlands in an economic union called Benelux. There is free trade between these countries and you won't even know when you cross a border.

British Isles (England, Scotland, Wales, Northern Ireland and the Republic of Ireland)

British culture is a result of centuries of successive invasions—Celts, Romans, Angles, Saxons, Vikings, and French Normans. The original inhabitants, the Celts, were shoved into the undesirable fringes of the Isles by the Anglo-Saxons. Today, the Angles , who settled in "Angle-land," are surrounded by a "Celtic Crescent" in Wales, Scotland, Ireland, and Brittany (in northern France). The English language, of course, dominates the area, but Celtic languages and ways survive in remote corners.

Ireland is a divided island, politically and religiously. The six countries called Ulster in the northeast quarter are the mostly-Protestant area governed from London. Catholics are fighting for a bigger voice, and both Catholics and Protestants are fighting for greater independence from Britain. The southern three-quarters is the independent nation of Ireland ruled from Dublin. The people are mostly Catholic, fiercely friendly and make Ireland warm and cozy even the coldest and drizzliest day.

France

Europe's largest country, the size of Texas, France has one of the most developed "high cultures" in the world. While its economy has suffered lately, the people are proud of their culture and heritage. The French are famous for being as bad with foreign languages as we Americans

are. Parisians see France much as New Yorkers see the USA. (Remember the "New Yorker map"?) They refer haughtily to all the rest of France as "provence".

Several trouble-making secessionist minorities—the Britons (Celtic descendants), Basques, and Corsicans—are making headlines. Most French are nominal Catholics.

Latin Countries (Spain, Portugal and Italy)

Language and religion set these southern countries apart from the north. While the north is generally Protestant and Germanic (even English is a Germanic language), the south is Catholic and Latin. Spanish, Portuguese, and Italian, along with French, are related Romance languages from the Latin of ancient Rome. A knowledge of one helps with the others.

These countries are more traditional, slower-paced, less efficient, and less predictable than their more modern northern neighbors. When traveling in Europe's South, it's important to adapt. Bucking the siesta, late dinner hour and other "colorful" ways of the Mediterranean region will only make life difficult here.

Economically, these countries are behind the North, but Italy has been doing well lately. It is not cheap for tourists. Portugal, with Europe's weakest economy, and Spain are in Europe's bargain basement. You'll enjoy plenty of cultural thrills per mile, minute and dollar in Europe's southern half.

European Festivals

Each country has a "4th of July" celebration. A visit to a country during its national holiday can only make your stay more enjoyable.

Austria	Oct. 26	Morocco	March 3
Belgium	July 21	Netherlands	April 30
Bulgaria	Sept. 9	Norway	May 17
Czechoslovakia	May 9	Poland	July 22
Denmark	April 16	Portugal	April 25
Egypt	July 23	Romania	Aug. 23
Finland	Dec. 6	San Marino	Sept. 3
France	July 14	Spain	Oct. 12
East Germany	Oct. 7	Sweden	April 30
Greece	March 25	Switzerland	Aug. 1
Hungary	April 4	Turkey	Oct. 29
Ireland	March 17	USSR	Nov. 7
Italy	June 2	West Germany	June 17
Luxembourg	June 23	Yugloslavia	Nov. 29
Malta	Dec. 13		

EUROPEAN FESTIVALS

Austria
Salzburg Festival, July 26-Aug 30. Greatest musical festival, focus on Mozart.

Belgium
Bruges, Ascension Day. Procession of Holy Blood. 3 p.m. (40 days after Easter). 1,500 locals in medieval costume.

"Adriaan Brouwerfeesten," last Sat & Sun in June. Beer festival in Oudenaarde, nice town 35 mi W of Brussels.

"Ommegang," 1st Thurs in July. Brussels' Grand Place. Colorful medieval pageant.

Denmark
Tivoli, May 1-Sept. 15. Always a festival. Copenhagen.

Midsummer Eve, June 23 & 24. Big festivities all over Scandinavia, bonfires, dancing, burning of tourists at the stake.

Roskilde Rock Festival, last weekend in June or 1st in July. Annual European Woodstock, fairground atmosphere, big acts. Roskilde, 20 mi W of Copenhagen.

Hans Christian Andersen Festival, mid July-mid Aug. in Odense. Great family entertainment. Danish children perform fairy tales.

England

Jousting Tournament of Knights, last Sun & Mon in May at Chilham Castle near Canterbury. Medeival pageantry, colorful.

Allington Castle Medieval Market, 2nd or 3rd Sat in June in Maidstone (30 mi SE London). Medieval crafts and entertainment.

Druid Summer Solstice Ceremonies, June 20 or 21. Stonehenge, Hoods and white robes, rituals from midnight to sunrise at about 4:45 a.m.

Alnwick Medieval Fair, last Sun in June to next Sat. Medieval costumes, competition, entertainment. Alnwick, 30 mi N of Newscastle.

Haslemere Early Music Festival, 2 Fridays before 4th Sat in July. 16th-18th c. music on original instruments. 40 mi S of London.

Sidmouth Int'l Folklore Festival, 1st to 2nd Fridays of August, 300 events, 15 mi E of Exeter.

Reading Rock Festival, last weekend in August. England's best. 40 mi W of London.

Nottingham Goose Fair, 1st Thurs-Sat in Oct, one of England's oldest and largest fairs. Nottingham.

Guy Fawkes Day, Nov. 5. Nationwide holiday.

France

Fetes de la St. Jean, around June 24, 3 days of folklore and bull running in streets. St. Jean de Luz (on coast, S of Bordeaux).

Tour de France, first 3 weeks of July, 2,000 mile bike race around France ending in Paris.

Maubeuge Int'l Beer Festival, Thursday before July 14 for two weeks. Great entertainment and beer in largest beer tent. In Maubeuge near Belgian border.

Bastille Day, July 13 & 14. Great National Holiday all over France. Paris has biggest festivities.

Great Festival of Corouaille, 4th Sun in July. Huge Celtic folk festival at Quimper in Brittany.

Alsace Wine Fair, 2nd & 3rd weekends in Aug in Colmar.

Festival of Minstrels, 1st Sun in Sept. Wine, music, folklore, etc. in Ribeauville 35 mi S of Strasbourg.

Fete d'Humanite, 2nd or 3rd Sat and Sun. Huge communist fair color festivities—not all red. Paris.

Germany

Der Meistertrunk, Sat before Whit Monday. Music, dancing beer, sausage in Rothenburg o.d.T.

Pied Piper's Procession, Sundays, 1:00 p.m. all summer, Hamlin (where else?).

Ayinger Volksfest, 2nd thru 3rd weekend in June. White bear, concerts and Maypole dancing at Aying, 15 mi SE of Munich.

Freiburger Weinfest, last Fri thru following Tuesday in June. Wine festival in Black Forest town of Freiburg.

Kinderzeche, weekend before 3rd Mon in July to weekend after. Festival honoring children who saved town in 1640's. Dinkelsbuhl.

Trier Weinfest, Sat to 1st Mon in Aug. Trier.

Gaubondenfest, 2nd Fri in Aug for 10 days. 2nd only to Oktoberfest. Straubing 25 mi SE of Regensburg.

Der Rhein in Flammen, 2nd Sat in Aug. Dancing, wine and beer festival, bonfires. Koblenz to Braubach.

Moselfest, last weekend in Aug or 1st in Sept. Mosel wine festival in Winningen.

Backfischfest, last Sat in Aug for 15 days. Largest wine and folk festival on the Rhine in Worms.

Wurstmarkt, 2nd Sat, Sept, through following Tuesday. And 3rd Fri through following Monday. World's largest wine festival in Bad Burkheim, 25 mi W of Heidelberg.

Oktoberfest, starting 3rd to last Sat in Sept through 1st Sun in Oct. World's most famous beer festival, Munich.

Greece

Epidaurus Festival, approx 1st of July to 1st of Sept. Greek drama and comedy. 2,500 yr old amphitheatre. Epidaurus, 100 mi SW of Athens.

Rhodes Wine Festival, 1st Sat in July through 1st Sun in Sept. Great variety of Greek wines. Arts, handicrafts, music, dancing. Rhodes.

Dafni Wine Festival, 2nd Sat in July through 1st Sun in Sept. Many varieties of wine, music, dancing, restaurant. Nominal cost. Special bus from Koumoundourou Square. 5 mi from center of Athens.

Ireland

Pan Celtic Week, 2nd through 3rd weekends in May. Singing competitions, bagpipes, harps, stepdancing, wrestling, hurling. Killarney.

Fleadh Cheoil na h-Eireann, last weekend in Aug. Ireland's traditional folk musicians. National festival, locale changes yearly.

Italy

Sagra del Pesche, 2nd Sunday in May. One of Italy's great popular events, huge feast of freshly caught fish, fried in world's largest pans. Camogli, 10 mi S of Genoa.

Festa de Ceri, May 15. One of the world's most famous folklore events, colorful pageant, giant feast afterwards. Gubbio, in hill country, 25 mi NE of Perugia.

"Palio of the Archers," last Sun of May. Re-enactment of medieval crossbow contest with arms and costumes. Gubbio, 130 mi NE of Rome.

"Palio," July 2 and Aug. 16. Horse race which is Italy's most spectacular folklore event. Medieval procession beforehand. 35,000 spectators. Siena, 40 mi SW of Florence.

Joust of the Saracen, 1st Sun of Sept. Costumed equestrian tournament dating from 13th c. Crusades against the Muslim Saracens. Arezzo, 40 mi SE of Florence.

Historical Regatta, 1st Sun of Sept. Gala procession of decorated boats followed by double-oared gondola race. Venice.

Human Chess Game, 1st or 2nd weekend in Sept on even-numbered years. Medieval pageantry and splendor accompany re-enactment of human chess game in 1454. Basso Castle in Marostica, 40 mi NW of Venice.

Netherlands

Kaasmarkt, Fridays only from late April to late Sept. Colorful cheese market with members of 350 yr old Cheese Carriers' Guild. Alkmaar, 15 mi N of Amsterdam.

North Sea Jazz Festival, weekend of 3rd Sun in July. World's greatest jazz weekend. 100 concerts with 500+ musicians. Den Haag.

Norway

Constitution Day, May 17. Independence parades and celebration. Oslo.

Midsummer, June 23-24. "Jonsok Eve" celebrated with bonfires, beer, open-air dancing, boating. Nationwide.

Horten Festivalen, 1st Sun in July. Small festival features all kinds of music, esp rock. Located 50 mi S of Oslo in Horten and reached by train & bus from the Oslo West station.

Portugal

Popular Saints Fair, June 12, 13; 23, 24; 28, 29. Celebration of 3 favorite saints. Parades, singing, dancing in streets, bonfires, bullfights. Lisbon.

Feirade Santiago, July 25-Aug 8. Celebration for patrons saint featuring feast day, cultural events, folklore, bullfights. Setubal, 20 mi SE of Lisbon.

Romaria de Senhor da Nazare, 2nd weekend in Sept. 3 colorful processions in picturesque fishing village. Daily bullfights, market, nightly folk music, dancing. 70 mi N of Lisbon. Nazare.

Scotland

Beltane Festival, approx 3rd week of June. Ancient festival dates from Celtic sun worship festival and is combined with annual Common Riding. Peebles, 25 mi S of Edinburgh.

Inverness Highland Gathering, 2nd Sat in July. Athletes in kilts, bagpipers, traditional dancing. Inverness, 160 mi NW of Edinburgh.

Edinburgh Festival, 3rd to last Sun in Aug through 2nd Sat in Sept. World's most comprehensive performing arts festival. Edinburgh.

Argyllshire Highland Gathering, 4th or last Thurs in Aug. Athletics, dancing, piping competiton. Oban, 95 mi NW of Glasgow.

Cowal Highland Gathering, last Fri and Sat in Aug. One of the largest Highland Gatherings. Complete highland festivities. Dunoon, on coast west of Greenock and 25 mi (via ferry connection) NW of Glasgow.

Braemar Royal Highland Gathering, 1st Sat in Sept. Largest and most famous highland gathering with Royal Family in attendance. Braemar, 60 mi W of Aberdeen.

Spain

Int' Music and Dance Festival, approx early July. Classical music and ballet in courtyard of the Alhambra. Leading performing arts festival in Spain. Grenada.

Running of the Bulls, July 6-14. World-famous "encierros," (running of the bulls), accompanied by religious observances, processions, jubilant festivities. Pamplona.

St. James Fair, approx July 15-31. Festivities, fireworks, fairs, cultural events. Santiago de Compostela, 390 mi NW of Madrid.

El Encierros de Cuellar, last Sun in Aug through following Wed. Spain's oldest running of the bulls event. Dances, bullfights. Cuellar, 35 mi N of Segovia.

Sweden

Midsummer, Fri and Sat nearest June 24. Dancing, games, music during height of summertime when days are longest. Nationwide, and throughout Scandinavia.

Asele Market, 2nd or 3rd weekend in July. Laplanders' most important folk festival for 200 years. Asele, 400 mi N of Stockholm.

Ancient Gotland Athletic Games, Sat and 2nd Sun in July. Ancient sports contests between Norsemen. Stanga (Gotland) 25 mi SE of Visby.

Switzerland

Landsgemeinde, 1st Sun in May. Largest open-air parliamentary session. Glarus, 40 mi SE of Zurich.

Montreux International Jazz Festival, 1st through 3rd weekends in July. Comprehensive annual musical events featuring top artists. Montreux.

William Tell Plays, 2nd Thurs in July through 1st Sun in Sept. Dramatic presentations retelling the story of William Tell. Open-air theatre. Interlaken.

Swiss National Day, Aug. 1. Festive national holiday! Parades, concerts, bell ringing, fireworks, yodeling, boat rides. Nationwide.

Yugloslavia

Hay Making Day, 1st Sun. in July. Competition in hay making, horseracing, stone throwing. Folk costumes, Kupres, by bus from Banja Luka (55 mi), Split (65 mi), or Sarajevo (75 mi).

Zagreb International Folklore Festival, next to last Sun through last Sun in July. One of Europe's largest folklore revues. Zagreb, 230 mi NW of Belgrade.

These are just a few of Europe's countless folk and music festivals. Each country's National Tourist Office in the USA will send you a free calendar of events. The best book I've seen for a listing of the great festivals of Europe is Playboy's *Guide to Good Times: Europe,* $2.95. ISBN 0-872-16819-0.

WORLD HUNGER
A CHALLENGE FOR YOU!

Many Americans fail to realize how richly blessed our nation is—until travel opens their eyes. Millions of people in poor countries will work for twenty years and earn less than what you might spend on this year's vacation ($2,000). As Americans, we are gluttonous kings of the money mountain. We don't have to feel guilty—but we should feel concerned about this inequity. I've found that education cements my commitment to fighting hunger. How's your education? Books like *Bread for the World* by Simon, *Rich Christians* by Sider, and *The Future In Our Hands* by Erik Damman are great eye-openers.

So many of us are outraged by the killing and suffering of innocent people we see on the news. Passive outrage. The news doesn't tell us that 15 million children die slow hunger-related deaths each year (40,000 per day) because our society doesn't want to hear that kind of news. It's hopeful, not hopeless. We all have compassion. If we can just educate ourselves and readjust our values, that compassion will power our generation to do to hunger what Lincoln's generation did to slavery—end it.

If your travel experiences spark in you a desire to become part of the solution rather than just another fat cell in the brotherhood of mankind may I suggest three things:

1. Cement your commitment by learning about the most serious problems confronting mankind.

2. See yourself as a trend setter. Challenge our consumptive American values.

3. Believe that you do make a difference then find a way to make things happen.

A better understanding of humanity on a global scale is the ultimate souvenir of your travel. The future will thank you.

For more information write:

WORLD CONCERN
19303 Fremont Avenue North
Seattle, WA 98133 Tel. 1-800-421-7010

Lobby Organization, BREAD FOR THE WORLD
802 Rhode Island Ave. N.E.
Washington, D.C. 20018

THE FUTURE IN OUR HANDS
Box 1380
Ojai, CA 93023

Europe in 22 Days: A Step by Step Guide & Travel Itinerary

104 pages, $6.95

Europe's best three weeks—in recipe form. The most efficient mix of famous "must see" sights, intimate "back door" nooks and off-beat crannies. A step by step handbook with city maps, day plans, train schedules, tips on cultural emersion. Ideal for do-it-yourselfers—with or without a tour.

Great Britain in 22 Days

104 pages, $6.95

Steves unfolds an itinerary designed to show you Great Britain in all its splendor. From famous landmarks to quaint seaside villages, Steves zeroes in on the England that the British themselves are so fond of. From Kew Gardens to the lush flower plots blooming in front of every countryside cottage, from high atop the Tower of London to an evening talking politics and throwing darts in the Clarence pub, here is the England you've always wanted to see.

Spain & Portugal in 22 Days

104 pages, $6.95

Steves takes you from Madrid to the walled frontier town of Cuidad Rodrigo, through Portugal's wildly natural countryside into the old quarter of Coumbra, from the fishing village of Sao Martinho to Sintra with its hill-capping, fairy-tale Pena Palace, and on to the stately resort town of Cascias and its noble beachfront promenade. Each day is treated as a separate unit and has a suggested schedule, sight-seeing, budget accommodations with addresses and telephone numbers, transportation notes and a map.

Travel Guides from
John Muir Publications

Qty.	Title	Each	Total
	Alaska in 22 Days - *Lanier* (March '88)	$ 6.95	
	American Southwest in 22 Days - *Harris* (April '88)	6.95	
	Australia in 22 Days - *Gottberg*	6.95	
	China in 22 Days - *Duke & Victor*	6.95	
	Europe in 22 Days - *Steves*	6.95	
	Germany, Austria & Switzerland in 22 Days - *Steves*	6.95	
	Great Britain in 22 Days - *Steves*	6.95	
	India in 22 Days - *Mathur* (April '88)	6.95	
	Japan in 22 Days - *Old*	6.95	
	Mexico in 22 Days - *Rogers & Rosa*	6.95	
	Norway, Denmark & Sweden in 22 Days - *Steves*	6.95	
	West Indies in 22 Days - *Morreale*	6.95	
	All-Suite Hotel Guide - *Lanier*	9.95	
	Asia 101 - *Gottberg* (March '88)	11.95	
	Asia Through the Back Door - *Steves & Gottberg*	11.95	
	Complete Guide to Bed & Breakfasts - *Lanier*	12.95	
	Elegant Small Hotels - *Lanier*	12.95	
	Europe 101 - *Steves*	11.95	
	Europe Through the Back Door - *Steves*	11.95	
	Gypsying After 40 - *Harris*	12.95	
	Heart of Jerusalem - *Nellhaus* (Feb. '88)	12.95	
	Mona Winks - *Steves* (April '88)	9.95	
	People's Guide to Camping in Mexico - *Franz* (April '88)	11.95	
	People's Guide to Mexico - *Franz*	13.95	

	Subtotal	$
Non-U.S. payments must be in	Shipping	$ 1.75
U.S. funds drawn on a U.S. bank.	**Total enclosed**	$

METHOD OF PAYMENT (CHECK ONE)

☐ Charge to my (circle one): MasterCard VISA AmEx
☐ Check or Money Order Enclosed (Sorry, no CODs or Cash)
Credit Card Number

Expiration Date ☐☐ — ☐☐

Signature _____
Required for Credit Card Purchases
Telephone: Office (____) _____ Home (____) _____
Name _____
Address _____
City _____ State _____ Zip _____
Send to: John Muir Publications
P.O. Box 613 Santa Fe, NM 87504-0613 (505) 982-4078
Please allow 4-6 weeks for delivery.

Books

While you may be saying, "Enough, already!" history does not end with this book. For a more detailed look at art and history, there are a number of good college texts from the library or university bookstores. Books we've found useful are:

1) *History of Art*, H.W. Janson

2) *History of the Modern World*, Palmer.

3) *Civilization*, Kenneth Clark.

Here are some sources you *won't* find recommended for your average college course.

ANCIENT WORLD:

Julius Caesar, Shakespeare

I, Claudius, Robert Graves (also BBC-TV production).

Fictional stories of real Roman emperors.

Greek Myths—Even children's versions are great to read.

Odyssey, Homer (or any Ulysses movies).

MEDIEVAL WORLD:

The Life and Words of St. Francis, Ira Peck

Decameron, Boccaccio

Masque of the Red Death, Poe

Stories of the plague

Robin Hood

The Medieval World, Friederich Heer

The Consolation of Philosophy, Boethius

Dr. Faustus, Christopher Marlowe

Faust, Goethe

Beowulf

Medieval Romances (King Arthur, Holy Grail Legends)

A Distant Mirror, Barbara Tuchman

The Once and Future King, T.H. White

Shakespeare's history plays, especially Richard III and Henry IV, part one

Canterbury Tales, Chaucer

RENAISSANCE:

The Agony and the Ecstasy (also movie), Irving Stone

Story of Michelangelo

The Prince, Machiavelli

The Name of the Rose, Umberto Ecco

EARLY MODERN WORLD:

War and Peace, Leo Tolstoy

A Tale of Two Cities, Charles Dickens

Marat-Sade (movie and play)

MODERN WORLD:
Down and Out in Paris and London, George Orwell
David Copperfield, Dickens
Trinity, Leon Uris. Historical novel dealing with the Irish problem.
Inside the Third Reich, Albert Speer. Most intimate look at the world of Hitler.
Origins of Totalitarianism, Hannah Arendt

GENERALLY:
Connections, James Burke. Science through history.
Blue Guides to various European countries, Michelin
Green Guides, Michelin
The World Since 1500, Stavrianos
Modern Europe Since 1815, Gay, Webb
American Express Guides to Florence, Venice and Rome

OTHER BOOKS WE FOUND USEFUL:
The Story of Western Architecture, Bill Riseboro
Great Architecture of the World, J.J. Norwich
The High Gothic Era, Marcel Aubert
Europe Through the Back Door, Rick Steves
The Castle Story, Sheila Sancha
World Book Encyclopedia
Art: a History of Painting, Sculpture, & Architecture, F. Hartt
Looking at History, Unstead
Civilization—Past and Present, T.W. Wallbank
Unfinished Journey, M. Perry
Anthem, Ayn Rand
A Gift From the Sea, Ann Morrow Lindbergh
Bread for the World, Arthur Simon
The Future In Our Hands, Erik Dammann

Send Me a Postcard— Drop Me a Line . . .

It's our goal to make this book the most helpful 370 pages of European history and art any traveler can read. Any suggestions, criticisms or feedback from you would really be appreciated (send to 120 4th N., Edmonds, WA 98020). Any correspondents will receive our Back Door travel newsletter and we'll be happy to send a free copy of our next edition of *Europe 101* to anyone whose advice helps shape it. Thanks and happy travels—Rick

BACK DOOR CATALOG

ALL ITEMS FIELD TESTED, HIGHLY RECOMMENDED,
COMPLETELY GUARANTEED AND DISCOUNTED BELOW RETAIL.

Combination Suitcase/Rucksack . . .$60.00

At 9″ x 21″ x 13″ this specially designed, sturdy, functional bag is maximum carry-on-the-plane size (fits under the seat). Made of rugged waterproof Cordura nylon, with hide-away shoulder straps, waist belt (for use as a rucksack), top and side handles, and a detachable shoulder strap (for toting as a suitcase). Perimeter zippers allow easy access to the room (2200 cu. in.) central compartment. Two small outside pockets are perfect for maps and other frequently used items. Over 6,000 Back Door travelers have used these bags around the world. Comparable bags cost much more. Available in navy blue, black, gray, or burgundy.

Moneybelt . $6.00

Required! Ultra-light, sturdy, under-the-pants, nylon pouch just big enough to carry the essentials comfortably. I'll never travel without one and I hope you won't either. Beige, nylon zipper, one size fits all, with instructions.

Catalog .Free

For a complete listing of all the books, products, and services Rick Steves and Europe Through the Back Door offer you, ask us for a copy of our 32-page catalog. It's free.

Eurailpasses

With each Eurailpass order we offer a free taped trip consultation. Send a check for the cost of the pass you want along with your legal name, a proposed itinerary and a list of questions and we'll send you your pass, a taped evaluation of your plans, and all the train schedules and planning maps you'll need. Because of this unique service, we sell more train passes than anyone in the Pacific Northwest.

Back Door Tours

We encourage independent travel, but for those who want a tour in the Back Door style, we do offer a 22-day "Best of Europe" tour. For complete details, write to us at the address below.

All orders will be processed within one week and include a rubber universal sink stopper and one year's subscription to our Back Door Travel newsletter. Sorry, no credit cards. Send checks to:

Europe Through the Back Door
120 Fourth Ave. N.
Edmonds, WA 98020
tel. (206) 771-8303

Other European Travel Guides by Rick Steves You're Sure to Enjoy!

Europe Through the Back Door

New 7th edition, 370 pp., $11.95

Rick Steves' popular guidebook to budget European Travel is now expanded, completely rewritten and offers more practical "how to" information on do-it-yourself travel than ever.

The first half of the book covers the basic skills of budget travel, teaching you how to travel as a temporary local person, getting more by spending less. Chapters cover all the basic skills plus some found in no other book: planning an efficient itinerary, long distance telephoning in Europe, hurdling the language barrier, travel photography, the woman traveling alone, theft and tourism, the ugly American, a calendar of European festivals and more.

The last half of the book contains articles on 32 special "Back Doors" — day-plans to Rick's favorite unheralded corners of Europe.